MEN AND MEMORIES

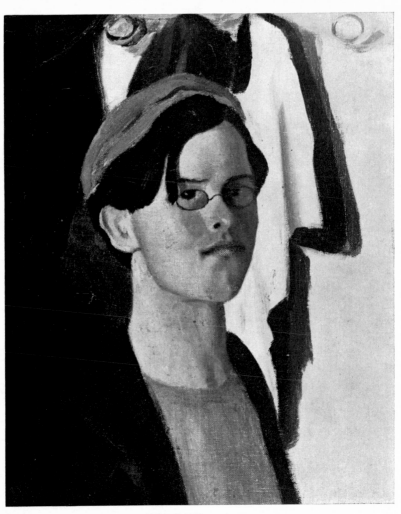

WR *Self Portrait* 1890

MEN AND MEMORIES

RECOLLECTIONS,

1872–1938,

BY

WILLIAM ROTHENSTEIN

Edited by
MARY LAGO

University of Missouri Press
Columbia, 1978

© Chatto and Windus Limited, 1978
ISBN 0-8262-0235-7
Library of Congress Catalog Card Number 77-14670

Printed in Great Britain
Published in the United States of America by the
University of Missouri Press
Columbia, Missouri

Published throughout the world
except in the United States of America
by Chatto and Windus Limited London

MEN AND MEMORIES, 1872–1900
to my wife

MEN AND MEMORIES, 1900–1922
to Herbert Albert Laurens Fisher

SINCE FIFTY: MEN AND MEMORIES, 1922–1938
to Max Beerbohm

*

This edition is gratefully dedicated
to John, Rachel, Betty and Michael

CONTENTS

LIST OF ABBREVIATIONS

AJ Michael Holroyd, *Augustus John*

IE *Imperfect Encounter: Letters of William Rothenstein and Rabindranath Tagore, 1911–1941,* ed. Mary M. Lago

MM I William Rothenstein, *Men and Memories: Recollections of William Rothenstein, 1872–1900.* (Rose and Crown Edition, 1934.)

MM II William Rothenstein: *Men and Memories: Recollections of William Rothenstein, 1900–1922.* (Rose and Crown Edition, 1934.)

MW *Max and Will: Max Beerbohm and William Rothenstein, Their Friendship and Letters, 1893–1945,* ed. Mary M. Lago and Karl Beckson

PC Private Collection

PD William Rothenstein, *The Portrait Drawings of William Rothenstein, 1889–1925,* comp. John Rothenstein

RP:HL Rothenstein Papers: The Houghton Library, Harvard University

SF William Rothenstein, *Since Fifty: Men and Memories, 1922–1938*

WR Robert Speaight, *William Rothenstein: The Portrait of an Artist in His Time*

ACKNOWLEDGMENTS

THIS edition was undertaken at the suggestion of Sir John and Lady Rothenstein, and with the permission of Sir John and Mr Michael Rothenstein, co-executors for the Estate of Sir William Rothenstein. I am most grateful to all of the members of the Rothenstein family for their kindness and patient assistance.

I wish to thank the Research Council of the Graduate School, University of Missouri-Columbia, for grants in partial support of this research. I have received generous assistance from many research centres, in particular, The Houghton Library at Harvard University; the libraries of the University of Missouri-Columbia and of Indiana University, Bloomington; the New York Public Library; the Academic Center Library, University of Texas, Austin; The British Library; the Bodleian and the Merton College Libraries, Oxford; the Library of the Victoria and Albert Museum; the Mocatta Collection and the Goldsmiths Library, University of London. Of the many individuals who have helped me pursue fugitive facts and works of art, I wish especially to thank Dr Wendy Baron, Mrs Mary Bennett, Mr Paul Chipchase, Mr Paul Delaney, Dr Richard Finneran, Mr Michael Holroyd, Mrs Margaret MacDonald, Dr Timothy Materer, Dr James Nelson, Dr John R. Roberts, Mr Peyton Skipwith, and Mrs Virginia Surtees.

I am grateful to all who have approved this re-publication of letters originally quoted by William Rothenstein. Despite diligent efforts, a few present owners of copyright were not found; if any such persons are inadvertently omitted here, I beg their indulgence. Copyright materials in The Houghton Library are quoted by permission of The Houghton Library. Sir John and Mr Michael Rothenstein have allowed me to quote from their letters, and from their parents' letters. Permission to quote from William Rothenstein's letters is given also by the Beinecke Rare Book and Manuscript Library, Yale University; Bibliothèque Nationale, Paris; Bodleian Library; Department of Rare Books and Manuscripts, Boston Public Library; The British Library; Brotherton Collection, Leeds University; William Andrews Clark Memorial Library, University of California at Los Angeles; University of Glasgow

Library Special Collections; Bibliothèque Doucet, Paris; Library of the University of Illinois at Champaign-Urbana; Fondation Custodia (coll. F. Lügt), Institut Néerlandais, Paris; National Archives of India, New Delhi; Academic Center Library, University of Texas, Austin. The following have also allowed me to quote from copyright materials: Mrs Mary Bennett (H. A. L. Fisher); M. Georges Mévil-Blanche (Jacques-Émile Blanche); Edward Gordon Craig Estate (Edward Gordon Craig); Miss Hope Harding Davis (Richard Harding Davis); Mr Richard de la Mare (Walter de la Mare); Mrs Imogen Dennis (Helen Rossetti Angeli); Mrs Pamela Diamand (Roger and Helen Fry); Miss Dorothy Dickson (C. B. Cochran); Mrs O. C. Dyson (T. R. Way); Samuel French & Company (Arthur Wing Pinero); Mrs Cicely Furse (Charles and Katharine Furse); University of Glasgow Library (James and Beatrix Whistler); Sir Geoffrey Harmsworth (Lord Northcliffe); Mrs René MacColl (D. S. MacColl); Mr E. C. Mason (Clara Watts-Dunton); Miss Riette Sturge Moore (Thomas Sturge Moore and Charles Ricketts); Mrs Frazier Murray (Kenneth Frazier); Mr David Parsons (Herbert Beerbohm Tree); Mrs Eva Reichmann, with the Henry W. and Albert A. Berg Collection, The New York Public Library, Astor, Lenox and Tilden Foundation (Max Beerbohm); Mr J-P. B. Ross (Robert Ross); Mr John Russell (Logan Pearsall Smith); Albert Rutherston Estate (Albert Rutherston); The Society of Authors, on behalf of the Royal Society for the Protection of Birds (W. H. Hudson), and the Masefield Estate (John Masefield); Société des Gens de lettres de France (Paul Verlaine); His Grace the Duke of Wellington (Lady Gerald Wellesley). Faber & Faber Ltd. made available their correspondence with William Rothenstein, and Mr Richard de la Mare allowed me to quote from letters to William Rothenstein and to myself. I wish to thank The Society of Authors, for the Trustees of the Bernard Shaw Estate, for permission to quote from copyright works of Bernard Shaw; Sir Rupert Hart-Davis, for letters of Oscar Wilde; Insel Verlag, for letters of Rainer Maria Rilke; Harvard University Press for passages from *Imperfect Encounter*; John Murray Ltd. and Harvard University Press for those from *Max and Will*.

Finally, my continuing thanks to my colleagues at the University of Missouri and to my husband and children, all of whom cheerfully bore with the complications of this long and detailed project.

M. L.

ILLUSTRATIONS

Works of William Rothenstein are reproduced here by courtesy of the artist's executors, Sir John Rothenstein and Mr Michael Rothenstein.

Between pages 144 and 145

Phil May, title-page decoration for instalments of *The Parson and the Painter*, in *St. Stephen's Review*, 1890. Copyright, The British Library. *Appears in the text on page 46.*

PREFACE

THREE criteria have governed the choices of text for this abridged edition of the three volumes of William Rothenstein's memoirs: first, selection of material pertaining to individuals and events of present interest to both the general reader and the specialist scholar; second, continuity of narrative line and a consistent chronology of events; and third, accuracy of information, especially of the texts of letters quoted, many of which are unique sources of information for biographers and for historians of literature and the arts.

Rothenstein's audience has changed greatly since his three volumes first appeared, in 1931, 1932, and 1939. A new generation of readers, more curious about the relatively recent past, see in it their own beginnings. It is important, therefore, that the record be as full and as accurate as possible.

Rothenstein did not set out to write a closely documented account of his life and times. He wondered, in fact, whether it was quite the proper thing to write intimately about one's friends, any more than a lawyer or a doctor ought to talk about clients' affairs, or a priest about the secrets of the confessional. He wrote because he knew that some information of value to historians would die with him. Unfortunately, Rothenstein, who was present at the creation of so many of the splendid reputations of his friends and associates, did not mention enough about his own contributions to those distinguished—and often lucrative—careers. This abridged, annotated edition offers a belated opportunity for giving him his due.

He drew principally upon two sources: his memory, and his friends' letters to him, most of which now make up a highly valued collection in The Houghton Library at Harvard University. In his own letters, which are to be found in collections scattered around the world, he refers frequently to his bad memory. His memory for details of personal appearance, not surprising in a portrait painter, was quite reliable, but he had a bad head for numbers. This, combined with the fact that he did not keep a journal, and with his tendency to digress widely as he wrote his memoirs, sometimes caused

him to confuse the order of events: two visits to the Leslie Stephen family, for example. In the abridgement I have transposed a few passages of the original text in order to restore correct chronology; where this could not be done smoothly, confusions of chronology are explained in the notes.

There are three categories of changes that appear in this abridgement of Rothenstein's text as taken from the Rose and Crown edition of 1934 and from *Since Fifty*, the third volume, published in 1939. The first of these categories is the correction of errors, a multitude of which appear especially in letters to Rothenstein quoted in the memoirs. Word changes drastically remote in meaning from what was originally written, together with the arbitrary re-arrangement of punctuation, often seriously distorted the letter-writer's meaning. Some dates of letters were omitted and others misread. Deletions of words and of entire passages were not indicated. In a number of important instances—in letters from Rodin and from Verlaine, for example—portions of several letters were jumbled together so that they appeared to be one letter, whereas they are passages from letters written days, months, even years apart.

The high incidence of error may be explained in part by the fact that Rothenstein, who was very ill during much of the work on the first two volumes, enlisted the editorial assistance of the New Zealand poet D'Arcy Cresswell, then living in London. Cresswell's transcriptions of letters indicate that he neither read these accurately nor did the research that would have resulted in correct texts based on evidence provided by general contexts. Rothenstein left this un-dated note in the bound typescript of his first volume, now owned by Sir John Rothenstein: 'This is the original transcript of Vol. 1 of "Men and Memories"; the writing was done when I had still not recovered from serious illness and I had D'Arcy Cresswell to read the text aloud while I lay in bed, when we discussed possible changes and emendations, D'Arcy using his pencil on the typescript. D'Arcy was apt to be argumentative and wanting his own way; I found this discussion often tiring, but it was certainly helpful, and D'Arcy's logical sense, if over-pedantic, often illuminating.' However, scholars are here warned not to speculate about texts, dates, or connotations of the unpublished portions of Rothenstein's correspondence, without reference to the original letters.

I have compared all letters quoted, with only a few exceptions in

cases where original letters have been destroyed or have proved unavailable, with the original letters, or with photocopies or microfilms of them. In those few instances where transcripts only were available, I have identified these as the source. A letter-writer's own ellipses are indicated by means of unspaced ellipsis points, as …; my deletions in letters quoted for the abridgement are indicated by spaced ellipsis points.

I have silently corrected only misspellings of proper names and minor errors of fact in Rothenstein's own text (Llewellyn Hacon, for example, was a widower, not a bachelor, when Rothenstein first knew him, and the title of Burne-Jones' painting is *Love among* [not *in*] *the Ruins*).

The second category of changes consists of Rothenstein's holograph emendations of his original text, noted in his personal copies of all three volumes. In a note dated May 14, 1944, he recorded his wish that any future edition 'follow the text herein corrected,' and I have honoured this wish. Many of his changes are merely adjustments of syntax or substitutions of more graceful usages. Others reflect revisions of judgement. Sir Henry Acland's views on art, for example, became 'unreliable' instead of 'worthless' (*MM* I, 140); a reference to Degas' '*Judenhetze* monomania' in a Sickert letter was deleted (*MM* I, 341); Augustus John's early paintings, first described as very 'messy,' became 'of uncertain quality' (*MM* II, 3); Tagore in London responded to 'adulation' instead of to 'sympathy' (*MM* II, 283); and Roger Fry became an 'intermittent' rather than an 'industrious' painter (*MM* II, 213).

The third category consists of editorial changes of three kinds. First, anything added for purposes of clarification or transition appears in brackets. Second, to some letters quoted only in part by Rothenstein in his original volumes, I have added passages, of interest and value for the purpose of completing the narrative; the remainder of Jacques-Emile Blanche's sympathetic letter about Sickert (pp. 122–3) is an example. All material in this edition not in the original volumes and not bracketed here is of this type. Third, I have interpolated in Rothenstein's text of the memoirs passages from his own letters to friends such as his Oxford hostess and lifelong friend, the novelist and poet Margaret Woods. I have selected these previously unpublished comments so that the reader may hear two voices of Will Rothenstein: the one contemporaneous and immediate, the other retrospective and reflective—the author

speaking, as it were, in temporal counterpoint. Such passages from Rothenstein's unpublished letters appear in italics to distinguish them from the running narrative of the memoirs. In all letters quoted I have respected the punctuation of the writer.

I have abridged Rothenstein's text, as distinct from the letters of other people quoted by him, without indicating any ellipses, the continuity of his narrative being my primary consideration here. Wherever possible, I have preserved his punctuation, although the process of abridgement necessitated some rearrangement of paragraphs. The 108 chapters of the three volumes have been regrouped as fourteen chapters which, with only a few exceptions (such as the combining of Chapters 25 and 28 from *Men and Memories, 1872–1900* as Chapter 6 in the abridgement), follow the original sequence of the 108 chapters. Rothenstein himself observed that the third volume, *Since Fifty*, had less continuity and was 'more of a mosaic' than the first two volumes; selected pieces of this mosaic make up the final chapter of the abridgement. It is an epilogue, a coda gathering up the themes stated in his Late Victorian and Edwardian years; it concludes on the eve of World War II, with his last visit to Paris, thereby bringing his story full circle from his student days.

<div style="text-align: right">Mary Lago</div>

London
March 1978

INTRODUCTION

WHEN Max Beerbohm had read some of the proofs of William Rothenstein's memoirs, Rothenstein thanked him and added, 'But I know how pedestrian the pages are; and as you say, to write about the living is profitless and needs qualities that are not mine, while romance gives form and colour to figures, such as Oscar's, Whistler's, Verlaine's, which have become legendary.'[1]

'"Pedestrian",' Beerbohm replied. 'Yes, you're that, right enough —in the sense that you plant your feet upon the ground and make swift sure progress on them, straight ahead, or around by-ways, according to your choice, and reach your destination every time, with us at your heels—us grateful, us enlightened. A much better performance than (say) the performances of non-pedestrian W. B. Yeats who (admired by you) floated about with his feet a few inches above the ground, with a dimly impressive grace, nowhither.'[2]

Rothenstein wrote three volumes of memoirs. Published in the 1930s but out of print since the second world war, they contain a unique record of a fascinating span: the turn of the century, the Edwardian years, and the inter-war period. With unswerving commitment to his vocation as artist, Rothenstein moves from Yorkshire to Paris and Julian's Academy; to London and the *Yellow Book* circle and the New English Art Club; and to the Principalship of the Royal College of Art. Along the way he made portraits of leaders in the arts, the sciences, and public life, and devised plans for the arts, of enduring national and international importance.

'What right had Will Rothenstein, fresh from Bradford and a short unprofitable apprenticeship at the Slade,' asked James Laver, 'to blunder, aged seventeen, into all that was interesting, all that was brilliant in the Parisian world of letters? Of course "blundered" is the wrong word. Rothenstein did not blunder; he possessed an infallible instinct'[3] He did indeed: it was an instinct for the most effective way of setting careers in motion and for recognising emerging genius in others—genius that very often produced works widely divergent from his own tastes.

Rothenstein's seriousness about art sometimes caused those who did not know him well enough to think of him as excessively prim. The author of his obituary in *The Times* concluded that it was difficult to resist the belief that the artist had 'deliberately trained himself along the lines of seriousness and responsibility.'[4]

Serious he was—where art was concerned, utterly so. But his memoirs sparkle with a dry humour that his friends knew and delighted in, and with his lively appreciation of the absurd. Witness his account of the farcical aborted duel between the young Charles Conder and Edouard Dujardin (pp. 57–8), and his description of the elderly Yeats imperiously frustrating George Trevelyan in conversation (p. 194).[5]

Rothenstein did not think of himself as a historian, but he was in fact a maker of history. He was patron, organiser, introducer, errand-runner, and fund-raiser. He launched new careers and he salvaged old ones. His elder son, Sir John Rothenstein, cannot remember his father ever turning away an artist who asked for assistance. Indeed, Rothenstein frequently urged prospective purchasers of his own work to buy instead the work of a struggling younger artist.

A complete record of Rothenstein's services would not be easy to compile. One learns from his memoirs that he urged Gosse to urge Balfour to get Joseph Conrad a Government grant in 1904, but not the fact that Rothenstein borrowed £150 for him, 'to which I have myself added £50, to ease his immediate difficulties, and I am trying to get £300 more, to put his affairs on a proper basis' (pp. 143–4). Nowhere in his memoirs does Rothenstein give a fully detailed account of the time, money, and energy that he expended on Augustus John's behalf (pp. 129–30). At a crucial point in Jacob Epstein's career Rothenstein solicited financial aid for him, to which he added 'further small contributions' from his own pocket. (He does not mention Epstein's savage discourtesy and ingratitude. 'Epstein, too, had chosen to quarrel with me,' he wrote, 'in a way I resented at first, but not for long. Epstein followed the tradition of a man of genius . . .' [*MM* II, pp. 128–9].) Of Rabindranath Tagore Rothenstein says casually that 'I wrote to George Macmillan, with a view to his publishing a popular edition of *Gitanjali*, as well as other translations which Tagore had made . . .' (p. 170). Thereby Rothenstein became prime mover of a career that brought Tagore wealth and fame, and set the pattern for modern literary exchange

between India and the West. It remained for Max Beerbohm, Rothenstein's friend of more than fifty years, to sum up his role as a career-maker: 'Will himself was assuredly a giver, a giver with both hands, in the grand manner.'[6]

He viewed himself primarily as an artist. Even as a student in Paris, his diligence and self-discipline were in striking contrast to the amiable but destructive bohemianism of friends like Conder and Phil May. Rothenstein wrote that 'half my friends disapproved of me because I sat with wine-bibbers, and the other half because I did not drink' (p. 48). A Beerbohm drawing of 1929 recalled a scene of the 1890's: Conder, Wilde, and Beerbohm, champagne glasses aloft and top hats wildly aslant, have abandoned themselves to alcoholic gaiety; Rothenstein, soberly erect with feet planted firmly on the floor, plainly feels the responsibility for getting his friends safely home, and regrets the time inevitably to be lost from the next day's work.[7]

The illustrations for the present edition, selected by William Rothenstein's sons, Sir John and Mr Michael Rothenstein, represent the range of his work. The self-portrait painted in his Paris studio (frontispiece) shows how very young and how very precocious as a painter he was at that stage of his career. The picture conveys all of the simplicity and the intimacy that also characterise *Parting at Morning* (Illustration 9), a work that attracted the attention of Degas, Toulouse-Lautrec, and Whistler. These same qualities were manifested also in his early 'interiors', such as the fine picture of Alice Rothenstein and the three-year-old John, framed in the Queen Anne setting of their Hampstead home (7), and in outdoor scenes such as *The Avenue* (17), in which the trees in the foreground gracefully enfold the receding line of nuns. Even the casual viewer must be sympathetically drawn into the mood of such pictures. Later paintings, in general those after 1910, were more spacious, less delicate in line and colour. This line of development was matched in his portrait drawings. There one finds the light, airy quality of the early studies, for example of Paul Verlaine (1), giving way to the greater solidity of the portrait of Joseph Conrad (12). But whatever the direction taken by his art, Rothenstein's fundamental purpose was a striving after complete honesty; uncompromisingly, he painted reality only as he saw it.

In all of his work, and at all stages of his career, Rothenstein was sustained by a coherent philosophy. He believed that the artist, on

the one hand, must give the public full value by making his best work available to the best sort of buyer. In 1921, during intricate negotiations for an exhibition of Gordon Craig's theatre designs at the Victoria and Albert Museum, Rothenstein chided Craig for his unrealistic attitude towards prospective purchasers:

> You are so far away from England that you believe it still to be a wealthy country. That it has enough wealth to waste nightly on drink, movies and ladies is true enough: but so I believe have Vienna and Berlin. But our Universities and Museums are not rich, and I doubt whether the Victoria and Albert people could invite you over to open an exhibition of theatrical art. . . .
> Herewith ends the first dreary lesson—now for the second, so that you may wish me from purgatory into hell. I loved your woodcuts: with Gill's they are the most beautiful things at Chenil's show (I also like John Nash's extremely). But they are 40 times dearer than Gill's (he sells his at 2/6 and 5/– each) and five times dearer than John Nash's. If wood blocks got choked, exhausted or worn down after 20 or 30 impressions your price would be fair enough. But our young men want good work to be bought by people with small means: there is a strong reaction against dealers and portrait painters' prices. . . .
> I think good men should give *intelligent* people the chance of acquiring their works, not only very wealthy people. Otherwise we may well be called and be in fact, parasites.[8]

On the other hand, if the artist has an obligation to the public, so also the community has a responsibility to the artist. In 1940 Rothenstein responded briskly to George Bernard Shaw, who proposed, as a wartime measure for the relief of artists, a cut-rate system for pricing and selling works of art. He suggested also that artists should forget about being gentlemen and join the hurly-burly of the marketplace. Rothenstein wrote:

> No one knows better than I how unsatisfactory is the market for painters' wares. But the subject is a complex one, not to be solved by your simple remedy. None of us want to be gentlemen and ladies, but since neither the State nor a Church offers work, we are of necessity parasites on a public which looks to us either for eventual profit or for social flattery of their perspicacity. Our livelihoods are largely in the hands of dealers, or of gentlemen who, unable themselves to use their hands and eyes, 'know all about art'. Remember that through a brain wave of Mr [Charles] Rowley, Madox Brown was paid by the foot—

at £10 a foot, bringing him £500 for each of his great Manchester paintings. Rex Whistler, a Slade student, was paid £5 a week while engaged on his Tate wall paintings. For the same sum I got 2 gifted youths, Bawden and Ravilious, to decorate the Refectory at Morley College, where Mahoney also decorated, for the same weekly sum, the concert-hall. But how was Madox Brown to live while he was painting his 'Work'? Holman Hunt and Burne-Jones always managed to get wealthy patrons to indemnify them for the time spent on their elaborate compositions. It is the fashionable portrait painter who is the gentleman.

So long as the painter isn't a servant, servant of state or municipality, he has to be an adventurer, that is, a sort of gentleman. If you would bend your great mind to the question and can find a solution how grateful we should all be![9]

What of the personality behind the pictures and the philosophy? Beerbohm put it most succinctly, in notes made probably between 1906 and 1909, for some projected (but unwritten) sketches of persons of the 'Nineties:

Will Rothenstein. . . . Japanese jew with a Franco-German accent. He *was* foreign. Full of gaiety and self-importance. Place Pigalle. Oxford went down before him. Undergraduates. Dined at high tables nightly. Same in Chelsea. . . . He started me. *Lane.* Yellow Book. a mascotte —inspiring—helping. . . . Social quality. What do you mean? Good at explaining things to women. . . . Good butt—strong sense of humour—whole body shaken. Cerebrative power. . . . Nowadays— with eminent men of science and letters.[10]

Beerbohm, with his customary aplomb, had selected the precise word for Rothenstein. He was indeed a *mascotte*: a veritable charm, a bringer of luck and good fortune: 'inspiring—helping.'

Rothenstein's Yorkshire childhood and early adolescence—by his sixteenth year he had in effect left Bradford for ever—was solidly *bon bourgeois*, with components both domestic and foreign. In 1859 his father, Moritz Rothenstein, had come from Grohnde, near Hanover, and had set up in the woollen trade. His firm prospered, and John Rothenstein remembers his grandparents' home as 'unostentatious but solid—I shall never forget the massive mahogany fittings in the bathroom. I remember, too, the solidly bound classics, mostly English—Carlyle, Dickens, Tennyson, etc.; some German— Goethe and Schiller etc. There was an air of extraordinary benevolence in the house, also an aroma of cigar smoke.'[11]

Moritz was a Liberal and a free-trader, in part Jewish on one side of his family. In Bradford he was a Unitarian who gave generously to local Jewish charities. His wife, Bertha Dux Rothenstein, was staunchly Jewish and kept to the orthodoxy in which she had been raised in Germany. She, Rothenstein notes, was the 'stronger character' of the two, but if it was she who laid down the law, Moritz was the prophet consulted beforehand (p. 31).

Most remarkable was the Rothensteins' willingness to allow their son to become an art student in London and then in Paris. Nothing in their surviving letters indicates that their confidence in him ever faltered. Indeed, ten years later William's younger brother Albert followed his example. Moritz gave them allowances and advances: 'Thank you, dear father, for the cheque' is a recurring refrain in the sons' letters. Only very occasionally did Moritz sound an anxious note: 'I only hope that you will earn a good deal more than hitherto and that you economise as much as possible in your living expenses. I am always ready to assist you as long as I am in good health and wish you a happy future with all my heart.'[12]

The parents' attitudes were shared by Rothenstein. He had his father's generosity and diligence. His mother's orderly ways were reflected in his Paris studio, conspicuous for its tidiness in bohemian Montmartre. Forty years later, Grant Richards remembered that 'it struck me then, and often again, that he did most things with method. . . . Everything in the room was very exact, even spartan, in its simplicity. A camp bedstead, a wardrobe, a row of boots and shoes all carefully fitted with trees, a bed-table on which was one book, Barbey d'Aurevilly's *Du Dandysme et de Georges Brummell.* . . . How one could work in a place like this, I said to myself, but I said it without any clear notion of what I wanted to work at.'[13]

Not merely the setting was orderly. John Rothenstein recalled the precision of his father's habits: 'He used to get up very early, read *The Times* and more often than not, reply to his letters immediately. . . . He then worked all morning, had a light lunch, lay down and read for half an hour, then went back to work until it was dark. . . . I never remember his drinking beer and he never drank by himself. He always dressed very soberly, his clothes being made by the best tailors, but he was always careful to avoid their looking in any way fashionable.'[14]

Robert Speaight, Rothenstein's biographer, ascribes his austerity to a 'messianic' temperament, the result of the family's Jewish

heritage. There is no doubt that his belief and practice in the world of art had a prophetic fervour. This alone is enough to suggest that a falling-out with Roger Fry, much publicised both at the time and after, was unavoidable, not because the two men were so different, but because they were so much alike. Both Rothenstein, and Fry, with his Quaker background, were tireless, not to say compulsive, testifiers to their faith in the power and importance of the arts in civilised life.

It is important that the circumstances of this falling-out with Fry be clearly understood, for it coincided with the aftermath of Rothenstein's journey to India in 1910, in such a way as to create a turning-point in Rothenstein's career. Both Virginia Woolf, Fry's biographer, and Denys Sutton, the editor of his letters, had access to the facts in the case, but neither has fully explained the sequence of events that turned Rothenstein away from the central arena of English art affairs, into a more solitary course.[15]

Since 1908, in fact, Rothenstein had been feeling restless in his professional life. He declined Associateship in the Royal Academy, for he felt that his primary allegiance was to the New English Art Club. In that same year, he resigned from the N.E.A.C., despite Henry Tonks' efforts to dissuade him, because he felt that its members disapproved of his views and his work. Then he decided that he had made a mistake. He returned, and Frederick Brown welcomed him with a kindly warning that he must expect some coolness from some of the members.[16] This did not help him to shake off the mood that he expressed in a letter to Fry: 'You must know how hopeless it makes me feel to know life is running by and that no one is there to hire one'[17]

In 1910 Rothenstein had an exhibition at which sales were few. Fry wrote an appreciative and perceptive review in which he warned the public that Mr Rothenstein painted reality as he saw it, not pretty pictures to please the popular taste. Rothenstein wrote to him: 'It seems to me that to have such a thing written while one is alive is a rare, perhaps an unique privilege, and that I should have to thank you for this rather than anyone else is a great delight to me . . . Your article makes all the trouble worth while'[18]

Still, Rothenstein seemed to be casting about for new fields of activity. Early in 1910 he had initiated a campaign on behalf of India's fine arts and vernacular literatures, and in the winter of 1910–11 he himself went to India, to see Indian art on its home

ground. Although (as *The Times* obituary correctly observed), India had 'a marked influence upon his painting, raising the key and brightening the colours,' this was a wrong turning with respect to his own work.[19] He was fascinated by Indian sculpture, and he longed to capture its solidity in his pictures, but he felt always he was somehow just missing this, and, as he wrote at the time, 'painting stones on a wall in the sun when the most wonderful figures are passing up and down all day seems a fearsome waste of my opportunities.'[20] He was right; people, not Indian stone walls, were his best material.

He was in India during Roger Fry's first Post-Impressionist exhibition, held at the Grafton Galleries in November 1910. At that distance it was difficult for Rothenstein to assess the extent and importance of the public furor that greeted this event. He told Fry that it had no doubt been 'a brilliant and gallant charge of the light brigade—a glorious episode, but leaving things very much what they were before.'[21] He was quite mistaken: the art world, in England at least, would never again be what it was before.

The friendship of Rothenstein and Fry, ever since the 1890's in Paris, had been warm and co-operative, but, at least until 1917, relations between them underwent a change. This change has been generally attributed to disagreement over the merits of Cézanne, whose work was, for Fry, the touchstone of all Post-Impressionism. Rothenstein did not share Fry's enthusiasm, but he respected Cézanne's industry and sincerity (p. 150). The primary cause of their misunderstanding was Fry's failure to make clear enough, soon enough, two points with a bearing on a second Post-Impressionist exhibition, which he was already organising when Rothenstein returned from India in March 1911. The first point at issue involved Rothenstein's Indian drawings. He heard from many quarters, but not from Fry, that Fry planned to include these in the new exhibition. A meeting planned for the eve of Fry's departure for a holiday in Turkey did not take place, and they were forced to rely upon uncertain communication by post.

The second point at issue was the rationale for the exhibition at the Grafton, and for its management. Again, Fry did not explain exactly what assistance he wanted from Rothenstein, who had the strongest possible convictions about the function of such an exhibition. He promised Fry his co-operation and his best efforts to bring older members of the New English Art Club into the scheme,

if the Grafton could guarantee annual exhibitions that would provide continuity and a focus for the group of English artists outside the Royal Academy. Rothenstein believed also that such an arrangement should be managed by a committee of practising artists, not by drawing-room amateurs, that is, by Fry's Bloomsbury supporters. He wrote to Fry:

I have heard no details of your Grafton schemes at all and was waiting to hear from you what it is you propose. Gill gave me a very vague idea and for the first time I heard something more definite from [Desmond] MacCarthy on Tuesday night, but no one has asked me for anything definite in the way of support, or advice or active help. I told Gill I was expecting you [to come to see me] and that I should know from you what it is you propose to do, and that I thought we might possibly all exhibit, but I could neither be enthusiastic nor detrimental over a plan of which I was ignorant. ... Surely if my support is worth anything to you it is worth while giving up half an hour to get; and if you are too busy to give me this, how can you reasonably expect us to entrust the management of a fairly important matter entirely to yourself? I think you go out of your way to misunderstand me.... I have seen, and felt something of the evils of giving too much power to people who are interested in art and I am quite frankly unwilling to belong to a new society for acquiring works of art. ... I will devote myself to any newer society which enters into the kind of spirit which seems to me to be the right one, and if you, or any one else, come to me with a fine proposal, I don't fear you will find me wanting, but how can I back up what is still a very vague proposal so far as I am concerned. As for you yourself, I have for many years had faith in you above all others acting and writing, and you have been virtually the only one who has consistently supported my own attempts and seen in them what I wanted to get there; I am not afraid of trusting you, but in matters of this kind you do not and cannot act alone, and I have no faith at all in the superiority of one manner over another, and this is where the danger lies. When you come back [from Constantinople] perhaps you will let me hear what your own plans really are ;in the meanwhile I shall probably hear many versions of them. (March 30, 1911. PC.)

Fry replied candidly and fully, writing from Constantinople on April 13, but his letter arrived after Rothenstein, who had been left in a quandary about the exhibition of his Indian drawings, had received a firm offer from the Chenil Gallery and had accepted it.[22]

Thus circumstances set his work apart at a crucial juncture in English art history.

In the event, the Grafton Gallery was unable to give Fry the guarantees that Rothenstein considered essential, and this second—and last—of Fry's Post-Impressionist exhibitions opened, after numerous postponements, in October 1912. Again, circumstances seemed to combine to prevent a rapprochement between Rothenstein and Fry. In May 1912, Rabindranath Tagore, whom Rothenstein had met in India, arrived in England. Tagore, a handsome and hieratic figure, was the personification of Rothenstein's infatuation with Indian art. Under his diligent sponsorship Tagore became the toast of certain of London's literary, artistic, and academic circles. For Tagore, already pre-eminent among Bengali men of letters, it was the beginning of a brilliant international career. For Rothenstein, its timing could not have been less opportune. His painting continued under the Indian influence, and if there were moments when he wished to get back into the mainstream of London's art affairs, there at his elbow was Tagore with his train of followers and imitators, in person or in urgent letters, making unreasonable demands and drawing heavily upon Rothenstein's resources.

In 1913 Rothenstein moved to Iles Farm at Far Oakridge, Gloucestershire. His self-confidence had been shaken, and the Fry episode grieved him because it was a break in the ranks of those who shared an evangelical zeal for liberating English art from the bondage of the Royal Academy. He resigned again from the N.E.A.C.; this time Brown pointed out that there had actually been 'only one period' when the N.E.A.C. had looked upon Rothenstein's work 'without much sympathy': this was a 'certain type of work after your visit to India.'[23] Rothenstein did his best to rationalise his voluntary rustication: 'The great thing is to *do* things, regardless of indifference. Better cry out a little and work than say nothing and fritter away your time. The pain and depression can be very keen, but work is the safe cure.'[24]

Until 1917, when Herbert Fisher persuaded him to inaugurate Sheffield University's Chair of Civic Art—the first such Chair in Britain—Rothenstein made only occasional trips away from Far Oakridge. In 1914 Emile Vandervelde, Belgian Minister of State, asked Rothenstein to visit the Western Front and to make a portrait of King Leopold, reproductions of which might be sold to benefit Belgian War Relief. The King was unavailable, and instead Rothen-

stein drew the ruins at Ypres. This experience prompted him in 1916 to propose the employment of artists to make an official record of Britain's role in the war. He broached the idea to Charles à Court Repington, whence it was brought to government notice (p. 176). The situation abounded in ironies. Although Rothenstein originated the idea, he was one of the last artists commissioned; French officials mistrusted him on account of his German name, which he had refused to anglicise. He was not allowed to go to the Front until 1918. When the War Artists scheme was revived during World War II, and he was classified as over age (which he was, by most reckonings, for he was nearing seventy and had a damaged heart), he got himself attached unofficially to the R.A.F. Flying from base to base in open planes and sharing the erratic schedules and uncomfortable living conditions of the crews undoubtedly shortened his life, yet he found this one of the most satisfying experiences of his career. In his memoirs he wrote only that 'I had something to do with the initial idea of [artistic] war records,' and today he is virtually forgotten as originator of the British War Artists scheme (*MM* II, p. 326).[25]

In 1920 the Rothensteins returned to London to provide more opportunities for their children, and Fisher immediately brought William into the official orbit of the Royal College of Art, first as a Visitor, then as Principal. There was a storm of protest in the National Society of Art Masters, and Fisher responded imperturbably to indignant questions in the House of Commons. 'To appoint a man without previous administrative experience was, I admit, a risky experiment,' Rothenstein commented rather slyly, 'and I could understand the art-masters' soreness. But I do not think the students were displeased' (p. 182).

Few of Rothenstein's friends and former students who have testified to the force of his personality and convictions about art were aware of a fundamental dissatisfaction with himself: that his appearance was actively ugly and unpleasing. It was essential to him to be in touch with perfect beauty, in objects as in individuals. Soon after their marriage in 1899, Alice Rothenstein told William's parents that 'he has such very exquisite taste that he cannot exist with ugly things—it is a positive pain to him.'[26] Certainly Alice herself was a pleasure to behold, but William plainly felt that her beauty heightened the contrast between them. Deprecation of his appearance is a recurring motif in his letters, to her and to others.

Early letters to Alice were sometimes signed 'Your own ugly—Will,' or 'Your own dear ugly devoted Will,' and in 1914 he urged Tagore, then in the full flush of Nobel fame, not to forget 'the queer ugly little man at Oakridge.'[27]

His appearance fretted others far less than it fretted him. Grant Richards recalled him at their first meeting in Paris: 'Small, yes; you saw it the first time; you did not notice it again. Small and put together with unusual neatness and, yes, dressed with unusual neatness too. Spectacles. Black hair. Very small feet. An effect rather Japanese. That he, even three or four years earlier when he went to the Slade, could ever have looked, as he said in his book, "a raw provincial lad, ignorant, ill-disciplined," I am prepared to deny.'[28]

He longed for the charm that compensates, he believed, for a lack of physical beauty. Although in this he is flatly contradicted by many who knew him, he was convinced that charm also was denied to him, a conviction reinforced by the presence of close friends who were not only physically handsome but positively radiated charm— were, indeed, famous for it: Max Beerbohm, Cunninghame Graham, Gordon Craig, Augustus John, Tagore. As a substitute for the charm in which he imagined himself deficient, Rothenstein relied upon hard work and an uncompromising adherence to his personal moral imperatives. His friends teased him about his taste for plain living and high thinking. They grew accustomed to his assuming what Beerbohm had called the role of the 'good butt', who bore their teasing because he had 'a strong sense of humour.' His complaints were rare. 'You have for so long been in the habit of chaffing me about my pedantry and bourgeoisism,' he wrote to Beerbohm after a misunderstanding in 1909, 'that I have got into the habit of assuming the part when I meet you'[29]

Rothenstein's sensitivity to others' feelings about him sometimes caused him to be oversensitive about his relationships with his friends. In 1911 he suggested a dinner to honour Gordon Craig but tried to keep his own name out of the announcement: 'I hate my name to be on things; as a rule no one will do much in the way of work where these things turn up, and in my unfortunate way I usually have to do some of it, and then one's kind friends say one wants to run everything'[30] It was his misfortune that, with his orderly ways, his generosity, and his wide circle of acquaintances, he became the ideal servant of his peers. Sometimes he rebelled. 'It is

not I who wish to give counsel,' he wrote in 1921 with reference to the oppressively dependent Tagore, 'but others that seek it overmuch for my peace of mind'[31]

He could be obstinate and impulsive, contradictory and quicktempered. Then he would sternly reprove and catechise his conscience. He longed to be perfect; the word *perfection* appears again and again in his memoirs and in his letters. At the same time he was a pragmatist and thus was buffeted by the collisions of ideals and practical necessities. He was a rationalist who believed in an ordered universe whose beauties the artist is commissioned to capture and convey to others. He saw tradition as a precious and powerful and invigorating force. Will it endure? was always his question about a work of art; and, why does it endure? Will dealers, collectors and museum curators be properly responsive to and responsible for the treasures they are privileged to select and protect? Will they give more than a sidelong glance to the artist who looks on helplessly as works that the market undervalued as they left his hand, escalate in price and in prestige as they pass from one hand to the next? Neither the banter of his friends nor the exasperation of art administrators deterred him from raising and re-raising these issues.

Rothenstein had his first serious heart attack in the summer of 1925. By mid-September he was up and about, but in a gingerly fashion. 'I sit in the Library of the Athenaeum,' he wrote to Gordon Craig, 'the only old gentleman under 80, in the afternoons now, and read. I forgot, my dear Teddie, that I was in the fifties, and went my way, very unwisely I think, as though these working days were still the 'Nineties'.[32] During one of the periods of complete rest that were mandatory for several years, John Rothenstein suggested that his father begin to jot down his recollections of Paris in the 1880's and of Chelsea in the 1890's. Rothenstein was never a systematic diarist; only a very few random notes, abortive attempts at journal-keeping, turn up among his papers. It was possible, however, with the aid of his friends' letters, to reconstruct an informal record of the past, in which the publisher William Heinemann expressed interest. Richard de la Mare, of Faber & Faber, told Rothenstein that he wished to consider the manuscript if Heinemann should turn it down: 'I don't like to say I hope they will?—although in secret I must confess I do.'[33] Four months later, Rothenstein got in touch with de la Mare, who wrote: 'The message as it came to me was that you now feel more inclined to consider what I suggested, and if that is really the

case, I am truly excited.'[34] Rothenstein completed three volumes: *Men and Memories, 1872–1900* (1931); *Men and Memories, 1900–1922* (1932); and *Since Fifty: Men and Memories, 1922–1938* (1939).[35]

When the first volume appeared, Beerbohm wrote to Rothenstein: 'I have read Men and Memories straight through now One of your great "pulls", of course, is in being a painter, a user of eyes; you *see* men and women and places, and you remember the sight of them; and thus the reader undeservedly shares your power.'[36]

While he wrote the second volume Rothenstein was spurred on not only by encouragement from friends like Beerbohm, but also by heavy family medical expenses. 'I am rather dismayed; if I knew how much was likely to be coming in I should know where I stand', he wrote to de la Mare. When this volume appeared in April 1932, he vowed that he would write no more memoirs: 'And now I am saying farewell to the pen for ever, thrown, like Excalibur (was that the name of the sword?) to the bottom of the deepest part of the Serpentine.'[37]

Rothenstein turned to the pen again in 1938. 'The third volume has to be something in the nature of a mosaic of comments and letters', he told de la Mare, 'as there have been no marked phases during the last years.'[38] There had been a conclusion, however, to one phase of Rothenstein's life, for in 1935 he had retired from the Royal College of Art. He jealously hoarded the free daylight hours for painting, but he finished *Since Fifty* by the summer of 1939, on the very eve of the war.

Beerbohm, surveying the international scene in 1931, had mused: 'Machinery and democracy have ground away the greater part of what one loved. To the young, of course, everything is as loveable as it was to us. But no!—that isn't quite so, alas. The young do seem pathetically aware that all's not well. And that is one of the reasons for the great success of M and M. The book gives the young a panorama of a time in which they take a yearning interest. Let us be sorry for the young, in this their time. *We* didn't take a yearning interest in the eighteen-sixties. We refused to know anything about them, and shone in the forehead of the morning.'[39]

In *Men and Memories* the men of the 1890's shine still, for the delight and instruction of the young, and for the reassurance of us all.

Chapter 1

ART STUDIES: BRADFORD, LONDON, PARIS

MY EARLIEST memory: the house in which we lived. I vaguely recall only two of its rooms—the drawing room, the least used, more clearly, on account of its pinkish grey carpet with a yellow pattern, and a black cabinet, 'hand-painted' with flowers and birds. Of the other, the dining room, I remember little, except its red-covered chairs and red curtains. But once out of the house my memory grows stronger: there was the small front garden, with a laburnam tree near the gate, and to the left of the house a path leading to the backyard, stone-flagged, with a stone 'ash-pit', a small building for rubbish. The house itself stood in a private road, but had gates into Manningham Lane. The houses hereabouts had gardens and were of unequal size; ours was the smallest of all.

My mother's character inclined to be strict; but her deep-rooted, carefully trained sense of household order and economy was helpful to everyone under her. For her there was a right way and a wrong way of doing things, and she insisted, undisturbed by doubt, on things being done in the way she thought right. As she was with the maids, so she was with us children. I could not abide cold beef or rice pudding; what I left on my plate was sent up for tea, to be finished before tea proper, with its generous home-made preserves and cakes, might be taken. My father was milder and less determined; from him we could get more concessions; but his trust in my mother's judgement was absolute; her word was law, and he consulted her on everything. I heard not only no cross word spoken between them but no impatient one. As my mother was the stronger character, she loved to dwell on my father's just and generous nature; to her he was the perfect husband. Such indeed he was; but in those innocent days we did not suspect there were any imperfect husbands.

Being an indifferent scholar, I thoroughly disliked my schooldays. The Bradford Grammar School was a dreary building, inside and out. We assembled in a hall of stained pitchpine, its single

decoration a framed wooden tablet, on which were inscribed the names of holders of university scholarships. To see my name among these was an honour I knew would never be mine. The class-rooms, with their shabby, bare walls, ugly, stained desks and hot pipes, smelt close and stuffy.

In my first year I gained a prize, which I received from the hands of W. E. Forster, then Member for Bradford, and being an under-sized lad, I got a round of applause. It was my only success—I never won another. The headmaster, known to generations of boys as 'Old Rusty', used to call out—'Stand up, Sir. You will have to earn your living with your hands, you will never do it with your head!' Only for English History did I show any capacity. Happily there came to the school, early in my career, an admirable master, Arthur Burrell. Burrell knocked a hole, as it were, in the stale, drab walls of the schoolroom and let in the fresh air. He was an excellent reader, and encouraged us to read Shakespeare and other poets aloud for ourselves. He asked me often to his room, talked of books and authors, and encouraged my love for reading which, since my eyes gave me trouble, was discouraged at home.

Having no taste for music, I never went to concerts; but I went, whenever I could, to the lectures at the Philosophical Society. Here I was able to see and hear great men from London, men like Andrew Lang and H. M. Stanley. Nothing excited me more. It is difficult for a Londoner to realise how cut off we were from art and literature, and how eventful a lecture was. I was all ears at these lectures. Often, when my father and others in the audience would suddenly laugh, I would fail to know why, and feel ashamed of not having laughed too.

My one talent, that for drawing, was recognised at school; instead of writing so many lines for misconduct, I was made to draw and paint lantern slides. But I showed little aptitude for scholarship when I reached my fifteenth year, and no inclination for commerce. I was constantly playing with pencils or paints, and was bent on becoming an artist. To Harry Furniss, whose caricatures of Mr Gladstone I particularly relished, I sent a batch of my own attempts. In returning them he wrote that I had wit of a certain, but drawing of a very uncertain kind; the latter sentiment was sound, but my ardour was unquenched.[1] About the same time W. P. Frith's *My Autobiography* was lent me to read. It was just the kind of book to kindle a boy's fancy for an artist's life. Accounts of the Bushey School of Painting had reached Bradford—accounts likely to dazzle

a provincial lad—a sort of Bushey-Bayreuth with acting, music and painting centring round the figure of the Bavarian woodcarver's son, Hubert Herkomer. My father, proud enough of my drawings, and of the praise they won from his friends, hoped that I would nevertheless do as most solid merchants' sons then did, and follow in his footsteps. But he was a man of large views. Seeing my little zeal for anything save drawing and reading, he probably had doubts concerning my fitness for business, for he finally agreed to let Herkomer decide whether my drawings showed sufficient promise to justify serious study. A batch of these was sent to Bushey; I anxiously awaited the verdict. Within a few days Herkomer wrote that, in view of my youth, I should work for a year at a local art school, and then come to Bushey. Crude indeed my drawings must have been; I marvel that Herkomer accepted this responsibility. However, there was his decision. My father had promised to abide by it.[2]

My headmaster was informed of what was intended; henceforward I was allowed to spend a great part of my time in the art rooms of the school. In the chief art room a succession of boys practised perspective, and what was then called 'freehand' drawing, from copies issued from South Kensington. The two or three hours weekly devoted to 'art' had until then filled me with gloom. The principles of perspective I was unable to grasp. I am unmusical, so I have always been unmathematical. Indeed, the only person who suspected any unusual talent in me was my mathematical master, who habitually said that anyone so stupid as myself must have some hidden genius of which he was unaware. The Science and Art Department, which rained green and white certificates on my elder brother, regularly withheld them from me.

The year 1887 was a momentous one in the history of the town. It was Jubilee Year, and at Saltaire, two miles from our home, an exhibition was held where for the first time I saw some famous pictures. The painting which impressed me most, indeed the only one that I remember clearly, was Hogarth's portrait of Garrick as Richard III, starting up from his couch. This I copied in chalk; but my desire to sketch certain other pictures was nipped in the bud by the attendant: I must first get the permission of the artists. For this sanction I was advised to write, and I actually sent letters to Leighton and Alma Tadema, and received replies from both these eminent painters![3]

But a greater experience was in store for me. I was invited to

Manchester to spend a week with my cousins, while the Exhibition was on, which included the most important collection of pictures ever brought together in the north of England. I had never been to London. There was not yet an art gallery in Bradford, but only a small museum, containing some pictures, mostly (except for a few by James Charles, Sichel and Buxton Knight) of the kind one sees in cheap auction rooms. The effect of the Manchester Exhibition was profound. I went from room to room, bewildered at first by the number and variety of the paintings; but gradually certain works emerged from the rest—by Frith, Faed, Fred Walker and Alma Tadema; then Burne-Jones' *Wheel of Fortune* and his series of *Pygmalion and Galatea*; and no doubt many others, which I now forget.[4] I felt as a colonial might feel when visiting the home of his forebears; everything was new and strange, yet there was a secret sense of kinship. I returned in a state of exaltation; but exaltation, I have noticed, not infrequently shows itself in the form of conceit and ill manners. School, where I rarely was happy, became still more distasteful, and my itch to be drawing more persistent.

It happened that there came to Bradford at this time, to assist in the Art Department of the newly-opened Technical College, a Mr Durham, who had been on the staff at the Slade School. He was not, I think, a very good draughtsman, but he upheld me in my dislike of stump and charcoal, and taught me to use sanguine. Mr Durham held evening classes in anatomy, and these I attended. Living models were used in the demonstration, and in this way I gained my first experience of drawing from the life.

I also had the advantage of frequenting the studio of Ernest Sichel, the gifted son of a wealthy Bradford merchant. Young Sichel had lately returned to Bradford after studying at the Slade School for several years. Shy and reticent, a man of uncommon modesty, he had already made a place for himself in a distinguished circle in London—he was a close friend of William Strang and of John Swan —but he preferred to work quietly in his native town, though there were few to appreciate the sensitive sincerity of his drawings and pastels. He was sternly critical of my attempts, rightly deeming me careless and inaccurate. Sichel advised my father to send me to the Slade School rather than to Bushey. I was only too willing the plan should be changed, for the glowing account of the students' life at Herkomer's school, which had turned my head, was soon forgotten when I saw Strang's and Sichel's drawings; and the hope that under

Legros' tuition I might some day do similar work made me long for the day when I might set my face towards London.

It was arranged that I should enter University College at the beginning of the coming session. My father was to take me up to London. My excitement was intense. The journey then took close on five hours; it seemed endless. The seats in the third-class carriages were higher than they are now, and my feet did not quite reach the floor. This failure to achieve the dignity of a 'grown-up' person distressed me. We reached King's Cross at last, and spent the first night in the Great Northern Hotel. For me it was a restless one; the thought that I was actually in the same city as Watts and Leighton (and how many others?) kept sleep away.

The Slade School in my time had much the same appearance it has at present, but the atmosphere was very different. At that time there were not more than a hundred students, of whom the great number were men. Men and women worked together in the Antique rooms only, but rarely met after working hours. I doubt whether the women were as brilliant as many of the women students are now; they were certainly more austere, as were the habits of the whole school. The older students who worked in the Life rooms had little or nothing to do with the freshers in the 'Antique'. During my time at the Slade, scarcely one of the older students ever spoke to me.

We drew on Ingres paper with red or black Italian chalk, an unsympathetic and rather greasy material, manufactured no longer I think. The use of bread or indiarubber was discouraged. From morning till late afternoon, day after day, we toiled over casts of Greek, Roman and Renaissance heads, of the *Discobolus* and of the *Dancing Faun*. However, we did *draw*, at a time when everywhere else in England students were rubbing and tickling their paper with stump, chalk, charcoal and indiarubber. Legros himself was first and foremost a draughtsman. He was a disciple of Mantegna, Raphael, and Rembrandt, of Poussin and Claude, of Ingres and Delacroix. He taught us to draw freely with the point, to build up our drawings by observing the broad planes of the model. As a rule we drew larger than sight-size, but Legros would insist that we studied the relations of light and shade and half-tone, at first indicating these lightly, starting as though from a cloud, and gradually coaxing the solid forms into being by super-imposed hatching. This was a severe and logical method of constructive drawing—academic in the true sense

of the word, and none the worse for that. There were no students of the stature of Strang and Furse working during my year. At heart I was disappointed; I had expected a great stream of talent; I found only a thin trickle.[5]

Legros himself, with his grey hair and beard and severe aspect, appeared to us an old man, though he was then little more than fifty. A Burgundian from Dijon, he had early been drawn into the more advanced group of artists in Paris, though he was by nature a traditionalist rather than an experimenter. A pupil of Lecoq de Boisbaudran, he used to say that one of the first tasks set him was to copy Holbein's portrait of Erasmus at the Louvre, going and returning until he had perfected his copy from memory, and that this had a lasting influence on his own methods of work. Like most of his contemporaries, Legros found it difficult to make a living by his etching and painting in Paris. Whistler, one of his earliest friends, advised him to try his fortune in England; so he came to London, and was introduced to Rossetti by Whistler. Dante Gabriel, with his usual generosity, put him into touch with Lady Ashburton, who had already commissioned Fantin-Latour to make copies of old masters [and] was prepared to employ Legros in the same way. This unhappily led to a misunderstanding between the two artists that was never healed.[6]

Though he married an Englishwoman and his children were all born in England, [Legros] never learnt to speak English, and this was awkward for those among us who knew no French. He relied on his assistants to interpret, although in the Antique room they had little need, since his criticisms there were usually laconic and somewhat bleak. None the less, Legros' personality commanded great respect. If he kept me and others for a whole year in the Antique Room, Legros' estimate of our abilities was probably shrewd enough. He urged us to train our memories, to note in our sketch books things seen in the streets. We were also encouraged to copy, during school hours, in the National Gallery and in the Print Room of the British Museum. Legros, as a student of Lecoq, had no doubt of the wisdom of this. He used to say, 'Si vous volez, il faut volez des riches, et non pas des pauvres.' And to work at the National Gallery was indeed a relief from the uneventful hours I spent in the cast-room.

It was a stirring event for us students when Legros, once a term at least, painted a head before the whole school. Practical demon-

stration is unquestionably the most inspiring method of teaching. Legros had a masterly way of constructing a head by the simplest means. He worked on a canvas previously stained a warm neutral tone, beginning by brushing in the shadows, then the half-tones, finally adding the broad lights. He had a particular objection to any undue insistence on reflected lights, and this is the part of his teaching I remember most clearly.

Legros was a supporter of both the Grosvenor and the New Gallery.[7] He took no trouble to hide the critical spirit in which he regarded the Royal Academy. He had little respect for most of the Academicians, not because they were academic, but for the reason that they represented neither tradition nor scholarship; on this account he never encouraged his students to exhibit at Burlington House, and in this way he fostered the independence for which the Slade School has been famous since.

There was no Tate Gallery in those days, and I was anxious to see all I could of Legros' paintings. There were one or two of his portrait studies (one of Browning among them) in the South Kensington Museum, but no pictures. So Charles Holroyd gave me an introduction to Stopford Brooke, who owned several works by Legros. The house had the rich air, the profusion, of the Victorian interior. Large prints of Rome and huge Italian woodcuts filled the hall. Prints and drawings covered the walls from bottom to top as one climbed up flight after flight of staircase, prints and drawings hung close together in passages, bedrooms and bathrooms. In the dining room and drawing room were paintings by Legros, Giovanni Costa, Lord Carlisle and Walter Crane; water-colours by Turner and Blake; drawings by Burne-Jones and Rossetti. A drawing by Rossetti hung high up outside the drawing room, an early study for *Found*. Later, when visiting Stopford Brooke, I used often to beg for a chair, to get close to this lovely drawing. After his death I found he had left it to me in his will.[8]

At the Egyptian Hall, where the exhibitions of the New English Art Club were held, I first saw paintings by Wilson Steer and Walter Sickert, with both of whom I was later to be intimately associated. The exhibition of paintings at the New Gallery was followed by the first exhibition of Arts and Crafts, inspired by William Morris and Walter Crane.[9] I can recall the general effect of the rooms, but no particular works. And there was a visit to a girls' school where, oddly enough, Whistler chose to show a number of his paintings.

While I was there classes were being held, and it was somewhat embarrassing to walk about and look at the pictures hung in the class-rooms. This was my first acquaintance with Whistler's work, of which I had heard but vaguely before. Full of excitement I returned to the Slade to discover that Legros strongly disapproved of Whistler's influence; so there was an added fascination in the taboo.[10]

On Sunday afternoons I frequently went to Little Holland House, when Watts threw open his studios to visitors. Our high estimate of Watts and his paintings I still feel to be justified. Some of his large compositions may be vulnerable enough. As with many English artists, Watts' vision was over-much influenced by painting—in his case by Venetian painting. His construction is often faulty and his subjects are admittedly didactic; yet he is likely to take his place finally as one of the most richly endowed artists of the English school. To-day the epic spirit is under a cloud; it does not now come naturally to modern painters. But to Watts it did come naturally, and the mention of his name evokes a luminous world of his own creation. This in itself is a proof of his genius. Carlyle said, of great talkers, that they may talk more nonsense than other men, but they may also talk more sense. So Watts may have painted more tedious pictures than men less copiously endowed, but he painted more splendid ones. Certainly, in the early days of which I am writing, Watts spoke to me more eloquently than did any other living artist. I was soon—too soon perhaps—to find other loves, some lighter, some equally worthy of devotion; but the impression the great compositions and portraits together made upon me at Little Holland House is unforgettable. At Little Holland House one saw great compositions in carefully chosen places; among these hung smaller studies and groups of portraits: Ellen Terry and her sister, Mrs Langtry in a delicious Quaker bonnet, Lady Lytton golden-haired, and Mrs Senior bending over her plants, the grave Joachim with his fiddle, William Morris and other blue-eyed, fresh-complexioned English men and women.[11] There was a racial quality in all these portraits, a spirit remote from the model-stand, from Louis XV settees and Coromandel screens. For Watts could still paint men and women in surroundings which belong to their own time. Victorian furniture, Victorian carpets and curtains, were not borrowed from other ages; 'period' furniture had not yet come in, nor had the fashion for furnishing homes through dealers in antiques.

Watts represented the flower of Victorian beauty and culture with a distinction which nobody since has been able to re-create. In Watts' studio all these pictures seemed thoroughly at home. Times have changed; his ample manner of living, the noble circle of men and women to which he belonged no longer survive; but for a youngster to get a glimpse of that great world each time one went to Melbury Road was an exhilarating experience. The memory of these visits to Little Holland House remains as something rich and precious, unlike any other experience.

Ernest Sichel had given me a letter to William Strang. Strang was a short, ruddy, broad-shouldered, thickset Lowlander with a strong Scottish accent and a forehead like a bull, above which the hair grew stiff and strong like a southern Frenchman's. Strang gave me much good advice; he was hospitable and always ready to talk—about artists, about drawing and painting, and of his own opinions. And I was all ears. He had just completed a set of etchings for *The Pilgrim's Progress* and complained that no publisher would take them: they all wanted prettier things.[12] He said he never used models for his subject etchings. I told him of my intense love for J. F. Millet's art, and he sent me to an exhibition at Dowdeswells, where, besides paintings by Millet, I first saw canvases by Ingres, Delacroix, Corot, Daubigny, Diaz, and James and Mathew Maris.[13]

Towards the end of the session I was given an introduction to Solomon J. Solomon, then a rising young artist whose first exhibited pictures had made something of a stir in the Paris Salon and the Royal Academy. Solomon showed himself to be a capable painter of the big Salon 'machine'. Immoderate labour and skill were, year by year, spent on these immense fabrications—historical, biblical or oriental—signifying little. Solomon's *Samson* was perhaps the most efficient example of this type of picture in England.[14] Students were rather dazzled by his power of painting nude figures. He was all for French methods, and thought little of the teaching they gave at the Slade. He strongly urged me to go to Paris. Legros was clearly getting tired of teaching; there were whispers of a certain Frederick Brown at Westminster, who was drawing a new class of student by new methods, some, even, from the Slade; and Paris had a magical appeal. I found that Studd was thinking of going to Julian's Academy. I therefore persuaded my father, to whom Solomon had written, to consent to my going at the same time.

My father had a brother living in Paris, to whose care I was now

confided. But for this I should scarcely have been allowed, at the early age of seventeen, to leave the safe rule of University Hall. I had no regret at leaving the Slade; and though Legros told me later that he had kept me back to gain a sound basis for my drawing, it was natural enough that the daily copying of casts for a whole year became irksome. Nor was my departure any loss, in their eyes, to the staff.

My uncle had taken a room for me, all bed and divan and armchair, in a respectable quarter near the rue Lafayette. He meant well, but I determined to change both the room and the quarter as soon as possible. Next morning I found my way to the rue du Faubourg St Denis.

The Académie Julian was a congeries of studios crowded with students, the walls thick with palette scrapings, hot, airless and extremely noisy. The new students were greeted with cries, with personal comments calculated, had we understood them, to make us blush, but with nothing worse. Perhaps this was still to come. Wild rumours were current about what the 'nouveaux' had to undergo.

To find a place among the closely-packed easels and tabourets was not easy. It seemed that wherever one settled one was in somebody's way. Happily Studd, who had arrived at Julian's before me, took me under his wing and found me a corner in which I could work. I must join him at his hotel, just across the river, opposite the Louvre. This was in the rue de Beaune, a small street, parallel to the rue du Bac, running into the rue de Lille. Nothing could have suited me better. First of all there was the hotel itself—the Hôtel de France et de Lorraine established at the time of the first Empire, and little changed since. Living at this hotel, besides Studd, there was Kenneth Frazier, a gifted American painter who had been at Bushey under Herkomer and was now also working at Julian's, and Herbert Fisher, a young and learned history don from New College, who was attending lectures at the Sorbonne, sitting at the feet of Taine and Renan. We were soon joined by a German artist who was also studying at Julian's—Ludwig von Hofmann. These first days in Paris seemed like paradise after a London purgatory.

And following on the orderliness of the Slade, and the aloofness of the students, the swarming life at the Académie Julian seemed vivid, exhilarating and pregnant with possibilities. Students from all over the world crowded the studios. Besides the Frenchmen, there

were Russians, Turks, Egyptians, Serbs, Roumanians, Finns, Swedes, Germans, Englishmen and Scotchmen, and many Americans. By what means Julian had attracted all these people was a mystery. He was said to have had an adventurous career, to have been a prize-fighter—he looked like one—and to have sat as a model. He himself used to tell the story of how, at his wits' end for a living, he hired a studio, put a huge advertisement, 'Académie de Peinture', outside, and waited day after day, lonely and disconsolate, for there was no response. One day he heard a step on the stairs; a youth looked in, seeing no one, was about to retire, when Julian rushed forward, pulled him back, placed an easel before him, himself mounted the model-stand—'et l'Académie Julian était fondée!' More students followed; another studio was added, and finally the big ateliers in the rue du Faubourg St Denis were taken, and a separate atelier for ladies was opened. Julian himself knew nothing of the arts. He had persuaded a number of well-known painters and sculptors to act as visiting professors, and the Académie Julian became, after the Beaux-Arts, the largest and most renowned of the Paris schools.[15]

At the Académie there were no rules, and, save for a *massier* in each studio who was expected to prevent flagrant disorder, there was no discipline. The professors were unpaid. You elected to study under one or more of these, working in the studios they visited. Over the entrance to the studios were written Ingres' words, 'Le dessin est la probité de l'art', and 'Cherchez le caractère dans la nature'.

We drew with charcoal on Ingres paper; the system in vogue was to divide the figure into four parts, measuring with charcoal held at arm's length, and using a plumb line to get the figure standing well on its feet. Drawing 'sight-size' was not encouraged. The figure must fill the sheet of paper. So many were the students, two models, not always of the same sex, usually sat in each studio. Our easels were closely wedged together, the atmosphere was stifling, the noise at times deafening. Sometimes for a few minutes there was silence; then suddenly the men would burst into song. Songs of all kinds and all nations were sung. The Frenchmen were extraordinarily quick to catch foreign tunes and the sounds of foreign words. There was merciless chaff among the students, and frequently practical jokes, some of them heartless ones.

Although I had never drawn from the life at the Slade, the professors seemed to find some character in my drawing, complimenting

me on my good fortune in having been a pupil of Legros. For Legros was still remembered in Paris: a painting by him hung in the Luxembourg Gallery, and his etchings were often to be seen in the windows and portfolios of the print shops.[16] Doucet was exceedingly kind to me. He frequently asked me to his studio, and gave me introductions to artists, among others to Rochegrosse, Bracquemond and Forain.

Forain was then working chiefly for *Le Courier Français*, week by week producing the mordant drawings and legends which were afterwards published as *La Comédie Parisienne*.[17] On an auspicious day, armed with Doucet's letter, I set out to find him. On reaching his studio, I noticed a quantity of furniture, including one or two easels, in the street. Before I could ring, a youngish man with a brown, fan-like beard, appeared at the entrance; he turned out to be the admired artist himself. The furniture in the street was his; he was being ejected. This, I found out later, not infrequently happened. Forain is now, I am told, one of the wealthiest artists in Paris. Such changes of fortune are not unusual, but there was little to show in those days that Forain would arrive at his present eminence.

Doucet had told me to show Forain my own drawings. These were done on thin brown paper in sketch books specially made by Newmans for John Swan. Forain's comments on the drawings were no doubt appropriately polite, but for the sketch books, bound in pleasant green cloth strengthened by leather, he expressed unstinted admiration. Could I get him some? Yes indeed; I was only too proud and ready. How many? Three or four. Four were ordered. Needless to say, the good Forain never thought of asking for the account, and I was too shy to proffer it. My finances, in consequence, were crippled for a month.

Besnard was our latest discovery. He stood between the more skilful of the Salon painters and independent artists like Degas, Monet and Renoir. He was not popular among the Impressionists, who regarded him as a Salon painter who had adopted the colour, but was incapable of the heat, of their fire. 'Besnard, vous volez de nos propres ailes,' Degas had said to him. But we knew little of Degas or his work, having seen only the small pastels then in the Caillebotte collection at the Luxembourg, while Besnard's effects of light and lamp-light on nudes were a fascinating novelty, much imitated at Julian's.

My fellow student, von Hofmann, had discovered Besnard's wall paintings at the Ecole de Pharmacie, and took me to see them. So

much did he admire these decorations that, with Besnard's permission, he made careful copies of them.[18] This devotion naturally gained him Besnard's acquaintance, to whom he showed one of my sketch books, which led to Besnard, out of the kindness of his heart, inviting von Hofmann and myself to dinner to meet Puvis de Chavannes, whom he knew we both worshipped from afar. The great day arrived; but could this rubicund, large-nosed old gentleman, encased so correctly in a close-fitting frock-coat, looking more like a senator than an artist, be the Olympian Puvis? The only other guest was Forain, who took the lead in the conversation, and made havoc of reputations which to us were sacrosanct. Puvis talked little and gave his attention to the food and wine; we heard later that it was his habit to work all day with no break for luncheon. After dinner we adjourned to the studio, where Besnard's latest canvases stood about on easels. We waited eagerly for Puvis' comments, but it was always Forain who played the critic. Puvis was discreetly genial, and said little that was remarkable.

I also met P. G. Hamerton—well known at one time as an art critic and writer on etching, as the editor of *The Portfolio*, and immortalised by Whistler in *The Gentle Art*. He was then an old gentleman with a French wife and a French family, living just outside Paris, at Boulogne-sur-Seine. One day he insisted on taking me to the Louvre to show me exactly where the old buildings had stood. With the touching, unsteady gait of an old man, he walked carefully over the ground plan of some of them, while I stood coldly watching him, little interested in this peripatetic demonstration. Poor Mr Hamerton! he little knew how small was my knowledge of history, and how slight my curiosity for buildings which no longer existed. The Louvre as it stood was good enough for me.[19]

Von Hofmann had pressed me to join him in Germany. Would I visit his people in Berlin first, see some of the galleries, and then go on to Rügen to work? Being greatly attached to von Hofmann, I at once agreed.

Von Hofmann, newly arrived from Paris, with his copies of Besnard, seemed, in museum circles, a revolutionary artist. The Emperor actually sent a message to his father, ordering him to discourage his son from painting in this modern manner! It seemed to me incredible that anything of the kind could happen; but I knew nothing of Court life, and was told this was characteristic of the Kaiser.

Among the German artists I met, I was most struck by Max

Liebermann. Liebermann was a wit, and a notable figure in Berlin society. An unashamed Jew, he was notoriously unpopular; but he was clever enough, instead of trying to minimise his characteristics, to exaggerate them. His talent could not be ignored, nor indeed could his tongue be bridled, and being possessed of large private means, he could afford to indulge it fearlessly.

The artist whose work I most admired was Adolf Menzel. This surprised the younger men, and the advanced critics whom I met. The German painters seemed to me to be neglecting the solid bourgeois qualities that had always distinguished German work, to be losing faith in their own culture and snatching at every latest fashion from France, Sweden and Norway. Menzel alone was not ashamed of the genial *bürgerlich* spirit which is the soul of German art.

In October I returned to Paris. At Julian's during my first day some students were looking over a brown-paper sketch book I had filled during the summer. They were joined by a blond, rather heavily-built man, blue-eyed, bearded, with long hair parted in the middle and falling over his eyes. Later he came up to me and said kind things about the drawings. He spoke with a soft voice, and walked with a peculiar, rather shuffling gait. There was something oddly attractive about him. I saw the drawing he was doing, which was not very capable. After work we lunched together. He was English, he said, but had been sent out as a youth to Australia, where at first he had led an adventurous life in the Bush as a surveyor; later he had done drawings for newspapers, and finally he had become a painter. His name was Charles Conder.[20] I felt a little shy with him; he knew so much more of the world than I did, or, I thought, than did any of my friends. We continued to meet at Julian's. He was living in Montmartre, a part of Paris then unknown to me. He took me to see his work, pale panels of flowers, and blonde Australian landscapes; a little weak and faded in colour, I thought, but with a delicate charm of their own. His studio contained little else save a divan covered with fine Indian materials—soft white muslins, with faint primrose and rose-coloured stains. Other muslins hung across the windows. Whistler, he said, was his favourite painter, and after him Puvis de Chavannes. He read me verses from Omar Khayyam, then entirely new to me. I was enchanted by the boldness of the verses as well as by their beauty. In Conder I also found an ardour for Browning which equalled my own. He talked to me of Ibsen and of Janet Achurch, whom he had known in

Australia, and of her wonderful acting in *A Doll's House*. I had not yet met anyone who was familiar with actors and actresses, and there, in his studio, was a beautiful photograph of Miss Achurch, signed by her hand and with his name on it. I was fascinated, but also a little disquieted, by his suggestive and oddly wandering talk. His paintings too grew on me. But lovely colour meant less to me than good drawing, and strength and shrewd observation more than charm.

Studd, too, admired Conder's work but was a little suspicious of his influence, and was inclined to dissuade me from seeing too much of him. But Conder seemed to have singled me out as a friend; and when he pressed me to join him at Montmartre, the idea of sharing a real studio was a formidable temptation. The Left Bank was very well for poets and scholars, but Montmartre was essentially the artists' quarter. The temptation, therefore, to cross the river and live on the heights was too strong to resist. So I left my beautiful Empire room, and my safe, solid friends for a land unknown. I was but seventeen years old, and though in many ways timid by nature, I had a blind faith in my star. Dangerous things might happen to other people, but somehow I should be protected.

The rue Ravignan lies above the Place Pigalle and the Boulevard de Clichy. At the top of the street is an irregular open space, bounded on the north by a flight of steps and railings, just below which are the studios. Above the steps was the pavilion of an eighteenth-century country house; beyond lay old, quiet streets, scattered villas with deserted gardens and *terrains vagues*. In a low, rambling building, which probably still exists (I went there some years later with Augustus John to call on Picasso), were the studios, mere wooden sheds with large windows; but great was my pride at working in any place which could be so called.[21] Sharing a workroom was not, however, without grave drawbacks. Conder's personality proved very attractive to ladies; I found myself often in the way; there were difficulties which led to quarrels, soon mended but often repeated.

I had not been long in Montmartre, however, when Phil May arrived from Australia. He had made his name, and some money too, as a cartoonist on *The Sydney Bulletin*; but he wanted to improve his drawing, and at the same time carry on fresh work for *The St Stephen's Review*, an illustrated London weekly long extinct. To us May seemed a man of wealth, who could afford all the models he needed. He hoped to do other work besides illustration, even to

paint. May being extremely modest and having been so long away from Europe, thought more of my drawings than they deserved. He pressed me to share a studio with him, where he could come and work from time to time. He would, of course, pay half the rent and would be delighted to have me share his models. One of the studios in the rue Ravignan was to let, and he proposed I should take it. Conder must have been as anxious to get rid of me as I was to have a studio of my own. Phil May in fact made little use of the studio; his [alcoholic] failing was already noticeable, and the influence of Conder, who shared it, was detrimental to regular work. Poor Mrs May was often in despair. Phil somehow managed each week to get his weekly drawings done for *The St Stephen's Review*, and sometimes he sketched at night in cafés and *café-concerts*, but he did little else.

May was illustrating a serial called *The Parson and the Painter*, for *The St Stephen's Review*, and later Whistler used to pretend that the figure of the parson was taken from me, and always called me 'the Parson' in consequence. Whistler praised Phil May's drawings highly, a little to my surprise; for though I admired their precision and facility, they did not seem to me to be in the same rank with those of Charles Keene and Forain.[22]

Toulouse-Lautrec and Anquetin were at this time the leaders of

The PARSON AND THE PAINTER

Their wanderings and excursions among men and women

CHAPTER XXVII.

THE GAY CITY.

*Overcome with shame I fly to Paris—
Charlie, the lady, and the disastrous
sketch — In durance vile — At a Café
Chantant—We revisit the Moulin Rouge
—I dance the Can-Can—We' repair to
the Rat Mort and drink absinthe—
Terrible result—Hurled from a tramcar
—Camel riding and Ostrich driving.*

the younger independent painters. Anquetin, of whom great things were expected—he was looked on as the most gifted and promising of the group that formed the Salon des Indépendents—was a man of magnificent physique. Broad-chested, with a powerful head and crown of thick, tufted hair, strong neck, ruddy complexion and a broken nose, he put one in mind at once of Michael Angelo. Beginning as a naturalistic painter, he gradually became absorbed in the methods of Rubens, Poussin and Delacroix. Among the first to revive an understanding of baroque art, he was himself a baroque artist, unfortunately both after and before his time, with something of the superhuman nature of a character from Balzac. It was in part owing to Anquetin that Daumier was finally recognised as one of the supreme artists of the nineteenth century.[23] Quietly sure of his own powers, physically and intellectually he moved among us all with a certain aloofness and proud indifference, his superiority tacitly acknowledged by all who knew him. If a visitor wished to see what he was doing he would point towards piles of canvases leaning against the studio walls and say, 'Look at anything you like.'

There was nothing romantic about Lautrec. Where Conder saw in the Moulin and its dancers a glowing shimmering dream of Arabian Nights, Lautrec's unpitying eyes noted only the sinister figures of *fille* and *souteneur*, of degenerate and waster. He seemed proof against any shock to his feelings, and he deemed others equally indifferent. He wanted to take me to see an execution; another time, he was enthusiastic about operations performed before clinical students, and pressed me to join him at the hospital. I *did* often go with him to the Cirque Fernando, a circus then established at Montmartre, which Lautrec used to visit assiduously, as he did the Moulin Rouge and less reputable places. The lithographs Lautrec afterwards made of circus life are perhaps the most remarkable of the records he has left. He regarded Degas as the master, but he looked on Puvis de Chavannes as the greatest living artist. The single picture on his studio walls was a large photograph of Puvis' *Bois sacré*.[24] In startling opposition to this were a huge Priapic emblem over his door and an immense divan placed against the wall. Not for a moment would Lautrec have claimed equality with men like Degas or Puvis de Chavannes, nor had he the puissant hand or great mind of a Daumier. But with his misanthropy and his personal excesses, he had the spirit of an epicure—he saw the artistic refinement of many revolting elements of human life.

Chapter 2

PARIS INFLUENCES: WHISTLER, WILDE, DEGAS, CONDER

AFTER the quiet and sheltered life at the rue de Beaune, the Montmartre days ran into many late nights. I was up early enough in the morning, however late to bed. The Moulin Rouge, with its dancers, was a constant source of inspiration to Conder; to me it was not; but a sense that I was somehow very close to life in these places took me often there, as well as to the Moulin de la Galette, a more plebeian dancing hall little known to strangers, frequented by the working-girls and youths of the quarter. Much of the life of the quarter was indeed repellent, unnatural and rather frightening, but I affected indifference and the ways of a person thoroughly seasoned to adventure and to the company of shady people.

Associating with men older than myself, I was living in a world to which I had not really grown up. That I was also living, in the eyes of my soberer friends, rather perilously, flattered my vanity. I was often called upon for sympathy when Conder was in difficulties. Sober men are, alas, poor comforters, and sorry companions for men crowned with vine leaves. But sensible at bottom I was. The wine that was red did not call up visions in me as it did in Conder. So I used to say that half my friends disapproved of me because I sat with wine bibbers, and the other half because I did not drink.

I remained but a few months in the rue Ravignan; I found a more convenient studio lower down the hill, [Number 23] in the rue Fontaine, almost opposite Julian's. This year Roger Fry also came from Cambridge, where he had been at King's College with Studd. He had done little drawing; I gathered that he had moved chiefly in scientific and philosophical circles; but he had a quiet attractiveness and was clearly very intelligent. He did not stay long in Paris; he was not much of a figure draughtsman and was somewhat shy and uneasy in the free atmosphere of Julian's. He had the habits and

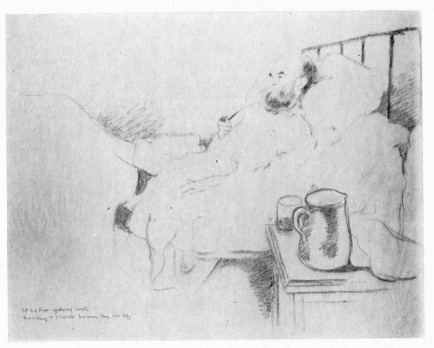

1 WR *Verlaine at l'Hôpital Broussais, Paris, September 1893*

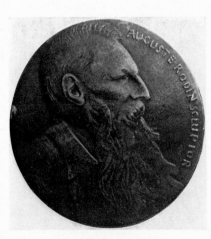

2 WR *Auguste Rodin* c.1898

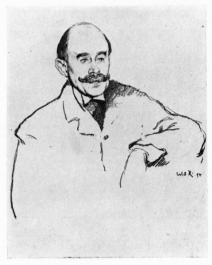

3 WR *Walter Pater* 1894

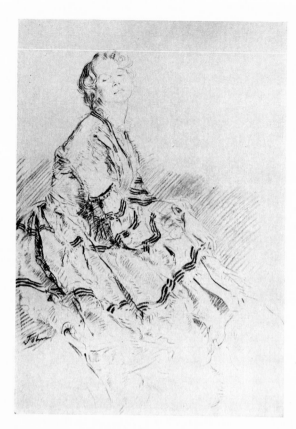

4 Augustus John *Alice Rothenstein* c.1900

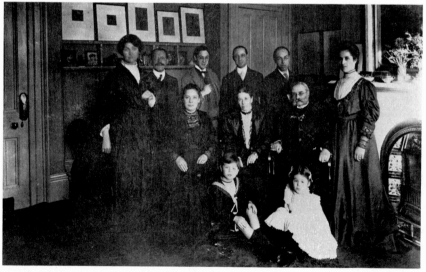

6 The Rothenstein family at Bradford, c.1905

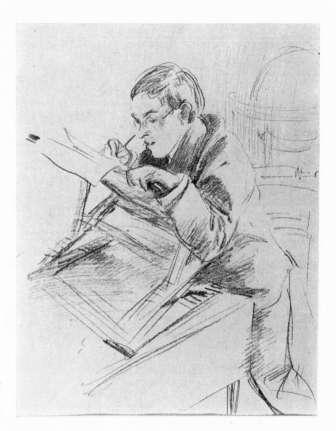

5 J.S. Sargent
William Rothenstein
1897

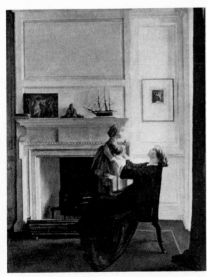

7 WR *Alice and John Rothenstein* 1903

8 Henri de Toulouse-Lautrec
William Rothenstein c.1890

9 WR *Parting at Morning* 1891

reserve of the student, and was more at home in the quieter atmosphere of Cambridge and London.[1]

The most notable personality among the Americans I met with in Paris was Miss Reubell, granddaughter of a Reubell who had been one of the Consuls during the Revolution. She was striking looking, with her bright red hair crowning an expressive but unbeautiful face, her fingers and person loaded with turquoise stones. In face and figure she resembled Queen Elizabeth—if one can imagine an Elizabeth with an American accent and a high, shrill voice like a parrot's. All that was distinguished in French, English and American society came at one time or another to her apartment in the Avenue Gabriel; she was adept at bringing out the most entertaining qualities of the guests at her table. She would often ask us to meet people whom she felt we would like, or who she thought might be of use to us. A maiden lady, with a shrewd and original mind, she permitted anything but dullness and ill manners, delighting in wit and paradox and adventurous conversation. It was at her apartment that I first met Henry James, and later—a momentous event—I was introduced there to Whistler. She was also a friend and admirer of Oscar Wilde, to whom she was constantly loyal, despite Whistler's jibes.[2]

Henry James often was in Paris, where he had numerous friends. He took a liking to Frazier and often wandered into the studio in the rue Madame. I was amused by his slow and exact way of speaking. He was not in those days so massive as he became later, either in person or manner, but was already elaborately precise and correct. He always carried his silk hat, stick and gloves into the room when paying a call, laying hat and gloves across his knee. I had not read his writings and knew him only as a discerning lover of Paris, who delighted in its old streets and houses, and as an arresting talker, of course.

To me Whistler was almost a legendary figure, whom I never thought to meet in the flesh. I must have felt very shy on this occasion. Mrs Whistler, a friendly and ample person, was, I think, amused and pleased at our obvious reverence for her husband (I say *our* reverence, for Studd, Frazier and Howard Cushing had also been bidden to meet 'the Master'), and put me at once at my ease, asking us all to come and see them when they were settled in their new apartment in the rue du Bac. They were to be at home on Sundays, she said; but before the next Sunday came round, early one morning there came a sharp knock at my door, and then who should walk

into my studio but Whistler himself! I was quite unprepared for his visit, and somewhat abashed, at which Whistler was pleased, I think, for he laughed and walked lightly round, examined all I had hung on the walls, rolled a cigarette and asked to see what I was doing. Studd and Frazier must have spoken generously of my efforts to Whistler; there was a strong element of curiosity in his nature— the reason, perhaps, of his visit. The next day came a little note asking me to dine, accompanied by a copy of one of his brown-paper pamphlets, with an inscription signed with his butterfly.[3]

Keen-eyed Whistler! fixing one with his monocle, quick, curious, now genial, now suspicious. One walked delicately, but in an enchanted garden, with him. He found amusement, I think, in my inexperienced ways. I remember his joy when, during a dinner-party at his house, my white tie—I was only then learning to tie my own tie—came slowly undone.

Whistler complained bitterly of his treatment in England. He never ceased disparaging England and all things English. His strictures were sometimes amusing; at times a little tiresome. He used to produce derogatory press-cuttings from his pocket and read them aloud; meanwhile I would ask myself why he took notice of such trivialities. Was he not Whistler, the acknowledged master? I know now that great artists are as fallible as small ones, that small things annoy them as much as great ones do; but I had less knowledge of human nature then. And because I was dazzled by Whistler's brilliant wit, by his exquisite taste, and of course by the beauty of his work, so I thought his powers beyond question, and I was puzzled that anyone else should fail to think likewise. He was so obviously a prince among men. There was something extraordinarily attractive, too, about his whole person. He wore a short black coat, white waistcoat, white ducks and pumps; a low collar and a slim black tie, carefully arranged with one long end across his waistcoat. He had beautiful hands, and there was a certain cleanness and finish about the lines of his face, the careful arrangement of his hair, and of his eyebrows. On Sunday afternoons, while talking to his visitors he usually had a little copper plate in his hands, on which he would scratch from time to time. But he was then doing more lithographs than etchings. He was experimenting with coloured lithographs, and it was at his studio in the rue Notre Dame des Champs that he made the delicate drawings, on a special kind of transfer paper, from his favourite model, Carmen.[4]

In spite of his constant reference to the stupidity of the English
and the intelligence of the French, I doubt whether Whistler's
work was so well understood in Paris as it was in London. It was
rather the cosmopolitan painters—Boldini, Gandara, Helleu, Tissot,
Jacques Blanche—who knew and understood him and his work. He
was generally considered a mere shadow of Velazquez and some-
thing of a *poseur*, in fact, as Wilde was in England.

I had heard of Wilde only vaguely as the original of Du Maurier's
Postlethwaite, as Bunthorne in Gilbert and Sullivan's *Patience*, the
young man who walked down Piccadilly with a poppy and a lily;
and when one day Frazier burst into my studio to announce that
Wilde was coming up the stairs, I expected to meet someone pale
and slender. Great was my surprise at seeing a huge and rather fleshly
figure, floridly dressed in a frock coat and a red waistcoat. I was not
attracted by his appearance. He had elaborately waved hair, parted
in the middle, which made his forehead appear lower than it was, a
finely shaped nose, but dark-coloured lips and uneven teeth, and his
cheeks were full and touching his wide winged collar. His hands
were fat and useless looking, and the more conspicuous from a large
scarab ring he wore. But before he left I was charmed by his conver-
sation, and his looks were forgotten. Whistler, whom I told of this
visit, was pitiless in his comments.

Oscar Wilde talked of me as a sort of youthful prodigy; he was
enthusiastic about my pastels. He introduced me to Robert Sherard,
to Marcel Schwob, and to Rémy de Gourmont, to a new circle of
writers and poets. Studd, who had got to like Conder, distrusted
Wilde. I, who was in some ways more innocent than most youths of
my age, saw little to be afraid of in this new friendship. Tell me
about so and so, Oscar, you would ask; and there would come a
stream of entertaining stories, and a vivid and genial personal por-
trait. He was entirely free from malice. Moreover, I had met no one
who made me so aware of the possibilities latent in myself. He had a
quality of sympathy and understanding which was more than mere
flattery, and he seemed to see better than anyone else just what was
one's aim; or rather he made one believe that what was latent per-
haps in one's nature was being actually achieved. Affected in
manner, yes; but it was an affection which, so far as his conver-
sation was concerned, allowed the fullest possible play to his
brilliant faculties. Painters show their pictures; poets publish their
poems, why should not a talker, when the mood is on him, make

sure of being heard? Wilde talked as others painted or wrote; talking was his art. I have never heard his equal; whether he was improvising or telling stories—his own or other people's—one was content that his talk should be a monologue. Whistler's jibe about Oscar's stealing was beside the point.⁵ His talk was richer and less egotistical than Whistler's, and he showed a genial enjoyment of his own conversation, which was one of his attractive qualities. Granted that Whistler was an artist far profounder than Wilde; that Oscar talked what he should have written; all the better for those who knew him as a talker. It is nonsense to say that he talked shallow paradox which dazzled young people; I still recall perfect sayings of his, as perfect now as on the day when he said them. Moreover, he took as much trouble to amuse us youngsters as he would a distinguished company. I remember that once, when he asked me to dine, I took with me a pretty English model, a good-natured but rather untidy and commonplace young woman. I understand now Oscar's amused expression when he saw us arrive together; but he was no less entertaining during the evening.

I was doing drawings of the two Coquelins at the time. Coquelin was anxious that Oscar Wilde should see him in the part of Petruchio in *The Taming of the Shrew*, so he sent me tickets. I invited the lovely Juliette, [Louis] Picard's *chère amie*, to come with us. But before Shakespeare's play there was a curtain raiser, the scene of which represented a dinner party. During this piece Wilde amused himself by pretending that the translation of *The Taming of the Shrew* was all wrong, as if he mistook the foregoing piece for the Shakespeare. He next feigned annoyance that the actors should dare to take their meals on the stage. 'In England,' he told Juliette, 'our actors are more correct; they have their dinner before the play begins. I am shocked at this want of manners—and really, at the Comédie Française!' Poor Juliette tried to explain that what we were seeing was not *The Taming of the Shrew* at all, and that the dinner was part of the play. At the end of this play we went behind, and I introduced Wilde to Coquelin.

'Enchanté de faire votre connaissance, Monsieur Wilde. Vous comprendrez combien je suis pressé en ce moment; mais venez donc me voir à la maison.' Wilde, who spoke a rather Ollendorfian French with a strong English accent, said: 'Je serai ravi, Monsieur Coquelin, quand est-ce que je vous trouverai chez vous?'

'Mais je suis toujours chez moi vers les 9 heures.'

'Vers les 9 heures,' said Wilde, 'bien, je viendrai un de ces soirs.' 'Mais, monsieur, c'est vers les 9 heures du matin que je veux dire.'

Wilde stepped back, looked at him as though with astonishment and admiration, and said: 'Oh, Monsieur Coquelin, vraiment vous êtes un homme remarquable. Je suis beaucoup plus bourgeois que vous. Je me couche toujours vers les 4 ou 5 heures. Jamais je ne pourrais rester debout jusqu'à cette heure-là! Vraiment vous êtes un homme remarquable.'

Coquelin stared blankly at Wilde, he quite failed to appreciate his Irish humour.[6]

I made several drawings and pastels both of Coquelin *aîné* and his younger brother, the first commissions I had.[7] Oscar Wilde also sat to me for his portrait, in a red waistcoat, which he wore, doubtless, in imitation of Théophile Gautier. The pastel I made was shown at the small exhibition I held with Conder.[8] I think it was rather more frank than he liked—only its colour pleased him, the red waistcoat and gold background. 'It is a lovely landscape, my dear Will; when I sit to you again you must do a real portrait.' Nevertheless, he acquired the pastel and used to take it about with him. It was stolen from him a few years afterwards in Naples, and has never been traced.

Wilde appreciated Conder's paintings on silk, especially the fans. He was surprised that people were not tumbling over one another to acquire these lovely things. Conder, who was always hard-up, was anxious to sell his work at any price, and Wilde said of him: 'Dear Conder! With what exquisite subtlety he goes about persuading someone to give him a hundred francs for a fan, for which he was prepared to pay three hundred!'

One night I went with Sherard, Stuart Merrill and Oscar Wilde to a famous night-haunt of the Paris underworld, the Château Rouge, a sort of doss-house with a dangerous and unsavoury reputation. The sight of the sinister types lounging about the crowded rooms, or sleeping on benches, made me shudder. None of us liked it, while Sherard, to add to our discomfort, kept shouting that anyone who meddled with his friend Oscar Wilde would soon be sorry for himself. 'Sherard, you are defending us at the risk of our lives,' said Wilde; I think we were all relieved to be out in the fresh air again.

To Paris came more than once Mr and Mrs Jack Gardner. Mrs Gardner was already famous as a collector of pictures, as a fastidious and somewhat eccentric woman, and for her great necklace of pearls.

She was notorious as a non-beauty, a fact she had the wit to recognise. Thinking she might be interested in my work, Whistler asked me to meet Mrs Gardner at dinner. She was curious, too, about the bohemian corners of Paris, and Whistler had advised her to have me act as her guide, 'un vieux qui moult roulé en Palestine et autres lieux,' he used to say of me laughingly. So I took her to hear Yvette [Guilbert] at the Divan Japonais and Xanrof at the Chat Noir; and to hear Bruant sing his songs at his cabaret. I also took her to Conder's studio, where she bought, I think, the first fan he had painted.[9] She was anxious to acquire a Whistler. Why she thought this a perilous project I had no idea; Whistler was surely not averse from selling his pictures; but she thought that I might be useful and took me with her to the studio in the rue Notre Dame des Champs. Whistler was in his most genial mood, and showed a number of his canvases, among which was a lovely sea-piece with sailing ships. Mrs Gardner nudged me; I could see she was eager to have it. 'Why don't you put it under your arm and carry it off?' I whispered. She was always ready for any unusual adventure, and told Whistler that she was taking the picture with her. Whistler laughed and did nothing to stop her. She told us later that on asking Whistler how much she owed him for this lovely work, he named £300 as the price.[10] How absurdly small a sum this seems to-day!

Whistler used to say that I carried out what in others was merely gesture; this of course was largely flattery. But with its many faults, my work at this time was generously noticed by older artists, among others, by Degas, who sent word, oddly enough through a little model of his who came often to our table at the Café de la Rochefoucauld, that I might, if I cared, pay him a visit. Degas as well as Whistler! And but two years before I was drawing casts at the Slade School and longing to know one or two of the older students!

Although I was always somewhat excited when visiting Whistler, his curiosity to know what I had been doing, whom I had been seeing, his friendly chaff, would put me at ease. With Degas, I was never quite comfortable. To begin with, nervous people are apt, when speaking in a foreign tongue, to say rather what comes into their heads, than to say what they mean. Moreover, Degas' character was more austere and uncompromising than Whistler's. Compared with Degas Whistler seemed almost worldly in many respects. Indeed, Degas was the only man of whom Whistler was a little afraid. 'Whistler, you behave as though you have no talent,' Degas had

said once to him; and again when Whistler, chin high, monocle in his eye, frock-coated, top-hatted, and carrying a tall cane, walked triumphantly into a restaurant where Degas was dining: 'Whistler, you have forgotten your muff.' Again, about Whistler's flat-brimmed hat, which Whistler fancied, Degas said: 'Oui, il vous va très bien; mais ce n'est pas ça qui nous rendra l'Alsace et la Lorraine!'

Degas was then making studies of laundresses ironing, and of women tubbing or at their toilets. Some of these were redrawn again and again on tracing paper pinned over drawings already made; this practice allowed for correction and simplification, and was not unusual with artists in France. Degas rarely painted directly from nature. He spoke once of Monet's dependence in this respect: 'Je n'éprouve pas le besoin de perdre connaissance devant la nature,' he mocked.

He never forgot that he was once a pupil of Ingres. Indeed, he described at length, on one of my first visits, his early relations with Ingres; with what fear he approached him, showing his drawings and asking whether he might, in all modesty, look forward to being, some day, an artist; Ingres replying that it was too grave a thing, too serious a responsibility to be thought of; better devote himself to some other pursuit. And how going again, and yet again, pleading that he had reconsidered, from every point of view, his idea of equipping himself to become a painter, that he realised his temerity but could not bring himself to abandon his hopes, Ingres finally relented, saying 'C'est très grave, ce que vous pensez faire, très grave; mais si enfin vous tenez quand même à devenir un artiste, un bon artiste, eh bien, monsieur, faites des lignes, rien que des lignes.' One of Ingres' sayings which came back to Degas was 'Celui qui ne vit que dans la contemplation de lui-même est un misérable.' Degas had lately been at Montauban, Ingres' birthplace, where the greater number of his studies are preserved. He was full of his visit and of the surpassing beauty of the drawings.

Each time I knocked at the door in the rue Victor Massé my heart beat fast; would I be admitted? But the old lady [housekeeper] had her orders; once accepted, one might come again. But I seldom went, afraid lest the acquaintance, so unlooked for, so intoxicating, might come to an end. How I looked forward to seeing something of Degas at work, to hearing his comments on painters and paintings! Yet, as in other like cases, I was sometimes too acutely self-conscious and inwardly excited to enjoy myself. I was, however, all

eyes and ears at the rue Victor Massé, and my friends too were eager
to hear me repeat Degas' latest *mot*. Truth to tell, I heard more of
admiration than of abuse.

Degas liked Forain and his work; he was interested, too, in
Lautrec's. To my surprise, he disliked Rodin, who, in our eyes, was
one of the Olympians. Among English artists, he rated Charles
Keene highly. He was curious about Brangwyn's work, which he
had noticed somewhere, perhaps at Bing's. Sargent and Helleu
Degas held in little esteem. Helleu was a rising star, an adroit
draughtsman and an able pastellist. Versailles was his temple, and
Watteau his household god; did not Degas call Helleu himself *le
Watteau à vapeur?*

Mrs Whistler sometimes gave us tea in her husband's studio; to
this we greatly looked forward, for if Whistler was in a good mood
he would bring out a canvas, and having shown one, others were
sure to follow. It was exciting to see such a succession of his works,
but the privileged occasion was not without its embarrassment; for
Whistler's comments on his own work were so loving, so caressing,
that to find superlative expressions of praise to cap his own became,
as one canvas or panel after another was slipped into the frame on
the easel, increasingly difficult and exhausting. But I was to see
another side of Whistler's character. We had been dining at the
Hôtel du Bon Lafontaine; after dinner Whistler proposed we should
go to the studio. We walked to the rue Notre Dame des Champs.
Climbing the stairs we found the studio in darkness. Whistler
lighted a single candle. He had been gay enough during dinner, but
now he became quiet and intent, as though he forgot me. Turning a
canvas that faced the wall, he examined it carefully up and down,
with the candle held near it, and then did the like with some others,
peering closely into each. There was something tragic, almost
frightening, as I stood and waited, in watching Whistler; he looked
suddenly old, as he held the candle with trembling hands, and stared
at his work, while our shapes threw restless, fantastic shadows, all
around us. As I followed him silently down the stairs I realised that
even Whistler must often have felt his heart heavy with the sense of
failure.

One evening, at the rue du Bac, a man from Goupil's came, much
worried, to consult Whistler. Before photographing Burne-Jones'
Love among the Ruins he had added high-lights, thinking it to be an
oil-painting, and in removing them, had ruined the picture. Whistler

had never forgiven Burne-Jones for giving evidence against him at the Ruskin trial. He shouted with derision at the disaster. 'Didn't I always say the man knew nothing about painting, what? They take his oils for water-colours, and his water-colours for oils.' Whistler never forgot and never forgave. His judgements on his contemporaries were as much dictated by his personal relations with artists as by his aesthetic standards. Hence his praise of Albert Moore. Of past English painters he praised only Hogarth—the one English artist, he used to say, who knew his business. He deemed *The Shrimp Girl* a masterpiece. Turner he called 'that old amateur'.[11]

Whistler never liked Conder, and did not care for his work. I do not think he ever invited Conder to the rue du Bac. He probably thought him too involved with ladies at Montmartre, too fond of his absinthe, for though Whistler was not censorious, he shrank from contact with anything coarse or ugly; he liked people to fit into the pleasant social frame in which he lived.

Poor Conder would have liked to cut a figure, to be a sort of Lucien de Rubempré. He had an immense respect for people he thought influential, believing that this or that man could effect wonderful things in his favour, wanting to introduce me, so that my fortune too could be made. Through the prism of Conder's dreamy imagination, the men and women he met would assume rainbow colours; especially the women. But to Germaine he had been faithful longer than was usual with him. For weeks they would be together, loving and quarrelling; and I was bewildered by adulation and complaints from each in turn. They had parted, for ever, and in a few days I would find them together again. Unfortunately, during the weeks at Vétheuil, the fickle Germaine had become friendly with [Edouard] Dujardin.[12] The friendship ripened, but the estrangement between Conder and the lady again proved impermanent and Dujardin found himself deserted. Relations became in consequence strained. One night, Conder and I were dining at the Taverne Anglaise, when suddenly Dujardin strode in, glowered at Conder, walked straight to our table and said: 'Bonsoir Rothenstein, je regrette de vous voir en si mauvaise compagnie.' Conder flushed scarlet, rose, raised his arm and made a gesture of striking Dujardin. I held his arm; Dujardin retired and sat down at another table. Conder sent a waiter with his card and Dujardin, calling for writing materials, sent across a note to me: 'Mon cher Rothenstein, M. Conder m'a fait venir sa carte; je voudrais bien savoir si je dois me tenir

chez moi demain et à quelle heure. . . . Pardonnez moi de recourir à votre intermédiaire pour le savoir, cela tout officieusement, d'ailleurs.'[13]

What a business! Could this be serious? To Conder it was serious enough; I was inclined to treat it as a romantic gesture. However, after dinner we went up to the Café de la Rochefoucauld to talk the matter over with [Eugène] Lomont and other French friends. They certainly took it seriously. Lomont, in his grave way, said that he and I must at once communicate with Dujardin and arrange a meeting with two of his friends. For an affair of this nature black gloves and black clothes were *de rigueur*. In the morning black gloves were duly purchased, and later Lomont and I set out for Dujardin's flat. Dujardin, who was expecting us, at once introduced us to two gentlemen, likewise in black coats and gloves, and retired. The matter was discussed with the utmost solemnity. Lomont claimed that Conder, being the insulted party, had the choice of weapons; the other two gentlemen disagreed; it was Dujardin who was the aggrieved party—Conder had made a threat to strike; technically he had struck a blow. This was not Lomont's opinion; no blow had actually been struck. Finally, after much argument, it was decided that Conder should have the choice of weapons. We had our instructions; Conder was no swordsman—we chose pistols. We prepared to retire. But before we left, Lomont, who knew the rules, pleaded for a reconciliation; so grave a culmination should at least be reconsidered; seeing that Dujardin had not been struck, 'Seriously, gentlemen, was there a sufficient cause for an encounter?' I forget the details of the final arrangement. We returned to the Café de la Rochefoucauld where Conder was sitting surrounded by friends, and when we informed him that the regrettable incident was to be considered at an end, Conder was half relieved and half vexed. I blush to say, serious as the matter was for Conder, to me it had a comic side—too comic for discretion.

At Whistler's I first met Joseph Pennell. I felt, the moment I met him, that he disliked me at sight. We were speaking of Mallarmé, and I happened to praise his poetry; Pennell sneered at me for affecting to understand what baffled other people. He was so rude that when he left, Whistler was apologetic, saying: 'Never mind, Parson; you know, I always had a taste for bad company.' After my return to England Pennell remained steadily hostile.

Walter Sickert also came to the rue du Bac. I took to him at once.

He and Whistler were close friends, but Whistler seemed to have some grievance against him, fancied or real, and Sickert was quiet and a little constrained. I was to see much of him later, and to find him, not less, but more fascinating on closer acquaintance.[14]

One day a young American came up to me at some party. He had a letter to me; he was told I knew everyone in Paris; would I introduce him to Whistler, and to some of the French writers? He was handsome, richly dressed, and spoke as though he were a famous writer. I knew nothing of his writing, but he was clearly a robust flower of American muscular Christianity—healthy, wealthy, and, in America, wise. His particular friend was Charles Dana Gibson, the popular creator of the type of which Davis himself (it was he) was a radiant example.

Richard Harding Davis had never met any artists like Conder and me; he was respectful of our dazzling intellects, but he regretted that we were not, like himself, noble and virtuous.[15] We puzzled him sadly; he even at times had doubts in regard to himself; but these doubts, when in the morning before his glass he brushed his rich, shining hair and shaved his fresh, firm chin and called to mind the sums his short stories brought him, proved fleeting as last night's dream. I liked Davis; I was touched at his wanting to make me a better and seemlier person, a sort of artistic boy-scout, springing smartly to attention before embarking on the good, wholesome work of art I was to achieve each day. He knew Basil Blackwood, and encouraged my going to Oxford; to mix with healthy young aristo-crats would do me all the good in the world; but when later he heard I was seeing Walter Pater, he lost hope.[16]

I also had a visit from a young journalist, Grant Richards, secretary to W. T. Stead, who had managed for the first time to come to Paris. Unlike Davis, he was frankly envious of the life we led, of the company we kept, of our familiarity with a world from which he was shut off. Some day he would get away from the obnoxious Stead, a man with no feeling for beauty, a kill-joy, a fusty-musty Puritan. To make up for the dreary letters he must copy during the day, he read with avidity the most venturesome books he could get. He was full of *Dorian Gray*, which he admired more than I did—he had never read *A Rebours*, and did not know how much Wilde had taken from Huysmans. He was enthusiastic in his appreciation of my drawings and paintings and Conder's fans, and begged me, when I came to London, to stay in his flat, which he shared with his

cousin, young Grant Allen, and with Frederick Whelen.[17] How hospitable English people seemed, I thought, compared with the French!

About the same time came D. S. MacColl, the protagonist of Whistler and Degas in England. Meeting Conder, he at once fell in love with his painting, with which he never fell out of love. He knew Whistler, had dined with him at the rue du Bac, and afterwards called on him at his studio. Whistler came to the door, palette and brushes in hand and declared he was hard at work. MacColl ran his fingers across his brushes, which were dry and devoid of paint, and Whistler, laughing, let him in. Hearing I was going to Oxford, MacColl kindly gave me letters to Frederick York Powell and Walter Pater.

Through Studd I got to know the Leslie Stephens at Hyde Park Gate. I found Leslie Stephen alarming. He came down to the family tea, which was held in the basement. George [Duckworth] was cheerful and talkative, but his sister Stella, and Virginia and Vanessa his half-sisters, in plain black dresses with white lace collars and wrist bands, looking as though they had walked straight out of a canvas by Watts or Burne-Jones, were embarrassingly silent. Beautiful as they were, they were not more beautiful than their mother.

Mrs Leslie Stephen was sister to Mrs Fisher, Herbert Fisher's mother, daughter of one of the Pattle sisters, had been brought up with the Prinseps and was among the dazzling circle surrounding Watts. During one of my visits I had the temerity to ask her to sit to me for a drawing; with her gracious nature she could not say no. When the drawing was done she looked at it, then handed it in silence to her daughter. The others came up and looked over her shoulder; finally it reached Leslie Stephen. The consternation was general. I was already looked on with suspicion, for in those days Whistler, whose disciple I was known to be, was anathema in Burne-Jones' and Watts' circles. The alarm must have spread upstairs; for a message came down from old Mrs Jackson, Mrs Leslie Stephen's mother, and the drawing was taken up for her to see. A confirmed invalid, Mrs Jackson had not for long come down from her room, but on seeing the drawing she rang for a stick, like the Baron calling for his boots, and prepared to give me a piece of her mind. I can still hear the thump of her stick as she came heavily downstairs, and the piece of her mind which she gave me was a solid one. I went away discomfited, well punished for my rashness.[18]

One more memory of the Stephen household. Calling one day to see George Duckworth, I was shown straight into Leslie Stephen's study. I was aware of a gaunt, bent and melancholy figure, pacing up and down. He looked startled at seeing me, and I too was frightened at finding myself alone and face to face with this shy and awe-inspiring figure. Knowing vaguely that I was a painter, and feeling it incumbent on him to provide some form of entertainment, he walked slowly to his book-case and took out a book, one of Thackeray's manuscripts, full of absurd little thumb-nail sketches. Holding the book stiffly in front of me, Leslie Stephen began slowly turning over the leaves, stopping each time he came to a drawing. I tried desperately to say something intelligent, while he went on turning, turning, turning the pages, and looking sternly at me each time to mark the result. My tongue was dry, sweat poured down my forehead, hours seemed to pass, when at last we were both relieved from the dreadful situation by George Duckworth's entry.

I spent a pleasant week with Basil Blackwood at Balliol, and met his attractive friends there. Dining with York Powell at Christ Church, I scribbled some caricatures of Verlaine and Rodin and others whom Powell knew, which seemed to amuse him. A day or two later he met John Lane, and showed him these scraps, suggesting that Lane, who was on the look-out for fresh talent, might get me to do a set of Oxford portraits. Lane wrote to me, and I saw him on my way through town. The upshot was, he agreed to publish twenty-four drawings of prominent Oxonians, for which he would pay me £120. This was an exciting commission; I was to begin work at the commencement of the autumn term. Returning to Paris I told Whistler of my good fortune. I thought of making pastel drawings; Whistler said, 'Why not do lithographs? Go to Way, he will put you up to all the tricks.'

Just a few words to say that I am once more in Paris [Gleeson] White gave me 3 guineas for my translation, not bad. I lunched in town with John Lane and we arranged somewhat about the work.[19] *. . . I met Beardsley yesterday. I am to do a small portrait here for Richard Harding Davis, who is a very good fellow. I spent yesterday evening with the Whistlers, and had a delightful time. (WR to Grant Richards, May 10 [1893]. Library of the University of Illinois.)*

When the time came to give up my studio, I wondered whether I

was wise to leave Paris. I had dug myself in, as it were, into Paris life; my sympathies, too, were with French painting. I loved Paris and I had made many friends there. My memories of London were not very happy ones; Whistler and Oscar Wilde had both extolled life in Paris, to the disadvantage of London. Conder thought I was making a mistake, that I would soon have a name in Paris, whereas people in England wouldn't understand what I was aiming at. But Lane's commission was not one to be lightly refused. I was already ready for fresh experience.[20]

Before I left Paris I heard that Verlaine was in hospital, and more than usually miserable. Latin Quarter poets, who were not over particular, had helped him again and again, but he had become impossible. Still, it seemed hard that a man of his genius should be thus neglected. Knowing him to be ill I wrote and told him how much I cared for his poems. A message came—would I come to see him at the Hôpital Broussais?[21]

Verlaine seemed pleased at my visit. We spoke about England, and of his memories of London and Bournemouth. His talk was amusing, with a childlike kind of humour. He liked being in hospital; he was well cared for, clean, and, in addition, perfectly sober. With a Silenus-like head, his baldness made his forehead look higher than in fact it was, and his small brown eyes with yellow lights and with their corners turned up, looked queer. He was very pale. His eyes had a half candid, half dissipated look, the effects of drink and of white nights; but they also had at times an engaging candour. Beneath were broad cheek bones, a short, Socratic nose, heavy moustaches, and an untidy, straggling beard, turning grey. One almost expected to find tall, pointed ears under his thin locks.

He begged me to come and see him again, and I went back to the hospital several times. He talked much of his bad health, and of his poverty, complaining bitterly of the miserable sums Vanier paid for his poems—and of the trouble he had to get paid. Lately he had been able to make a little money by giving some conferences in Holland and Belgium; but the money had all disappeared. Why not give some readings of his poems in England? I suggested. I was sure he would meet with a cordial reception. The idea pleased him; he talked again of the days spent at Bournemouth, where he had been a school-master, and of visits to London with Rimbaud. Meanwhile the doctors and nurses, he said, were all kind to him; he had nothing to pay, and lived à l'oeil like a fighting cock. It was his leg that trouedbl

him; but he would soon be out, and then I must come and see him and meet his friend Eugénie. She was a good creature, he said, 'mais quelquefois un peu rosse'.

I heard from him when he came out of hospital; would I come and see him at the rue Descartes? I found him living in a single room, poorly furnished, and not very clean. A short, shapeless, coarse-featured woman with dark hair dressed close over a low forehead, with the hoarse, throaty voice of the *banlieue*—could this be she to whom Verlaine had written so many passionately amorous verses, and to whom, despite infidelities, he returned again and again? Eugénie treated me with humiliating respect, not as an artist, but as a kind of *miché*; she was on what she thought her best behaviour. Verlaine must have told her of English editions, of possible conferences, which to her meant, *tout bonnement, la galette*. On subsequent visits the Krantz resumed easier ways and a more natural manner. She threw out hints that any money coming to Verlaine should pass through her hands; she whispered terrible things into my ear as to what would happen otherwise. Verlaine, with his shrewd and un-ashamed frankness, taunted her with her greed. She continually robbed him, he cried; he never had a sou, quoi! hadn't even enough to buy himself a shirt and collars; as for drinking, why, he didn't want to drink, but still, *nom d'un nom*, sometimes one wanted to offer a glass to a friend. There would be fearful *engueulades*, and then, like two cats in a yard, they would walk away from each other, and Verlaine would quietly resume his talk about literature, poets, and plans for new poems.

Paul Verlaine, the French poet, is coming over to London to lecture on recent French poetry and will also deliver a lecture in Oxford. I did two portraits of this extraordinary man in Paris, while he was lying at the hospital.[22] He is always ill enough to come to the hospital when he has no money and well enough to go out when he makes some. Do you know his verses? Some of them are most beautiful and some almost unreadable (I do not speak in the gerundive) but of his life, alas, none of it has been beautiful and all of it has been unreadable. (WR to Margaret Woods, October 28 [1893]. RP:HL.)

Chapter 3

OXFORD, AND A RETURN TO PARIS

IN THE autumn I prepared to migrate to Oxford. Basil Black-wood had asked me to stay with him at Balliol for a week or two, while I searched for rooms. York Powell offered to put me up later at Christ Church, and Mrs Woods invited me to Trinity College. So there would be time to look round before I settled in lodgings.

Before going to Oxford, I spent some days with Grant Richards in London, making final arrangements with John Lane about the book I was to do, and practising lithography on stones and transfer papers at Way's printing office. Grant Richards was still acting as secretary to Stead. He had literary and sartorial ambitions; neither one nor the other received encouragement from Stead nor indeed from Richards' own family. He, too, looked with envy on my frock-coat; on my freedom and my reckless ways. Meeting Stead in London, I sympathised with Richards. Stead, journalist, mystic, reformer, rescuer of fallen women, imperialist, and goodness knows what else, did not impress me. He had the typical nonconformist presence; the way his hair grew suggested nonconformity, so did the rather obvious piercing eyes. A strong plain man, whose mission was naturally wasted on me.

I was anxious to meet Ricketts and Shannon, of whom Wilde often spoke admiringly; he had shown me the drawings they did for his *A House of Pomegranates*, and Ricketts' lovely cover; and it surprised me to hear of these gifted men, of whom we knew nothing in Paris; so I went to the Vale one evening with Oscar.[1] I fell at once under their charm, and hoped, when settled in London, to see more of them and their work. They spoke to me of Beardsley, who, earlier that year, had called on me in Paris.[2] He had lately sprung into fame through an article by Pennell in a new periodical—*The Studio*. He had seemed interested in my paintings in Paris, and welcomed me warmly when I went to see him.[3]

Beardsley was living in Cambridge Terrace, Pimlico, with his

mother and his sister Mabel. The walls of his rooms were distempered a violent orange, the doors and skirtings were painted black; a strange taste, I thought; but his taste was all for the bizarre and exotic. Later it became somewhat chastened. I had picked up a Japanese book in Paris, with pictures so outrageous that its possession was an embarrassment. It pleased Beardsley, however, so I gave it him. The next time I went to see him, he had taken out the most indecent prints from the book and hung them around his bedroom. Seeing he lived with his mother and sister, I was rather taken aback. He affected cynicism, however, which was startling at times; he *spoke* enormities; *mots* were the mode, and provided they were sufficiently witty, anything might be said. Did not someone say of Aubrey that even his lungs were affected? It was a time when everyone, in the wake of Whistler, wanted to take out a patent for brilliant sayings. Referring to my bad memory, Beardsley remarked, 'It doesn't matter what good things one says in front of Billy, he's sure to forget them.'

Beardsley was an impassioned worker, and his hand was unerringly skilful. But for all his craftmanship there was something hard and insensitive in his line, and narrow and small in his design, which affected me unsympathetically. He, too, remarkable boy as he was, had something harsh, too sharply defined in his nature—like something seen under an arc-lamp. His understanding was remarkable; his mind was agate-like, almost too polished, in its sparkling hardness; but there was that in his nature which made him an affectionate and generous friend. Max Beerbohm, in the sympathetic and discerning study he wrote on Beardsley after his death, said no one ever saw Beardsley at work.[4] I could not quite understand this, as Beardsley pressed me, whenever I came to town, to make use of his workroom. Before going to Oxford and while I was mainly there, I was glad enough to have somewhere to work when in town. Beardsley seemed to get on perfectly well as he sat at one side of a large table, while I sat at the other. He was then beginning his *Salome* drawings. He would indicate his preparatory design in pencil, contriving his complicated patterns with only the vaguest pencil indication, over which he drew with the pen with astonishing certainty. He would talk and work at the same time, for, like all gifted people, he had exceptional powers of concentration.

When I had sufficiently practised drawing on stone at Way's I proceeded to Oxford, to begin work on the portraits for Lane. I

must have appeared a strange apparition in Oxford, with my longish hair, and spectacles, and my un-Oxonian ways and approach to things and people. Moreover, I was supposed to be an Impressionist, a terrible reputation to have at the time.

MacColl had given me a letter to Walter Pater. Pater's appearance was unexpected; always correctly dressed in black morning coat; slightly stooping shoulders; a thick moustache, above rather heavy lips; grey eyes a shade too close together, a little restless, even evasive, under dark eyebrows. He had a habit, disquieting to young people, of assuming ignorance on subjects about which he was perfectly informed. He questioned me closely about Mallarmé and Verlaine, Huysmans and de Goncourt, and the younger French writers. Guarded in his talk, careful of expressing his own opinions, he was adept at inviting indiscretions from his guests. I naturally wanted to hear his own views on things and people, but young men cannot decently ask older men what they think of their contemporaries. He asked much about Whistler, for whom he had no great admiration. I did try one day to get his opinion of Oscar Wilde, who regarded Pater as his master. 'Oh Wilde, yes, he always has a phrase.' I told this afterwards to Oscar, who affected to be delighted. 'A perfect thing to have said of one,' he murmured, *'he always has a phrase.'* Just as certain intellectuals affect a passion for detective stories, so Pater made a practice of entertaining the football- and cricket-playing undergraduates, while he ignored the young *précieux.* He gave regular luncheon parties on Wednesdays; each time I was invited, I met tongue-tied, simple, good-looking youths of the sporting fraternity. But Pater's inseparable companion, Bussell, was always of the party, to share Pater's slightly malicious enjoyment.

York Powell was not only a generous host, but he took endless trouble to guide me in the choice of likely subjects for my book; and to persuade these subjects to sit. One of my first sitters was old Sir Henry Acland, who had been the intimate friend of Ruskin. I fear I at once shocked him by beginning my drawing without pinning down my paper; every artist for whom he had sat had always stretched or pinned down his paper. It was my misfortune at this time to draw many people who, like Sir Henry Acland, had in their younger days sat to George Richmond. Richmond's portraits were extremely capable, and showed a high finish, which delighted his sitters. So, all at once, my task was fertile with surprises and

troubles. But with the hopefulness and cocksureness of youth, I foresaw them not, but plunged gaily into my task.

The first drawing I did of Sir Henry Acland was a feeble one, which both he and his daughter, quite properly, disliked. I should never have had it put down on the stone. Like many young men, I was conceited and thought that any objection to a drawing was a proof of its worth. I respected Sir Henry's taste for Ruskin's drawings, but his bias against anything new doubtless encouraged me to believe that his judgement of a contemporary drawing was unreliable. I myself had misgivings about the drawing; and Sir Henry's opinion, whether reliable or not, was far-reaching, for there came a letter from Elkin Mathews telling me that the publication had failed largely on account of the antipathy of Sir Henry Acland and his friends to the portrait of Sir Henry in Part I, and the booksellers were rebelling against taking the second and future parts.[5] After the first drawing appeared, Sir Henry Acland sent me a courteous letter, with a view to my doing another: 'I happened to mention to you my valued friend Mr George Richmond the Academician, last night. Should you care (though it is a delicate task for me to suggest it) to look at his sketch [of] a few years ago, I can show it you: both original and engraving. There is often with every artist a view of style and subject—and it is interesting often to compare the ideas. Then Mr Richmond sketched with deliberate care. I have several of his drawings which I should be delighted to show you.'[6] I knew it was hopeless for me to attempt a drawing comparable with George Richmond's; alas, I did not sketch with deliberate care, but I was willing to try again; fortunately my second attempt was more adequate.

After Acland came Robinson Ellis, a character, but not handsome like Acland. The eminent Catullus scholar wrote agonised letters to Joseph Wells and York Powell. To Powell he wrote: 'Rothenstein's "character sketch" of me seemed to me yesterday so remarkably hideous that I should be very unwilling to let it appear. He said he would show it to you, and I feel assured you would agree with me. Will you let him know unmistakably that *it must not appear*. I might be a Calmuck Tartar or a Mongol of an unusually horrid type.'[7] Both Powell and Wells reassured him; then came the following letter: 'I suppose it may be that I for the first time saw my true self, and comparing it with previous photographs, and with Mr J. Hood's picture, felt annoyed at coming out so dreadfully ugly. For

that, I think you cannot deny it is, and in a great degree.'[8] Of course I was ready to try again, and Ellis was equally willing to sit. The second attempt, as with the drawing of Acland, was more satisfactory, both to my sitter and myself. Nevertheless, Ellis took a morbid delight in praising, among my drawings of other people, the ugliest ones—more especially because of the accurate likeness.

An eminent Victorian, to whom York Powell introduced me, was Burdon-Sanderson, remarkable-looking, tall and gaunt, with features strangely like Dante's. Before luncheon he took me round his garden, in which I noticed he kept rabbits. I was rather touched at this gloomy, sardonic, old man keeping pets. At Christ Church, during dinner at the High Table, I remarked on this charming trait, upon which the whole company burst into laughter. Only then I discovered that Burdon-Sanderson was a famous vivisectionist!

I was particularly amused at my reception by Max Müller. Before I drew him, he went upstairs and fetched an illustrated paper with a tailor's advertisement showing him dressed in a very smart frock-coat. This, he observed, was how he wished to be drawn! It seems incredible; but unless I dreamt this it was so. The drawing done, he took me downstairs to show me a large cabinet full of photographs, all of himself, and all ready signed, with quotations from favourite poets inscribed on each. He solemnly presented me with one. Was this too a dream? And did I also dream of a life-size full-length photograph of the German Emperor hanging on the wall?

I insisted, much against John Lane's wishes, on including a few portraits of undergraduates among those of the dons, arguing that, in a record of contemporary Oxford, undergraduates should have a place. So I drew C. B. Fry, the greatest all-round athlete of the time; W. A. L. Fletcher, the leading oarsman; Hilaire Belloc, and Max Beerbohm. A baby face, with heavily lidded, light grey eyes shaded by remarkably thick and long lashes, a broad forehead, and sleek black hair parted in the middle and coming to a queer curling point at the neck; a quiet and finished manner; rather tall, carefully dressed; slender fingered, with an assurance and experience unusual in one of his years—I was at once drawn to Max Beerbohm and lost no time in responding to an invitation to breakfast. He was living in a tiny house [No. 19] at the far end of Merton Street—a house scarcely bigger than a Punch and Judy show. His room, blue-papered, was hung with Pellegrini prints from *Vanity Fair*. Beside these, there were some amusing caricatures which, he said modestly, were his

own. 'But they are brilliant,' I said, and he seemed pleased at my liking them.

We met frequently. Though we were the same age, and in some ways I had more experience of life than he, his seemed to have crystallised into a more finished form than my own. So had his manners, which were perfect. He was delightfully appreciative of anything he was told, seizing the inner meaning of any rough observation of men and of things, which at once acquired point and polish in contact with his understanding mind. Outside Merton few undergraduates knew him; all who did know him, admired him. His caricatures were sometimes to be seen in Shrimpton's window in the Broad; and in time, through these, he acquired some reputation outside his own small circle; for he was fastidious in the choice of his friends. My Balliol friends scoffed when I spoke of him as the most brilliant man in Oxford.

Max played no games, belonged to no college society, never went to the Union, scarcely even to lectures.[9] While aware of everything that went on in Oxford, he himself kept aloof; going nowhere, he seemed to know about everyone; unusual wisdom and sound judgement he disguised under the harlequin cloak of his wit. He always declared he had read nothing—only [Thackeray's] *The Four Georges* and Lear's *Book of Nonsense*—and, later, Oscar Wilde's *Intentions*, which he thought beautifully written.

He boasted once that he had never worn cap or gown; I swore I would see him in both before he left Oxford; for he spoke of going down without taking his degree. I managed to get hold of a Proctor's notice, had it copied by a London printer, and sent out the copies to Max and a dozen others; they were to present themselves before the Proctor at Balliol College, at 9 o'clock on a certain morning. I took care to be at Balliol betimes, and saw them all arrive in trouble and uncertainty *and*, Max among them, in cap and gown. Then I watched them disappear up the Proctor's staircase. At Christ Church in the evening I found the other Proctor furious over the hoax. I told York Powell about it privately; he was fearful lest my crime be found out, staying as I was with him at the House. He tried to be solemn about it, but I think he was secretly amused. But not a word must I breathe to anyone about the unpardonably wicked thing I had done.

Wilde came regularly to Oxford during the year I spent there. He and Beerbohm Tree were friends, so Max knew him already. Max

the man appreciated to the full Oscar's prose and his talk; he thought him, in his way, a perfect writer; but nothing escaped the clear pitiless grey eye of Max the caricaturist, and Oscar Wilde winced under the stinging discharge of Max's pencil. Pater, Max knew only by sight; he attempted more than once to caricature him, but couldn't hit on a formula. I tried to show him where he had gone wrong, offering to fetch the lithograph I had recently made of Pater; 'No thanks, dear Will; I never work from photographs,' was Max's reply.

I had to go up to London from time to time to take my drawings to Way, and there, meeting Arthur Symons, I told him of Verlaine's readiness to give some readings in England. He too had heard from Verlaine, and was warmly in favour of the project. He promised to make all the arrangements, and to look after Verlaine while he was in London; and would York Powell arrange for a lecture at Oxford?

Verlaine wrote from more than one address. He had been giving conferences in Holland, at Lunéville and other places; but he must still return to the hospital from time to time for treatment. 'Mais ma maladie, grippe, influenza, coqueluche ou le diable! m'a repris de plus belle et suis littéralement sur le flanc.'[10] 'Mon intention est de parler de la Poésie Française en ce moment du siècle (1880–1893) avec beaucoup de citations dont plusieurs de moi,' he writes of his coming conference in London; and again: 'Je compte sortir bientôt mais vous recevrez de moi quelques mots auparavant. En attendant jusqu['] à nouvel ordre—15 jours, 20 jours à peu près.'[11]

A few days later he is back in hospital: 'Veuillez m'indiquer les heures de départ et d'arrivée. Dois-je passer par Londres? Et quand aura lieu la conférence? Les prix des trains et bateaux. Les bénéfices approximatifs à Oxford et Londres?'[12] He was not long detained by the doctors, and reached London safely. Here he stayed with Symons at Fountain Court. He gave two readings in the Hall of Barnard's Inn, which were well attended. I heard from both Arthur Symons and John Lane about the lecture. Lane wrote: 'Verlaine was a great success last night; he, so I learn, leaves Paddington to-morrow morn: for you. He called at the Bodley Head this afternoon—but I was out.'[13] Symons put Verlaine into the train at Paddington. I met him at Oxford station. A strange figure he looked on the platform, as he limped along in a long great-coat, a scarf round his neck, his foot in a cloth shoe. I took him at once to Christ Church, where Powell put him up.

Verlaine gave his lecture in a room at the back of Blackwell's

shop, and read a number of his own poems. As a conference it was a poor affair; he spoke indistinctly in a low, toneless voice; he had brought nothing with him, and he knew but few of his poems by heart; fortunately, York Powell and I between us provided the books, from which he read. There was only a sprinkling of persons present; probably few people in Oxford knew much about the poet or his poetry; but Verlaine was tickled with the idea of having lectured before what he believed to have been an audience of doctors and scholars of the Ancient University of Oxford.[14]

Verlaine was delighted with Oxford—with the beauty of the colleges, with the peace of the quads and gardens. He showed no sign of wanting to leave; he was gay and talkative, and wished to be taken everywhere; but York Powell, admirer of Verlaine though he was, was uneasy lest the poet should get drunk while staying at Christ Church. So far, nothing untoward had happened; but after two or three days, Powell suggested that I should give poor Verlaine a hint that guest-rooms were only to be occupied for a short period at a time. This was not easy, for Verlaine, in spite of a certain childishness, was yet shrewd enough, and surmised that York Powell was nervous; but he by no means wished to leave Oxford. He needed some gentle persuasion before he was helped into the train again for London.

I wanted to include a portrait of Pater in the Oxford set, but he was morbidly self-conscious about his appearance. He had been drawn as a youth [in 1866] by Simeon Solomon, and was reluctant, later in life, to be shown as he then was. Still, he seemed interested in the drawings I was doing and, hesitatingly, suggested I should try Bussell first. Bussell sat and Pater approved of the result. Perhaps Bussell added his persuasion to mine; at any rate he said that Pater was no longer averse to sitting. A drawing was duly made, and sent away to be put down on the stone. When the proofs came I showed one to Pater. He said little, but was obviously displeased; according to Bussell he was more than displeased, he was upset. He had taken the print into Bussell's room, laying it on the table without comment. They then went together for their usual walk; but not a word was spoken. On their return, as Pater left Bussell at his door, he broke silence. 'Bussell, do I look like a Barbary ape?'[15]

Some time afterwards I heard from Tom Way, the printer: 'We had just had a visit from Mr Lane before your note came. He came expressly to say that no more proofs were to be pulled from the

Pater as its exhibition would be equivalent to publication and I understand, Pater has used great threats as to what he will do if it is published. It is very small for these people to go on so, I think.'[16]

I usually found that each of my sitters thought twenty-three of the twenty-four drawings excellent likenesses; the twenty-fourth was his own. Had I paid too much attention to my sitters' feelings, few of my portraits would ever have seen the light. Any record sincerely made from life has a certain value; this, I felt, was my justification.

I hope within the next few months to do some lithographs which will be more interesting than my dull portraits of Oxford people. . . . When I say dull portraits, I mean dull in execution, as my dread of displeasing my sitters has not allowed my pencil to pirouette as freely as I could have wished. (WR to Margaret Woods, December 11 [1893]. RP:HL.)

When the summer term ended I went over to spend some weeks in Paris. William Heinemann, who was preparing an English edition of the de Goncourts' *Journal*, was also going to Paris, and he proposed I should make a portrait of Edmond de Goncourt to be reproduced in the book.[17] I jumped at the chance, not only of drawing him, but, as I hoped, of seeing his treasures. I had read more than one volume of the famous *Journal*, and knew something of the house at Neuilly. Ushered in and led up a staircase hung with precious prints and drawings, I at once received a promise of good things to come. I was shown into Edmond's study, lined with books, where was the white-haired veteran who had known Flaubert, and Gautier and Gavarni—a powerful head, wax-like in its pallor, with two great velvety eyes looking out. He appeared surprised at my youth. When I returned to the house for a first sitting, he was interested at my drawing directly on to the stone. I was the first person he had seen to work in this way since Gavarni died. When later I mentioned Daumier, he was disapproving. 'Ah, fashion,' he said, 'how stupid she is. Gavarni had a hundred times Daumier's talent,' and then, in the same breath, he assailed Villiers de l'Isle-Adam and Barbey d'Aurevilly: 'Oui, c'est la mode aujourd'hui d'admirer tous les morts qui, vivants, n'avaient pas le sou.' When he came to look at my drawing, he did not approve of the hair; to show me how he would like it, he went to the glass, and with his old trembling fingers carefully untidied it.

That Whistler was a great artist he was unwilling to hear. 'Il m'ennuie, c'est un farceur.' With Degas he was annoyed, because Degas had told him that modern writers got their inspiration from painters. He had replied that in *Manette Salomon*, before Degas had begun to paint in his present manner, he and his brother had written that ballet girls and laundresses were subjects made to an artist's hand. 'Degas is too clever,' he said, 'and is sometimes scored off. For instance the other day, at Alphonse Daudet's, he remarked that our writing was twaddle, that the only man of real talent among us was le père Dumas. To which Daudet: "Yes, my dear Degas, and the only modern artist of genius was Horace Vernet."'

De Goncourt gave me a letter to Zola, whose portrait was also to appear in the English edition of the de Goncourts' *Journal*. Zola's manner was not at all amiable, in fact rather sulky. I suspected that there was little love lost between him and Daudet and de Goncourt. Perhaps it was because I had come from Edmond de Goncourt that Zola was not very cordial. Zola wore a kind of monk's habit; he was writing his book on Lourdes, and getting himself into the right frame of mind though not knowing this at the time, such a costume on Zola was somewhat startling.[18] He was not in a mood for talking. I had my drawing to make, and as this was the only occasion on which I was with him, my impression of his character was of course superficial.

I had not forgotten Verlaine. Verlaine's room looked more forlorn still after Zola's palatial *hôtel*; and he was, as usual, *dans la dèche*: 'Voudrez-vous et pourrez-vous contribuer *un peu* aux frais de nos frugales orgies pour ce déjeuner-là et m'apporter le *Figaro* avec son supplément.'[19] Verlaine was not well enough to come out to meals, so of course, since he often asked me to join him and Eugénie at lunch or dinner, I usually procured some addition to their larder from the restaurant below. But Verlaine must indeed have been poor to have asked for the *Figaro*; and lately he had been in hospital again, this time at the Hôpital St Louis, where he had had to pay for his keep. 'Mon cher ami,' he wrote. 'Que devenez-vouz? Moi toujours ici. Mieux, mais que lent à redresser, ce pied qui n'en veut pas finir! Et 6 francs par jour! ... Aussi serais-je bien reconnaissant à vous si pouviez activer auprès du Fortnightly l'avance ou le solde qui me ferait tant de bien.'[20]

Then again complaints about the *Fortnightly*: 'J'ai tant besoin de cette galette! Il y a aussi des vers dans l'*Athenaeum* dont j'attends

de vagues argents. Pour ce voir Gosse à qui j'ai écrit sans encore de réponse.'[21]

'J'ai tant besoin de cette galette'—not he alone, for his needs were few; but Eugénie was greedy, and there was someone else, too. For, soon after, I heard from him again: 'J'ai une rechute de mon mal, ... J'ai déménagé et même *divorcé*. Ecrivez moi rue St Jacques 187 et veuillez m'y envoyer 2 ou 3 exemplaires du Pall Mall Budget où est mon portrait par vous. *Surtout n'envoyez rien rue Broca*.'[22]

The last sentence is significant. When I saw him again he said he had got rid of 'l'harlot'. But soon after the Krantz was sharing his new room in the rue St Jacques, and Verlaine wrote: 'Notre ménage est dans la joie. Nous allons avoir des petits ... canaris—et nous nous sommes enrichis d'un "aquarium" avec deux cyprins dedans.'[23]

Chapter 4

CHELSEA IN THE 'NINETIES

WHISTLER had said 'of course you will settle in Chelsea'. The men who counted most for me lived there—Sickert, Steer, Ricketts and Shannon. The name itself, soft and creamy, suggested the eighteenth century, Whistler's early etchings, Cremorne, old courts and rag-shops.

> *And I (how glad he is to get into the first person, say you?) am again at work, after having spent many delightful hours with the Wild Oscar, who lives in a lovely white house in Chelsea, white within and black without, like his own soul. And I met Dorian Gray, walking the streets under the name of John Gray, and Ricketts and Shannon, most delightful of painters, living in Whistler's old house in Chelsea—pale lemon and yellow.[1] (WR to Conder, January 19, 1891. Boston Public Library.)*

Walter Sickert too lived in the Vale, in a house belonging to William De Morgan, with a studio full of Mrs De Morgan's paintings. For this reason perhaps Sickert preferred painting elsewhere. He had a small room where he worked, at the end—the shabby end—of the Chelsea Embankment, west of Beaufort Street. Needless to say, this room was in one of the few ugly houses to be found along Cheyne Walk. His taste for the dingy lodging-house atmosphere was as new to me as was Ricketts' and Shannon's Florentine aura. I had known many poor studies in Paris, but Walter Sickert's genius for discovering the dreariest house and most forbidding rooms in which to work was a source of wonder and amusement to me. He himself was so fastidious in his person, in his manners, in the choice of his clothes; was he affecting a kind of dandyism *à rebours?* As a talker he could hold his own with either Whistler or Wilde. Further, he seemed to be on easy and familiar terms with the chief social, intellectual and political figures of the time; yet he preferred the exhausted air of the music-hall, the sanded floor of the public-house,

and the ways and talk of cockney girls who sat to him, to the comfort of the clubs, or the sparkling conversation (for so I imagined it) of the drawing rooms of Mayfair and Park Lane. An aristocrat by nature, he had cultivated a strange taste for life below stairs. High lights below Steers, I used to say, in reference to this predilection, and to his habit of painting in low tones. Every man to his taste, I thought; but had I a tittle of your charm, your finished manners, your wit and good looks, I should not be painting in a dusty room in the squalidest corner of Chelsea. Nor, for that matter, should I be laboriously matching the dingy tones of women lying on unwashed sheets, upon cast-iron bedsteads.[2] And there were other things in Walter's pictures that puzzled me. He himself told how Menpes, looking at one of his canvases, praising it to the skies— 'Lovely colour, my dear Walter, beautiful tone, exquisite drawing, but—could you—not that it isn't perfect as it is—could you manage just to coax—the *one* eye is capital—to coax that other eye into the face?' And Walter would go off into a peal of laughter.

Whistler would, on occasion, make use of Sickert's studio. Indeed, one day, seeing a half-finished canvas on the easel, he began working on it, and getting interested, he finished the canvas, carried it off, and sold it as a work of his own.[3] But a coolness was already beginning between them at this time, while Sickert was asserting himself more and more as an independent painter.

Steer and Sickert, though not so closely allied as Ricketts and Shannon, were associated together as leaders of the English Impressionists. There was also a similar contrast between the two— Steer had affinities with Shannon, Sickert with Ricketts. An instinctive artist, with a faultless sense of colour, Steer had the conservative instincts and prejudices of the middle-class Englishman. Had he been a politician, he would have voted against the Reform Bill, against the abolition of the army purchase system, against the entry of Jews and Roman Catholics into the House of Commons. Why change? he would have said; change only means bother, and England is all right as she is. The first literary criticism I heard from him was that he didn't see why anyone need write poetry now; wasn't Byron good enough? He preferred painting to poetry, of course; but here his insularity broke down. He placed Monet and Degas beside Turner and Constable, and he particularly relished French eighteenth-century engravings. He respected Whistler's painting; but he couldn't understand why, if a man could paint like Whistler, he

should want to write letters and make things uncomfortable. Steer was all for a quiet life. He was in constant dread of colds; they were certainly disturbing. So even in the height of summer he wore a heavy overcoat, and a yachting cap, and his footwear resembled a policeman's. His studio was filled with pictures; he had scarcely sold anything, he said, for seven years.[4] They were mostly paintings of yachts and the sea, and of girls paddling, girls with red hair and long, slender legs, like Sheraton tables. He was fond of painting pretty girls; he liked them young, and had a shrewd eye for any who would make good models. His habits were simple. He was extremely matter of fact; in life, for him, there was little romance. Without a brush in his hands, he was indifferent to most things save dry feet and freedom from draughts. If he had any passion it was for Chelsea figures. I used to say that he had the best bad taste of anyone I knew. A revolutionary painter, he hated change. He was content to meet the same people every day. He liked, too, to hear the same jokes; with a little gossip, a naughty story or two, the evenings passed pleasantly. Sickert and George Moore, Tonks and [Laurence] Harrison, MacColl, Frederick Brown, Sargent and myself formed his regular circle. He was modest about his achievements. He used to say, when we praised his work, that if he got a kind of quality it was because he couldn't draw or paint with any certainty, as Sargent could, for instance; he could only get something done by muddling about and repainting. In Steer there was a stolid unimaginativeness, combined with an intuitive rightness of judgement, peculiar to a certain type of Englishman. For English he was to the core; neither Scotch, Irish nor Welsh. He was like a piece of Staffordshire ware in a collection of Sèvres china—a little absurd, a little crude, but there is something ampler and saner and more poetical in this rather naïve English piece, than in the refinement and finish of the more expensive ware. His painting, like himself, was unintellectual but intuitively right. I thought him easily the most interesting of the English realistic painters, though in the early 'nineties his painting seemed to me a little loose. But then loose painting was admired. MacColl was its prophet, and for him the looser the nearer to excellence.

MacColl was the Ruskin of the Impressionists, and like Ruskin, he was a sensitive draughtsman. His belief was in the survival of the commencement; woe to anyone who, like myself, strove to carry painting and drawing beyond this. Whistler and Degas among the

older, and Conder and Steer among the younger men, were Mac-Coll's idols.

I had met Furse in Paris, where we had been to the Louvre together and made friends. He proved a helpful and hospitable neighbour; he liked people to come in while he was painting, to discuss his work, and to make suggestions; and while he was painting his talk boiled over into politics, military tactics and literature.⁵ So his studio was usually full of generals, admirals, distinguished and admiring ladies, painters and poets; while he strode up and down, working away with huge brushes and boisterous energy. At his studio I first met Laurence Binyon—Furse flung at us, 'Binyon! Rothenstein! don't you know one another? Two decadents!' For Furse, with his high spirits and genial faith in his artistic and social security, behaved like a kind of elder brother to us all, though he was but four years my senior, and was considerably younger than Sickert and Steer. Had he lived, he would have been President of the Royal Academy.*

*When Charles Furse was made an Associate of the Royal Academy in 1904, he told Rothenstein that although he received '200 letters to answer, my most immediate pals preserved a discreet silence with the exception of [yourself and] the majestic Tonks. Stern and unbending but withal kind, he condoled with me any loss of artistic caste—gaunt and ascetic, moving in the rare air of high Sierras he was pained to see me slithering into a fat valley, beguiled by the fleshpots of the vulgar. But he never descended to undignified remonstrance—hoped I should be happy and enjoy the high living, hoped that it would not immediately lead to fatty degeneration of my Art, thought that there need not necessarily be a cleavage in our friendship, prayed that if I still climbed into the snows in Spring and Autumn my works would be good enough to admit me to the select circle of those whose feet had never strayed from the narrow mountain path. The whole of it from first to last calm and largely tolerant so that I went to bed with that terrible conviction of Sin, which the pious tell one is the threshold of a better life—all night I tossed and wondered by what mortification of the Flesh I could so refine my mind that it would invent those serene idylls which he has made so dear to us—Isabellas with marked fatuity of gesture ... But I woke after all the same coarse but appreciative Beast that I have ever been.' ([1904] RP:HL.)

Katherine Furse wrote to Rothenstein: 'I suppose we shall have to go round calling on R. A.'s. What a farce it is. I love the way people one meets seem suddenly to realise that Charles paints and look at me in a benign way, seeming to sympathise so kindly in our great success. And what does it all matter. I suppose to put an R. A. after your name means a more certain income and *nothing* else. Some day it may mean putting an R. A. after a good many other people's names—here is its importance. I do hope Charles may get a chance of improving things a little. It sounds conceited to talk of an old institution in this flippant way! But much might be done and the old ones are getting very old and the world is getting impatient and all this points to a revolution. In the meantime great tact will be needed and I wonder whether it will be found—my only job is once to be polite to the wives [of the] R. A. and then I shall have done. A hansom for one afternoon ought to accomplish this

But in those early Chelsea days I was especially attracted by Ricketts and Shannon—they were so different from any artists I had met hitherto. Everything about them was refined and austere. Ricketts, with his pale, delicate features, fair hair and pointed gold-red beard, looked like a Clouet drawing. Half French, he had the quick mind and the rapid speech of a southerner. He was a fascinating talker. His knowledge of pictures and galleries astonished me; he had been nowhere except to the Louvre, yet he seemed to know everything, to have been everywhere. And he knew the names of rare flowers, of shells and of precious stones.

Shannon was as quiet and inarticulate as Ricketts was restless and eloquent. He had a ruddy boyish face, like a countryman's, with blue eyes and fair lashes; he reminded me of the shepherd in Rossetti's *Found*. Oscar Wilde said Ricketts was like an orchid, and Shannon like a marigold. Ricketts, in giving his opinions, always said 'we.' The partnership seemed perfect; there was never a sign of difference or discord; each set off the other, in looks as in mind. They knew few people, and prided themselves on going nowhere: their few intimates came to see them, usually on Friday evenings. Oscar Wilde often came to the Vale; he was devoted to both, and at his best in their company; and but for Beardsley's *Salome* [drawings], they alone illustrated his books. I wondered whether he knew how gross, how soiled by the world, he appeared, sitting in one of the white scrubbed kitchen chairs next to Ricketts and Shannon and Sturge Moore.[6] And sometimes Sickert came over; he too at his best, irresistibly witty and captivating in his talk, and appreciative of both our hosts.

We all admired Shannon's lithographs, which seemed to me the loveliest things being done at the time. Both he and Ricketts were then busy cutting wood-blocks for their edition of *Daphnis and Chloe*, working late into the night, and rising late in the day.[7]

and then I shall get back to my own workshop and say "not at home".' ([1904]. RP:HL.)

Another letter from Charles Furse hints at the kind of President he might have been: 'Should you come to any conclusion among yourselves [in the New English Art Club] of a possible policy I would of course be most heartily with you, but as you know I should advocate the most conciliatory and courteous approach to the R. A. Our position will be twice as strong if we formulate our desires with no amplification of personal attack on the R. A.'s. The danger always seems to me that an air of unforgivable superiority may insert itself into a document of this kind and utterly destroy all chance of friendly and reasonable discussion.' (N. d. RP:HL.)

Bending over their blocks they looked like figures from a missal. I had not come into touch with the Morris movement, and this craftsman side was new to me. I was therefore the more impressed by their skill and patience. From them I heard countless stories of Rossetti, of Burne-Jones, Holman Hunt, Millais and Madox Brown; in fact, at the time, I thought they would carry on the Pre-Raphaelite tradition. But their admiration for the Pre-Raphaelites was tempered, on Shannon's part by admiration for Watts and Puvis, on Ricketts' part by his predilection for Delacroix and Gustav Moreau—Moreau, of whom Degas remarked 'celui qui peint des lions avec des chaînes de montre'. I revered these two men, for their simple and austere ways, their fine taste and fine manners. They seemed to stand apart from other artists of the time; and I was proud of their friendship, so rarely offered, and of the encouragement they gave to my work.

Fry at this time was living with Robert Trevelyan in Beaufort Street. There was then little to indicate the road he took later. He was still much as he was when he first came to Paris—shy, rather afraid of life, painting in the manner of the early English water-colour painters. He, too, sat at Ricketts' feet, though he was never admitted to the inner circle of the faithful, to which Sturge Moore and the others belonged. Fry was a scholarly writer, and was beginning to follow in MacColl's footsteps as an art critic. He was then, and for many years afterwards, a staunch supporter of my work, both in private and in the press.[8]

After spending some weeks in [George Percy] Jacomb-Hood's house, I found a studio with a couple of rooms in Glebe Place. One of my first sitters was Jan Toorop, the Dutch Symbolist. I painted a one-sitting study—a small canvas later acquired by the Tate Gallery. In those days, indeed, I did each part of my painting in a single sitting; not because of any theory I had, but for the reason that I did not know how to repaint. I sometimes regret that later the habit of repainting grew upon me. I remember Sickert saying that, with Whistler, repainting was like trying to say the Lord's Prayer in a shorter time than was possible—as though one would at first get as far as 'Thy will be ...', at the next time would manage 'on earth as ...', and so on; but never have the time to achieve the whole prayer. For some time, however, I remained under Whistler's influence. To Whistler any roughness of pigment was abhorrent; he habitually scraped down his canvases after each day's painting. But he was

careful to place his model far back in the studio, well out of the range of direct light, so that he need not render the full strength of colour and light. He was doubtless wise to limit himself in this way; but like others in need of defence, he thought the best way of defending himself was to attack; so he was unjust, at least when I knew him, to many of the French painters, who loved sunlight and full colour.

Another portrait I painted was of Cunninghame Graham in fencing dress.[9] Graham was one of the most picturesque and picaresque figures of the day. He had a witty and caustic tongue, told the best Scotch stories I had ever heard, wrote, fenced, and rode a frisky horse with a long tail, all in an equally gallant manner. I liked to see him putting his fingers through his long, thick, golden-red hair, making it stand high above his fine, narrow, aristocratic forehead. Twirling his moustaches, and holding his handsome person proudly erect, he would stride into the room with the swagger of a gaucho, and the elegance of a swordsman. He insisted on taking me, graceless as I was, to Angelo's, then in St James's Street, that I too might learn to fence. Whether I acquired any grace from the lessons I doubt; but I enjoyed the strenuous exercise, and the Regency atmosphere of Angelo's; while Max and Beardsley, who used sometimes to join me there, looked on, fascinated by the survival of this classic establishment; now, alas, a memory only! I often think now how Beardsley must have envied us, who were so robust and full of life. He must have known how slender were his own chances of living; yet he showed no sign. The two earliest letters he wrote me, in 1893, both refer to illness, and to difficulties with Lane, which I shared.[10]

Wilde admired, though he didn't really like, Beardsley's *Salome* illustrations; he thought them too Japanese, as indeed they were. His play was Byzantine. When he gave me a copy on its first publication in its violet paper cover, he knew at once that it put me in mind of Flaubert. He admitted he had not been able to resist the theft. 'Remember,' he said with amusing unction, 'dans la littérature il faut toujours tuer son père.' But I didn't think he had killed Flaubert; nor did he, I believe.

I fancy Beardsley was relieved to get his *Salome* drawings done. The inspiration of Morris and Burne-Jones was waning fast, and the eighteenth-century illustrators were taking the place of the Japanese print. Conder, and also Sickert I think, influenced Beardsley just at

this time. Ross told me that in his introduction to *Volpone*, after Beardsley's death, he had written of Beardsley's debt to Conder and myself, but Smithers obliged him to take the passage out.[11] I remember Conder and myself chaffing Beardsley about the influence of Morris and Burne-Jones on his work, and Beardsley saying that while Burne-Jones was too remote from life he was inimitable as a designer. 'Imitable Aubrey!' I agreed, 'imitable surely?' a jest that delighted Aubrey.

One of Beardsley's most ardent supporters was Robert Ross. Oscar Wilde was never wittier than when at Ross's parties; the same was true of Aubrey Beardsley and Max Beerbohm. Ross was a member of the Hogarth Club. On one occasion he had been entertaining a party, one of which was Oscar Wilde. After dinner we adjourned to the Hogarth Club. As we entered the room, an old member of the Club, ostentatiously staring at Wilde, rose from his chair and made for the door. One or two other members also got up. Everyone felt uncomfortable. Wilde, aware of what was happening, strode up to the member who was about to leave, and haughtily exclaimed: 'How dare you insult a member of your own club? I am Mr Ross's guest, an insult to me is an insult to him. I insist upon your apologizing to Mr Ross.' The member addressed had nothing to do but to pretend very lamely that no insult had been intended, and he and the others returned to their seats. I thought this showed great pluck on Oscar's part.

Sargent I met soon after I settled in Chelsea. Reticent, yet cordial, there could be none of the easy familiarity with Sargent, which existed between Steer, Sickert, Tonks, Furse and myself, although there was nothing superior about him. Like Henry James, he had the English correctness of most Europeanised Americans, which brought a certain *je ne sais quoi* of self-consciousness into his relations with his friends. We all acknowledged his immense accomplishment as a painter to be far beyond anything of which we were capable. But the disparity between his gifts and our own we were inclined to discount, by thinking that we had qualities that somehow placed us among the essential artists, while he, in spite of his great gifts, remained outside the charmed circle. I was used to hearing both Whistler and Degas speak disparagingly of Sargent's work; even Helleu, Boldini and Gandara regarded him more as a brilliant executant than as an artist of high rank.

Sargent must have given me some advice about portrait painting,

for I find in a letter from him the following: 'Hood told me that he had told you certain views of mine about the dangers of going in for portraits—I hope you did not think me impertinent.'[12] Sargent at once saw that I was insufficiently trained; he thought he could help me, and proposed I should join him to paint a nude in his studio. I was glad enough of the chance to see Sargent at work, and to benefit by his counsel; but although the nude I painted was thoroughly bad, and Sargent's was a marvel of constructive skill, I tried to believe, despite this clear evidence, that there was something vaguely superior in my temperamental equipment. Sargent's reticence prevented his telling me how bad my painting was, and I was too stupid and conceited to see that here was a chance of acquiring the constructive practice I lacked, and above all, a scientific method of work.

I was touched by Sargent's generous enthusiasm for Manet and Monet, for Rodin and Whistler; for, as I said, I had heard Degas and Whistler speak disparagingly of Sargent, as a skilful portrait painter who differed little from the better Salon painters then in fashion. With the exception of Rodin, I never heard anyone in Paris acknowledge the worth of Sargent's performance. On the other hand, at the Royal Academy where, having settled in England, he exhibited regularly, Sargent appeared as a daring innovator. Although he had as many commissions as he could execute, they came chiefly from Americans. In London his warmest admirers were the wealthy Jews. But it would be a mistake to suppose that Sargent preferred the aristocratic to the Jewish type, that he painted Jews because they happened to be his chief clients. On the contrary, he admired, and thoroughly enjoyed painting, the energetic features of the men, and the exotic beauty of the women of Semitic race. He urged me to paint Jews, as being at once the most interesting models and the most reliable patrons. Oddly enough, when later I was painting Jews in the East End, he thought I was aiming at too abstract a representation, and wanted me to paint scenes in Petticoat Lane, or the interiors of tailors' shops, as showing the more intimate side of Jewish life.[13] Yet it was just this lack of intimacy that I missed in his portraits. But then Sargent himself had little of this intimacy in his own life. His studio was that of a cultivated cosmopolitan, filled with French, Italian and Spanish furniture and bric-à-brac; he could scarcely be expected to paint people in the middle-class interiors in which Degas, Fantin-Latour and Cézanne saw their sitters. But

herein Sargent was true, and wisely true, to himself. On the other hand, when he gave up portrait painting to devote himself solely to his Boston decorations, he showed unworldliness and a touching desire to escape from the slavery of the model-stand; but his short-comings were at once revealed. The American element in his nature asserted itself; he approached the scene of the Divine Comedy not with the great Mantuan, not with the noble Giotto, nor yet with the passionate El Greco, but with Edwin Abbey by his side.[14]

I had not been long in Chelsea when I made friends with a cultured picture-dealer named van Wisselingh. He generously offered me the use of his gallery [the Dutch Gallery, in Brook Street]; I talked the matter over at the Vale, and Shannon agreed to join me in a small exhibition of prints and drawings. His prints and drawings found many purchasers. I too, on this occasion, sold some of my drawings, including a pastel of a beautiful girl whom I had met at the Vale, whom Shannon had drawn more than once. At the Vale she was called Amaryllis; she looked like a 'Rossetti', had rich auburn hair, and a heart of gold. Shortly afterwards I heard that the purchaser of this pastel had bought my painting of Conder as well, at the New English Art Club, and Francis Bate, then, and for long afterwards, acting as honorary secretary to the club, wrote that the purchaser wished to make my acquaintance. His name was Llewellyn Hacon, a widower, a conveyancer by profession; I met him first at his club, and found him a typical clubman; a man of the world, well read and informed on a variety of subjects, with that special knowledge of the secrets of notables, past and present, which men of his character possess.[15] His friends were mostly clubmen like himself: good-living, easy-going, slightly cynical, prosperous men. Hacon, stout, ruddy and clean-shaved, looked the picture of a seventeenth-century country gentleman; he might have walked out of one of Congreve's or Wycherley's comedies. He proposed I should paint his portrait; he would take a house in the Isle of Wight, hire a yacht to do some 'mud-dodging', and any other work I might do there he would take off my hands.[16] This all seemed too good to be true; but true, at least for a time, it was. A house was hired at Yarmouth, where Hacon's butler and a manservant looked after us.

Hacon seemed to enjoy sitting, and there was the yacht, with a skipper and a couple of handy men, in which we sailed round the island. I enjoyed the sight of the proud yachts, leaning over at dangerous angles as they cut through the waters of the Solent, and

the sensation of steering the sensitive and responsive organism that I discovered a yacht to be.

I am in great luck, for the kind uncle of my kind friend has lent him a yacht for the summer, an ideal thing to have. She is, I assure you, a most splendid craft. Not so splendid as all that, and rather small, you say? ... let me tell you that she requires two men (besides ourselves) to manage her: one of them, the Captain, wears golden buttons to distinguish him from the other, the crew, who doesn't. They have, I am bound to say, but little respect for me, as my knowledge of sailing winds is limited, and they behave like dastardly cowards whenever I take the helm. I think it absurd to be so afraid of Death. My friend Hacon seems to get along splendidly with them—he has an irritating way of talking about the jib, and the stern sheet and the spinnaker, which seems to interest them very much. I suspect him of studying a nautical dictionary all night. ... As for entertainment, the town [Yarmouth] affords none, unless it be, perhaps myself, if I may judge from the crowd around me when at work. (WR to Margaret Woods, August 1 [1894]. RP:HL.)

Hacon's portrait finished, we returned to town, where I introduced him to Conder, and to Ricketts and Shannon. Hacon had generously offered to finance me—taking so many pictures and drawings each year. With a yearly allowance of £100 from my father, and with the confidence of youth, I declined. But knowing Ricketts to be eager to design type and to embark on book production, I urged Hacon to finance this promising adventure instead. This he was ready to do, and again a new interest came into his life.[17]

I soon ceased to regret Paris. While I lived in France, I believed life to be freer and more quickening than elsewhere. But I soon came to think, in spite of Whistler's jibes (he asked me if it was true that I was to become a naturalised English artist), that English social life was the flower of European civilisation.

London is like a garden of tulips just now. There seems to be a sort of madness on the town, and all the women seem struggling to hide their faces, their characters, their everything, under a mass of éclatant silks and ribbons and artificial flowers—splendid with bad taste. The private views are like race meetings—I don't know what the race meetings are like, for I daren't for the life of me go to one. (WR to Margaret Woods [June 1894]. RP:HL.)

People who have never known the quality of the Victorian

atmosphere may be excused an ill-informed attitude towards it. Sir Henry Taylor had been associated with the most eminent men of his time, and the daughters were a mine of information about the Gladstonian period. They were both ardent Home-Rulers. John Redmond was one of their intimates. And the example of finely-bred women caring less for their private privileges than for public causes, was not then so familiar to me as it afterwards became. No wonder many delightful people came to their little house in Montpelier Square. There I first met Watts. He was then a very old man, very gentle, obviously delicate in health, but of serene and dignified aspect. He wore a black velvet skull-cap and a fine cambric shirt, with delicate wristbands setting off beautiful, old, veined hands. When I spoke with admiration of one of his latest exhibited pictures —a great oak tree strangled by ivy—he said hesitatingly that he had something in his mind at the time which inspired it, though he scarcely liked to speak of this to me—the undisciplined art of the day slowly sapping the life of a centuries-old artistic inheritance.[18] In the presence of a man of Watts' character and achievement, I realised how trivial our painting must appear in his eyes; and how misguided our lives. Watts and the Pre-Raphaelites are now held in small esteem; but they are still with us, to be assailed. How many of us now painting will survive to meet with similar treatment by a succeeding generation?

Watts' didactic comment had some point: compared with the giants then still alive, Watts and Whistler, Burne-Jones and Ruskin, William Morris, Meredith, Hardy and Swinburne, we were little men. Consider the achievements of these others, and their relation to the great social and aesthetic movements of their time. A generation which knew these veterans was reluctant to accept Oscar Wilde, Sickert, Beardsley, George Moore and [Hubert] Crackanthorpe as their successors.

There was one writer, however, who stood apart from the aesthetic school, and who, if he looked abroad, looked rather to Norway than to France. Bernard Shaw I had met soon after I settled in Chelsea. He was then chiefly known as a journalist, at this time writing musical criticism for *The World*, and as a Fabian closely associated with Sidney Webb. Already he had ardent admirers, and ardent detractors. Roger Fry likened him to Christ. I could not see the resemblance; but I admired Shaw for one thing especially—he did not wait until he was famous to behave like a great man. In fact,

he had early singled himself out from among his fellows as a re-
markable character. He had all the ease and assurance, the endearing
right-headedness and wrong-headedness, the over-weening out-
spokenness, that English society recognises so generously, now that
the whole world has acclaimed him. But he worked long and hard
to be accepted in the position he so candidly assumed. He declared
that he missed no opportunity of attending meetings and speaking
in opposition to other speakers, no matter how little he knew of
their subjects. Thus, by these mental gymnastics, he exercised his
natural gift of speech, and his mental alertness.

[Frank] Harris was a good talker, though as a talker he played
what Wilde called 'the Rugby game'. He had a rich, deep voice,
which rose and swelled like an organ as he charged into the conver-
sation. With ample means, he was able to become a patron of art and
literature. Alas! our patrons in those days were not reliable supports.
English dealers sold only on commission; so that until something
was bought the artist got nothing. I remember Sickert telling how,
when he was unusually hard up, he took a trunkful of his canvases
over to Paris. To impress the dealers, he took a room in a good hotel,
which, before he had disposed of something, he could ill afford. He
was long in finding a purchaser, and directly he had been paid
he had to settle his bill. Once he had money in his pocket he felt
bound to leave his clean comfortable room in the excellent hotel
and take the cheapest room he could find in a third-rate *maison
meublée*! Steer had private means, and could afford to wait; I lived by
my drawings; so did Shannon, who in fact had not yet begun to
paint.

Arnold Dolmetsch, among others, was hard put to it to earn a
living. In spite of an unmusical soul, I used to go to Dolmetsch's
concerts at his little house in Bayley Street, off Tottenham Court
Road, to watch him, his wife and daughter, playing on their lovely
instruments.[19] He had just made an exquisite clavichord, with a key-
board [i.e. the case of the instrument] painted by Helen Coombe
[afterwards Mrs Roger Fry]. Runciman brought Frank Harris to see
it; Harris seemed really moved by its beauty. He boomed and
bellowed enthusiasm, wanted at once to possess it, and hearing it
had been specially commissioned, he insisted that Dolmetsch should
make a similar instrument for himself. When some months after-
wards the clavichord was completed, Harris's enthusiasm had cooled;
now he wanted to get out of his bargain. Runciman protested, and

insisted on Dolmetsch being paid, when Harris gave the lovely instrument to Runciman.[20]

To me, too, Harris talked as though he were going to be a marvellous patron. He sat for his portrait which, needless to say, he rejected—since, as he said, I had made him appear a truculent rascal. However, he bought three of my pastels; one of Shaw wearing a broad-brimmed hat, one of Alphonse Daudet, and another of Verlaine.[21]

These were Harris' days of prosperity, when he entertained lavishly, usually at the Café Royal. I remember especially a dinner he gave there at which Oscar Wilde, Max Beerbohm, Aubrey Beardsley, Robbie Ross and myself were the guests. Harris on this occasion monopolised the conversation; even Wilde found it difficult to get a word in. He told us an endless story, obviously inspired by the *Etui de Nacre*, while Oscar grew more and more restive; when at last it came to an end, Max said, 'Now, Frank, Anatole France would have spoiled that story.' But Harris wasn't thinskinned; he proceeded to tell us of all the great houses he frequented. This was more than Oscar could bear—'Yes, dear Frank,' he exclaimed, 'we believe you; you have dined in every house in London, *once*'—the only time I heard him say an unkind thing.

Another time, I was lunching with Max at the Café Royal, when Harris was sitting near with a lady friend. As we passed his table he called out, twisting his moustaches, 'You're getting older, Will, I'm getting younger.' 'Well, Harris,' I replied, 'we can both do with it.'

While I was painting Cunninghame Graham he was planning a journey to Morocco and pressed me to go with him. As an inducement, he proposed returning through Spain.[22] Sargent had told me at all costs to go to Toledo to see the great El Grecos there, but unfortunately the violent storms that had swept over Spain early that year had broken down the railway and we were unable to go to Toledo, to our great disappointment. Sargent told me also of Goya's decorations: had I seen the El Grecos at Toledo I should have thought less of these. But Goya's art was of the kind to dazzle a young painter.

I can think of no other place, which could fall in so entirely with my dreams of a romantic country and yet astonish me so completely. Surely the Spanish are a simple people. Our joy is as apathy to theirs, when they would show thirty-eight teeth if they had them, and our anger as a

gentle breeze to their hurricane. Joy and anger, or complete indifference, and they appear to have no intermediate emotions. . . . But I would sing the praises chiefly of their cheap trumpery. Go into one of the great cold romantically ascetic churches, breathe the heavily perfumed air, reflect on the strange chill of ages you feel upon you—then what do you see along the wall? A tawdry doll with crimson cheeks dressed up in the gaudiest of clothes, seated amongst the greenest of grass and the most artificial of brilliantly dyed flowers, with toy lambs on magenta rockers placed round her—in a glass case, with candles all a-burning. On the altars the same thing, and always the flowers have that curious dyed look of the Neapolitan ice. I wish I could make you feel the charm of this mingling of lowering sternness and pink and green analyne. . . . And indeed both Velasquez and Goya are still alive in Spain. . . . Not even the Americans can take away the extraordinary savageness of the Seville tobacco factory—how I would like to lead Burne-Jones through it! The Flamencos still dance as they danced for Goya, Goya who understood them as no other Spaniard has ever done. Let them do what they will with Morocco, let them put spats upon the feet of the Moors, not a word would I say. But if the bull ring be closed, if the knives be taken from the belts of the men and the roses and powder from the women, if the marbled courts of Cordova be turned into kitchen gardens, then let the grassy mound be chosen whereon I may rest me from my bitter fury. (WR to Margaret Woods, March 17, 1895. RP:HL.)

Arriving in Paris one morning soon after, and buying a newspaper, the first thing therein that caught my eye was a large headline —something about Oscar Wilde. This was the first I knew of the libel action that Wilde had brought against the Marquis of Queensberry, which was to end in Wilde's imprisonment. When I got back to London this matter was naturally the chief topic of conversation. People who had been glad to know Oscar while he was successful, hastened to deny him when he was down. John Lane withdrew his books from circulation; George Alexander removed his name from the play bills of *The Importance of Being Earnest*; the bailiffs took possession of his house; all his books, papers and effects were sold.[23] I went to Tite Street on the day of the sale with the intention of buying some small thing (my voyage to Spain and Morocco had emptied my pocket) which I might sell later to benefit Wilde. The house was filled with a jostling crowd, most of whom had come out of curiosity; the rest were dealers, chiefly local people, come to pick up bargains. And bargains there certainly were. Bundles of letters and masses of manuscripts, books, pictures and prints and bric-à-

brac went for almost nothing. I bought a painting by Monticelli for eight pounds, which later I was able to sell to Colnaghi to help Wilde.[24]

And now, Mistress Millamant, I am going to put on a respectable suit of clothes and a nice white shirt, to sally forth even as far out as Bayswater, to make enquiries after a certain Monticelli, and a parcel of books and various photographs I recently acquired where I would a thousand times sooner have left them. (WR to Alice Mary Knewstub, April [1895]. PC.)

Chapter 5

CROSS-CHANNEL FRIENDSHIPS

SOON after my return from Spain I found that Ricketts and Shannon were planning a new annual, *The Pageant*, of which Shannon was to be the artistic and Gleeson White the literary editor. Ricketts was to design the cover and to look after the lay-out; and besides all the great swells, several of us younger men, Conder, Max Beerbohm and myself, were to contribute. Shannon asked me to write to Whistler to induce him to give us a lithograph, and to Verlaine for a poem; Verlaine, he suggested, might write on Whistler's *Symphony in White*; I was to find out whether this would appeal to Whistler. Shannon asked Conder for one of his beautiful paintings on silk, and he wanted me to do a portrait. He heard that Maeterlinck was coming over to London, and proposed I should draw him.[1] At the reception to Maeterlinck I was introduced to a beautiful young actress, Miss Alice Kingsley (Miss Knewstub in private life), who was then playing Miss Ansell's part with Miss Irene Vanbrugh, and with Toole, in *Walker, London*.[2] I used to wait for Miss Kingsley at the stage door, to drive her home to Tufnell Park, where she lived; walking back the four or five miles to Chelsea.

> *Dearest—I am ever so little disappointed at being warned off your premises this afternoon—but you know I shall come to the theatre to-night. . . . I dreamed of you all night (which you didn't deserve) and thought of you all morning, you little traitor. And now I am going to do some work, and try and banish you entirely from my head and heart—a task you accomplish with such ease with regard to myself, and that I can never pull through. (WR to Alice Kingsley [Autumn? 1895]. PC.)*

Miss Kingsley introduced me to the Rossetti household at St Edmund's Terrace, and I became warmly attached to the family. William Rossetti was the only one of the Pre-Raphaelites who was sympathetic towards the work of the younger writers and painters.

He even thought that we youngsters were better draughtsmen and more skilful painters than was his brother. This, of course, was absurd; Rossetti's early drawings are among the great drawings of the world, and none of us could approach their quality of closely knit design. When talking with me, William Rossetti would constantly say: 'I am so glad to hear this from you. That was Gabriel's opinion too.' This was heartening and flattering, yet it made one feel humble and ashamed.*

With Miss Kingsley, at Theodore Watts' invitation, I paid my first visit to The Pines, Putney.³ Watts was a little, round, rosy, wrinkled man, with a moustache like a walrus, and a polished dewlap. He was dressed in a sort of grey flannel frock-coat, which I suppose he had hurriedly donned, since a shabbier coat lay on the sofa. As we came in, he rose to greet us. He was very welcoming. I was naturally interested to see the interior of The Pines. The room we were in had a fine large window looking on to a long, narrow garden, surrounded by ivy-grown walls. In the middle of the garden stood a small plaster statue, near which was an ugly iron and cane seat, painted yellow. Round the walls hung large drawings by Rossetti, mostly studies for the *Pandora*, stippled in chalk, and a splendid drawing of Mrs Morris, lying back, her hair spread luxuriantly about her head, her hands held up before her. There was also a drawing, in coloured chalk, of Watts himself. Besides these there was a portrait of Rossetti by Ford Madox Brown, obviously like, but a little thin and somewhat dirty in colour; and an admirable self-portrait by Brown against a gold background; and there were

*When W. M. Rossetti died in 1919, his daughter wrote to Rothenstein: 'I always felt that you understood and loved Papa, and I know he had a strong regard and liking for you. He told me so more than once. In his later years, however, he was not, as you realized, much inclined to see friends, even those he cared for. He hated old age, and felt its infirmities—even in the limited degree in which he was afflicted by them—very keenly, especially his partial deafness which he exaggerated. He was very sensitive to such matters and imagined that other people were incommoded thereby. . . . Advanced age was not desired by him, and I could not wish it to have been prolonged much further, for I so understand and sympathise with his view of it.

'But the end came with tragic suddennesss to me, for I was in Paris, and could not get home in time. I cannot tell you all that this meant and means to me. . . .

'I hope someone will record briefly, but in an adequate manner, something of what Papa himself was, apart from being "a member of an illustrious family". But there are few people who really knew him.' (Helen Rossetti Angeli to WR, March 2, 1919. RP:HL.) In 1931 Mrs Angeli gave the National Portrait Gallery, London, Rothenstein's portrait (c. 1909) of her father.

several heads, charmingly painted, by Knewstub—Miss Kingsley's father; and a lovely little water-colour by Miss Siddal.[4]

'Ah, I hear you know Whistler. Dear Jimmy,' said Swinburne's companion, 'how clever he is, indeed the most brilliant of men. I have known him intimately these twenty years. What genius! Latterly, owing to his quarrelsome nature—though I myself have had no difference with him—still, owing to his misunderstanding with my friend, I have ceased to see him. But what a talker! Is he doing well now? Some say yes, some no. Surely he was in the wrong over Sir William Eden. George Moore I am rather prejudiced against; but of course I don't know him, and I have not read his books. But I trust Jimmy always for being in the wrong, he loves a quarrel.'[5]

I gently told Watts some of the facts of the Eden business. 'Yes, yes,' he broke in, 'but how foolish of Whistler, to challenge Moore. And so you have drawn Pater! A curious man, whom I never quite understand. Swinburne of course invented him—took him round to see Rossetti, who disliked him extremely. Yes, a wonderful prose writer, a better one than Swinburne to my mind. But will his work last? Baudelaire started *l'art pour l'art* in France, then Swinburne trotted her round here, dropping her very soon, seeing there was nothing, after all, in her. Then Pater took the theory up—beautiful prose, yes, beautiful prose, but surely a little late; and will it last? The *coup de grâce* was given to the movement by that harlequin Wilde.'

Watts was not very kind to men who had had a youth since his own; he ended every criticism by saying 'but will the movement last?' He even wanted to know if *The Yellow Book* would last. He seemed to think Beardsley represented all that was living in modern art. It was pleasant to hear him praise Théophile Gautier 'up to the skies'. I wanted, of course, to hear him speak of his contemporaries; he who had been intimate with Dante Gabriel Rossetti and was one of the last links which joined us to the most remarkable band of men of the century. Before we left, he told me he had made Swinburne, with great difficulty, promise to sit to me—'A rare thing for the poet to be gracious on that point; we both dislike sitting,' he added, with a glance at his own portrait drawn twenty-five years earlier by Rossetti.

I was amused at Watts, but did not take to him. I remember, by the way, Oscar Wilde saying: 'I have suddenly realised why Watts

is an authority on the sonnet; the sonnet of course is made of six and eight.' Watts was, by profession, a solicitor! He seemed to me absurdly vain, but he must have had great qualities to win the trust and friendship of Swinburne, and of Rossetti before him; and though I would not have called him a great talker, he was certainly an entertaining one. There was a good deal of malice in his talk—not unattractive to one of my age.

Watts told me one thing that Whistler had never mentioned. In complaining of Whistler's attack on Swinburne in *The Gentle Art*, he said Whistler had pressed him to get Swinburne to write something about the *Ten O'Clock*; a review by the Bard, it appeared, would be a very good thing. Swinburne had needed a good deal of persuading, but at last had consented; hence the resentment of both Swinburne and Watts at Whistler's subsequent onslaught.[6]

After I had drawn Swinburne, Watts asked me to make a portrait of himself, and was very tiresome when sitting. He said that while drawing him Rossetti would consult his opinion, as I ought to do, and be guided by him. He was plainly afraid of a too realistic portrait, and his want of faith in my interpretation prevented my finishing the two drawings I began.[7]

I found, among some notes which I made in 1895 (I have sometimes wished I had made others), the following account of Swinburne: '*August 10, 1895*. Go to The Pines, Putney. Swinburne gets up as I enter, rather like Lionel Johnson in figure, the same *chétif* body, narrow shoulders and nervous twitch of the hands, which, however, are strong and fine. A much fresher face than I would have imagined from hearsay, a fine nose, a tiny glazed green eye, and a curiously clear auburn moustache, and a beard of a splendid red. How young he looks! notwithstanding his years. He was so nervous, that of course I was embarrassed, and Watts being there we both talked at him, keeping our eyes off one another. Occasionally I would glance at his profile, less impressive, less "like" than his full face. When at last the sitting began, no sitter ever gave me so much trouble. For besides always changing his pose, he is so deaf, that he could not hear me, and after sitting a short time, a nervous restlessness seized on him, which held him the whole time. I felt a beast sitting there torturing him. Nor did I feel that I could do anything worthy of him. When he saw the drawing he was kind enough to say "It must be like, for I see all my family in it." While I was drawing he recited a burlesque of [John] Nichol's, *The Flea*, he called it, and he talked

a good deal of recent criticism—a bumper of newspaper cuttings were strewn over a couch near the window. He speaks with the accent of an Oxford Don, and with a certain gaiety, with gracious and old-fashioned manners. He behaves charmingly to old Watts. He had a new suit of clothes, as though especially for a portrait, which seemed to cause him as much discomfort as sitting still. He was like a schoolboy let out of school when I said I would not bother him any longer. He then showed me a number of his treasures—odd views of different scenes, an early Burne-Jones drawing, photographs of people, including a fine one of Rossetti.[8] Watts suggested I should make a drawing of this for Swinburne, but Swinburne asked me if I could make one from a rather poor engraving of George Dyer, Charles Lamb's friend, for him instead. . . . And this of course I promised to do. Swinburne talked violently against the French, saying that he had lost all interest in them, since France had become a Republic, as they are always ready to fly at our throats and would crush us at any moment, if they could. He praised Baudelaire as a poet and said he liked Meredith immensely—as a man—the same thing that Leslie Stephen said of Browning one day at Hyde Park Gate.'

On my way home I went to the Vale and showed the drawing to Ricketts and Shannon. To my surprise they were immensely pleased with it. They want to reproduce it at once in *The Pageant*.

I made a second drawing of Swinburne, and he afterwards, when I lunched at The Pines, very charmingly asked me to make a small painting of him for his mother. I was proud and delighted, of course, and a first sitting was arranged. But how indiscretions come home to roost! Something quite unexpected was to come in the way. I happened to notice a review of the last volume of Edmond de Goncourt's *Journal*. Being curious to read it, since it dealt with the years I had spent in Paris, I got the book, and there, to my horror, was a reference to me, together with an account of the Rossetti household I had light-heartedly given.[9] For de Goncourt, I remembered, had asked me to tell him anything I could of the Pre-Raphaelites, of whom little was known in France. To me, people like Rossetti and Swinburne were immortals of whom one talked as one might speak of Keats or Shelley. But how easy and pleasant it is to repeat what one hears! I had never imagined that tales told to an old man by a youngster would one day be printed. I was very upset. The best thing, it seemed, was to draw Watts' attention to the passage before someone else should do this, and to make a clean breast of the matter. I

was to lunch at The Pines to discuss the portrait I spoke of, so when the day arrived and before going upstairs where Swinburne awaited us both, I showed the menacing passage to Watts in the hope that he was human enough to understand my dismay. Watts went and quietly closed the door, read the paragraph, and said: 'This is the kind of thing that gets into the newspapers.' He then suggested that I had better not lunch with Swinburne—I should have my lunch brought down to Watts' room! There was nothing to do but to leave the house. Dining that night with York Powell, I told him of this; he was indignant, especially that Watts should stand in the way of the painting which Swinburne wished me to do. I never saw Watts again, nor Swinburne either, to my great regret.

George Moore, it was often supposed, was associated with the decadents in literature, yet he had nothing in common with such, save an admiration for French literature and painting. In art his sympathies were with the New English Art Club. He had written one of the few remarkable books on modern painting which showed appreciation of the aims of Manet, Whistler, and the so-called Impressionists. He had known Manet personally—had indeed been painted by him.[10] He would sometimes clinch an argument, when driven into a corner, by saying 'But I have known Manet'! Moore amused and puzzled me. Although he was many years my senior, his character did not command unmixed respect from a youngster. There was no reticence in Moore, but a Rousseau-like candour, naked and unashamed. He had no pretence of dignity—that mantle Moore, even in his later years, has never assumed—but he had humility, the humility of the artist, mixed with an ingenuous egoism, which gave him unique personality. His pastime was talking—'O Rothenstein, I am so glad you have come, I can only think when I am talking.' And talk he would, unceasingly, sometimes so admirably, that I would leave him with the affection that great intelligence invariably arouses in me; at other times he could be frankly silly. He would insist on his absence of moral and social sense, sometimes amusingly, at other times in a wearisome way, and often, too, with an indiscretion that made me wonder how much was naïvety and how much *méchanceté*. He talked as he wrote, with a stress on his gallantries that was quite unconvincing. Were it otherwise, he would have compromised half the women he knew. But no one could have a subtler appreciation of his own absurdities than has Moore himself.

He had one thing in common with Steer: as Steer was possessed by his brush, so was Moore by his pen. With a pen in his hand, Moore's intelligence was uncanny; without it his hands looked limp and purposeless, his brows were lifted in vacant expectancy, his eyes without depth, his lips loose under the pale moustache. It was as though Moore's pen supplied rectitude, tact and delicacy— virtues which were sometimes discarded when his pen was laid down.

Moore wanted me to make a drawing of him for his next book: 'I think I have arranged for Scott to give you a fiver for the right to reproduce the drawing. In that case you will, I suppose, give me the drawing,' he wrote; but for some reason, now forgotten, the drawing was not used, and remained on my hands.[11] Moore said of this drawing rather fatuously—'Now of whom do you think it reminds me?' I could think of no one like Moore. 'Don't you see a likeness to de Goncourt?' he said. I couldn't conceive of two men more unlike.

He talked with enthusiasm of Pater's prose, but he ridiculed Newman: 'They call him a great stylist, but his style is execrable.' And he took up the *Apologia*, and began to read—'Did you ever hear anything more ridiculous? But the English don't know what style is.' Then he talked of Héloise's letters to Abelard. He had just read them; 'Last night, I dined with Mrs Craigie, and I talked about these letters; no woman has ever written *me* such letters, I said; could they be genuine?'

He had lately been staying with Sir William Eden at Windlestone. During his visit Eden drove over to the funeral of one of his neighbours; 'I thought I would join him, for the sake of the drive,' said Moore. 'And when we got to the church, as I was wearing a rather loud check country-suit, Eden said it wouldn't do at all for me to come into the church, dressed as I was. But I got tired of waiting, so I strolled in, and sat by Eden; and, would you believe it? he was quite annoyed with me afterwards.'

But what he most liked was to talk about painting. Having known Manet and Degas, not to speak of Walter Sickert and Steer, he was familiar with the opinions of painters. But why should a writer wish to see like a painter? and to talk like one, too? Moore had attuned his mind and eye to one kind of painting; to great dramatic or imaginative art he was insensitive. I had rather he talked about

literature. But to Steer and Tonks, who then preferred eighteenth-century and nineteenth-century painting to that of the earlier schools, Moore's opinions were always acceptable. Not that Steer minded much what Moore said; so long as Moore did not worry him with anything unexpected, and was happy talking, Steer would sit and listen, at his ease, his hands folded across his stomach, his feet closely drawn up under his chair.

Moore found in Steer and Tonks his most sympathetic listeners; in neither was there any intellectual nonsense; like Moore they laughed at my strange taste for Giotto and Millet, and the rather austere subjects that appealed to me did not attract Steer and Tonks. Nevertheless, close ties of sympathy and affection united us, and we met constantly, at one another's studios, or at the Chelsea or the Hogarth Clubs, and often at Moore's flat in Victoria Street. I was teased about my penchant for Ricketts and Shannon; Moore especially railed against them; Sickert alone supported me. You never knew what Sickert would like or would not like. He did like Beardsley and admired his drawings, and the feeling was mutual. One of Beardsley's rare oil paintings (now at the Tate) is a portrait of Sickert.[12] Moore could not abide Sargent; he was abusive whenever his name was mentioned. It was one of his rare differences with Steer and Tonks. But he could not let Sargent be. He was like a puppy worrying a rag doll.

Smithers, Symons, Beardsley, Dowson and Conder used often to run over to Dieppe. Dieppe, with its harbour and quays, its beautiful churches and dignified streets, had for long attracted artists. Like many Continental places, it kept much of its original character. It was one of Sickert's favourite haunts; Thaulow had settled down with his family at Dieppe, and Jacques Blanche had a villa and spent most of the summer there. I remember Beardsley, Conder and Dowson starting off from The Crown one night, wandering about London, and taking the early boat-train to Dieppe without any luggage—Beardsley and Dowson coming back a few days later looking the worse for wear. Conder stayed on. He made great friends of Thaulow and of Jacques Blanche. Conder wrote and begged me to join him: '... I miss you very much Willy Rothenstein and you would simply love Dieppe. ... Life is so beautiful that one thinks it must end soon and ambition only comes in and interferes and makes one want to do for example—pictures of *next* spring illustrated with portraits. It is very likely I shall settle here, I like the

place so well and fancy the winter months will be encouragingly dull and good for work—I can't appeal to you now as a reasonable man, I know, but still the idea seems good.'[13]

I did go over and join Conder, and met Blanche and Thaulow. Thaulow was then at the height of his fame. A huge Norwegian, bearded, genial, a great trencherman, he dispensed hospitality to all and sundry. He was devoted to Conder, as was Mme Thaulow—a familiar figure through Blanche's portrait of the Thaulow family.[14] She too was a Norwegian giantess. I used to go bicycling with her on a tandem bicycle; she, dressed in bloomers, on the front seat, taking charge of the machine, making me feel smaller than ever, behind her handsome, redoubtable figure. Blanche for a long time could not make me out; I was always joking and laughing, though Sickert had told him, he said, that I was a very serious artist. Blanche was an admirer, and a warm supporter, of Sickert, buying his pictures, and praising his work to his French friends, but he used to complain that Walter was unreasonably *difficile*.

On returning to London, I thought it right to pay my respects to my old Professor. I found him living in a dullish house in Brook Green [Hammersmith]. Whether from want of success or ambition, or through indolence, he had for some time produced little work. There was a discouraging atmosphere about him; nor by his own household was he treated with due respect, I thought; perhaps, now he had retired from the Slade, he contributed little towards the household expenses.

Though I had not been a favourite of Legros' during my year at the Slade School, my visits seemed to raise his spirits. He was glad of someone to talk to; and I was eager to hear him speak of his early days, and to listen to his account of Delacroix and Ingres, of Baudelaire and Meryon, of Rossetti, Watts and Alfred Stevens. As a young man he had joined the crowd of students who followed Ingres round the Louvre. Once Ingres, he said, out of the corner of his eye, caught sight of Delacroix crossing one of the galleries. Turning quickly away and raising his head, he sniffed the air. 'Hu, hu, ça sent le soufre ici.' He told me an amusing story of his first meeting with Delacroix, at the house of a financier whose delight it was to entertain the young lions of art and literature. They came with flowing locks, flowing neckwear, fancy waistcoats, velvet coats, peg-topped trousers, *habits râpés*, in fact every kind of sartorial extravagance. Suddenly there entered a figure attired in a quiet but

extremely correct frock-coat, wearing canary-coloured gloves.'Quel poseur!' Legros heard from the outraged *rapins*. It was Eugène Delacroix.

Because I spoke French and admired his own work, [Legros] could not see too much of me. He would often come to my studio, where sometimes his visits were inconvenient; for Legros was a little selfish, and would expect me to stop work and go with him to the Print Room or to the National Gallery. When I had a nude model, he would be glad to join me (models I gathered were frowned on at home). In his painting room at Brook Green, a dull room looking on to a backyard, hung the *Femmes en Prière*, which I had seen at the first exhibition of the New Gallery.¹⁵ No one had wanted to buy it, he said, and he had not in fact sold any pictures for a long time.

Legros told me that he had taken Swinburne's French poems to show Baudelaire. Baudelaire, while he recognised Swinburne's genius, declared that none but a Frenchman could write true French verse; yet when Swinburne sent him an appreciation in French of his *Fleurs du Mal*, he held this to be the most discerning study of his poetry. He sent it to his mother, and expressed his thanks in the warmest terms; but he inadvertently put the letter to Swinburne into a drawer, where it lay until after his death.¹⁶

Legros had hinted more than once that we might go together to see Burne-Jones, but had done nothing further. Then, one day in Regent Street, whom should we meet but the illustrious artist himself. Legros introduced me, and suggested our going to the Café Royal, nearby, for a talk. Burne-Jones gaily assented; and it amused me to sit in this place with these two grave artists; Burne-Jones saying that of course Rothenstein would order an absinthe. He and Legros had not met for a long time, and were pleased, I could see, to have encountered each other. My friends, with the exception of Ricketts and Shannon, cared nothing for Burne-Jones. I, too, was aware of certain weaknesses; but no man who can draw and design so nobly and thereby impress his vision on the world is to be swept aside.

I spent most of the summer of 1895 in France, painting landscapes and visiting old friends and old haunts in Paris. During this visit in 1895 I made a drawing of Huysmans, whom I had met before, at one of Edmond de Goncourt's parties at the Grenier. Huysmans, a small, shrunken, nervous man, with a parchment skin—looking rather like

a *fonctionnaire*, I thought, with his bourgeois collar and tie, and provincial clothes—was then at work on *La Cathédrale*. He had become absorbed by Catholicism—so absorbed, indeed, that he was soon to retire from the world. He smoked cigarettes one after the other, rolling them incessantly between his quick, slender fingers, yellow with nicotine. He asked about George Moore, who was writing about nuns, he had heard, but wondered—for he said that when he last met Moore, Moore didn't know a Poor Clare from a Sister of Charity.[17]

Going to see Degas, I took some drawings with me, as he had asked to see them. I found a visitor with him, and as Degas looked at my drawings, this stranger glanced at them too. Before he left, he turned to me and asked me to come and see him. 'M. Fantin-Latour,' said Degas, in explanation. Fantin-Latour, of course! I thought his face seemed familiar. I should have known him through his self-portraits.

Fantin lived quietly with his wife, seeing scarcely anyone, occupied with his painting, or pottering over prints and drawings, or else going to the Louvre, where he had passed so much of his life, copying. Everything about him was simple and unpretentious: a few commonplace chairs, a sofa, a small table, and many shabby, ample portfolios ranged against the walls—just the sort of studio Daumier drew or painted. And Fantin himself, stout, baggily dressed, with list slippers on his feet and a green shade over his eyes, looked like one of Daumer's artists. His talk was quiet and unpretentious; there were no fireworks nor sharp wit, as with Whistler or Degas, yet what he said was wise and to the point. Fantin had been one of the pioneers of modern painting, but though he knew his own paintings were out of fashion, I never heard him complain. When Degas and others acquired his *Hommage à Delacroix*, and offered it to the Louvre, Fantin was quietly pleased. He knew the world and its vanities too well to be elated.

I went too to see Verlaine as often as I could. He was obviously far from well, and looked alarmingly yellow. He was still living with Eugénie Krantz in a single room—a little tidier, I think, than when I last saw them. One day I arrived to find he had gilded all the chairs with cheap bronze paint, and was childishly delighted with the effect. 'This is how a poet should live,' he said, 'with golden furniture,' and he laughed, half childishly, half cynically. No one ever seemed to visit him; at least I never met any of his old associates there. Only

Cazals was still faithful. As usual Verlaine was in need of money. He complained, whenever Eugénie was out of the room, that she robbed him of everything. I had been doing my best to get people in London to publish his poems. Heinemann was helpful, taking several for *The New Review*, and paying for them generously. Frank Harris, too, had published some of his poems in *The Fortnightly Review*. Verlaine complained that these were not always paid for, but this Harris denied.[18]

In a few days, Verlaine told me, he would be fifty years old. I said we must celebrate the occasion; but the state of Verlaine's leg did not allow of his going out. I spoke to Eugénie and arranged for a little birthday party in Verlaine's room. She was to get food sent up from a neighbouring restaurant. Ray Lankester, who was on a visit to Paris, wanted to meet Verlaine, and I suggested his coming to the birthday party. We arrived punctually, Ray Lankester carrying a large bouquet of flowers in which a choice bottle of wine was concealed. Eugénie was as amiable as she knew how, though her standard of charm was not a high one; she had an uncomfortable way of fawning on people who she thought might be useful. The flowers plus the wine pleased Verlaine's fancy; he was in the best of spirits during lunch. But the next time I saw him he was depressed and full of misgivings. 'Restez sage,' he said to me, 'take warning from me,' and as he leaned out of the window and looked down on the people in the street below, he envied them, saying they were happy; they could still walk. He spoke feelingly of Francois Coppée and Mallarmé, as the two friends who had always been true to him.

I found saying goodbye a painful business. I did not expect to see him again, and when I spoke with enforced cheerfulness of coming to see him when I returned to Paris, I felt that he too knew what was in my mind. The day after I left he sent me a note with a poem, *Anniversaire*, describing our birthday party. I was touched at his writing and dedicating a poem to me, the more so since I had promised to make him a drawing of the interior of Barnard's Inn (a drawing he had asked for more than once) to remind him of his last visit to London, a promise I was not able to carry out.[19]

My forebodings were only too true. A few weeks afterwards I got a letter from Eugénie Krantz to tell me Verlaine was dead. She added that he had kept a reproduction of one of my drawings hung over the bed on which he died.

Chère Mademoiselle Krantz—j'ai été fortement bousculé par la triste mort du cher poëte, pour lequel j'avais une si grande affection—vraiment ie l'aimai beaucoup et Paris ne sera jamais plus le même, sans lui. Et je sais que vous avez été pour lui une bonne et fidèle amie, et que vous avez tout fait pour lui rendre la vie supportable—pauvre Verlaine, qui souffrait tant! Je voudrais vous demander s'il y a encore de l'argent qu'on lui doit à Londres—en ce cas, je ferai mon possible pour que vous l'eussiez; envoyez-moi, n'est-ce pas, un mot sur ce sujet. Un de mes amis devait s'en occuper, mais il se trouve en voyage. Adieu, chère Mlle Krantz, acceptez l'assurance de ma cordiale sympathie. J'ai raconté à tout le monde ici, comme vous avez été une brave femme et amie envers Paul Verlaine. Tout à vous de coeur, Will Rothenstein. (January 25, 1896. Transcript, Bibliothèque Doucet, Paris. RP:HL.)

Whistler was still living in Paris, but he often came over to London, staying at Garland's Hotel. He went occasionally to the Chelsea Club. There, one evening, I found Whistler dining with Pennell. Whistler made me sit down next him, saying, 'My dear Parson, I can't play second fiddle to anyone, so I could not reply to your amusing letters.' He was very charming and lively, but Pennell was sulkily hostile. Talking of *Trilby*, which had lately been published, Whistler said that Du Maurier's manuscript had actually been sent to him, that he might delete anything he considered offensive to himself. He was in London, he said, about lithographs and law.[20]

When Whistler was talking of someone to whom he had given letters of introduction, Pennell said pointedly, 'They all start that way, whether they have them or not.' I was angry, and I assured Pennell I had been received in London with open arms, because people knew I was not one of *his* friends. Whistler laughed and calmed Pennell down. I didn't really dislike Pennell; but he showed such hostility to me that I was forced into an aggressive attitude towards him. He was an uncritical worshipper of Whistler, resentful of sharing Whistler's friendship with people who showed independence. No one admired Whistler more than myself, but the gross flattery offered him by men who could keep his friendship only by compromising their own dignity, revolted me. My admiration for Whistler has never changed. His faults were obvious; among them his habit of judging people in relation to himself. But his character was a whole and rounded one, and one accepted it, and still accepts it, as unique and legitimate—legitimate for the reason that he made

of his life a unity. The Pennells were blind to Whistler's human fallibility, blind to qualities outside Whistler's compass. One of the most touching letters Whistler wrote was a letter to Fantin-Latour in which he regrets that he could not draw with the precision of Ingres. Absurd modesty! say the Pennells: Whistler drew much better![21]

Hearing that a drawing by Eden had been accepted by the jury of the New English Art Club, Whistler went down to the Chelsea Club and said disagreeable things about me, for I was one of the jury; and all he said was of course repeated, probably with additions, when I next went into the Club. I was rather upset at what I was told, and a little annoyed that Whistler should discuss my affairs before the gossips and fossils of a club which, incidentally, was my club as well as his; he knew too there were many there who were glad to hear anything against the New English element. I was rash enough to write complaining of this to Whistler:

> *I have heard from various sources that you have been openly expressing your belief that I was in a great measure responsible for the acceptance of a water-colour by Sir William Eden by the jury of the New English Art Club. I assure you, firstly, that I was entirely ignorant of the fact of his having been invited to send and secondly, that I took no part in the voting for any of the water-colours, and thirdly, that on hearing that the drawing in question had been accepted, I immediately expressed my disapproval of this action. I am hurt that you should have jumped to so false a conclusion, as your remarks with regard to me seem to indicate. I trust that you will accept my explanation in this its simplest form. (WR to Whistler, draft dated November 23, 1896. RP: HL.)*

Of course, I was no match for him. He pounced on me at once. 'Your name is publicly posted in the list of the Committee responsible for an act, of which you hasten to wash your hands. You profess yourself "entirely ignorant" of what was going on, and further say that you "took no part" in what everyone will suppose to have been your duty!

'How shall I sufficiently condole with a poor gentleman in your present forlorn position!

'Ashamed of your Society's humiliation, you volunteer an "explanation" in its "simplest form", and therein confess yourself, as an appointed Officer of that Society, uninformed, neglectful, and

serenely ineffective. . . . Bestir yourself then, jeune Rothenstein, and come out of the situation completely—for as long as your name shall remain on that list, so long have you, in common with your less fastidious fellows, *officially*, the "toad in the belly".'²²

I must keep, then, officially, 'the toad in the belly.' You would seem to have mistaken the point of my note. I merely wished to answer an accusation you more or less admit having made against me openly, to my back, of my having been in great measure responsible for the hanging of Sir William Eden's water-colour drawing on the walls of the New English Art Club. I care not one atom for what every one 'supposes' to have been my duty. The fact remains unaltered—I did not vote for any of the water-colours; the drawing in question came before the unneglectful and seriously effective portion of the jury ignorant, I am assured, of its identity and was accepted. I have no reason to doubt my colleagues' word in the matter nor have I now any reason whatsoever for disassociating myself from them. I can see no cause for you to have discussed the affair in my own club, and knowing as you did that Baron Bodenhausen was buying, amongst other things, work of my own, it was more than unnecessary to have attempted to bias his mind against me. (WR to Whistler, draft dated December 5, 1896. RP:HL.)

'Well, of course Rothenstein, mon ami, this is a case of in—or out! and the Baronial toad once in the belly, if not incontinently cast out, stays *in*—morals and emetics notwithstanding. So God save you kindly Rothenstein! . . . But whether you go, or stay, it were well, in your place, Rothenstein, to make less distinction between your "back" and your front. It pleased me to "discuss" the "affair" in that club—which carelessly is "*my* own" too:—even though you *do* belong to it—and if your front had been there that night, it would have received the crisp, clear and "open" statement en plein: as well you know Rothenstein—and immediately—for I came, as I declared, that I might see you all in the first throes of digestion. . . . P.S. Of your commercial complications with the Baron Bodenhausen, it must be clear to you that I do and can know nothing.'²³

I have ever admired your neat hand with the foil; but when in the other hand you brandish a scythe, with intent to lop off my legs when my eyes are on your button—NO! Does the fact of your being a member of the same club as myself allow you any more liberty to discuss my conduct publicly in that club? Back and front indeed! If you had made your

*'crisp, plain and open statement' to my front, it would, as you well know,
have answered yours too, 'en plein', less crisply perhaps, but just as
plainly and openly. ~~Observe the 'openness of the Master's attack! for
now~~ And now when I have answered you, you, veering round, twist my
first 'plain' statement into one of ~~false~~ 'hastily repudiating the pro-
ceedings of my colleagues' and so you swing your scythe they, cher maître,
shall judge between us. You know perfectly well that as you attacked me
virulently and personally, I gave you a curt explanation to prevent there
being any suspicion of malice, in the part I played in this [word erased]
affair. (WR to Whistler, draft dated December 17, 1896. RP:HL.)*

He promptly retorted: 'That is it Rothenstein. Through life, you
keep your eye on the button—*I'll* do the rest!'[24]

And in subsequent letters he remarks on my having 'the toad in
the belly'. I had a genuine enough grievance; but my letters were
foolish and disrespectful, and I deserved these sound raps on my
knuckles. Having administered them, Whistler seems to have
relented; for I find friendly letters following.[25]

Chapter 6

ENGLISH PORTRAITS AND LIBER JUNIORUM

THERE was talk of a Cambridge set [of drawings], and MacColl wrote of a plot to get me to Manchester and Liverpool, his brother-in-law, Oliver Elton, being the chief plotter. But nothing came of it, and the following year I proposed to Grant Richards, lately become a publisher, to produce a set of drawings which should make a wider appeal.[1]

I began working on these at once, at first drawing people I already knew, at the same time getting introductions to others whom so far I had not met. My friends were generous in providing the text to accompany the portraits. As I asked people to sit for drawings, I clearly could not expose them to unflattering criticism as well; nor indeed to sugary praise. More than once I had to reject text which showed a touch of malice or more than a touch of flattery. My friends made many suggestions as to who my subjects should be. Henley wished me to include George Wyndham. Unfortunately my list had been made out, and most of the portraits were already done; and I could not find room for George Wyndham. Robert Bridges was keen that I should include his friend, Canon Dixon. Again I had to explain that the portraits were all arranged. Canon Dixon came to sit notwithstanding—an interesting man, with a long nose and a beard like a goat's, a poet who in early days had been intimately associated with the Pre-Raphaelites.[2]

When Shaw was to send me some lines on Ellen Terry, he wrote: 'On the occasion of the production of "The Silver Key" at the Haymarket three months or so ago, I wrote a lot about Ellen Terry, which ought to do exactly (part of it) for what you want. ... I feel incapable of writing another word about her: she's a frightfully difficult subject.'[3]

I tried to draw Irving; the first attempt was a dismal failure. 'I know Sir Henry must be difficult,' wrote Miss Terry, 'but you have given him a *very* grim visage—and his wig fits him not at all! I like

the *profile* however.'⁴ But I had another try, a little, but not much, more successful. Pinero, always a conscientious worker, was unable to write the note to accompany the drawing. He answered: 'I have not the knack of "dashing things off", or I would send you what you ask for; everything with me must be well considered and most carefully done—a sure mark of a poor intellect.' Pinero was among those I drew for the *English Portraits*; Max wrote the note on Pinero to go with this drawing. Max could not resist a fling at Pinero. Pinero objected to the text and proposed that William Archer should write in place of Max. 'He, at least writes like a gentleman.'⁵

[Thomas] Hardy I had met at the Gosses' earlier in the year. He had been to the studio once or twice, and I had made several attempts at a portrait. He took a kindly interest in the new series, and suggested someone, though, I thought, with hesitation, who might be included—Lady Jeune; also, more hopefully, George Gissing.⁶ [Hardy] remarked on the expression of the eyes in the drawing I made [of himself]—he knew the look, he said, for he was often taken for a detective. He had a small dark bilberry eye which he cocked at you unexpectedly. He was so quiet and unassuming, he somehow put me in mind of a dew-pond on the Downs.

I asked Mr Hardy whether he would write a few lines on George Gissing, since he had suggested him as one of the subjects for the *English Portraits*. He wrote in reply: 'Strange as it may seem, I have not the requisite knowledge either. But I think I can help you to some one who could supply the lines. I send herewith an excellent little "appreciation" of Mr Gissing's work by Henry James—and I think if you were to ask him he would shape some of the passages into what you require; or allow you to do it yourself. He could do it in a few minutes if willing: and certainly nobody else could do it so well.'⁷ I doubted Henry James doing anything in a few minutes.

Then came Sargent. While I was drawing Sargent he could not bear to remain idle; he puffed and fumed, and directly I had done, he insisted on my sitting to him. He made a drawing on transfer paper, which was laid down on the stone by [Frederick] Goulding, six proofs only being pulled. One of these Sargent gave to Helleu, who asked for it, one went to the Print Room of the British Museum, and two he gave to me.⁸ I asked Henry James to write a few lines for the Sargent portrait, and had the following very Jamesian reply: 'I am afraid I am condemned, in answer to your note, to inflict on your

artistic sense more than one shock; therefore let the outrage of this ponderous machinery deaden you a little at the start perhaps to what may follow. I am sorry to say, crudely speaking, that I don't find myself able to promise you anything in the nature of a text for your characterisation of Sargent. Why shouldn't it, this characterisation, be complete in itself? I am sure nothing will be wanting to it. At any rate, the case, as it stands with me, is fairly simple and expressible: I have written so much and so hyperbolically and so often upon that great man that I scarce feel I have another word to say in public. I must reserve my ecstasies for mere conversation, at the peril of finding myself convivially silent in the face of future examples. Only the other day, or the other month again, I sounded the silver trumpet in an American periodical—I mean on the occasion of his Academy picture. You painters are accustomed to such thunders of applause that the whole proportion for you is in these matters, I know, different. Yet I have thundered myself empty on the particular theme, and, with every appreciation of the confidence of which your invitation is a sign, I must ask you, this time, to excuse me.

'After this, how shall I dare to say Yes to your still more flattering proposal that I shall lay my own head on the block? You can so easily chop it off to vent any little irritation my impracticability may have caused you. However, please take it as a proof of my complete trust in your magnanimity if I answer: With pleasure—do with me whatever you think I now deserve. Only I fear I shall not be in town with any free day or hour to sit for a goodish while to come. Kindly let the matter stand over till we are gathered together again; but don't doubt meanwhile how delighted I shall be to see the copy of your series which you are so good as to promise me.'9

Among others, I had approached Seymour Haden, who at once replied, asking me down to stay at Woodcote Manor [Alresford, Hampshire], a beautiful Tudor house, kept in marvellous order. I had never seen such shining floors, such polished panelling and furniture, bright brass handles and sparkling silver. Haden must surely have been something of a tyrant. He was proud of his position as President of the Painter-Etchers; and if he had a marked sense of his own importance, it must be said that no one, not even Whistler, had a greater European reputation as an etcher than Haden. A big, impressive figure, whose word was law; for this reason, perhaps, Legros and Strang resigned from the Painter-Etchers.10

Lady Haden was Whistler's half-sister, a gracious, dignified lady,

rather quiet and subdued in manner. When her husband was out of the room, she asked me timidly if I knew her brother, and whether I was one of his supporters or not. She was pleased when I assured her of my ardent devotion; but it was obvious that Whistler's name must not be mentioned in the Haden household.[11]

I drew him making a mezzotint. It seems to me now surprising that he should not have seen what I did. Although it is unwise to allow a sitter to see a drawing before it is done, above all an unsatisfactory one, one usually shows the completed drawing; and Seymour Haden, with his dictatorial ways, was scarcely the person to let me carry anything away without first inspecting it. Yet when the print appeared, he wrote that I would be surprised to hear he had never yet seen the portrait 'which I allowed you to take of me, on conditions which your publisher it seems has taken upon himself to disregard. This is bad enough, but to add to it a personal account of me which I have, also, neither seen or consented to, is inexcusable.'[12]

In reply to a letter explaining the position, he said: 'I did not accuse *you* of not adhering to your engagement with me. I expressed surprise at the high handed liberty taken by your publisher with my personality, as well as of the impropriety of not sending me for my approval a copy of what he was saying about me.'[13]

This was not very logical, nor very kind. If Seymour Haden had made an etching of Meryon, or of Whistler, I presume he would have felt himself free to publish it. I had written him of my intention to print a series of portrait drawings, and asked whether he would allow me to make one of him. He had courteously replied: 'I shall be most happy to give you a sitting' There were no conditions mentioned on either side.[14] He had shown marked interest in my lithographic work; indeed, he wanted me to submit to him, officially, a plea for membership, as a lithographer, of the Painter-Etchers on my return to town, and to approach Shannon with a view to our acting together in this. We had parted with cordial expressions. Still, on the whole I met with far less trouble at this time than I met with at Oxford.

Whistler had promised to sit for one of the *English Portraits*; but when I wrote to remind him he replied, very kindly, that 'the drawing is all right—but the *moment* is difficult.' He was greatly pushed and at work from morning till dusk. Besides, he thought '*two* Napoleons at a time are surely enough!' The Napoleons were 'the African filibuster, and the Apothecary of Hants'. The last clearly was

Seymour Haden; may be the first was Rhodes. 'Why then,' he added, 'the champion [uitlander?] lithographer?'[15]

For one difficulty I had no one to blame but myself. When Oscar Wilde came out of prison, he went straight over to France. I knew he would feel the need of friendship, and wrote offering to come over if he cared to see any of his old friends, to which he replied: 'I cannot tell you how pleased I was to get your kind and affectionate letter yesterday. . . . I am not really ashamed of having been in prison: I often was in more shameful places: but I *am* really ashamed of having led a life unworthy of an artist. . . . I hope you never forget that *but for me* you would not be *Will*. Rothenstein: *Artist*. You would simply be *William* Rothenstein, *R. A.* It is one of the most important facts in the history of art.'[16]

Wilde met me on the quay at Dieppe. I did not know in what state I should find him, but I saw at once that the meeting would not be embarrassing. He was carrying a heavy stick, and as I got off the boat and greeted him, saying how well he was looking, he waved it over his head and exclaimed 'How can you say such a thing; can't you see I am unable to stand without a stick?' He looked, indeed, surprisingly well, thinner and healthier than heretofore. He was happy at Berneval, he assured me, full of plans for the future. He seemed to have lost none of his old wit and gaiety. He told how, although talking was strictly forbidden, one of his wardens would exchange a remark with him now and then. He had a great respect for Oscar as a literary man, and he did not intend to miss such a chance of improving himself. He could only get in a few words at a time. 'Excuse me, Sir; but Charles Dickens, Sir, would he be considered a great writer now, Sir?' To which Oscar replied: 'Oh yes; a great writer, indeed; you see he is no longer alive.' 'Yes, I understand, Sir. Being dead he would be a great writer, Sir.'

Another time he asked about John Strange Winter. 'Would you tell me what you think of him, Sir?' 'A charming person,' says Oscar, 'but a lady, you know, not a man. Not a great stylist, perhaps, but a good, simple story teller.' 'Thank you, Sir, I did not know he was a lady, Sir.'

And a third time: 'Excuse me, Sir, but Marie Corelli, would she be considered a great writer, Sir?'

'This was more than I could bear,' continued Oscar, 'and putting my hand on his shoulder I said: "Now don't think I've anything against her *moral* character, but from the way she writes *she ought to*

be here".' 'You say so, Sir, you say so,' said the warder, surprised, but respectful. Was ever so grim a jest made in so strange a situation?

He inquired, of course, after his friends; I told him that Ricketts and Shannon had now become prosperous; Shannon especially was selling his pictures and getting portraits to paint. Oscar appeared surprised. 'The dear Valeists rich!' Then, after a moment's reflection, he said, 'When you go to sup with them, I suppose they have *fresh* eggs now!'

I had brought a few prints to give Wilde, among them one or two proofs of the portraits I was doing for the Grant Richards book; it struck me that it would be a delicate and heartening thing to ask him to write one of the character sketches. He seemed delighted with the idea, and offered to write on Henley. He agreed, since the notes were to be anonymous, that it was essential, firstly, that the criticisms should not be derogatory, and secondly, that his lines should not differ noticeably from the rest of the text. He assured me that he quite understood; but when his letter-press came, I saw at once how rash I had been: 'He founded a school and has survived all his disciples. ... His prose is the beautiful prose of a poet, and his poetry the beautiful poetry of a prose-writer. ... He has added several new words to the language, and his style is an open secret.'[17]

I wished I might use it; but Henley would be furious. And the authorship would at once have been obvious. It was an awkward situation; I hated having to reject it, and before writing to Wilde, I consulted Max Beerbohm. He of course recognised the quality of the lines, but agreed they would never do.[18] Oscar was naturally annoyed. In reply to my letter, explaining that the text would not fit in with the rest of the letter-press, he replied: 'It was to oblige you I did it—but with us, as with you, as with all artists, one's work est à prendre ou à laisser. ... When I said of W.E.H. that his prose was the prose of a poet, I paid him an undeserved compliment. His prose is jerky, spasmodic, and he is incapable of the beautiful architecture of a long sentence, which is the fine flower of prose writing, but I praised him for the sake of an antithesis—"his poetry is the beautiful poetry of a prose writer"—that refers to Henley's finest work, the Hospital Poems—which are in *vers libres*—and *vers libres* are prose.'[19]

The *English Portraits* duly appeared in book form; but there was no great demand for them. Only a proportion of the edition of 750 copies was bound up. Later, most of the remaining parts (they were

first issued in paper covers, two at a time, like the Oxford portraits) were destroyed in a fire at Leightons', the binders. I remember Oscar Wilde laughing when I told him that Robert Bridges alone had written me—that I rather expected to hear from one or two others whose portraits appeared in the book. 'Simple Will!' he said. But I have felt much in the same way over each book of the kind.[20]

After the *English Portraits* I published a set of portraits of younger men—*Liber Juniorum* I called it. This portfolio of prints was distinguished for one thing—no single copy of it was sold.[21] The *Liber Juniorum* was followed by a French set which had little more success —Legros, Fantin-Latour and Rodin—a companion to the *Three Portraits of Verlaine* which Hacon and Ricketts issued from the Vale Press, every copy of which was subscribed for: 1898 was a busy year.

These portraits, like the *English Portraits*, were, as might be expected, of unequal quality. The success of a portrait drawing depends on many fortuitous things, on the quality of paper and chalk, on the artist's mood at the time, but mostly on the sitter. For the sitter helps to make or mar his own portrait; some, the moment they pose, excite one's pencil; others paralyse the will; some, again, cannot keep a pose, while others, especially old people, must be kept interested. Sometimes, too, one is tempted to talk, and talking while at work has spoilt many a drawing. Men, equally with women, wish to appear other than they are—the mirror will not lie, but the artist may be persuaded; yet if he compromises over form, his drawing suffers. Englishmen especially seem ashamed of their features; foreigners are less sensitive about supposed defects. I have noticed too that men who affect to admire Holbein or Rembrandt are often shocked at a faithful presentment of themselves. Great works of art rarely affect their possessor's taste. What pictures have I not been asked to admire in the boudoir, in houses where Rembrandt and Bellini hang in the drawing room!

O collectors, O museum directors and other experts, your familiarity with art, the complacency and familiarity with which you speak of masterpieces, sometimes make me long to say 'Down on your knees' before a work even by a good living artist. For he acts each day without any action being demanded of him; and the act of creation calls for supreme energy, will and sustained effort; and this not for days, but for weeks, months, years—in fact for a lifetime. In

comparison with this exercise of will, how rarely is the so-called man of action required to exercise all his faculties. It is not appreciation nor industrious scholarship; it is creative energy alone which keeps beauty immortal. To know about things is less difficult than to do them.

Chapter 7

THE END OF THE CENTURY

WHILE I was engaged on these lithographs, Legros had an itch to revisit Paris and see some of his old friends. Would I go with him? I was always glad of an excuse to go back to Paris; moreover, I had heard from Conder, from Dieppe: 'Aubrey Beardsley left about three weeks ago and I fear is very bad in Paris as he caught cold on arriving.' I gathered from his sister Mabel that he was seriously ill. I found Aubrey staying at a hotel on the Quai Voltaire, much changed, less in appearance—he had always looked delicate—than in character and outlook. All artifice had gone; he was gentle and affectionate, and I realised now how much I cared for him. He had found peace, he said; but how rudderless he had been, how vain; and he spoke wistfully of what he would do if more time were allowed him; spoke with regret, too, of many drawings he had done, and of his anxiety to efface the traces of a self that was now no more. Alas, that this new self, of which he was so poignantly aware, should have so frail a hold! He was going south, to Mentone, to gain fresh strength, though he foresaw, I felt, there was little hope.[1]

I went to pay my respects to Fantin-Latour, and told him that Legros was in Paris; the idea of two old friends, long separated, keeping up an ancient quarrel, irked me, and I was eager to bring them together again. Legros was willing, but Fantin hung back— 'What is the use?' he asked, 'there is nothing to be gained.' He was in a bitter mood, brooding over a recent meeting with Whistler. There had been a knock at his door, and there stood Whistler— Whistler, whom he had not seen for how many years! But, scarcely greeting Fantin, he walked back to a lady outside, saying: 'It's all right, he's here.' Then Whistler brought the lady with him into the studio, where hung the *Hommage à Delacroix*, and he straightway took her up to it. 'Me voilà,' he said of the frock-coated figure in the foreground of the picture, then turned to leave. 'Au revoir Fantin!' and with a wave of the hand Whistler was gone.[2]

I returned with Legros to dine at the rue Victor Massé. Degas described how [the London collector, J. P.] Heseltine had been lately to see him—he was after his Ingres drawings, he thought. Never should any of these leave his charge, he declared emphatically; he would keep his collection intact; France should have his pictures after his death, but not Paris. He was looking out for a place not too far from Paris, where he could house it. He had the Dulwich Gallery in mind. Good things were worth taking trouble to see; to-day everything was made too easy; his pictures were well worth a pilgrimage to some quiet village. I was surprised to hear, when, during the war, Degas died, that he had made no such provision as this he spoke of. His collection was to be sold at the Hôtel Drouet.

It was Rodin, of whose eye to business Degas spoke so scornfully, who left his collection to the nation. Legros of course went to visit Rodin; Rodin was his closest friend; and I received an unexpected welcome when I found myself, with Legros, at the studio in the rue de l'Université. I had for long revered Rodin from afar: I had seen him once at the *vernissage* of the Salon, and admired his magnificent head; now I was face to face with the man, and his works. When I drew him I felt I had seen no grander head.[3] I noticed how strongly the nose was set in the face, how ample its width between the two brows, how bold the junction of the forehead with the nose. The eye was small and clear in colour, with a single sweeping crease from the corner of each and over the cheek bone, and the hair grew strongly on his head, like the hair of a horse's mane, like the crest of a Grecian helmet; and again I noticed the powerful hands, with the great thumbs, square-nailed. I think Legros must have told Rodin that I had been helpful to him; for Rodin was more than friendly, and almost embarrassed me by his attention. I must come and stay with him at Meudon, he said, before returning to London. At his house at Meudon I was able to study Rodin's work at my ease. Besides many now well-known pieces, he showed me a cupboard full of *maquettes*, exquisitely modelled. He would take two or three of these and group them together, first in one way and then in another. They gave him ideas for his compositions, he said.

In the evenings we walked in his garden, and looked down on the Seine and on the distant panorama of Paris, bathed in the warm glow of the evening mist. During a walk, Rodin embarrassed me by remarking: 'People say I think too much about women.' I was going to answer with conventional sympathy—'but how absurd!' when

Rodin, after a moment's reflection, added 'yet, after all, what is there more important to think about?'

I was eager to get people in England to realise Rodin's genius; Henley and Sargent would support efforts on his behalf. I was, in fact, able to be of some service to Rodin; and I call to mind, how, a year or two later, he said: 'I want to do something for you in return; I have engaged the most beautiful model in Paris; you shall come and draw her.' What a charming acknowledgment from an old artist to a young one, I thought. The model was indeed beautiful. I drew her—how I longed to draw better!— under Rodin's approving eye; but his eye was shrewd as well as approving. For when I asked the lovely creature —could I do less?—to dine that evening, she promised to come, but I waited in vain; and next day I found that Rodin knew all about it. 'She shall sit for you, mon ami, as often as you please, but no dining! I have lost too many models that way!'

Rodin was generous in his praise of the proofs I sent him. 'Mon cher ami,' he wrote, 'j'ai reçu un magnifique portrait et j'en suis très reconnaissant. Notre maître Legros a dû le trouver bien. Merci, ami, d'avoir fait ma commission à Henley.'[4] I made a small medallion of Rodin. He refers to some delay in acknowledging it and writes of the bad state of his affairs: 'Quel[les] excuses je dois vous faire car vous ne savez que penser. Mais j'ai très certainement votre indulgence; ma position est si mauvaise que je suis accablé. Que votre médaillon m'a fait plaisir, et que je vous suis reconnaissant comme sculpteur et comme ami. Vous avez bien voulu encore ajouter un bronze qui m'a fait plaisir aussi, et pour la sculpture et pour l'intention.' By way of return, Rodin sent me a plaster of a satyr carrying off a woman. About this plaster he wrote, "Le petit plâtre ne sortira pas de chez vous" [Later, he wrote,] 'Vous me rendez très heureux quand je reçois vos amis qui deviennent les miens. Votre amour de l'art est une des grandes règles de notre vie, et c'est cela qui nous a familiarisés si vite ensemble aussi l'amitié de Legros pour nous deux.'[5]

Rodin spoke to me later about his plaster figures. He feared that some day the friends to whom he gave them might get them recast, and dispose of them as bronzes. Rodin insisted that they were not suitable for casting. He expressed himself strongly on this subject, and begged me to keep his views in mind if ever I saw casts of this kind.

In 1899 my brother Albert came to London; he also was to enter the Slade School. He was sixteen, the age at which I left Bradford. My brother soon became a favourite at the Slade; Brown, Tonks and

Steer thought his work promising. He often spoke of two of his fellow-students who had entered the Slade before him, who drew, he said, like the old masters: John and Orpen were their names. I thought the praise was excessive, but was curious about them, so he brought them to see me. Orpen, a young Irishman, was small and shy, spoke little, called me 'sir', and looked long and carefully at my paintings. He had grey eyes, thin rather sunken cheeks, and thick brown hair, and he wore a light jacket, cut round at the neck, with no lapels—the kind of jacket engineers buy in the East End. Orpen was my brother's particular friend. John was a more arresting figure; he looked like a young faun; he had beautiful eyes, almond-shaped and with lids defined like those Leonardo drew, a short nose, broad cheek-bones, while over a fine forehead fell thick brown hair, parted in the middle. He wore a light curling beard (he had never shaved) and his figure was lithe and elegant. I was at once attracted to John. He brought me his drawings, which were truly remarkable; so remarkable that they put mine, and Shannon's too, into the shade. Here was some one likely to do great work; for not only were his drawings of heads and of the nude masterly; he poured out compositions with extraordinary ease; he had the copiousness which goes with genius, and he himself had the eager understanding, the imagination, the readiness for intellectual and physical adventure one associates with genius. A dangerous breaker of hearts he would be, I thought, with his looks and his ardour. He talked of leaving the Slade, and was full of plans for future work; but he was poor and needed money for models. I showed his drawings to Sargent, Furse, Conder and Harrison; Furse chose a number of his drawings, but was taken aback when John asked £2 for each of his nudes. This seemed a modest price, but Furse hadn't expected a student to ask so much. Frederick Brown and Harrison bought drawings too, and John was able to take a small studio.

Tonks had a story that John was quiet, methodical and by no means remarkable when he first came to the Slade. Then, while diving at Tenby (his native town) he struck his head on a rock, and came out of the water—a genius![6] Tonks and Steer were rather critical of John's 'genius'. For Moore did not wear his hair long nor did Sargent, nor indeed did either Tonks or Steer. Let an artist's work be remarkable; but he himself in their view should pass unnoticed. I thought John's appearance was splendid, and I did not want him to look otherwise.

When Pinero's *Trelawney of the 'Wells'* was put on at the Court Theatre, I went with Sickert to see it. What fun it all was; and how enchanting the costumes! and such a chance it provided that Sickert asked Miss Hilda Spong, one of the players, to sit for him; while I approached Irene Vanbrugh. Miss Vanbrugh gave up precious time and endured many sittings. Sickert had Miss Spong photographed, and from a small print and a sitting or two he achieved a life-size portrait. Miss Vanbrugh's portrait I sent to the first exhibition of the International Society.[7]

This new society was started under Whistler's presidency. A committee was formed, with Alfred Gilbert as Chairman; Guthrie, Lavery, Strang, Ricketts, Shannon, besides myself, were among those invited to serve. Gilbert was charming and considerate, and all went well until Whistler wrote from Paris proposing that Pennell and Ludovici should be co-opted onto the Executive. Ricketts and Shannon objected; Pennell was then writing art criticism for *The Star* under the initials A. U., which stood for 'Artist Unknown' (I used to say that his *nom de plume* would serve as his epitaph), and neither he nor Ludovici was taken seriously as an artist. But they were both his faithful followers, and Whistler insisted; the committee gave way, and I left with Ricketts and Shannon.

> ... *I have resigned the Council, with most of the other people on it, with the exception of the Scotchmen. I don't want to be ill natured about it, but I don't think it will really be a very distinguished affair. It is, with the exception of the foreigners who will send, simply a show of Whistler and the Scotchmen, with what other men they can rope in. Pennell and Ludovici have come on to the Council instead of us, and I have no intention of sending, and can no longer take any interest in its proceedings. Don't imagine I take any serious view about such things; I have lost my ambition to be a-pioneering in new shows and it is a dirty business really, and one is best out of it; death and human stupidity are two things one's brain won't rise to. (WR to Conder, March 25, 1898. Boston Public Library.)*[8]

The first exhibition was certainly a remarkable one. Whistler showed some of his latest paintings: *The Master Smith*, and *Little Rose of Lyme Regis*.[9] There was a collection of Degas' work and many other important French paintings. When I next saw Degas he was furious, not so much about the [catalogue] reproduction, but because works of his had been exhibited against his wish. For Degas had

a rooted objection to showing at current exhibitions. He advised me, too, to refrain from doing so. 'Show in colour shops, in restaurants— anywhere but at the brothels that picture shows are,' he advised me.

Meanwhile Sickert was becoming more and more estranged from Whistler. He found occasion for an attack on Pennell, since he called drawings, made on transfer paper, true lithographs. Whistler chose to regard Sickert's comments on Pennell as a veiled onslaught upon his own methods. He saw his chance, and induced Pennell to bring an action for libel against Sickert. Sickert's attack on Pennell had appeared in *The Saturday Review*, and Frank Harris promised to stand by Sickert and see him through.[10] I at once offered Sickert my support, knowing that this action might well spell financial ruin in his case. Though my early drawings had been done directly on the stone, the greater number of my lithographed portraits were drawn on transfer paper, and I knew what risk I ran as a witness.

Soon after proceedings were instituted a telegram came from Whistler, asking me to go and see him in his studio in Fitzroy Street. When I got there Whistler talked for some time about things in general and then suddenly said: 'What is this I hear, Parson, that you are going to be on the wrong side?' I explained that I was devoted to Sickert, that he was an old and close friend; that he, Whistler, was a powerful person needing no support; and that I felt it right to do everything possible for Sickert. Whistler, forgetting that he was trying to ruin Sickert, suddenly became jealous. 'But I have known Walter longer than you have,' he drawled.

When the case came on, Sir Edward Clarke was counsel for Pennell. Among Sickert's witnesses was George Moore. He had begged to be allowed to give evidence, but never did anyone cut so poor a figure in the witness-box. When he was pressed regarding his knowledge of lithography he was completely at a loss. Finding nothing to say he at last stammered: 'But I have known Degas.' I was called later and severely questioned by Clarke; finally he handed me a set of my *Oxford Characters* and asked what I called them. I said that I had called them lithographs, but in the true sense of the word they were lithographed drawings, and that is how I should have described them. Pennell says in his *Life of Whistler* that I fell over my hat as I left the box.[11]

During his cross-examination, Sickert suavely admitted that there was a spice of malice in his article. Clarke, satisfied with this, at once sat down. Pennell won his case and Harris, true to his word, stood

most of the racket. Sickert, though his share of the expenses took most of his capital, bore no malice against Pennell; and Whistler was so pleased with winning the case—he considered it his case—that he too forgot the affront. I dined with him shortly afterwards—he was radiant. Helleu and little Jonathan Sturges were of the party. Returning with me, Sturges talked with enthusiasm of Whistler. 'You never get to the end of his knowledge,' he said. 'Why, Jimmy never lets on to me that he was a classical scholar; yet there he is, he knows everything; did you notice during dinner, he said "hinc illae lachrymae"? amazing! *Am*azing!'

But this was, I think, the last time I was Whistler's guest. Some time afterwards Sir William Eden decided to sell a part of his collection of modern paintings and drawings at Christie's; among these were several by Sickert, Steer, Conder and myself. Steer was somewhat alarmed at our works coming up at Christie's. He knew that they would fetch insignificant sums; Eden should be asked to put a small reserve on each work. Eden agreed, and Steer and I went to Christie's to meet him. While we were talking with Eden, in came Whistler. He put up his eyeglass, stared hard at us, and turned his back. We were seen in Eden's company; we had become 'enemies'. There were limits to the price one should pay for Whistler's friendship. I felt that explanation would be useless and undignified. I never saw Whistler again.[12]

I became more and more attached to John. While his drawings and pastels got better and better, his painting was still uncertain; he found it difficult to control his palette, but now and again he gave promise of astounding genius. And what a draughtsman he was! Yet it was hard to persuade collectors to buy his drawings. It was not so much the indifference of the critics, of artists and collectors that angered me, as their constant assertion that John could not draw, that his work was 'ugly'. These lovely things badly drawn and ugly! were people blind? So John often needed his friends' help: 'It's very nice of you to remember my penury. Many thanks!... I've evacuated my kopje in Charlotte Street, trekked and laagered up at the above [61 Albany Street, Regent's Park]; strongly fortified but scantily supplied. Generals Laurence and Young hover at my rear. With your timely reinforcement I hope to hold on till next Friday when the home supplies are due. The garrison in excellent spirits.'[13]

Sickert too found it hard to live. He was now living at Dieppe, working on small canvases and panels, which he sold with difficulty

and for such small prices, that when he sent over a number to Carfax, and Sir William Eden offered £20 for three of his paintings, Sickert pressed me to accept.[14] Yet Sickert knew the value of his work well enough: 'I do wish you could see my table piled up with drawings of music-halls, etc. Funny to think of the present value in the market of a S[hannon] drawing and one of mine, and their real relative importance.'[15] But no one grumbled less than Sickert. His letters are full of fun, and of plans for his future and for mine: 'I think we might follow the Ricketts and Shannon plan and mutually confide in each other our poor opinion of all but ourselves,' he wrote.[16] [And again:] '... I do so wish you well in your shop [Carfax Gallery], de bon coeur. Partly affection, partly because you are so small and so devilish earnest, partly because of the têtes your success will make to all the other damned fools.'[17]

Whenever Sickert went to Paris, he saw Degas. 'I wish you could see what Degas is doing now. He asked affectionately after you ... His work seems to me absolutely sublime.'[18] And again: 'Degas and others. We talked of you. I told Stchoukine you were doing an étude sur Goya and would like to see his pictures. Degas said "Vous êtes heureux de colliger les Espagnols, parce que—il n'yen a pas." Quel dommage, he said of Whistler, qu'un peinture si fin soit doublé d'un "humbug", using the English word.'[19]

Sickert used to see Whistler at Dieppe, in the Grande Rue, 'looking very well and very dignified' or else lunching at Lefèvre's, where he was also painting a little panel, sending constantly for Arnold Hannay to come and talk to him. But of Conder, Sickert disapproved: 'Conder I think has disappeared, which relieves me. I can't drink and I am a snob. ... Whistler's doctor has forbidden him to work out of doors, has told him it is at the risk of his life. He gets such attacks of influenza. Poor old Jimmy. It was all such fun 20 years ago.'[20]

Of his troubles Sickert said but little. But Jacques Blanche wrote, while we were at Vattetot: 'Je vous sais, comme moi-même, ami et très-ami de notre charmant Walter Sickert et je vous demande la permission de venir vous parler de lui. Vous savez sans doute qu'il a passé un mois à Auteuil, avec nous; il est arrivé dans un état de dépression morale et physique, tout à fait déplorable et je l'ai vu de si près, qu'il me semble mieux [de] le connaître et pouvoir le soutenir, dans la terrible crise qu'il traverse dans ce moment. En venant ici (je suis à une heure de distance de Dieppe), j'ai été le voir dans le milieu

qu'il s'est fait. Il venait d'apprendre que sa femme–malgré tout ce que Madame Blanche et moi nous avions tenté–persistait dans son idée folle de divorce. Walter m'a absolument donné l'impression d'*un homme, qui perd sa raison.* Je n'exagère pas.

'Walter est un vrai enfant, sous certains rapports pratiques et je crains beaucoup qu'il ne se fixe à Dieppe et s'y enlise, comme dans un sable profond. Vous connaissez les conditions matérielles et morales où il vit à Dieppe: il faut, n'est-ce pas, que ses amis, sans en rien dire et sans qu'il se doute de leurs intentions, tâchent de l'arracher, pour l'hiver prochain, à ce danger. Je l'ai engagé à venir passer plusieurs mois chez moi. J'essaierai de lui faire faire une exposition chez Bernheim ou Durand Ruel: il *a beaucoup* de talent, quand il ne se lance pas dans de trop grandes toiles. Son affaire, c'est de légères esquisses dans de petits panneaux. Il est né pour mettre de jolis tons sur un dessin rapide et nerveux. N'est-ce pas?'[21]

Conder, too, wrote often from Paris, hoping that I would help him to sell his work. He wanted to marry, and badly needed money. I could do little to help all these gifted men; indeed, I found it difficult to keep my own head above water; but about this time I met a young archaeologist, John Fothergill, who was working with Edward Warren, a distinguished Bostonian, a classical scholar who translated Pindar, and collected gems and Greek sculpture, both for himself, for he was wealthy, and for the Boston Museum. Fothergill was the youngest of Warren's fellow archaeologists, who lived with him at Lewes House. Lewes House was a monkish establishment, where women were not welcomed. There was much mystery about the provenance of the treasures at Lewes House. This secrecy seemed to permeate the rooms and corridors, to exhaust the air of the house. The social relations, too, were often strained, and Fothergill longed for a franker, for a less cloistered life.[22]

Fothergill was not well off; but he was extremely generous, and of an adventurous spirit. Fired by the example of Hacon and Ricketts, he proposed to start a small gallery, where Conder's, John's, Sickert's, Orpen's, Max Beerbohm's and my work could be constantly shown; a gallery in fact that would be a centre for work of a certain character. I was to be responsible for the choice of artists, Arthur Clifton for the business side. Premises were found in Ryder Street, St James's, and Robert Sickert, a younger brother of Walter, acted as manager, as Holmes did for Ricketts and Shannon.

Besides Rodin, Conder, John, Orpen, Max Beerbohm and I in turn

had exhibitions at Carfax (for so the firm was named); while Conder, who there did better than ever before, proposed that Carfax should take all his paintings on silk, as in fact we did; and for the first time in his life Conder was assured of a regular source of income. I persuaded him, too, to try lithography—his pencil drawings had the quality of lithographs—and he made a number of admirable drawings, mostly illustrating Balzac, on transfer paper.[23] Carfax took them all, and Conder began to feel his feet in England. For a while all went well. Then I heard that Conder, knowing that Carfax had to ask considerably more for his fans and silk panels than they paid him (for only a proportion of what he did found buyers) told someone (he could not have been sober at the time) that I had induced him to sign an agreement with Carfax while he was drunk. This cruel statement made me furious, and I hurried to Bramerton Street, where Conder was living, and so angry was I that I seized Conder—a much stronger and heavier man—and threw him down. He complained of my attacking him thus at his own place; I replied that I could not well have invited him to come to mine in order to assault him. Conder did finally confess the baselessness of his accusation. But for long I could not forgive him, and this unpleasant experience showed me there was something equivocal in my position, and I was sorely troubled: I must at all costs withdraw from Carfax. Fortunately Robert Ross was willing to take over the business, when I was relieved from an irksome engagement; while Fothergill, who got his capital back, lost nothing by his enterprise. Carfax had been of notable assistance to all concerned, to John and Conder especially.[24]

In the spring of 1899 Conder, Max Beerbohm, Robert Ross and my brother Albert accompanied me to the Kensington Registrar to witness my marriage to Alice Knewstub.

After I met her more than four years ago, Miss Kingsley gave up everything for me, and next to your own devotion to me, dearest, as a mother, came her devotion as a friend. We were both younger and more thoughtless then, but I believe we have both got older and finer and wiser since we have known one another. . . . I have been a little cowardly about her, and as I write this, indeed, since I made up my mind as to my duty, I feel happy at doing what I know you, with your kind hearts, will see is right. London life is so complicated, and my dear Alice's position so hard and lonely, that I am looking forward to giving her such a home as I can. I have no illusions about marriage, mother mine, as you know. But as I love my work more and more, and care less for journalistic admiration,

I do feel that this will simplify my life and help the loneliness I feel so
terribly. Dear Alice is an artist's daughter, and knows how to sympa-
thise with an artist's irritable mind: her tastes are as simple as mine. . . .
And it would be wicked of me to put off what is my wish and desire and
duty, as my friend Max has been doing, for more years. (WR to his
parents, May 22, 1899. PC.)

As Miss Alice Kingsley, my wife was then playing at Her Majesty's
Theatre, with Herbert Tree, in *The Three Musketeers*. She obtained
two weeks' leave, and she and I went off to Dieppe, where Walter
Sickert met us. We did not tarry long in Dieppe, but mounting our
bicycles (which we had brought with us) said farewell to Sickert, and
rode down the coast towards Etretat. We were on the look out for a
place where I could paint in the summer, and passing through Cany,
this seemed a promising spot; but farther down the coast we found a
still likelier place, Vattetot, a village near the sea, where was an inn
which had once been a farm, with a large *bassecour*. Nearby was a
small house, with an odd little staircase leading upstairs from the
single sitting room, with which we fell in love; so we rented it then
and there for the summer.

On our return to London we spoke of Vattetot to John and
Conder, who, with Orpen and my brother, proposed to join us there
next summer. When the summer came, it was a large party which
descended upon Vattetot; never had so many easels and paint-boxes
been seen. It was a glorious time, divided between painting and play.
Being in France, we must needs look like Frenchmen. At Yport, two
miles away, lived a tailor, who sold corduroy and a coarse blue linen,
such as the fishermen wear in those parts. The corduroy took John's
fancy, and he presently appeared, a superb figure, in a tight jacket and
wide pegtop trousers; so superb that I painted him standing beside
my wife, my wife sitting on the staircase I mentioned earlier.[25]

I wonder whether the French get their bad taste from their churches:
there is a beautiful church here, still beautiful, though over-restored, with
the vilest altar decorations in the world, and a busy priest, whose com-
plexion is perfect gallous, who tried to make me buy 'La Croix': which
opened the way to a violent discussion on the Dreyfus case between Welsh
John, who is a red hot anarchist, and this same priest, who had I fancy
never been tackled quite so frankly before. His ignorance was simply
stupendous. (WR to Margaret Woods, August 10, 1899. RP:HL.)

At the autumn exhibition of the New English Art Club, I showed some of the pictures I had painted at Vattetot; but I sold nothing there; and being now married, and no money coming in, I was hard put to it to continue even in the modest manner in which we were living. Charles Rowley, who visited us at Vattetot, proposed I should do a set of Manchester portraits; and hinted that, if I came to Manchester, other work would follow. We offered our house until our return to John and his sister, who had comfortless quarters in Fitzroy Street, where Orpen too had a cellar-studio. Before returning to Kensington we paid a visit to my parents at Bradford. There I fell ill with influenza.[26] Before I had quite recovered, having to go to London for a night, I wired the Johns, who were still in our house, to expect me, for it was the middle of the winter; but when I reached Kensington I found the house empty and no fire burning. In front of a cold grate choked with cinders lay a collection of muddy boots. I managed to light a fire; and late in the evening John appeared, having climbed through a window; he rarely, he explained, remembered to take the house-key with him. There were none I loved more than Augustus and Gwen John; but they could scarcely be called 'comfortable' friends. My wife, who loved the Johns just as I did, declared that the walls must be whitewashed and the floors must be scrubbed before the little house would be habitable.

When the summer [of 1900] came, we thought of bicycling abroad; where should we go? As usual we were drawn to France. I had seen an illustrated article by Pennell in one of the American monthlies on a place, Le Puy, in which he suggested Auvergne as a centre for work.[27] John, too, had heard of Le Puy, and we decided to meet there; John, with Michel Salaman, a fellow student from the Slade and a patron of John, going to Le Puy by rail, while my wife and I, leaving the train at Nevers, mounted our bicycles, stopping to draw several places that attracted us on the way to Le Puy.

In a shop at Le Puy we saw a photograph which struck us; it was taken, the shopman said, at Arlempdes, some miles away, and we set out to find it, no easy task. 'There were evil people at Arlempdes; better not go there,' we were told when we inquired the way. But we persisted and at last drew near it along a lonely bypath. A remarkable place, truly, this small, rough hamlet, clustered round the ruins of a tiny stronghold, set on a high rock sheer over the Loire, with, nearby, the remains of a small, primitive chapel. While we were looking about, the curé approached—no strangers had ever come to

Arlempdes, he said. He had never heard English spoken, nor indeed any foreign tongue. He rarely met intelligent people, his parishioners were poor, ignorant folk, so this was a great day for him. Every three years they acted a Passion-play, he told us, but last year the fellow who played a Roman soldier had taken too much wine, and had really stabbed 'Jesus' in the side, and there was a scandal. And looking at John, seeing his long hair and russet beard, he was struck with an idea: 'But you would make a perfect Jesus,' he said; and the good curé called to his sister as she came from the kitchen; 'Tell me, of whom does this gentleman remind you?' 'Mais—de Notre Seigneur,' she answered in a matter-of-fact voice, rubbing her greasy hands on her apron. And the curé leaning back in his chair laughed till the tears came into his eyes. 'What did I tell you?' he said. 'You must stay with us and play the part.' But John, though flattered, had no desire to be martyred; and our friend, unruffled, again disappeared, returning with two fresh bottles, heavily coated with dust.

Usually, when we were in Paris, we asked Oscar Wilde to dinner. But on our last visit he had proposed dining in an open-air restaurant, where a small orchestra played. He chose a table near the musicians; he liked being near the music, he said; but during dinner it was plain that he was less interested in the music than in one of the players. I was annoyed, and resolved not to see him again. I did not, therefore, this time let him know that we were in Paris; but the very first evening we met Wilde on the Boulevards, and I saw at once that he knew we had meant to avoid him. The look he gave us was tragic, and he seemed ill, and was shabby and down at heel. Of course we asked him to join us. He came in a chastened mood, and made himself very charming, but his gaiety no longer convinced; there was a stricken look in his eyes, and he plainly depended on drink to sustain his wit. We were never to see him again. He died later that year.

I must have written Robert Ross after Wilde's death, for I find the following letter: 'I have been so touched by your letter, the only one of the several kind ones I have received that has given me any pleasure. I feel poor Oscar's death a great deal more than I should, and far more than I expected. I had grown to feel, rather foolishly, a sort of responsibility for Oscar, for everything connected with him except his genius, and he had become for me a sort of adopted prodigal baby. I began to love the very faults which I would never have forgiven in anyone else.

'During the months I was in Paris I saw him every day and he was often in the best of spirits, though he sometimes suffered a good deal of pain. One of the doctors however warned me that unless he was careful he would not live for more than *three or four years*. The night before I started for Nice on Nov. 13th he became very hysterical when I said goodbye to him, but I never attached any importance to this: I knew he was much worried as usual over financial matters and for a few nights had been taking morphia by the doctor's orders. I was rather angry at what I thought was merely nerves. But he asked everyone to go out of the room and sobbed for a quarter of an hour, and said he knew he would never see me again. For several days one of his jests had been that he would never outlive the century as the English people could not stand him any more and that he had kept them away from the Exhibition, so the French people would not stand him, and I did not take his *serious* remarks more seriously than these. Reggie [Turner] promised to come and see him and keep me posted, and during the fortnight I was absent he more than fulfilled his promise, taking Oscar for drives and really acting as a nurse. On Sunday night Oscar became quite suddenly light headed and Reggie wrote to me an urgent letter telling me that I ought to prepare for coming to Paris. This reached me on Tuesday. On Wednesday I was just going to move from Nice to Mentone with my mother when I got a telegram from Reg. saying "almost hopeless" and started for Paris at once. I could never have got on without Reggie. The last hours were inexpressibly painful but I hope and believe that Oscar was unconscious. He died at 2 o'clock on Friday afternoon. You can imagine the terrible formalities with the French authorities. They very nearly took him to the Morgue, because no relative turned up, and did not pay any attention to my telegram. Among the wreaths I placed a simple one of Laurels, as "a tribute to his literary achievements and distinction" and on it I put the names of those who I thought would like to be remembered and yours and Alice's were among them. He was always fond of both of you.'[28]

INTO THE NEW CENTURY

O NE day [January 12, 1901] John and Ida came to see us; they had been married that very morning, they said.[1] We gave a small party to celebrate their wedding, to which Ida and her mother, Ida looking exquisitely virginal in a simple white dress, Conder, Gwen John, Steer and Tonks, McEvoy and my brother Albert came; but of John there was no sign. Someone said he had met John early in the afternoon on his way to take a bath; and then John arrived, in a check suit, with earrings in his ears. During the evening charades were played; one scene represented the Slade, with Steer teaching. He who played Steer looked long in silence at a canvas on an easel, then turned to him who played the student and remarked, 'How's your sister?' This, John swore, was a perfect version of Steer's teaching!

Orpen didn't come to the party. He wrote: 'I hear it was a great success. Miss Grace was not at all well all the afternoon . . . so it was too late to go.' 'Miss Grace' was my wife's youngest sister; ever since the summer at Vattetot she and Orpen had been meeting, and we were not surprised when, some time after John's marriage, Grace Knewstub and Orpen became engaged.[2] My wife sat to me for most of my pictures, and my sister-in-law copied her clothes, and sat like-wise to Orpen. Thus, for a time, Orpen's pictures were confused with mine; indeed I think Orpen would have agreed that at this period he was somewhat influenced by my 'interiors'. But Orpen was much more skilful than I was; his merits won immediate recog-nition. Robbie Ross used to say that people came into Carfax and prostrated themselves before a John but went off with an Orpen. But John, whose first paintings were of uncertain quality, was beginning to show promise as a painter too. His mastery of drawing astonished me more than ever, while no one living had his range of sensuous, lofty and grotesque imagination. Quite suddenly he achieved a striking portrait of an Italian girl, a Miss Cerutti, who

lived in the house where he lodged. This portrait was followed by
another of Rosa Waugh, and one of his wife, holding a basket of
flowers, the hands of which were beautiful, though finally he spoilt
the freshness with bad glazing. That was the worst of John; he was
impetuous, undisciplined, and had scant respect for his materials.
But I thought this portrait of his wife masterly; and when it was
shown at the New English Art Club, I persuaded my brother
Charles to buy it for £100.[3] Steer and Tonks were critical, deeming
it wrong for one so young to ask so large a price, forgetting that they
were bachelors, and both had comfortable posts at the Slade School.

I remember sitting one evening at the Café Royal with Steer and
George Moore. Moore was ridiculing my praise of John's drawings.
'Why, the man can no more draw than I can! Ingres could draw,
Degas can draw; when I see a drawing I know at once whether a
man can draw', and so forth, when John himself strolled in, and
seeing us, sat down at our table. Truth to tell, John had been dining
well. He took no notice of Moore, though I dare swear he knew who
was with us. Moore tried to engage his attention, but John remained
silent, while he took out a sketch book, and made as if to draw,
doing nothing, however, but scribble. Moore, flattered, imagining
John to be sketching him, sat bolt upright, not moving a muscle.
When John, tired of scribbling, shut up his book, Moore asked to
see it, and turning over the pages, said unctuously, 'One can see the
man can *draww*.' O tempora! O Moore! I said to myself, inwardly
laughing. And Steer, too, shook gently.

Since he was now married, John needed more money than
hitherto, and being invited to take charge of the drawing and
painting school at Liverpool University, he decided to go north, for
a time at least. Ida John, too, settled down in Liverpool, though
since she and John wrote from several addresses, settled down is
perhaps a euphemism. More than one exhibition of John's drawings
and paintings was held at Carfax. He depended on this little firm,
which served him well; and again he wrote: 'I would paint any man
a nice big picture for £50 if he paid down £25 first.'[4] But no one bit.

In 1901 our first child was born. We named him John. Augustus
John was pleased to think we had him in mind: 'And you have
called him John. My vainest of hearts refuses to deny itself the grati-
fication [and] the pride you have unwittingly but fatally laid in its
way like a snare, tho' my mind is well aware of your intention in thus
reviving and propitiating the memory of that distinguished figure

John of Gaunt (or can it be Prester John?). I hope in confessing such a weakness I exonerate myself from a portion of it.'[5]

I had written to John that I was asked to have a one-man show in Berlin, at Schulte's, then the most visited of the Berlin galleries, and my friend von Hofmann advised me to accept.[6]

I am going to Germany in January—they are going to have a show of my work in Berlin—to me an absurd proceeding, but it gives me a good excuse for seeing some of the galleries. (WR to Margaret Woods, October 17, 1901. RP: HL.)

While my show was on, I stayed with von Hofmann, who was now married. The exhibition received a good deal of notice, both in the press and from artists, and though only one of the paintings was sold, the Print Room of the Kaiser-Friedrich Museum acquired some prints, and Max Liebermann bought some of the drawings.[7] At the von Hofmanns, I met a Norwegian artist, Bernt Grønvold, an ardent admirer of Adolf von Menzel, whom Grønvold took to my exhibition. Then came a message from Menzel: 'He was glad to find a young man who still took pains over his work; he would be glad to see him at his studio.' Grønvold told me, too, that Menzel would sit for a drawing; he had praised my portraits.

As I mounted the long flights of stairs that led to his door, I wondered at Menzel's endurance; for he was a very old man and there was no lift. In answer to my knock, Menzel himself appeared and led me into a large and untidy studio. I am small enough, but beside Menzel I felt tall, so short was he; and he had short arms and small hands. His head was large and quite bald, while his mouth was still firm; his eyes, slightly clouded, most showed his age. I told him how highly he was esteemed in England; that Millais and the Pre-Raphaelites had studied his early drawings, which, in fact, had inspired their own. The old man flushed and said: 'Really, am I so well known in *Grosse England*?'

He knew and admired Millais' early drawings, and Charles Keene's, which he praised highly. He also thought well of Bernard Partridge's work, which surprised me. Of his own drawings he said, 'Well, I early cultivated the habit of drawing things as though I were never to see them again.' I thought this admirable. I was inwardly excited while drawing Menzel, and after a preparatory study of his head, said I would like to do a better one. This Menzel understood: 'One

is often nervous during a first sitting; *nicht wahr?*' I might come
again, once, twice; he had plenty of time to spare; better make a good
job of what one was doing. But next time I must stay for lunch.[8]

Well, next time, after sitting, old Menzel began to show me his
drawings, which he took from countless paper folios. We went
through a number of these, forgetful of time. Suddenly Menzel
looked at his watch. His face fell, and he seemed embarrassed; would
I mind, he asked, lunching below in the Friedrichstrasse? But of
course I didn't mind, and he took me to a famous restaurant where
he was treated with marked attention. He drank his bottle of Rhenish
wine with his lunch; not bad, I thought, for a man of his age, for he
was eighty-seven. He was born the year of Waterloo, he said with
pride, and had known many of Blücher's veterans; and he told me
how, when he was painting historical pictures for Kaiser Wilhelm I
—'My Kaiser', he called him—some of the great generals and cour-
tiers were inclined to be difficult, but 'the Kaiser, he would always do
exactly as I wanted, and sit or stand without any complaint, keeping
his pose, until my study was done.' We talked of Degas—'Das ist
ein tüchtiger Mensch!' and he told me how he had attended an
artists' banquet in Paris as an honoured guest, and had met all the
famous French painters there, among them Puvis de Chavannes,
whom he had shaken warmly by the hand, saying 'Grand payssa-
chiste! Grand payssachiste!'

After a while the old man began to get sleepy, but he would not
return to his flat before he had taken me past the Palace, where the
Guard, he being an Excellency, stood to attention as he went by. He
was pleased, I think, that I should see him thus honoured. He took
my arm as I walked back with him to his door; and now he had all
those stairs to climb! I went on to the Pariser Platz, to the Lieber-
manns. A singular thing, I told them, that an old man like Menzel
should go out to lunch at a restaurant, down all those stairs and up
again. Liebermann was highly amused. 'Don't you know what
happened?' he said. 'Menzel lives with a sister, as old, or still older
than he; *eine alte Hexe*, who rules him with a rod of iron. If he is a
minute late the dining room door is shut against him, and he must
go out for lunch!' Incredible! a man of his age and fame to be treated
thus!

I was eager to acquire one of Menzel's drawings; but he wouldn't
hear of such a thing. But he would give me a drawing to take back to
England; and after sitting he got out some of his folios. I was too

shy to ask for any particular drawing, leaving it to Menzel to choose one he could spare. But he lovingly handled each drawing in turn and slipped it back; and after some time, remembering what happened before, I prepared to take my leave; alas, Menzel either forgot his promise, or could not decide to part with anything. 'You should have taken one,' Liebermann said afterwards. 'He would have been quite pleased; but he can't ever make up his mind to part with any special study; besides, that old devil of a sister tries to prevent him giving his drawings away; she is to inherit everything; though Menzel might well outlive her.' But in the end 'the old witch' outlived her brother.

People in Berlin were friendly and hospitable. We were much entertained by, among others, the Lippmanns. Friedrich Lippmann was Head of the Print Room of the Kaiser-Friedrich Museum. He was proud of his early German paintings, which were hung on a gold background, and he asked me to paint him and his wife (a lady whose substantial proportions were as striking as his) sitting beside his pictures. I made what excuses I could; I was not an illustrator of fairy tales, and the subject of such a picture could only have been that of strange monsters guarding fine treasures.

Lippmann, whose reputation as a expert stood high, was outspoken, at times crude. One night, at a dinner-party at his house, Lippmann, becoming impatient with tedious talk of orders and decorations, a common topic in official society, 'Herr Rothenstein,' he bellowed in his loud, gutteral voice, 'give me your Rembrandt drawings for the Museum, and you can have any Order you like!'

I feel the strain of being always in a family circle, no common friends to talk of, ignorant of music and German art and literature, and you know how dull I get when I have no human, moral or artistic subject in common with anyone—I find the Kekulés terribly hard to talk to. Anything morally broad is to them 'social democratisch' and as friends and loyal supporters of Kaiser and State, that is the last word of withering criticism they can utter. (WR to Alice Rothenstein, March 29, 1902. PC.)

I had just finished my portrait of Herr and Frau von Kekulé, when I met Gerhart Hauptmann. What a beautiful appearance! a strong, well-shaped nose, and a sensitive, finely chiselled mouth, and hair

brushed back from a radiant forehead. An immediate sympathy sprang up between us; Hauptmann was then a mere name to me; I had read none of his plays, but felt at once that here was a man. He pressed us to come to the Riesengebirge, in Silesia, where he lived; I would find the landscape inspiring, he promised.[9] What a happy change it was from Berlin! And what splendid hosts the Hauptmanns were! Hauptmann's views on life were large and generous. Artists, he said, should live proudly, as Dürer and the great German craftsmen had lived, putting on fur-lined gowns and gold chains as it were at the end of each day's labour. We had neither fur-lined gowns nor gold chains; but every day we sat down to a table glistening with silver and glass. We drank choice Rhenish and Mosel wines out of great Venetian glasses; huge salmon were handed round, boar's head or saddle of veal, dish following dish; I was put in mind of the feasts in Harrison Ainsworth's *Windsor Castle*, of which I had read as a boy.

Hauptmann himself thought Kipling the most powerful poet of the time; I could not convince him that England had other writers of merit. In Germany, as in France, the Boer War had undermined English prestige. Nevertheless, when the day before our departure from Agnetendorf, I asked Hauptmann, as we sat pledging one another in German champagne, or maybe in *Mai-bowle*, what I could do in return for his noble hospitality, he replied: 'Lieber Freund, a man must be as generous in what he takes as in what he gives.' But when I insisted, he said at last, with a flourish of his glass, 'I should like to be a Doctor of the ancient University of Oxford.' A romantic whim, prompted by the moment, or else the *Mai-bowle*. Soon after our return to England, while staying with Walter Raleigh at Oxford, I asked him would he do me a favour, and get a degree for a distinguished German. That was for Gerrans to decide, Raleigh said—Gerrans knew all about Germans. Gerrans was consulted and at once approved; a letter was duly despatched from the Vice-Chancellor, but when it reached Hauptmann, why, it was one of my jokes! a good joke! It was not until Hauptmann chanced to show the letter to a friend, that he was assured of its genuineness; and when the time came, Hauptmann found himself in truth a Doctor of Oxford.[10]

About this time, a young Slade student, Wyndham Lewis, came often to see us. [William] Stirling had shown me some poems he [Lewis] had written, which I thought strange and interesting, and

Wyndham Lewis would bring me his poems to read.[11] Lewis was striking looking (an early etching by John shows him as he then was) and even then showed signs of a formidable personality. He hesitated between writing and painting, meanwhile he made sensitive studies of the nude; I recall no compositions by Lewis—the imaginative and romantic side of his nature he put into his poems and into his daily life. He liked to shroud himself in mystery. After hiding for weeks he would suddenly appear, having been, he would declare, in Sweden, or in some remote country; and he would hint at a conquest. His 'conquests' seemed for the most part to be Swedes, Germans, Poles or Russians, shadowy figures whom one heard of, but never met. I was doubtful whether, indeed, he ever had left England—perhaps John knew. He certainly went later to join John in Paris. Lewis's relations with John recalled mine with Conder, an intimacy frequently disturbed by violent quarrels and again renewed.[12]

In 1902 we began to think of leaving our delectable cottage; another baby was expected, and the cottage would be too small. In my Slade days I thought, if ever I were rich, I should live in Church Row, at Hampstead, a perfect Queen Anne street. I was far from being rich, but a house there that had once been Gilbert Scott's, who had put it into perfect order, was now to let. The rent was £120—but what should have concerned me more, a block of flats, which shut out direct light from this house I coveted, had lately been built. We took the house notwithstanding.

Soon after came a note from Conder: '... perhaps you may be able to read between the lines and understand that there has been a long silence between us. I went to bed to-night but came down again to write this letter which is to say that you are the friend that I miss most.'[13] I had seen little of Conder since the episode I related earlier. For a time I had felt bitter, so bitter that I wanted to get rid of the paintings I had of his—to efface all signs of our friendship. But his letter touched me, and I answered it at once, and there followed an affectionate letter: 'I was delighted to get your letter with its friendly assurances and kind messages to us both and am more glad than I can tell you that a quarrel with one of my oldest friends has come to an end. I often felt very much to blame about the whole thing and had often meant to write before—for some time past I have tried in every way both in London and abroad to be a strong partisan of yours and I am so glad to tell you how very good I think

your work is and what great pleasure it always gives me to see it.'[14] I found Conder greatly improved by marriage—happier, gentler and more sober; and so he continued until serious illness came; and glad I was then that there was no longer coldness between us.

Chapter 9

PORTRAITS AND PLANS

HAMPSTEAD delighted me; why hadn't we come there earlier? There was the Heath, and immediately beyond it was open country. Golders Green was not yet, and the view from the White Stone Pond was not unlike that which Constable saw.

I have long meant to paint something of the crowd on the Heath. All that is 'peuple' always appeals to me strongly. There is something in real commonness that is most alluring—the bad music of the vilely coloured roundabouts—the hoarse voices of the people, the crowd's pushing and horseplay—what is it makes it all so attractive? I didn't mind the soldiers drunk at all. The August holiday is much worse in that respect, and is more like a Dionysian festival I like to think, than anything I know. (WR to Margaret Woods, June 18, 1905. RP:HL.)

And such charming old lanes and houses and cottages! At first I was happy about the house, with its panelled rooms, carved staircase and noble Queen Anne fireplace. But I came to feel its very beauty to be a defect; it was all *too* perfect, too stylish, for I was aiming at something more elemental than a Queen Anne interior. I was painting wife and child, and wished to suggest every-wife and every-child; and Queen Anne got in the way, while for portraits the light was too diffused.

I now discovered a new subject matter. Having business in the city with a solicitor, a brother of Solomon J. Solomon, and on his asking whether I chanced to know the Spitalfields synagogue in Brick Lane (a curious sight, he assured me, well worth seeing), I accompanied him there. My surprise was great to find the place crowded with Jews draped in praying shawls; while in a dark-panelled room sat old, bearded men with strange side-locks, bending over great books and rocking their bodies as they read; others stood, muttering Hebrew prayers, their faces to the wall, enveloped from head to foot in black-bordered shawls. Here were subjects Rembrandt

would have painted—had indeed, painted—the like of which I never thought to have seen in London. I was much excited; why had no one told me of this wonderful place? Somehow I must arrange to work here. But to draw in a synagogue, I was told, was out of the question, was against the Law. The Jews here, I saw, were suspicious of strangers; they had lately come from the ghettoes of Russia and Galicia, and were fanatically strict; so strict that they rejected the authority of the Chief Rabbi who, in their eyes, was unorthodox. I was suspected, since I was ignorant alike of Hebrew and of ceremonial, of being a missionary from a society for the conversion of the Jews. They believed that if I painted them, I would sell the pictures to churches. Now and then a few good-for-nothing rogues were converted for a handsome price, I was told. Determined not to waste a subject so precious, I took a room close by in Spital Square, where at last I persuaded three or four men to sit. Here I worked for two years, painting eight pictures in all.[1] It was the time of the Russian *pogroms*, and my heart went out to these men of a despised race, from whom I too had sprung, though a stranger among them. Sargent wanted to join me at Whitechapel, but he never found time.[2]

[A. E.] Housman sat to me more than once, never failing to tell me how repellent he appeared to himself in my drawings.[3] Housman, with Hudson and Conrad, whose acquaintance I made about the same time, I think of especially in connection with our house in Church Row. Hudson would walk in with his strange, rather crab-like walk; very tall he was, a little awkward as he sat himself down and disposed of his long limbs, folding his large, beautifully formed hands across his knees. He had haunting eyes, brown with yellow lights, eyes that scarcely moved in their orbits, but remained level, fixed on no particular point, held rather by memories of things past, than by what was before them. His cheek-bones were wide and prominent (once he said he had Indian blood in his veins), and his jaw seemed narrow by comparison, a narrowness emphasised by the shape of his beard. His fine, slightly narrowing brow was deeply furrowed, and his nose was that of a predatory bird. Yes, he put me in mind of those sad, caged eagles at the Zoo, whose motionless eyes look out beyond the bars of their cages, as they sit, desolate prisoners, their wings unused and drooping, through the long dull days.

I never tired of drawing Hudson. He was a willing sitter, though he too disliked my drawings, thinking I made him look too old and

worn. He could not bear the idea of growing old and concealed his age. Ford Madox Hueffer, coming in one day while I was drawing Hudson, suggested I should draw Conrad, and seeing Conrad shortly afterwards, for Conrad was living at The Pent, the farmhouse where [Walter] Crane had stayed, which now belonged to Hueffer, he spoke to him about sitting, whereupon Conrad asked me down for a weekend. He was then writing *Nostromo*, and working himself into a fever. In addition he suffered much from gout, and his wife, Jessie, had trouble with her knee. 'I can't get anything out of myself quickly,' he said. 'It takes me a year of agony to make something like a book—generally longer. And, my dear fellow, when it is done there are not more than twenty people who understand *pourquoi on se tue pour écrire quelques phrases pas trop mauvaises.*'4 There was always an element of strain in Conrad—an excitability, which may have been individual, or may have been Polish—I cannot say. Perhaps something of each.

During 1903 Rodin came to England again.* I took him down to

*Rodin became President of the International Society in 1902, and his visits to England were major events. Albert Rothenstein sent his parents an ecstatic and delightful description of the 1902 visit: 'I was at the great Rodin dinner on Thursday evening [May 15]! it happened thus—Tweed the sculptor, who helped to arrange the dinner, and Tonks and Steer thought it would be most charming if some of the students also welcomed Rodin so about ten Slade students and the same number of [South] Kensington students were asked to go to the Café Royal after the dinner and hear the speeches. This we did—it was amazing; everyone was there—Sargent, Alma Tadema—York Powell—Prof. Carr [W. P. Ker]—Ray Lancaster [*sic*]— Sir Charles Dilke—Lord Ribblesdale—Max—[Robert] Steele—Robbie and Alec Ross. Steer—Tonks—[Frederick] Brown—MacColl—Hawksley—Shannon— Sturge Moore—Swan—Brock—Lanterry [Lanteri]—a host of others—Wyndham M.P. being in the chair. Wyndham made a fairly good speech but was too charming and somewhat insincere. MacColl spoke wonderfully as did also Prof. Carr—we were most enthusiastic and cheered the great Master again and again—the whole company were drunk and I have never seen the like—the dinner was held in a large banqueting hall at the Café Royal—there being over a hundred people at table—but now comes the great event. After the dinner was over we got a cab—took out the horse and with Sargent on the box pulled Rodin from the Café Royal to the Arts Club in Dover St. The like has never been done in London before—it was about 12.30. We rushed along shouting vive Rodin! at the top of our voices—the Police were staggered and at first did not know what to do, but when we arrived at Dover St (which is not far from the Café Royal) they tried to arrest us. When we got there Rodin shook us all by the hand and then—then the Arts Club—the swaggerest arts Club in London—one has to be an R. A. to be a member—asked us in to supper—it was tremendous—speeches and toasts—everyone drunk. Magnums of Champagne flowing like water. Wyndham—Sargent and Rodin—Brock—Abbey—Alma Tadema and Swan all spoke and it was three o'clock before we left the table. Max and MacColl were also at this supper—it is impossible for me to describe you anything—

Lewes House, to meet Warren, and to see the Greek bronzes, gems and marbles there. These delighted him so, it was with difficulty he was persuaded to leave them. At table the talk naturally led to the subject of beauty. Warren, like so many archaeologists at that time, believed beauty to be a monopoly of the Greeks. Rodin, who would go into rhapsodies over Greek marbles and bronzes, yet was a creative artist first and foremost, getting somewhat impatient with the table talk, 'Let me go out into the street,' he said, 'and stop the first person I meet; I will make a work of art from him.' 'But suppose he were ugly,' Warren replied; to which Rodin: 'If he were ugly, he would tumble down.'

I heard from time to time of Whistler, of how ill he was, and miserable. My heart went out to him. He had never recovered from the shock of his wife's death. I remembered how happy he had been with her. Now he had taken C. R. Ashbee's house—a house with a beaten copper door, arty-and-crafty, too, inside. I wondered at his choice. Soon he was complaining of incessant noise—building was going on outside the house, and his heart was troubling him. Next I heard talk of swelling of the legs. Then came the news that he was no more. I was greatly affected by Whistler's death; he, and his art, had counted for much in my life; and he drew from me from the first, loyalty and devotion. Now I deeply regretted the difference which had prevented my giving him such to the end.[5]

Towards the end of the year 1903, I was asked to make a pastel-portrait of Leslie Stephen, who was hopelessly ill, for Trinity Hall, Cambridge, his old College. So near was he to death, I felt awed in his presence. He looked painfully worn and sad, but resigned; while every word he spoke was significant, for me, from the knowledge that he was soon to leave the world.

so will tell you by word of mouth when I see you on Tuesday—only let me say in conclusion that I shall always look back to Thursday as being one of the greatest days of my life—for Rodin is not only the greatest living sculptor but also the greatest sculptor the world has seen probably since the days of the Renaissance—Rodin is a wonderful looking man—very small—with a huge head and hands and exactly like Will's drawing of him. I have little of interest to write you otherwise or rather I can think of nothing for I have always had lots to do, but Thursday has made me forget all else. I have been working hard (except yesterday when as you can imagine I wasn't exactly fresh).' (May 17, 1902. PC.) Max, in his notes on contemporaries (Berg Collection), wrote: 'Rodin. Speech on envelope—Lady Robinson. hair-dresser—forelock curled like a shell [.] old peasant—pretty to see his delight. Banquet. Café Royal. George Wyndham's *voix d'or*. no contrast of simplicity. boulevard journalist—florid platitudes.'

January 31 [*1904. PC.*][6] *After lunch went to Hyde Park Gate, and started a drawing of Leslie Stephen. A magnificent head, with that touching kindness in the eyes which comes from suffering. Afraid he is very ill—when I said I was so sorry he had been ill, 'I have not been, but am ill.' He uses an ear-telephone with the greatest tact and delicacy. Was quite unable to sit—would give much to be able to do a drawing of his splendidly pathetic head, but fear useless, and felt I was a strain. He talked most charmingly at tea. Spoke of Swinburne's Quarterly article on Dickens as being without apparent attitude—I never could see what attitude he ever had in his prose, he said.[7] Spoke of Carlyle's Frederick* [*the Great*], *with especial appreciation of the part dealing with Voltaire.*[8] *Strange that Carlyle and Thackeray should have been so sympathetically eloquent about wicked or perverse people they affected to despise. Said that Carlyle never minded being painted, drawn or photographed. Had heard Mrs C. somewhat vixenish. The house unchanged since I first saw it a dozen years ago—full of that quality of serious refinement which comes in a curiously hidden way, for few of the things they have are in themselves beautiful or even tasteful, or particularly well arranged, and yet there is a sense of distinction about the whole of it.*

In 1903 Ellen Terry took a lease of the Imperial Theatre, Westminster, and appointed her son her producer. He chose, for her opening night, Ibsen's *Vikings*, and so beautifully was the play staged, so nobly were the figures grouped in scene after scene, that I felt something important had happened to the English stage. But no one, not even Max, made mention of this; and I was impelled to write to *The Saturday Review* to say that what Craig had done would surely affect the European theatre.[9]

My letter to the Saturday was dull enough—I just wanted to express my feelings about your production simply and uncritically. I was amazed that so few critics had done either you, the interpreters or Ibsen's magnificent and elemental play justice—so few, I should say, none. It is innocence, not knowledge only, my dear Teddie, these gentlemen lack. When my rich relations present my son John with gentlemen riding real miniature bicycles and rabbits that jump about in real rabbit skins, or musical clowns, he quickly relegates them to the coal box. A shilling wooden engine becomes his motor car for life, full of the most wonderful possibilities, and strongly and simply enough made to allow him to push it, sit on it, or hurl it through the air. So do knowledge and innocence go hand in hand. (WR to Craig, May 20, 1903. Bibliothèque Nationale, Paris.)

Craig wrote from the Imperial Theatre: 'Your letter to the Saturday Review was as pleasant as it was unexpected. Max didn't quite manage it. Tell him when you see him that if possible I shall put my next production round a realistic play. "Much Ado" will please the others a bit ... I don't think any will be able to giggle about it. I am especially glad you saw and liked the Vikings ... for you see and dislike so much.'[10]

Notwithstanding the unique beauty of the production, *The Vikings* ran for little more than a fortnight; *Much Ado About Nothing* followed. This again was a glorious production. Ellen Terry herself played with her wonted grace and charm; but her season proved a failure, and no other London manager beckoned to Craig. But keen-eyed Kessler saw what Craig was after; I must bring Craig to see him; he must get him to Weimar. However, the Weimar plan didn't materialise; instead of Weimar, Craig went to Berlin. He wrote to me while I was in Yorkshire: 'I've had a long charming letter from Count Kessler—and I don't seem to be able at all to show him that I feel certain that my visit to Weimar would merely end in my returning after a very pleasant waste of time.

'I can do nothing talking to Dukes, Grand Duchesses and Poets with a court actress or two thrown in—

'I have had so much experience of these *discussions* about a production.

'If only he or the duke would make me a definite offer I would then make a definite answer.

'As I have told him I can do nothing without first reading the play—secondly I can do nothing unless he can assure me that absolute power will be given me over *play*, *actors and actresses*, scenery costume and every detail in the production.

'You see, my dear Will, it is the only way to do the work and probably the Grand Dook [of Saxe-Weimar] will see me to 'ell before he'll give me full powers. His poets, and actors AND *actresses* and even horses would all be up in arms against the idea—there would be mutterings of resignation and Weimar's actors would all leave in a body for Berlin—

'But if I am to do the work some definite proposal can *easily* be made same as in any business affair—and I can then take it or leave it.'[11]

We went to Yorkshire for the summer [of 1904], to Hawksworth, a village but a few miles from Bradford. During this summer

Bradford opened its new Art Gallery, and wished to mark the occasion with an important exhibition of pictures. They asked Masefield, who had organised the Wolverhampton Exhibition so well, to act as secretary. We got together what was probably the best exhibition of contemporary art that had yet been held in York-shire, not without opposition from Bradford however. They thought we were being too revolutionary. Some members of the Academy must have frightened them, for all of us then, except Swan, were outside the fold. As for Swan, he backed out before the exhibition opened. The exhibition, however, drew crowds of people, and was a great financial success.[12]

While I was at Hawksworth I heard from Conrad. His letters sometimes made painful reading, so harassed he was by expenses— worse still, by old debts. When I returned to town, I spoke to various friends and Hugh Hammersley, Henry Newbolt, W. P. Ker, Gilbert Murray and others helped to relieve Conrad from some of his pressing difficulties. Later Henry Newbolt and Edmund Gosse approached Mr Balfour—was there no fund for such a man as Conrad? Balfour went off to Scotland, taking with him half a dozen of Conrad's books, which so impressed him that he arranged for a substantial sum to be put at Conrad's disposal.

Conrad told me some little time ago that his earnings during the 10 years he has been writing were £1400. In correspondence, in spite of the help he has had from the Literary Fund, he has always been in difficulties. What has largely contributed to his present ones, besides his wife's seri-ous illness, was the failure of Watson's bank. Watson himself liked Con-rad and knew, I fancy, of his difficulties, and allowed him to overdraw, with the consequence that Conrad had to refund an overdraft of £350. This sum I believe was advanced him by his agent Pinker on his present story he is writing for Harper's, with whom he has, for 2 future works, excellent contracts. I rather fear most of the money due to him for his present story (Nostromo) will have been advanced him by Pinker, and the painfully slow habits of work which Conrad tells me are his will not allow of his producing the other two before three years.[13]

His wife broke both her knees, and at the same time developed heart trouble a few months ago, at a time when I fear there was very little money in the house: her condition is still serious, and the knowledge of his unsatisfactory circumstances has been seriously depressing Conrad, who wishes to take her away, or send her to a home, and yet feels he ought not to lose a day in writing, so that he may earn money sufficient to

enable him to do what he wishes for her. He has one son, six years old. I believe he has had to help his wife's family. I know he sent her sisters to school. I fear he has no savings, and a policy of £500 is in his agent's hands, as security. His contracts with Harpers are for £900 each. I have borrowed £150 for him, to which I have myself added £50, to ease his immediate difficulties, and I am trying to get £300 more, to put his affairs on a proper basis. This sum he promises to repay in 3 years' time, before which it will be impossible for him to carry out his part of the contract. You asked for precise information, which I have given, without asking Conrad's consent, to the best of my knowledge. I hope I have not done wrong, but I know the information is safe in your hands. WR to Gosse, July 12, 1904. Brotherton Collection, Leeds University.)

Mr Balfour appointed Newbolt as a kind of trustee for the money, an arrangement which Conrad found irksome. Conrad, as often happens in like cases, had underestimated the sum needed to pay off his debts, and was not therefore relieved from worry, as I had hoped.[14] He was then finishing *Nostromo* and wrote from the Pent Farm: 'What the book is like I don't know. I don't suppose it'll damage me; but I know that it is open to much intelligent criticism. For the other sort I don't care. Personally I am not satisfied. It is something—but not *the* thing I tried for. . . . But I am ready for more. I don't feel empty, exhausted. I am simply joyless—like most men of little faith.'[15]

Hudson, too, was poor, but he spent much time wandering about the countryside, and needed little. It was some time before we discovered that Hudson was married. One day he spoke of his wife. 'Married!' said my wife, 'and you never told us. How long have you been married?' 'As long as I can remember,' was Hudson's answer, the gloomiest verdict on married life I have ever heard. Mrs Hudson owned a large, dreary house at Westbourne Grove, of which she and Hudson occupied two floors; the rest of the house they let to lodgers. Poor Hudson, so fastidious as a writer, lived with the most forbidding furniture, the commonest pictures and china, the ugliest lace curtains and antimacassars. No wonder he chose poor illustrations for his books. It irked me to see a man of a nature so elemental, living in this lodging-house atmosphere. His peculiar, mysterious charm was indescribable; something about him tore at one's heart, so lovable he was. Yet he never invited affection; he was a lonely man, with something of the animal about him, walking away, and returning with the nonchalance of an animal, and then disappearing again.

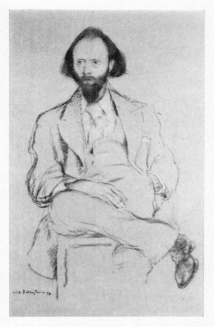

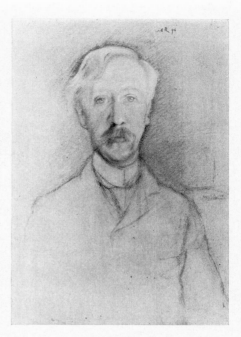

10 WR *Arthur Symons* 1894 11 WR *George Moore* 1896

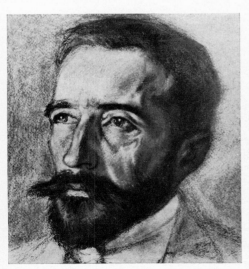

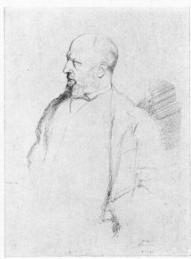

12 WR *Joseph Conrad* 1903 13 WR *Henry James* 1898

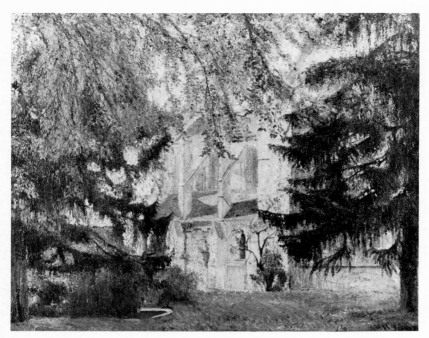

14 WR *French Cathedral*
1906

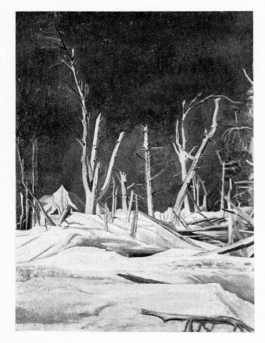

16 WR *Trees. Bourlon Wood,*
Western Front 1918

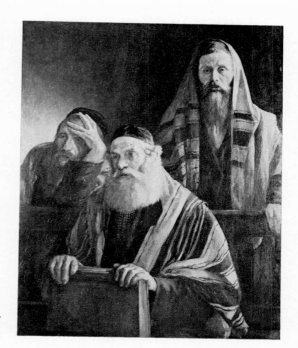

15 WR *Jews Mourning in a Synagogue* 1906

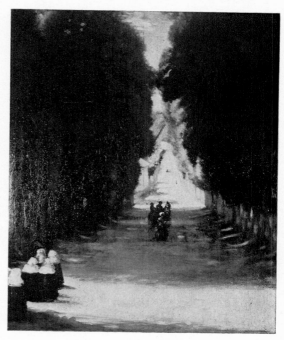

17 WR *The Avenue* 1891?

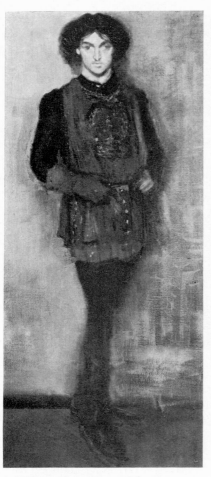

18 WR *Sir John Martin-Harvey as Hamlet* 1898

19 WR *L'Homme qui sort* (Charles Conder) 1892

During 1904 a few of us met together with a view to starting a small society of draughtsmen, etchers, wood-engravers and lithographers. Muirhead Bone was the leading spirit; the original members were Bone, Cameron, Clausen, Conder, Gordon Craig, John, Legros, Sturge Moore, Nicholson, Ricketts, Shannon and myself. We called ourselves the Society of Twelve. Bone was the most generous of men. I had a passage of arms with him once, a small matter, a question of the election of Lucien Pissarro to the Society of Twelve—during which Bone was handicapped by his kind nature. Ricketts and Shannon for some reason opposed Pissarro's election. Bone was uncomfortable, but took his stand on the question of Pissarro's nationality. But I was tenacious, and many letters passed between Bone and myself, until Pissarro was admitted.[16]

I went over to Paris during 1906; Conder was having a show of his pictures at Durand-Ruel's Galleries, the last he was destined to hold.[17] I noticed, while sitting with Conder and his wife, he would grow suddenly irritable; but this is no unusual thing between husband and wife, and Conder seemed to be enjoying Paris as of old. Soon after Conder's return to London, Mrs Conder came to me, in great distress. Conder had been very queer; he had long periods of weakness and she feared his health might be permanently affected. I was anxious, knowing how reckless with his strength he had been, and his letters had in them something sad, though with the old enjoyment of beauty: 'I was delighted to get your postcard, and I envy your pilgrimage to Courbet's home—when I was in Paris his work attracted me I think more than anyone else's after Fragonard and Watteau. The horrible *obvious* pomposity of the so-called *great masters* is too much for me—I confess.'[18]

I was thinking of you and your letter all day, and my heart went out to you all the time I sat painting, and all the time between. . . . I often wonder whether my friends realised how ridiculously green and young and inexperienced I was in those days. Because my mind was rather active I think people thought it was also developed somewhat, and this I am sure it was not. So I know what a lot you must have had to put up with from my extreme youth and fecklessness And to you, dear Conder, may I say to you once in a letter, I love you, love you very dearly. And although Newquay is a long way off, I have a constant vision of you by a turquoise sea, vague to the eye, but sharp and living in

the mind, all this time. And if will to make you feel this can be of any
service, you at Newquay will know *it. (WR to Conder, September 8,*
1906. Boston Public Library.)[19]

Meanwhile John had joined Orpen in starting a school in Chelsea,
which, proving successful, was to be taken over by some other
painter; they were to be paid £200 for the good will on condition
that they continued to teach.[20] Scarcely was the agreement signed,
when John was again sounded about Liverpool, where there was
talk of Lever founding a new University chair of Art. John consulted
me; 'An excellent proposal, dear John,' I said, 'but aren't you bound
by your recent agreement?' 'Only morally,' was John's laconic reply.

About this time a stranger came to see me, bringing a letter from
Bernard Shaw. Epstein was a young sculptor with a powerful head
and frame, determined looking, enthusiastic. His people were
Russians who lived in New York, he told me. He wanted to work in
Europe, but had no means. Shaw couldn't help him; he thought his
drawings mad, like burnt furze-bushes, he wrote; but Epstein
deemed I would think otherwise; so Shaw sent him to me. He showed
me his drawings, illustrations to Walt Whitman, which were intense
in feeling, if somewhat thin and tenuous. Judging from the style of
the drawings I believed he would find more sympathy in Paris or
Berlin than in London. But Epstein replied he had reasons for
wishing to work in London. For the moment he must return to New
York, but must somehow get back to England again. A friend of
Epstein told me that his parents would not hear of his being an
artist; if he remained in New York they would ruin his career.
Perhaps if I wrote to them they might be persuaded. There was a
brother, too, who might help. Of course I would write, but would
a letter from me be of any use? Somehow Epstein did manage to
return from New York. I approached a Jewish society and persuaded
them to assist him; and with further small contributions, Epstein
was just able to live and work for two years.[21] With a small shed for
a studio, he began to model Rodinesque figures, wanting in form, I
thought, but with a strange and uncouth power.

I don't think I can manage to get the money for the casting this week,
but will write you directly I can promise it. I had no idea you intended
having your group cast so soon. I admire the conception immensely, and
some parts of the figure seem to me excellent, but other parts very in-

complete, and I am rather sorry you contemplate it as so nearly finished
that it can be cast within the next few days. I cannot rid myself of the idea
that sculpture, most of all forms of art, occupies itself with the perfection
of form, and it is of no use pretending that I consider see this perfection
in your group. I do not refer to the smooth characterless decadent model-
ling of most contemporaneous sculpture, but to the nervous and radiant
expression yet nervous form to be found seen in all excellent work fine
pieces of sculpture. You have an unusually fine, robust and fundamental
vision of what your work should be, which should give you an unique
place among men of your craft. . . . You may think that views of mine on
a question of this kind are not required by you I want to write you this,
not because I think it the finest thing a man can do with his life is to
devote it to making the creation of fine works of art: and as no humbug is
put into such things, there should be none said about them: I have as little
sympathy with the bourgeois ideas as you have, but I should blame
myself if I were to give don't like to pretend. (WR to Epstein, undated
draft [1907?]. RP:HL.)[22]

Epstein never complained of having to live on a very small sum,
but worked ceaselessly. Then came Adams and Holden, those
paragons among architects, who were planning a new building for
the British Medical Council. They at once realised Epstein's power
and proposed he should fill certain spaces on the façade of their
building with symbolic figures. After fourteen months' work on his
figures Epstein complained bitterly that, on the score of indecency,
secret malice and enmity seemed likely to bring about the destruction
of his conceptions.

A very dastardly attack is being made on some work Epstein has done
for the new medical society's buildings in Agar St (almost opposite
Charing Cross Station). The figures are actually archaistic and ascetic
in character, but the police have been called upon to take action because
of the nudity of one or two of the figures, and there was a most shameful
article in the St James's [Gazette] to-night on the subject.[23] *Will you go*
and see them, and help, if it is necessary, to assert the decency of the man
who did them. It is Epstein's first commission, and he is terribly upset:
clearly he is the victim of something very like malice from some unknown
quarter. Some of the figures are hidden by the scaffolding, but all those
facing the Strand are clearly visible. There is a great crowd outside be-
cause of the scandal reported to exist: I enclose cutting from paper which
will show you the spirit of the attack. (WR to MacColl, June 19, 1908.
Glasgow University Library.)

I am very glad indeed you had already seen Epstein's remarkable figures. I now understand, though it seems hard to believe it, that the committee propose meeting to-morrow, to decide on the part-removal of the work. This would be a most monstrous piece of injustice and must in some way be prevented. The sec. of the British Medical Association . . . will put any favourable letters before the committee, so if you would write him at once I am sure your letter would be of very great service to Epstein. I wish we had some body which had a sufficiently responsible position to intercede officially in a matter of this kind. (WR to MacColl [June 23, 1908]. Glasgow University Library.)

Besides the architects, John, McEvoy and myself wrote strong letters to the authorities defending Epstein, and finally the work was left undisturbed. And, as usually happens after all the fuss no further objection was made, and the building with its figures remains one of the most significant examples of modern architecture in London.

The Johns were then living in Paris; Ida was expecting another baby. Suddenly there came a telegram, saying that she was dangerously ill. My wife too was expecting a baby; she could not have gone. But I should have hastened to Paris on receipt of the telegram, even though we were on the eve of moving—and there were other circumstances that made me hesitate—before it was too late. I never forgave myself for this hesitation; in my heart I knew I should have gone at once, as McEvoy did, to whom John also telegraphed. I was never to see Ida again; her beauty and her light were gone.[24]

SOME COMINGS AND GOINGS

D URING 1906 Charles Holroyd was made Director of the National Gallery. He was succeeded by MacColl at the Tate, at which the Academicians were not displeased, for as Curator of the Tate Gallery MacColl became an official and must now give up his free-lance writing in *The Saturday Review*.[1] Fry, too, had lately been asked by the Trustees of the Metropolitan Museum in New York to take charge of their Department of Paintings; but he put them off as long as he could, hoping to be appointed to the National Gallery. But the time came when he had to say yes or no to the New York Trustees, and he decided to accept. Just before sailing for New York he told me he had been offered the Directorship of the National Gallery, but the offer came too late.[2]

Fry, master of an American purse, was now courted and cajoled by collectors and dealers. It seemed strange to me that the once shy and retiring Fry should now be swimming in such dangerous waters. I saw what his difficulties were, when he asked me to accompany him to Paris, to see an important collection of paintings which was in the market. For though I was no expert, Fry respected my judgement. A fashionably dressed and attractive-looking lady showed us over the collection. While Fry was occupied, the lady joined me. What taste and knowledge Monsieur showed! was Monsieur alone in Paris? Perhaps Monsieur was married, though he looked so young—had even children? No doubt Monsieur found life expensive, and so forth. I wondered at her interest in a stranger, before I realised that since Fry consulted me over various pictures, she thought my influence of importance and was hinting at a bribe! I did encourage Fry to acquire a beautiful Renoir, about which he was hesitating.[3] Renoir had not then his present reputation. I re-collect that during an exhibition of Renoir's work at Durand-Ruel's in the early 'nineties, one of the loveliest exhibitions I had ever seen, I found myself the only person in the gallery; but there was Renoir

sitting disconsolately on a red velvet sofa in the middle of the room. I remember too speaking of this to Whistler, who shrugged his shoulders; he was indifferent about Renoir's work.

I was surprised that Shaw should have the means to employ Rodin [to model his bust]. Rodin had never heard of Shaw, but Rainer Maria Rilke, who was acting as Rodin's secretary, being a writer and a German, of course knew who Shaw was, and Shaw was received at Meudon as a great man. Rilke wrote while the bust was in progress: 'Le Maître et moi nous avons toujours espéré de vous voir passer encore une fois à Meudon avant de votre retour en Angleterre; vous auriez dû venir partager encore quelques jours notre vie paisible, et Rodin aurait été ravi de pouvoir vous montrer le buste de Shaw qui s'avance merveilleusement et qui, dans les commencements déjà, vibrait de vie et de caractère; ce que ne serait point accessible, si M. Shaw n'était pas ce modèle extraordinaire qui pose avec la même énergie et sincérité qui font sa gloire d'écrivain.' I believe Shaw tells the story that Rodin made his bust without knowing anything about him: Rilke's letter shows that Rodin was well aware of Shaw's 'gloire d'écrivain'.[4]

During the autumn [of 1907] Bernhard Berenson asked me to come out to Florence to paint his portrait.[5] The cognoscenti in Florence had just discovered Cézanne; Loeser had bought several of his smaller landscapes; but there was already a large collection of Cézanne's work in Florence, that of Signor Fabbri.[6] It was through Anquetin in the early 'nineties, that I first became acquainted with Cézanne's paintings; one could see them at Vollard's, and at one or two other picture-dealers. But it never occurred to me, nor to anyone else at the time, that Cézanne would become an idol to be worshipped. I thought him a puzzling and provocative artist; his pictures seemed awkward, but yet had a strange and powerful honesty, so that despite his lack of skill, they had an intensity which was denied to the pictures of men of greater natural capacity. What impressed me, too, was the way he scorned to hide his defects; what mattered defects, when his aim was so far ahead of what he, or any painter, could ever achieve? But to assert that he did what he wished to do, that he was in fact, a great master, is—it appears to me—to miss Cézanne's importance as a painter. It is for his integrity, his dogged tenacity in the pursuit of a certain grandeur he saw, but could not represent adequately, that he is to be considered, tenacity in attempting again and again, despite failure, the unattainable.

I forget what it was that Loeser admired so much in Cézanne, not I think the third dimension or volumes, for these had not yet been invented. Still, I was thankful to see anything so fresh and vital as a Cézanne painting in an Anglo-American-Italian interior. The palatial rooms in which the scholar-aesthetes lived, their massive Italian furniture, their primitives, bronzes, wood-carvings and Venetian stuffs which one was expected to appraise, wearied me. Everyone lived among these princely things which, for all their beauty, seemed as misplaced as an enamelled and bewigged mistress in the house of a young man. The atmosphere in these vast apartments seemed heavy with past intrigue.

Do not believe that even in the fairy land in which I am now living that I am faithless to Hampstead. As I walk among the cypresses and about the steep paths round Settignano, following mountain streams and rocky glades through which I see the Dome, the Dome of Domes, and Giotto's sweet tower glittering in the sun far away below I think often of the Heath of Heaths and of a dome we see, less wonderful and significant, but dear to our hearts all the same, from our own heights. . . . And, as everywhere where gardens and terraces and villas are, such scandals, such tragic and comic stories as have come within my ken. It would seem as though whenever English, German, American lady meets Italian, high tragedy follows close upon the heels of mating: and where there is no mating there is tragedy too. Something of past horrors seems to have cast its spell upon the walls of the old villas and palaces. But how admirable they are in their grandeur and solidity, these old villas about the hills! and how vain and insignificant do most of those who now live in them appear, alas, for they are not all in the best of hands. (WR to Mary Hammersley [mid-October, 1907]. Collection F. Lügt, Institut Néerlandais, Paris.)

It was a relief to turn from such acquisitive people, to Gordon Craig who dreamed of creating wealth. He was working out his latest experiments in his *villino*—of course he had found a perfect treasure of a house—and had in his work-room an exquisite model theatre, fitted with lights, which threw mysterious shadows upon his miniature stage, on which he tried his scenes. Craig had discovered too an actual theatre, long deserted, where he wanted to produce plays, after the manner of the old *Commedia dell' Arte*. He hoped Berenson might help him; but Craig, who impressed many people, failed to impress Berenson.[7] Perhaps Berenson thought it was a pity

that the disciples who ministered to Craig neglected to mend the holes in his pockets, through which coins disappeared with alarming rapidity.

I had been reproving him for his improvident and uncompromising idealism; why not come to earth and work with others? He would willingly work with Tree, he assured me. I heard from Tree: 'I am greatly interested in your letter about Gordon Craig. Would it be possible for you to call here one day and we might then have a talk about him. I quite agree with you that his powers are remarkable but I have felt that he would refuse to work at any regular theatre and that it would be impossible for me to secure his services at any time. But from your letter I gather that I may have misunderstood him.'[8]

Tree needed some persuasion before he made a definite offer to Craig. Teddie meanwhile was becoming impatient: 'I have seen Viola Tree and spent 2 days with her talking in the hope of hearing her say "I will" ... but she said only "how beautiful"—"how fair a dream" and not "I will now go home and tell papa to be quick and invite you over".

'I have also written to Whelen who is secretary to Tree, and who I hear is clever and quick.

'But I have had no answer

'So much for

'England

'my England—

'But there must be something queerly nervous about London for other cities here [on the Continent] have responded to me.

'I have been asked to Berlin, Moscow—Warsaw and Budapest ... possibly to St Petersburg ...

'So all being well I shall go on a swift and short tournée to each of these cities at once.

'How nice it would be to call in on London and stay a while at the Carlton Hotel. We could make quite a little fête of it—and you should find no sorrow for a few days at any rate for you could put off your spectacles.'[9] Finally Craig came over to London, dissolved Tree's doubts, and at once set to work on designs for *Macbeth*.

... now Tree wants to use the least you have to give him, and you will do what he wants, and I know we shall have the best such a man can give us with you behind him. But I know how little that will be compared with what may some day be possible, if you have luck. ... I am glad it is to be

Macbeth, for you will do wonders with the chances the play offers you—
if only Tree weren't such an ass, and he had other than asses in his
company. (WR to Craig, September 25, 1908. Bibliothèque Nationale,
Paris.)

You will be amused to hear that Tree—I suppose having failed deservedly
with his miserable Faust, finding stupidity and vulgarity don't even pay
he is determined to try decency as a last venture—has sent for Craig,
who is now busy setting Macbeth for him in London! So our visit wasn't
in vain after all, and your presence on the settee was not so ineffective as
Mr Tree might have supposed. You must meet Craig when you come to
London. He has been supping with Alice, but I haven't seen him yet, and
is in excellent spirits at the prospect of Macbeth. He is quite sure to make
it magnificent, only Tree doesn't deserve it. (WR to Frances Cornford,
September 28, 1908. The British Library.)

Tree was delighted, and for a time it looked as though we were to
have a great interpretation of a Shakespearean play. Clouds gath-
ered; suddenly Craig proposed that Tree should leave London and
himself in charge of his theatre! Alas, it was Craig who left London;
and Tree, and Craig and all of us were the poorer for missing a
unique production, worthy of Shakespeare's *Macbeth*. Craig had
fallen out, too, with Brahm in Berlin.[10] But he got his chance with
the Russians. The Russians! of course, they were just the people to
appreciate Craig; and appreciate him they did. They thrust *Hamlet*
into his arms, Hamlet, King, Queen, Polonius, Ophelia and all, and
then argued about each of these characters day after day, night after
night—for what is time to Russians? The play must wait until every-
thing, down to the smallest detail, had been discussed to exhaustion.
I got an enthusiastic letter from Craig: 'I am in Russia—and the
theatre here has asked me to be their Régisseur or stage manager and
for Life!

'God, dear Will this kind of thing takes one's breath away. It's
like a leap year proposal—heavenly because so innocently new. And
who knows if I won't be ever at the disposal of this theatre which has
prevented applause—by presenting its actors appearing to bow
before the curtain—this vivid theatre which has dared to waste years
in the production of one piece—this darling theatre which is so
generous that it gives its audience a 30 hours' show—bless its inno-
cence. If I loved anything but a theatre which must obliterate the
theatre I would stay here for ever and do my dull best—but *I* must

do my gambling *worst*—must risk all and again all to drag the soul of the theatre out of its cursed body and free it of all tricks and trappings—then—then—others!!

'Tree disgusts me—the charming fellow—I could murder him with *great pleasure*.

'Here they are all so good—so true—so wildly believing in it and its trappings as moths the candle—their faith wins me back for one moment—makes me *miserable*—and them—terribly happy....

'I wish you were here—I have lived 2 days here and lived a year in each. 1st day three angelic creatures took me out at 11 o'clock at night and fêted me till 6 next day. Folk songs—dances—motors—flying from Volgas over Dons into Niepers—speeches—such as "You are a splendid man, that I have seen in my life—Hoch!!!" One instantly leaps to his feet and dances a God's dance—nothing short of it'[11] And *Hamlet*, when it was at last produced, was a triumph. Only we heard that Craig's simple cubes, against which the play was enacted, proved more costly than the gold and glitter of traditional scenery. Craig indignantly denied the truth of this report.

A strange thing is personality; there is also a counter-charm, a touch of aggressiveness, equally mysterious, which, be the heart never so kind, and the altruism never so ready, antagonises certain persons. Hudson, too, fascinated people; but while no one could be more charming when he wished, Conrad had an aggressive side, which his friends overlooked, because of his obvious genius. Yet Conrad was nervous and sensitive, and he could be very irritable. When he liked people he would admit no faults; indeed, he was inclined to flatter—perhaps this was a Polish trait—both in speaking and writing. His letters show his anxiety regarding his future, and how much he had to struggle against ill health. 'Here I've been 2 years writing a novel which is not yet finished. Two years! of which surely one half has been illness complicated by a terrible moral stress. Imagine yourself painting with the Devil jogging your elbow *all the time*.'[12]

More than once we tried unsuccessfully to get Hudson to join us [during summer holidays at Vaucottes. He wrote:] 'I wish I could go and visit you but 'tis impossible. We were at Deal awhile and one day at Dover. I tried to drag Mrs Hudson to Calais, but she would not. I've never been in France and am quite sure I never shall now. The only place out of England I wish to go to (and hope to go before long) is New England—Maine and New Hampshire and

Vermont where my mother's relations are. I've never seen any of them nor her native place and have a sort of desire—a kind of pious or superstitious feeling—to pay it a visit. It is the red man's feeling and I am a red man, or at all events a wild man of the woods.'[13]

'I am a red man.' This explains Hudson's forlorn feeling when he must remain in London. He and his wife were at home on Wednesday afternoons, where we would meet the faithful—[Margaret Brooke] the Ranee of Sarawak, Edward Thomas, Edward Garnett, Cunninghame Graham, and sometimes Mrs J. R. Green, but Hudson didn't get on very well with Mrs Green. 'I think Mrs Green was not too well-pleased with me for what I said about her wings, aigrette and bird of paradise plumes. But I say what I think and shall do so till I die, even if it results in alienating the last friend I have on earth.'[14] But what Hudson said alienated nobody; no man had more devoted friends.

While I was staying at Bradford [in February 1909] there came a letter from Max, telling me the news of Conder's death.[15] This, though not unexpected, was a blow no less. So much of my life had been bound up with his; we had loved and quarrelled, and parted and come together again.

My dear Mrs Conder— . . . I feel like a fool, sitting here unable to be of use, and no one of us can be of any use or comfort to you at present. And the old days are crowding into my mind, and I can't bear to think of Conder suffering somewhere, and I sitting here useless. It may be difficult for you to understand how deeply I feel what you write—I don't think many people quite understand how closely Conder and I have always in a certain curious way been united. . . . no one has done a life's work in so short a time as has Conder, or been able to express such a vision of beauty in our day as he. (WR to Stella Conder, July 10, 1906. Boston Public Library.)

In some ways Conder was more adventurous than other painters; he was instinct with inventive powers, and could put down a complicated composition with ease and ability, giving life and beauty to his figures. His art was based partly on his sense of style, of gesture, of artificial comedy, in a word, the comedy of Davenant, of Congreve, and of Watteau and Fragonard; and in large measure too, on his subtle observation of actual life. Each side of his nature helped the other. His richly suggestive art is at present underrated; but its vitality, when the moment comes, will blossom again in men's eyes.

Chapter 11

A POST-IMPRESSIONIST EXHIBITION

I GOT into touch with the Arts and Crafts movement through Eric Gill, who taught lettering on stone at the Central School of Arts and Crafts, of which Lethaby had been Principal.[1] I admired Lethaby's integrity and learning, but he was inclined, as were others connected with Morris, to say 'No' to life. Perhaps, among themselves, these men said 'Yes', but they made me feel that we painters were doubtful characters, with second wives hidden away somewhere, and an absinthe bottle in the studio cupboard. However, my arts and crafts friends were indulgent enough towards me. I was even elected to the Committee of that admirable body, The Society for the Protection of Ancient Buildings, and a member of the Advisory Committee of one of the L[ondon] C[ounty] C[ouncil] Schools—Bolt Court, of which Emery Walker was Chairman.

It happened that [in 1908] at a dinner in connection with this school, George Frampton said he had been meaning to tell me that some time ago, he, Sargent and John Swan had put down my name for the Associateship of the Royal Academy; he hoped I would allow it to remain. I was taken by surprise for I had not been consulted, yet at the moment I felt it would be churlish to object to a generous gesture.

I heard to my surprise from Frampton on Saturday that he and Sargent and Clausen had taken upon themselves to put my name down for the Academy without consulting me: Frampton was to write and tell me, and he didn't, and I met him by chance and he suddenly remembered. I could not be churlish or priggish enough to say—no, the name must be crossed out—it seemed only decent to acknowledge the compliment. In a sort of way it is a compliment: and so there it is, and without my asking: and so if some day anything happens, you will know how it has occurred. And I know that you and your father have always been sweet to me on the subject. (WR to Frances Cornford, December 21, 1908. Cornford Papers, The British Library.)

But I was not comfortable at the prospect of joining the Academy; in due time I wrote to withdraw my name, at which my parents were much upset; to them the three letters A.R.A. were magical ones. It distressed me to disappoint them, but I believed my place to be with Steer, Tonks, John, McEvoy, and other colleagues of the New English Art Club. Some of my friends, Mrs Herringham especially, were concerned when I told them what I had done; the Academy was constantly accused of narrowness and prejudice, yet now a generous move had been made towards me. Kind things were said about my influence for good; I was persuaded to ask for my name to be replaced. My parents were overjoyed, but my discomfort persisted, and at the risk of being thought an absurd wobbler, which indeed I was, I again wrote to Frampton (who had behaved with consideration) telling him of my twice changed decision. I was then much happier; but that I had ever even contemplated joining the Academy rankled in sound New English hearts.[2]

It happened that some months before this I had been painting a lady who, though neither young nor old, yet had both charm and beauty. I failed to do her justice, and seeing Sargent's painting of the Duchess of Connaught, I admired the way in which he had overcome the difficulties which floored me, and thereupon wrote to tell him so.[3] I had forgotten this, until a friend said I should know that Tonks was saying that I had written a flattering letter to Sargent, with a view to being elected to the Academy. Such a suspicion, and one so unwarranted, upset me, and I wrote to Sargent, who replied: 'You never wrote me asking for my help to enter the Royal Academy, and I never said you did. I signed my name in support of your name as a candidate when Clausen asked me to do so. I supposed from the fact of his taking this step that you were willing to be proposed, though I never had had any intimation from you that you wished to become a member.

'The only way in which I can account for a possible origin of this gossip, is that I remember having mentioned a long time ago, that you had written me a very kind and complimentary note about some picture I had exhibited. I was then told that you had resigned from the New English Art Club. Can this have been interpreted into an electioneering manœuvre? It would have been very far fetched, but it is the only possible starting point that I can think of for this entirely unfounded rumour, which I by the way have never heard, and which I shall make a point of contradicting if I ever do.'[4]

Oxford friends, when Holmes resigned the Slade Chair, wanted me to be a candidate. I was pressed by others, besides Fisher, to apply for the chair, by Lethaby especially; but I heard that Fry was a candidate, and knowing that, at this time, he needed a platform, I did not send in my name.[5]

. . . I am not competing for the Oxford chair. I had not very seriously considered doing so, but you put my back up ever so little when I talked with you the other day, and I felt a little obstinate about it. (WR to Mac-Coll, March 23, 1910. Glasgow University Library.)

To express a word or two of truth, by lending myself to its spirit, so that it may enter into my work and my words, like a thief in the night—this is my object in life. Hence I dread leaving my work for long, lest I miss the chance, having no brush in hand, when the spirit walks my way. Twelve lectures need much preparation: and I am more wont to trust to improvisation, to quick digging down to the [voids?] of experience within, than to toil at an ordered composition of words. . . . Some day perhaps there will be a university of the fine arts, where men will learn to respect only that which is worth the dignity of noble expression, where the past shall be used to make present ideals possible, to illumine and guide contemporary thought and all triviality will be relegated to the lumber room of picture dealers. The time was when it was seemly, nay, fit and natural for an artist to glorify man, now it is the patron he must flatter, and the chatter of the drawing room informs respectful ears. . . . I hope that either Lethaby or Fry may be chosen by your Elders for the coveted post.[6] (WR to Fisher, March 30, 1910. Bodleian Library.)

But neither Lethaby nor Fry was chosen. As often happens, the 'safe' candidate was elected. But Fry was soon to find an outlet for his restless and varied energies elsewhere. The Grafton Galleries had been for some time unoccupied, and Fry thought some use might be made of them. The older independent artists, who were outside the Royal Academy, could show their work there, together with some of the more adventurous younger men. He approached Steer and Tonks, but they were disinclined to move. In spite of the somewhat strained relations consequent on the Sargent episode, I still felt the New English Art Club to be the body with which I had most sympathy. As Fry had from the first been my warmest supporter he expected that I would now support him; but since I held aloof, the good Roger, who can always convince himself as magically as he convinces others, discovered that my work was no longer of any

importance. Fry's first idea was to show a group of Russian paintings: finally he got together an exhibition of what was then, or just afterwards, called French Post-Impressionist painting, which provided a greater sensation than any collection of Russian paintings would have done.[7] Fry thenceforth became the central figure round whom the more advanced young English painters grouped themselves. He became for the younger generation what D. S. MacColl had been for Steer and Conder and other members of the New English Art Club.

Our Wednesday evenings continue to be the most brilliant entertainments of Hampstead, the refinements of Mayfair being weekly married to the rougher eloquence of the new cut. Gill is now discovered as the latest genius, he having carved some beautiful things, which Fry in a rash moment praised to Lady Ottoline, who immediately found his things too inexpressibly beautiful and is now universally eloquent on the subject to all and sundry. (WR to Albert Rothenstein, March 5, 1910. RP: HL.)

I was away in India when the [first] Post-Impressionist show at the Grafton Gallery was held. Gill wrote to me: 'You are missing an awful excitement just now being provided for us in London: to wit: the exhibition of "post-impressionists" now on at the Grafton Gallery. All the critics are tearing one another's eyes out over it and the sheep and the goats are inextricably mixed up. John says "it's a bloody show" and Lady Ottoline says "oh charming", Fry says "what rhythm" and MacColl says "what rot". As a matter of fact, those who like it show their pluck, and, those who don't, show either great intelligence or else great stupidity. The show quite obviously represents a reaction and transition and so if, like Fry, you are a factor in that reaction and transition then you like the show. If, like MacColl and Robert Ross, you are too inseparably connected with the things reacted against and the generation from which it is a transition, then you don't like it. If, on the other hand, you are like me and John and McEvoy and Epstein, then, feeling yourself beyond the reaction and beyond the transition, you have a right to feel superior to Mr Henri-Matisse (who is typical of the show—though Gauguin makes the biggest splash and Van Gogh the maddest) and can say you don't like it. But have you seen Mr Matisse's sculpture?'[8]

Yes, I had seen Matisse's sculpture in his studio in Paris. I could not pretend to like it, notwithstanding that Matisse gave an elaborate explanation of his intentions. It was massiveness and significance of form he aimed at. 'But is form merely massive?' I asked; 'may it not

be alert as an animal resting is alert, ready to spring?' I little thought when I saw this first example of the newest sculpture what was to follow. Indeed, it was puzzling, knowing the charm of Maillol's virginal figures, to meet with this sudden move away from the smooth radiance of form, akin to that which Renoir had shown in his paintings of young girls, which had replaced Rodin's more restless modelling.

I had also seen Matisse's paintings in Paris—chiefly studio-nudes. Matisse had given up his rather dry studies and was now painting violent forms with violent colours. Here were powerful studies, but how they smelled of paint! and the red hair he painted was too crude a red, the black eyes too large and black, and the drawing was over-deliberate. But Matisse was very intelligent, a man to be reckoned with. He knew his museums, had looked about him with a discerning eye, and was aware of the charm, not only of improvisation, but of direct statement of pattern. So he aimed at giving on canvas something of the quality of design which Persian potters and tile painters gave to their deft brush-work.

There is still surprising creative vitality in Europe, yet one asks one's self, seeing how naturally rich and fertile is the artistic field, whether the publicity given to artists in vogue does not corrupt many young, ingenuous natures, who, but for influences forced on their notice, would do more personal, more scrupulous work. Now advertisement itself offers scope for much ingenuity, and the effect of contemporary painting on design, on the quality and pattern of our fabrics, pottery, book illustrations, posters, book-jackets, fashion plates, indeed, on everything connected with the making of books and magazines, has been highly stimulating. Elegance and finish, disdained by painters, are happily expressed in the minor arts; much that is inappropriate to canvas and paint is perfectly suited to the crafts, and herein Picasso's influence—I once called Picasso the gigolo of geometry—has been fruitful. We are singing, maybe, the swan-song of luxury before a new social order sweeps it away.

Chapter 12

ROTHENSTEIN IN INDIA: TAGORE IN LONDON

DURING the summer of 1910 I returned to Vattetot, to paint cliffs and barns. While I was in France, Geoffrey Scott wrote enthusiastically about a Mohammedan Exhibition then being held at Munich: '. . . if you haven't yet seen it, you really *must*; cut the countesses who have booked you to dinner, put away your work, pawn your possessions, and come. I kept thinking of you when I was there today, for I know nobody who loves these things as much as you do, and to me they were a revelation,—the cumulative effect was so astonishing, and the pleasure of seeing all the Persian things in succession without anything to clash. In one way the effect is depressing, for it brings home the sense of being, racially and by culture, hopelessly out of it and separated from the finest art.'[1]

I could never understand the lack of interest in Indian art—in Indian sculpture especially. I had heard vaguely of a man called Havell, who in India was preaching its significance; but here in London Mrs Herringham alone supported me in my estimate of Indian painting and sculpture. She, indeed, who knew much more of the subject than I, spoke of going to India to make fresh copies of the paintings in the Ajanta Caves, believing she could improve on those in the South Kensington Museum.[2] Binyon encouraged her; he at least had an open mind, though he did not think Indian art compared with that of China and Japan. But I am forgetting Coomaraswamy, whom I met while staying with Ashbee at [Chipping] Campden. He had written a book on the art of Ceylon, and was now beginning to take an active interest in Indian art. He showed me drawings by Abanindranath Tagore and other artists of the Calcutta school, which he admired. He then knew little of earlier Indian painting. I had noticed the difference between paintings which were named Indo-Persian and others I called folk-paintings. Coomaraswamy was to go more deeply into the matter, and to distinguish Rajput from Moghul art.[3] But, as yet, only Indian craftsmanship was

admired by the experts. Later, when Havell returned to England, Coomaraswamy and I went with him to hear a lecture by Sir George Birdwood, who while praising her crafts, denied fine art to India; the noble figure of Buddha he likened to a boiled suet pudding! This so disgusted me that, there and then, I proposed we should found an India Society.[4]

Mrs Herringham was now planning a second journey to India; copies she had commenced at Ajanta were unfinished and there were others she wished to make. She pressed me to go out with her. I had lately seen photographs, taken at Benares, the beauty of which had greatly excited me. There must be marvellous things to paint there, so I decided to accompany Mrs Herringham to Ajanta to see the wall paintings; then I would look for suitable subjects for work. I spoke to the Ritchies about my intended visit. Sir Richmond asked me down to the India Office; he was not encouraging; he was afraid that my sympathy for Indians and for things Indian would encourage the Nationalists, now beginning to be heard through Gokhale and Tilak; I must promise to keep in touch with the officials, and to this end he provided me with letters to Provincial Governors.[5] Thomas Arnold, then at the India Office, gave me different advice and less official introductions.

I was to join the P & O boat at Marseilles. In the morning came a rumour that we were not to join the P & O boat; no one knew why. Then, while the steamer lay out in the bay, we were told there was illness on board; passengers would embark at their own risk. I did not hesitate; Mrs Herringham was expecting me. It was not long before we heard what the illness was—a case of plague, perhaps more than one. The Anglo-Indians were indignant; such a thing had never yet happened on a P & O boat, and no one could find out precisely how matters stood.

I think Mrs H and myself are actually the only 2 tourists on board, all the rest being officers and civilians with their wives, sisters, and daughters. The women mostly young, very gay and perfectly unaware, most of them, that there are any people in the world who count outside the services: would not, I think, drive Tonks and Steer to desperate resolves. (WR to Alice Rothenstein, fragment dated October 14 [1910]. PC.)

At Port Said we found ourselves isolated. At Aden again no one

might land; our ship was outlawed, an object of fear and dislike. Then, after four broiling days, we reached Bombay. Here there were no difficulties about landing; no unfriendly feeling towards us. We were soon on shore, among a brilliant bustling crowd.

My friend Mr [Henry] Nevinson has been kind enough to give me the enclosed letter, and it is pleasant to anticipate that the first of your countrymen on whose kindness and sympathy my friends tell me I may count should be yourself. . . . I am a painter, and to me the mere beauty of the face of the world seems at times one of the most satisfactory keys to the problem of existence, and all I have seen of the people and buildings of India in books and pictures has moved me deeply. I am not coming, I hope, with the tourist's view that it is only as a country of palaces and show places that India is to be regarded (WR to G. K. Gokhale, October 10, 1910. National Archives of India, New Delhi.)[6]

At the Taj Mahal Hotel I found my Russian friend [Victor] Goloubew, with his secretary Müller, a photographer, and a retinue of servants. He was keen to go at once to Elephanta to visit the cave-temples, so I went with him to Cook's to hire a launch for the next day. Cook's man told me confidentially that it was not worth while to hire a launch; there was nothing to see at Elephanta! Though many tourists [now] visit both islands, on this occasion no voice inspired by Murray or by Baedeker disturbed us: we were the only visitors. Silence suited the hour and the place. The rock-cut entrance to the cave-temple was simple and impressive; then deep within the shadow we came upon the great Trimurti, a brooding group of the three heads of Brahma, carved with a breadth I had never seen surpassed. Then out of the gloom there emerged figures of Siva, of Siva and Parvati, and of attendant *apsaras*. How much sculpture loses when detached from its original setting and placed in a museum, I felt here as never before. We were overwhelmed by the dynamic force of these great carvings, and I returned to Bombay with a new conception of plastic art.

At Fardāpur [near Jalgaon] we found tents, servants and provisions sent by the Nizam [of Hyderabad], a welcome attention, for there was only a primitive dak-bungalow at Fardāpur, and a few mud dwellings. Up betimes, I borrowed a pony to get a first look at Ajanta, which was a couple of miles away, but found riding by no means easy; it took a while to get used to the stirrups, which were thrown over the pony's back, unattached to the saddle. Though I

had seen photographs of the façades, I was unprepared for the magnificence of the temples. Still less than at Elephanta could I conceive that these churches and monasteries, with their porticoes and columns and courts, with their niches filled with sculpture, had been carved out the solid hillside. Once within the temples, the effect was bewildering—a forest of elaborately carved columns, rich ceilings, stupas, sculptured figures and walls covered with paintings— I wandered from cave to cave throughout the day. On the day following I was able to concentrate on the wall-paintings. At first I thought these irreparably damaged; then I deciphered vast compositions wherein the whole life of ancient India seemed to be displayed, with an observation and grasp of form, of character and movement set down with a swift precision and energy of line.

[Chitor, Udaipur, Jodhpur, Jaipur, Alwar, Ajmir, Agra, and Delhi followed Ajanta.] From Delhi I turned southwards to pay a promised visit to the Maharaja of Chhatarpur, an old friend of Thomas Arnold and Theodore Morison. Chhatarpur is a small state in Bundelkhand containing one of the rare groups of Indian medieval temples which escaped destruction at the hands of the Muslim conquerors. We reached the capital late in the morning, where I found the usual guest-house and a message of welcome from the Maharaja, who seemed pleased at my coming—visitors at Chhatarpur were rare. Philosophy, His Highness told me, was his favourite subject, and he asked affectionately after his old friends and tutors, Arnold and Morison.[7]

This is like a wonderful summer, in the open all day, either working or seeing amazing things. I am afraid India will spoil me for work in London: the only difficulty is that there is too much to see and to do. . . . The Maharaja likes me to go and talk with him when I am not working, and sometimes I am too tired to do anything but read and feed and go to bed after a long day. (WR to Alice Rothenstein, December 5, 1910. RP:HL.)

The Maharaja administered such justice as his people claimed, sitting in an open courtyard with his *Diwan* beside him, rather bored, I felt, with his task. He complained of interference in the affairs of his state by the British Agent, Major X, who incidentally, he told me, made unauthorized demands on him, demands he could not well refuse. He was also constantly borrowing his motor-car. He would take me, of course, in his car to Khajurāho, knowing I was

keen to see the medieval temples there. Khajurāho was some miles from the capital. Suitable arrangements must be made. The major and his wife wanted to join us and luncheon must be provided. Motor-cars were then new to India, and the Maharaja had built some miles of road especially for driving. How I disliked to see the poor frightened peasantry get out of our way, dragging their buffalo carts into the ditches to let us pass. The temples, reflected in the water of some neighbouring tanks, shone white in the distance. Remarkable though the temples were, I was even more interested in the carvings with which they were covered. In the medieval sculpture there is little of the static quality associated with Indian Buddhist art, though I was put in mind of the Amarāvati carvings on the staircase of the British Museum. Here all was motion; the buildings appeared at one and the same time to rest solid and square upon the ground and, through the tiers of ardent figures carved upon them, to quiver with life. The major and his wife could not understand my interest in the temples. Surely the carvings were grossly indecent; I felt they regarded my liking for things Indian with suspicion—it was not natural. And they threw out dark hints of the Maharaja's morals.

One day I found His Highness poring over catalogues. He was choosing Christmas presents and would be glad of my help; and he handed me an illustrated price-list of cheap German jewelry from a Calcutta firm. Now I daily admired the gold ornaments, made by local goldsmiths, which the townspeople and villagers wear at Chhatarpur, indeed throughout India. But the Maharaja preferred the commercial products of Europe to native workmanship. He could not possibly offer the work of humble Chhatarpur goldsmiths to his friends. I have heard the decay of Indian crafts laid to the charge of British rule. This is unjust; I met with few Indians who valued their own art.

I liked being in Chhatarpur, but was eager to get to Benares. In Benares I put up at Clark's Hotel, in the cantonment, a couple of miles from the city itself. Each day I drove into Benares, in the mornings the ecstatic scene of the bathing, in the afternoons and evenings to watch the quieter life of the ghats. After seeing this pulsating life along the Ganges, I explored the streets of the town, looking for subjects to paint. But so bewildering, so crowded and varied was the Indian scene, it seemed impossible to decide. To find a quiet spot was another difficulty. Finally I settled down on the Dhamaswamed Ghat, under the shadow of a huge umbrella. My

servant tried to keep back the people who crowded round me until the bathers who frequented the ghat got used to my presence, and protected me from the curious. But, 'Why was I painting here? What made me come so far? Did people buy my pictures? How much money did they pay for them? Wouldn't I do better to paint Maharajas?' Now, 'Anyone can dress up to look like a Maharaja, but no one can look like a Sannyasi unless he has found peace', a remark which won their sympathy.

The amount of the life is so overwhelming—if you came down the ghats with me you wouldn't be able to look at the buildings because of the beauty of the women in their saris, yet you couldn't look at them for wondering at the seated Buddha-like figures of the ascetics and then you would want to watch the brown strong bodies of the bathers and behind all these you would be trying to follow long lines of pilgrims making a frieze against the walls and steps. One becomes an abject slave to the work one has started—I mean to make every effort to do something while I am here to bring back to show you—and I drive 12 miles at least to and from work every day! (WR to Alice Rothenstein, December 28, 1910. RP: HL.)

In Benares I found that which I had come to India to discover; but each evening, to return to the hotel, with its self-satisfied tourists, became more distasteful.[8] A majestic bearded Bengali, in the dress of a Sannyasi, often stopped as he passed by to watch me at my work. He was friendly and took me up to his cell, high above the ghat. My new Bengali friend, Nrusingh Sharma, pointed out that no one would come to sit to me at the hotel; why not come and stay in the city? He introduced me to a Mr Biswas, who offered me quarters at the Maharaja of Vizianagram's residence. When I told the Commissioner and the Collector that I thought of moving into Benares, I met with immediate opposition: I should be running grave risks of plague, typhoid, and cholera. They meant well. But they could not follow my liking for 'fakirs' of whose loyalty they were, moreover, doubtful. But I had not come so far to live in an English cantonment; I must be in touch with the people whom I wanted to draw, near the scenes I wished to paint. So I went.

What had before been difficult was now easy; all sorts of people came to sit for me. In the evenings I painted on the ghats, which were then less frequented. Here and there a few elderly men sat together, or walked quietly along the terraces watching the setting sun. I

would sometimes join some group and listen to the talk. Each evening I was exalted by the peace and beauty of the scene. Over the water came the sound of women's voices, chanting hymns, as the boats glided down the swift-flowing river.

Sir Montagu Butler had sent me a letter to the Maharaja of Benares; his *Diwan* called on me. After many compliments and some desultory talk—I felt that he had something on his mind—the *Diwan* came to the point. A painter visiting India could not be disinterested. What Maharajas had I already painted? He feared that the fee of so eminent an artist would be too high for His Highness. He was surprised as he was relieved to hear of my strange taste for the life of the ghats, that I had not come to India to paint portraits. His Highness would at once place a state-barge at my service. A state-barge manned by some twenty retainers awaited me next morning. Sir Harry and Lady Stephen, with Sir John Woodroffe had come to spend Christmas at Benares, and together we saw from the barge the entire length of the city. We enjoyed the experience, but I preferred to go on the river in a more modest equipage—and in a more thrifty one, too, for retainers and rupees are synonymous.

Sir Harry and Lady Stephen had asked me to stay with them in Calcutta; and wonderful as Benares was, I confess to a grateful feeling at finding again the ample comfort of a well-ordered English household. Then Abanindranath Tagore and his brother Gaganendranath came to take me to their home at Jorasanko; a delightful house, full of lovely things, of paintings, bronzes, stuffs, and musical instruments. Their collection of Indian paintings was the best I had seen, made, as it was, by artists. Gaganendranath, a man of singular charm and culture, was a kind of Indian Ricketts, who seemed to have seen and read about everything. I was attracted, each time I went to Jorasanko, by their uncle, a strikingly handsome figure, dressed in a white *dhoti* and *chaddor*, who sat silently listening as we talked. I felt an immediate attraction and asked whether I might draw him, for I discerned an inner charm as well as great physical beauty, which I tried to set down with my pencil. That this uncle was one of the remarkable men of his time no one gave me a hint.[9]

But I found cultivated Indians surprisingly ignorant of their own art, somewhat embarrassed by my enthusiasm for the carvings on the Bhuvaneshwar and Khajurāho temples, for they deemed these ugly and indecent; while for my part the furniture and pictures in the palaces of the Maharajas and in the houses where I was so hospitably

entertained, set my teeth on edge. Perhaps the effect on a Japanese artist of the bamboo tables and Eastern knick-knacks of the average English home, even of the overcrowded rooms of men who pride themselves on their good taste, is similar to that which the uphol-stered anglicised interiors in India made on me. Had India's rulers a sense of beauty, their understanding of India and of Indians would be profounder, I thought, and there would be less friction between rulers and ruled.

If we [artists] can only help by sitting aloof then we must have a much higher place in our system than we have now. . . . What our place really is we all of us know pretty truly—if we could only have a university with such men as F[rancis] C[ornford] and your Mr [George] Meredith all through, and get the Johns and the Gills and the Synges and the Craigs into it, and show the world that we are not senile idiots every hour of our lives, what a week or two we could give it of joy and consciousness that the earth is provisioned for all men.

Since I came back from India I am feeling stultified, and I have a great longing for something more adventurous than the life I am leading here—not necessarily physically so, but I want something more than the stupid exhibitions and lecturettes and gatherings and quarrels I get enough and to spare of—can't we somehow do something more lively and dangerous and respectable and inspiring than this? I am ready for any lark you will join in. . . . (WR to Frances Cornford, June 12, 1911. The British Library.)[10]

I happened, in *The Modern Review*, upon a translation of a story signed Rabindranath Tagore, which charmed me; I wrote to Jora-sanko—were other such stories to be had? Soon afterwards came an exercise book containing translations of poems by Rabindranath, made by Ajit Chakravarty, a schoolmaster on the staff at Bolpur. The poems struck me as being still more remarkable than the story, though but rough translations. Then news came that Rabindranath was on his way. I eagerly awaited his visit. Then he arrived, accom-panied by two friends and by his son [and daughter-in-law]. As he entered the room he handed me a note-book in which, he said, since I wished to know more of his poetry, he had made some translations during his passage from India. He begged that I would accept them.[11] That evening I read the poems. Here was a poetry of a new order which seemed to me on a level with that of the great mystics. Andrew Bradley, to whom I showed them, agreed: 'It looks as though we have at last a great poet among us again,' he wrote.[12]

I sent word to Yeats, who failed to reply; but when I wrote again he asked me to send him the poems, and when he had read them his enthusiasm equalled mine. He came to London and went carefully through the [note-] book, making here and there a suggestion, but leaving the original lines little changed: '. . . I find Tagore and you are a great inspiration in my own art. Thank you for asking me,' he said in a letter.[13]

Tagore's dignity and handsome presence, the ease of his manners and his quiet wisdom impressed all who met him. Stopford Brooke asked me to bring Tagore to Manchester Square; 'but tell him,' he said, 'that I am not a spiritual man.' I think the dear old man, with his love of beautiful surroundings and of the good things of life, was a little nervous of Tagore's purity and asceticism, as it appeared to him; and when we sat down at the Brookes' generous table, though the talk might be of angels, Stopford must be true to himself. 'You and I,' he said to my wife, 'are going to drink champagne.'

Young poets came to sit at Tagore's feet, Ezra Pound the most assiduously. Among others whom Tagore met were Shaw, Wells, Galsworthy, Andrew Bradley, Masefield, J. L. Hammond, Ernest Rhys, Fox Strangways, Sturge Moore, and Robert Bridges. Tagore, for his part, was struck by the breadth of view and the rapidity of thought that he found among his new friends. 'Those who know the English only in India, do not know Englishmen,' he said. 'All you people live, think and talk while a strong critical light is constantly focussed on you. This creates a high social civilisation. We in India, on the contrary, live secluded among a crowd of relations. Things are done and said within the family circle which would not be tolerated outside, and this keeps our social standard lower than yours.'[14]

We asked George Moore, among others, to hear Tagore [read his play, *The King of the Dark Chamber*]. Moore was cautious, but, except for A E [George Russell], suspicious of idealists: 'I owe you many apologies for not having answered your kind letter inviting me to Hampstead to hear some poems by the Indian poet. Yeats tells me they are very wonderful and that he is going to write a preface.'[15] I do not think Moore and Tagore ever met; I could not readily imagine them together; nor could Shaw come to hear the play read. He wrote: 'My own mother (82) has just had a stroke; Charlotte is blue and gasping for life in paroxysms of asthma and bronchitis; and I am rehearsing no less than three plays; therefore my reply to your

letter is a hollow laugh. It will be a good solid month before I can fix an hour for lunch again, and I will come with the greatest pleasure.'[16] But they did meet, though I was away when the Shaws came to dinner. My wife told me that Shaw was rather outrageous, while his wife was all admiration—'Old bluebeard,' said Shaw to mine while he was leaving, 'how many wives has he got, I wonder!'

It was pleasant to see homage paid so readily to an Indian; nothing of the kind had happened before. I was concerned only lest Tagore's saintly looks, and the mystical element in his poetry, should attract the *Schwärmerei* of the sentimentalists who abound in England and America, and who pursue idealists even more hungrily than ideals. Tagore had, indeed, all the qualities to attract such. It was easy to protect him at first, for he enjoyed the society of men whose books he had read but whom he never expected to meet. Then when the summer came, we escaped to Gloucestershire, where Tagore joined us.

Fox Strangways wanted Oxford or Cambridge to give Tagore an honorary degree. Lord Curzon, when consulted, said that there were more distinguished men in India than Tagore. I wondered who they were; and I regretted that England had left it to a foreign country to make the first emphatic acknowledgement of his contribution to literature.[17]

I now proposed to the India Society that they should print, for its members, a selection of Tagore's translations of his poems. Yeats, when the Committee agreed, generously offered to write an introduction; he had previously gone carefully through the translations, respecting Tagore's expressive English too much to do more than make slight changes here and there. Indeed, Yeats was as keen over the issue of the book of poems as he would have been over a selection of his own lovely verses. He wrote to me: 'In the first little chapter I have given what Indians have said to me about Tagore—their praise of him and their description of his life. That I am anxious about— some fact may be given wrongly, and yet I don't want anything crossed out by Tagore's modesty.'[18]

The poems were published by the India Society with the title of *Gitanjali*. They were well received and were favourably reviewed in *The Times Literary Supplement*. Since only a limited edition of *Gitanjali* had been printed I wrote to George Macmillan, with a view to his publishing a popular edition of *Gitanjali*, as well as other translations which Tagore had made; Macmillan, after some hesita-

tion, finally published others, perhaps too many, of Tagore's books, to his profit, and their own.[19]

During the autumn of 1913 came the news of the award of the Nobel Prize to Rabindranath on account of *Gitanjali*. Tagore had the courage at a ceremony given in his honour [in India], to comment on the adulation which followed, not on his work, but on his success in Europe. Henceforward Tagore was to become a world-figure. But great fame is a perilous thing, because it affects not indeed the whole man, but a part of him, and is apt to prove a tyrannous waster of time. Tagore, who had hitherto lived quietly in Bengal devoting himself to poetry and to his school, would now grow restless. As a man longs for wine or tobacco, so Tagore could not resist the adulation. He wanted to heal the wounds of the world. But a poet, shutting himself away from men to concentrate on his art, most helps his fellows; to leave his study is to run great risks. No man respected truth, strength of character, single-mindedness and selflessness more than Tagore; of these qualities he had his full share. But he got involved in contradictions. Too much flattery is as bad for a Commoner as for a King. Firm and frank advice was taken in good part by Tagore, but he could not always resist the sweet syrup offered him by injudicious worshippers.

Chapter 13

THE WAR AND THE WAR ARTISTS

DURING the summer [1912] we spent in Gloucestershire my wife and I, walking one afternoon with Tagore [and John Rothenstein], came upon an old farmhouse [at Iles Farm] overlooking the Golden Valley. The house was in a state of decay; there was no gutter to gather the rain and the walls were soaked with damp. But we saw its possibilities. My wife, impetuous as usual, said we must rescue the place. We made inquiries; the property belonged to a Miss Driver whose family owned most of the land thereabouts. She was willing to sell the house, with fifty-five acres, part of which was woodland, for £1,300. I borrowed £1000 from my father, wrote out a cheque for £300 (my savings from my American journey [in the winter of 1911–12]) and became the possessor of a tiny estate. Oh the pride with which I first explored each field, and the hanging beech wood, and the house and barn! I was too ignorant to notice the lamentable state of the walls and fences.

Standing on the edge of the hill, the house, built in 1614, with its plain stone front and irregular mullioned windows, faced due south, opposite Sapperton and Frampton Mansell. An orchard fell away from it steeply, and below were fields and a fringe of beech wood running down to a canal, a proud engineering feat of the 18th century, and nearby was a tunnel which ran for four miles under Sapperton, hereabouts out of repair, through which barges could no longer pass. Nature had now taken possession, and everywhere weeds and rushes grew, and there were wild water-lilies, and kingfishers nested along the banks. Here and there a lock still held enough water, in which the children could bathe and fish. There were too many locks to be tended. Thus far and no further; man can say nay to nature, but he must not let go of that which he makes; so long as he watches over his handiwork nature respects it. At Chalford, two miles away, the canal was in use again, and boats were built between Chalford and Stroud. The old mills thereabouts

with the millers' houses attached put me in mind of those near Bradford.

In the changing drama of the year I found constant inspiration. In London, when no model came, I would feel at a loss; not so in the country, and the Cotswold buildings are especially paintable. Stone buildings always move me—austere in grey weather, pale, livid even, against a stormy sky, they are warm and sparkling in the sunlight. In our house and outbuildings and in a great wych-elm in a field below, I found subjects to my hand. Just before the war we threw a wing betwixt the house and the barn adjoining. I would have no builder, but entrusted the work to the village stone-masons: my friend Norman Jewson acted as architect. The Oakridge masons were noted throughout the countryside, but naturally this job at home was too good a thing to be quickly finished. Idealism has to be paid for. I certainly paid for mine, but I gained an experience in building I had otherwise missed.

Then came the shock of the war. What its effect would be, no one in the village knew; men still went on working. But at Stroud and Cirencester officers in khaki bustled about, examining horses, buying provender, recruiting men. Across the valley we heard trains passing all night; it was said that the bridges and tunnels were all guarded, and rumours of German spies, of station-masters being shot, of German defeat at the hands of the Belgians were brought us by the vicar. We knew from the papers that the expeditionary force had been safely landed in France, but for many days we heard nothing more. We could not yet grasp the power of the German armies in men and materials which the French and our small expeditionary force had to face. Recruiting became urgent; some of our young men left and were lost to us.[1] But others came along, pleading for work. Was work to go on, or should it stop? No one knew; then came the word 'business as usual'. It was hard to deny men who wanted work, but was I likely to earn? Painters would not be wanted. What was to be done? I bethought me of my Rembrandt and my Daumier drawings. I consulted Holmes—my Rembrandts were worth £200 each. It was hard to part with these. But human life is more important than property; and it seemed wonderful to me that a few lucky purchases could now enable me to keep twenty men in active work. Soon pressure was put on the young, and one by one men left the village for the training camps. Then rumours began to reach—us our house dominated the valley: we had laid down concrete floors, to be used

for gun emplacements. I joined others in drilling at Bisley, a village nearby; a lady with whom we had been friendly spread fantastic stories. Lord Beauchamp, the Lord Lieutenant, sent a curt message, threatening to disband the volunteers unless the charges against us were withdrawn. Oakridge stood gallantly by us, and the rumours died down.

One naval reservist and one territorial represent the whole martial spirit of the 4 villages which make our parish, yet we have been de-nounced to the police as spies, have been watched by them and spied upon, ourselves unaware of anything of the kind being in the air. It would appear I had been painting a picture of the railway tunnel! Of course at moments of extreme danger such as we live in at present [people] are bound to create scares, and the risk from spies must be great and must be guarded against: but I am a little inclined to believe that, apart from my own intensely disagreeable experience, we should do better to organise, as Albert tells me the French are doing, the non-military element as patrols or special constabulary, than to leave them to read military detective stories of the most sensational kind day after day, with no healthy action to counteract what is really only the gossip and petty scandal of war. (WR to Margaret Woods, August 10 [1914]. RP: HL.)

Belgian refugees were still coming out to England; all who could took them into their homes. We had a family of Belgians at Oak-ridge; and Emile Vandervelde, whom I met in London at the Binyons', came to stay with us. He wanted to take me with him to the Belgian front, there to make a drawing of the King. For, like everyone else, I wished to do something to help the Belgians, and reproductions of such a drawing, Vandervelde believed, would have a wide sale. He was to start in a week's time and undertook to get me a passport. Here was an unlooked-for chance to see something of the war. A telegram came to say that all was arranged, and a day later I stood, provided with a cork jacket, the only civilian besides Vandervelde, on a ship crowded with soldiers bound for Calais.[2] Then we reached Belgian Headquarters. La Panne was a sea-side pleasure-resort in the sand dunes, full of tawdry little villas, built for prosperous bourgeois families, and, save for the presence of a few thousand soldiers, there was little to suggest that we were near the seat of the war, though I was told that the German lines were but four miles away.

We were all right, but a little dull, and I wanted to get a sight of Ypres; so did Vandervelde; but Ypres being in British occupation, Vandervelde said we must get a special permit. The Military Mission were a little suspicious of Vandervelde; wasn't he a bit of a socialist? I reassured them, and when they met Vandervelde, they were charmed by his eloquence. As we approached the war area, though the day was still, and there was no sound of firing, something heavy, sinister and menacing hung in the air. Near to Ypres this sinister silence grew yet more threatening. Outside the town a sergeant with two or three of his men barred the way. Orders were that no one was allowed into Ypres. We showed our permit, but the sergeant was obdurate. Happily ignorant of military discipline, I said a word to the chauffeur, who started his engine, and we left the sergeant behind. The ominous silence continued; not a soul was in the streets and as we drove on we saw that the houses were mere empty shells. It was like a city of the dead. Then we entered the *grande place* and came on the great Cloth-Hall and the Cathedral, livid and scarred with wounds against a lowering sky, a magnificent and unforgettable sight. It came as a sudden shock, awful and distressing, as though the buildings felt the agony of approaching dissolution, but the scene had a sombre beauty, and I vowed that I would return to make some record of what I had seen. I was so impressed by the dramatic character of the scene, both by night and by day, that I determined when I got home, to petition that artists be attached to the British forces, to make records of the scene of war. Meanwhile my return to England was nearly prevented by an absurd misadventure.

During a visit to the trenches with Vandervelde, we were entertained at lunch by Belgian staff officers. I was astonished at the profusion of food and wine. Afterwards I wandered away to make drawings. Presently a French officer strolled up, of whom I inquired whether these trenches were held by French troops. If so, might I continue my drawing? I had a written authority from Belgian Headquarters. He must first ask his superior officer, he replied, and returning shortly, invited me to follow him. A motor-car was standing close by, which he asked me to enter. Within was another officer; we were soon travelling at a great pace along the high road. I inquired where we were going. 'To Dunkirk' was the grim reply. Further inquiries were received in silence. At Dunkirk I was taken to the French H.Q. where, after long waiting, I was closely questioned. What was I doing, drawing *French fortifications*? It was an

awkward situation, for my explanations were brushed aside. My
sketch book in which were drawings of Belgian soldiers, notes of
landscapes, and of trenches too, was sent upstairs to be examined. A
Colonel descended, who took a grave view of the matter. I was a
civilian, what business had I in the French lines? My passport meant
nothing; anyone could have a forged passport. The position was
getting serious. War is war. The French were intensely suspicious,
and one heard tales of suspected spies being summarily executed.
Suddenly an idea struck me; would the Colonel telephone to Belgian
H.Q. where my identity would be explained? Fortunately this was
done, and I found myself at liberty and provided with a military pass
to take me back to La Panne.

I implored my friend Colonel Repington to plead at the War
Office that artists should be allowed out in France. Repington spoke
to Northcliffe, who wrote to me: 'I heartily agree with you, and have
long ago suggested that we should copy the Germans (whom we
always have to copy much as we dislike them) and send distinguished
artists to the front. As for the British authorities, they are absolutely
impossible people, but in regard to the French army I think I might
be able to do something.'3 The French army be damned, I replied; it
was the British front of which records should be made. Two days
later Northcliffe wrote again, 'Why does not the Royal Academy or
somebody approach the War Office on the subject? If they will do
so I will support them. If I were to approach the War Office they
would kill the scheme at once. They have had more than enough of
me—although they are still going to get more!'4

I appealed to Repington again, who got Lady Cunard interested,
while MacColl and others began to move in the matter. Finally the
project received full official support. I wrote to thank Northcliffe for
his help. He answered: 'The carrying out of your scheme as to
artists was very little helped by me. I spoke of it at G.H.Q. several
times, and urged it, but it was carried through by young Sir Philip
Sassoon.'5

*A year ago, after my visit to Belgium, I wrote to Northcliffe and
others urging the sending out of artists and Lady Cunard got hold of the
idea and worked it in her own fashion. I was very glad to hear Bone
had been sent out, and lately [Eric] Kennington has been. I now hear
Orpen is to go and paint portraits. Is there any chance of my being used
to make any portrait drawings? I ask only because I believe I was one of*

the first to be allowed out, and to make drawings, and further because I
believe I can make a decent portrait drawing. (WR to MacColl,
December 29, 1916. Glasgow University Library.)[6]

John, too, wanted to go out to France; he wrote of his chances:
'I have had the idea of going to France to sketch for a long while and
I have hopes now of being able to do so. But I am still in suspense.
I have applied for a temporary commission which I think indispen-
sable to move with any freedom in the British lines where the disci-
pline is extremely severe. A friend of mine who went sketching in
France avoided the British army as one avoids death but got on very
well with the French. I fully sympathise with your proposal and am
convinced there's enough material to occupy a dozen artists. ... You
might suppose I could do something with Lloyd George but I fear
that gentleman will never forgive me for painting a somewhat un-
conventional portrait of him. Northcliffe's popularity is a very
variable quantity, I should think and he and the Military are probably
very much in agreement, so that he might do more than another to
effect your purpose. I can quite understand your reluctance to alter
the form of your name which after all *you* have *made* but I see the
reason[s] you have for doing so are sound and good.'[7]

Although I had something to do with the initial idea of war
records, I scarcely expected, in view of my name, to be among those
sent to France.

I am, as you see, still here in England. There has been delay in my per-
mit, and I am kept waiting week after week, and it has been something of
a strain. . . . In the meanwhile I am painting, not working is a little
wearing. . . . When I was last in London I went to the Café Royal and
met John and [Christopher] Nevinson and an amusing horsy painter
called Munnings—do you know him? . . . There was a wild dinner after-
wards, from which Charles [Rutherston] and I retired early—I am too
old for the Johnian society. It is rather amazing—there were young
ladies there whose parents I know, and really! And John himself is very
touching. He is still a Major and always, I believe, on the verge of being
court-martialled. (WR to Albert Rutherston, October 14 [1917].
RP:HL.)

But there came a letter from Campbell Dodgson, from the
Ministry of Information, asking whether I would be prepared to go
out to France during the winter as one of the Official Artists. I

jumped at the chance, and in December 1917 I crossed the Channel.[8] We had no instructions from H.Q. and were free to go where we wanted, yet surely more might be done were each artist attached to a particular army. But people at home were too busy to take notice of so relatively unimportant a matter as the making of artists' records. John, who was with the Canadians, was worried, as I was, by the magnitude of the task: 'The British authorities seem strangely mean in their treatment of artists. I shall need to be about here for a year at least I feel and can only hope *I* shan't be interfered with before I have collected everything I want. Yes, the problem is immense and magnificent. One can only familiarise oneself as much as possible with all the multitudinous details and then set about arranging them in order. So much contraction is necessary.'[9]

I met John more than once, looking superb in his uniform, the only bearded major, I believe, in the army. He had refused to shave, to the concern, I gathered, of the authorities. I heard from Orpen, while I was visiting some of the famous Somme battlefields: 'John in the Army is a fearful and wonderful person. I believe his return to "Corps" the other evening in a Steel Helmet will never be forgotten —followed by a band of photographers. He's going to stop for the duration.'[10]

I used to carry my drawings with me; while on a visit to a unit of the Third Army the Colonel sent for me early one morning; was it not time, he asked, I took my drawings to G.H.Q.? I took the hint, and, motoring up to Montreuil, handed my drawings over to Major Lee, and asked him, in view of coming events, if there were any place on the Fifth Army front he might wish recorded. I had been drawing guns, I told him, between Hervilly and Hargicourt; after I had drawn some guns discreetly hidden in a sunken road, I was met with signs of embarrassment by Captain Turnbull, the officer in charge; his orders were, he explained, with many apologies, to place me under arrest. He sent me down in my car, in charge of two armed sergeants, to Brigade H.Q., where I was interviewed by an indignant Brigade Major. He heard I had been drawing his guns; he used strong language, and behaved, indeed, like a stage Major. I produced my White Paper, signed by the Adjutant General, which allowed an official artist to go where he wished. Next he could not decipher my name, and asked me roughly what it was; more strong language followed, and Lee was amused when I told how I pronounced the first 'R' with a strong Teutonic accent, adding, 'Now, I suppose

were my name Smith, you would have me shot.' Lee, too, knew that important events were portending, and gunners were naturally jumpy. I left him to return to the front, and arrived late in the evening of March 20th at Tincourt, where I spent the night at a C.C.S. At dawn came the sound of a terrific bombardment continuing without intermission. Here at last was the preliminary to the expected offensive.

Major Lee had spoken of some tanks near Templeux which I might like to draw. I started out in a dense fog; the bombardment growing ever louder. As we drove along, the road became encumbered with troops, many coming in our direction. My chauffeur looked anxious; he had had his share of fighting and never liked taking me near the front. Passing some Brigade H.Q., I stopped to make inquiries. Here some staff-officers flung at me the astonishing news that I should as likely as not find the tanks I asked about in German hands. I had better go back, they said. I told my chauffeur to go to Roisel, where I had lately been working. There I found the guns in action, and heard rumours of a German breakthrough. It was doubted whether Roisel could be held much longer. Wounded men were already being brought into the dressing station. To draw now seemed indecent, and I was advised to go on to Tincourt, to offer my services in the C.C.S. there, but at Tincourt they were already packing up; I was sent on to Marchélepot, where I had lately stayed with Howard Somervell. On the way thither I passed through Péronne, which was soon to be evacuated. Péronne was full of stores of all kinds which I believe fell into German hands. I went to the Officers' Club to get a bite, and found it empty save for a sergeant who was aimlessly, I thought, engaged in smashing the looking glasses, as though they could be of use to the Germans. Marchélepot was well behind the front, yet even here numbers of wounded were being brought in and laid down on their stretchers. My offer to stay and help was welcomed. My first task was to find out the names of the more desperately wounded men, so that their relatives could be written to, a ghastly business, for they were so fearfully mangled, it was often impossible to get at their identity disks.

As the day wore on more and more stretchers with their pitiful burdens were carried in. The beds in the wards were full, and stretchers were set down wherever there was space to receive them, while outside the wards they were laid in long close rows. One had to stride across dying men to get to the beds, whence came piteous

appeals for water. But in the case of abdominal wounds, water must
be refused; and my heart was wrung to a pitch that, but for the in-
cessant call for activity, would have been insupportable. The places
of those who died were quickly taken by the living, whose endurance
was beyond praise. The zeal of the nurses, and of the surgeons, was
untiring. For three days and three nights no one got more than an
occasional snatch of sleep. For three days and three nights I wit-
nessed this devotion; for Somervell had asked me to take charge of
the Officers' Ward. On the fourth morning, going outside for a
breath of air, I saw some staff officers sitting by the side of the road
studying maps. A few minutes later my chauffeur came up, much
perturbed: they wanted to requisition my car; we must leave at
once, before it was taken. It appeared that the Germans had crossed
the Somme at St Christ; a hospital train, the last likely to get through,
had just come in. Stretcher bearers came up to carry the wounded to
the train. I left the C.C.S. reluctantly, and to my chauffeur's relief
we were soon on the road towards Amiens, and were scarcely out of
Marchélepot, when, at a cross road, I heard my name shouted from
a passing car; within was Captain Turnbull, who told me he had
managed to get his guns away from Hervilly. Passing through
Villers-Carbonnel some shells fell not fifty yards away. At Amiens I
could get into touch with Neville Lytton, who was then head of the
Press Bureau, and would know what was happening.[11]

When, in Amiens, I saw everything going on as usual, the shops,
and the women marketing, and the children playing in the streets, as
though nothing untoward was about, I wondered if the horrors I had
left behind me were real. When I saw Lytton, and spoke of the rapid
German advance, and how shells had fallen in Villers-Carbonnel, he
was frankly incredulous. So was a staff officer who came in. How-
ever, it was not my business to discuss military matters. On Lytton's
advice I remained in Amiens to await events. Meanwhile John and
Orpen and the other official artists had been recalled, my where-
abouts being fortunately unknown to Major Lee, but it was not long
before I received an emphatic order to report myself at G.H.Q. No
artists were to remain any longer in France.

While I was hoping to be sent back to France, to continue my
records, the military age was raised, and I now came under the new
law. I was to report at Gloucester, travelling thither in a railway-
carriage full of sturdy farmers; at least so I deemed them to be.
After stripping to be examined, to my surprise I found myself classed

as a C.1 man. Only one other had been thus approved. Something wrong had been found with all the rest—varicose veins, weak hearts, and what not.

Of course everyone at Oakridge laughed at the idea of my joining up—one could not make the villagers believe that herein no difference was made between the classes. What others had stood I could stand. Came the day when I had to present myself at Gloucester, when I bade farewell to Oakridge, and walked down to Chalford Station. On the way I met a telegraph boy; I was to report in London immediately. There I was told to go to Cheshunt College, Cambridge, to lecture to Australian Education Officers. I was a little disappointed, having resolved to face the hardships of a Tommy's life, but I found myself in agreeable society; the Australians were warm-hearted and enthusiastic students. I lectured on town-planning, on the museum of the future, the decoration of buildings, and I took the young Australians round the colleges.

Of my many strange experiences as an Official Artist, perhaps the strangest was to find myself, but a few months after the terrible March retreat, actually in Germany, among a subdued and apprehensive people. I was to paint, for the Canadians, some aspect of the German occupation; it was not at first easy to find a subject in Bonn, where there were few signs of military operations. The guns were parked in the square, opposite the University. But while lunching with Major Molyneux, the eccentric British Town-Major, and his staff, I chaffed them for their lack of imagination. Surely one British gun at least, a modest symbol of final triumph, should be seen somewhere on the banks of the Rhine. For I bethought me that a gun so placed would make an appropriate subject for a painting. My suggestion found favour. A howitzer was taken down to the Rhine and placed on the parapet with its muzzle poking across the river, and a sergeant and a small contingent of men sent with a lorry to guard it. It was bitterly cold; snow fell, and I was sorry for the men told off to look after the gun. The wind was icy, there was no shelter, and again and again I thought I should have to give up my work; but with a pair of fur gloves hanging from my shoulders, into which I could put my numbed fingers from time to time, I struggled on. Every officer in the Army of Occupation came along and photographed that gun. It amused me to think that, but for my wish to paint this symbol of the final triumph, no gun had been seen on the Rhine. One thing struck me as curious. Germans walking by often

stopped to look at my painting and would say, 'O, wie schön!' Now, I thought to myself, had the Germans won and placed a gun on the Thames-side in London, and a German painter been painting it, no Englishman would have said, 'How beautiful.' No one thought of putting his foot through my canvas, which now hangs in the Imperial War Museum in Lambeth Road.

During 1919 the question of a return to London had to be faced. Our children missed the companionship of others of their own age, and they were pining for concerts and plays. We found a house with a studio on Campden Hill, a pleasant quarter of the town, with its quiet lanes and sequestered houses and gardens.

There was as yet no whirl of committees, but shortly after our return to London, Fisher sent for me—Lloyd George had lately made him Minister for Education—and asked me to undertake the direction of the Royal College of Art; its prestige as the chief Government school of art had declined and must be raised; a change of policy was desirable. The appointment raised a storm in the National Society of Art Masters; both Fisher and I were abused, questions were asked in the House of Commons, a protest was made at the Board of Education.[12] Certain qualifications were required to entitle a man to become head of an art school; the Board had selected a man with none to be Principal of the chief school in the country, and moreover, a painter, with no knowledge of the crafts. To appoint a man without previous administrative experience was, I admit, a risky experiment, and I could understand the art-masters' soreness. But I do not think the students were displeased.

Fisher was very good in making it possible for me to accept his sugges-tion—all administrative work to be carried out by an official, a studio and a maximum of 3 days a week at the College. So I can have sitters there and give time before and in between to necessary duties. It will mean having the pick of the Provincial students in touch with the best of the work done in our time—and this has not really been the case in the past. There is a disastrous 'studio' influence running through country schools and workshops—if one can hope to raise the standard of art and industry by a millionth of an inch it will be worth while. (WR to John Drinkwater, May 24, 1920. Beinecke Library, Yale University.)

Chapter 14

SINCE FIFTY: PIECES FROM A MOSAIC

IT WAS at the end of July 1922 that we went back, for the first time since we gave up the farmhouse two years earlier, to spend the summer at Oakridge. Here for some four years had lived John Drinkwater and Kathleen his wife, the best of neighbours—John, the poet incarnate, generous, high-minded, enthusiastic over the work of other poets, delighting in the countryside, in his little garden, in playing host to friends in his cottage. Here in the little sitting-room Max spread a green cloth on the table, laying his paint brushes out neatly beside the few tubes of paint that he used, strips of blotting paper and pot of crystal-clear water. Both for his drawings and for his writings he habitually used a ribbed paper called Wessex Antique. (It is no longer manufactured, and he constantly mourns it.) Here, too, at this table he began *Rossetti and His Circle*, his series of Pre-Raphaelite drawings, wrote the story of 'Maltby and Braxton' and the play 'Savonarola Brown', published in *Seven Men*.[1] And the children laughed at the recollection of him emerging from the cottage, dressed with scrupulous care, with stick and gloves, to walk the 100 yards to the Nelson Inn to buy cigarettes; farther than this he never ventured. During the winter he was content to stay indoors with all windows carefully shut, and we remembered how, when with us, if he noticed an open window, he would stroll round the room, talking and smoking while he gradually approached the window and, as though absent-mindedly, carefully close it. Florence would go for walks with us but never far: Max must not be left alone in the cottage. One early spring day walking with my wife, she heard a bird singing high up in the air. 'What bird is that?' asked Florence, and when told it was a lark, 'A lark! Max has never heard a lark!' and she hurried back. When she returned with Max, in heavy overcoat, gloved and attentive, alas, the lark had finished her song!

During 1922 I made my last drawing of W. H. Hudson. Poor Hudson, he was one of the rare men I have known who feared to

grow old, unable to face the prospect of death. Yet he knew he had now little time before him, and told us he had burned all the letters he had kept, and his manuscripts too. We upbraided him for the destruction of these last, which seemed to us wanton. The next day he left a package at our door. Within was a note, and a number of MSS., odd chapters of his books, and one complete manuscript, saved from the burning.[2] A few weeks later, while we were away, we read of Hudson's death. He was buried at Worthing beside his wife. We went to his flat when we returned, to choose some books he wished me to have. His field-glasses he left to my wife. I was surprised to find these, which he used for watching birds, were little more powerful than ordinary opera glasses. There was nothing of value in his flat; only a few poor ornaments.

'I acclaimed him as probably the first writer of English,' wrote Cunninghame Graham. 'Nothing can fill the gap left by Hudson for he was like nothing else in the world. As a man and as a writer he was unique. He wrote to me on July 31 saying he had been staying with Wilfrid Blunt who appeared very ill. He was to go first himself, then Blunt, a very old friend of mine. I made them known to one another and though so unlike they had a side in common, the love of birds and nature. . . . Both men of genius and both remarkably handsome and striking in appearance. R.I.P.'[3]

I never ceased to urge on the Board of Education the desirability of attracting distinguished young artists, designers and craftsmen, to posts in the more important country schools. But there was an unfortunate system under which students at the Royal College of Art, if they wished to qualify as fully certified teachers, must give up the major part of their last year to the theory of teaching, instead of using precious time to improve their practice. The passing of a paper examination qualified a man or woman for full pay as a teacher and for a future headmastership; while those who were keen to continue their practical work during their last year were excluded from the higher posts and salaries offered to supposedly fully qualified teachers. I failed to convince the Board of the injustice of this ruling, but had the satisfaction of knowing that after my retirement the Committee of Art and Industry were able to carry out this long delayed reform.

There were other things that worried me. Many of the local scholarships were too small to allow of the students keeping themselves decently—the women especially. There was, moreover, a system of

loans from local authorities under which the students, bound to repay the sums advanced, were practically forced to accept teaching posts immediately on leaving the College. Now, I held the view that only those should envisage teaching as a profession who, besides being good craftsmen, had abundant personal vitality. I know too well the effects of poor teaching on students from some of the provincial schools.

At least I was gradually changing the College from being in large part a training school for teachers to an active school for practical designers and artists. The professional art-masters remained suspicious and sullenly hostile, and did all they could to counter this tendency by overt and secret attack.[4] Fortunately, for most of the changes I proposed, I had the full support of the Board of Education with the confidence of each succeeding President. A different class of student was now attracted to the Royal College. Whereas, under my predecessor, no one from the painting school had entered for the much-sought-after Rome scholarship for mural painting heretofore regularly gained by students from the Slade School, a fair proportion was now won by College students, as well as scholarships for engraving and sculpture.

At the end of the [1925] College session I went back to Oakridge for a summer's painting. I had been somewhat overworked of late at the College, the Geddes axe having descended on all public departments; to ensure a staff sufficient for an increasing number of students, I took on an additional burden, that of the Professorship of Painting. At Oakridge I unwisely chose two subjects to paint down in the valley, carrying back my painting tackle and two large canvases up the long steep hill each day. This put an extra strain on my heart. In the autumn my health broke down.

I am troubled about the College. I have cared so much about the students, and it is not easy to find a practising artist, like Tonks, who is a true teacher. If I could find one, I should not worry about retiring. This sounds very vain, as though one were a very rare bird indeed. Yet so far I haven't been able to think of anyone to take on the work and I doubt my own capacity now to carry it on. I have now plenty of time 'to stand and stare'. But one doesn't create by looking, and without the creative struggle one doesn't see enough. I can understand Gordon Craig's irritability at only writing about the stage, instead of producing plays. (WR to Frances Cornford, March 8 [1926]. The British Library.)

I saw in Morocco, and later in India, how crowds of men and women will sit rapt, listening to a storyteller in the market place. Was it the style, the form, the sound and rhythm of the verse they appreciated? Surely not, it was the story of fighting, love and adventure that kept them rapt. So men who have been through the War can at once follow Stanley Spencer's great paintings in the Memorial Chapel at Burghclere, near Newbury; the difficult idiom does not trouble them. It was in Stanley Spencer's studio in the Vale of Health at Hampstead, high up in the little green-tiled public house, the Vale Hotel, overlooking the pond there, that I saw, with my younger son, Michael, the first designs for these wall paintings; a studio wholly without furniture, save a table and a couple of Windsor chairs, barely large enough for the big canvas of the *Resurrection* which took up one whole side. The table was pushed up against it, on which were tea and breakfast things, with white marmalade jars which seemed to lead up to the white tombstones of the canvas. There was a fire in a small stove, enough to take the chill from the room, scarcely sufficient to warm it. Spencer, with his slight figure, rough dark hair low over his forehead, and something gipsy-like in his small, high-coloured animated face, might have been taken for a jockey rather than a painter, but for the innocent gaiety of his speech and manner. He was always ready to talk about painting, his own and other people's, and when he spoke of a painting he admired he showed extraordinary observation and an intensely personal insight into the mind of the painter. It was characteristic of Spencer to be painting his *Resurrection*, one of the significant paintings of our time, over a public house, with its taproom and barmaid and spirits below. We left, both my son and I, profoundly impressed by what we had seen.[5]

Talking of the material difficulties an artist has to meet, Spencer said he felt, each time he set to work, as though he were setting out in a boat, with provisions only for a day 'smack into the black'. 'I am still painting the big Resurrection picture which I began last February,' he wrote some weeks after our visit, 'and it will take me another year to finish and longer possibly. Although the world in this picture is not "without form and void", the ground and the grass and bushes having been painted, still I have not yet come to the exciting point of "creating" (painting) the people. I find I am painting things in this picture in the same order in which God created them; first the Firmament (there is only a tiny bit of it in my pic[ture], but I

nevertheless began with it) then all the bare earth bits and the river bits, then the bushes and flowers and grass and trees and creepers and here I also do walls and buildings, then come animals and human beings together at the end.'[6]

I told him how impressed my son and I had been with his designs, and touched on one thing that seemed incoherent, the contrast between the summary treatment of the figures in relation to the Pre-Raphaelite finish of the landscape. He at once replied: 'It certainly is very disconcerting this weakness of mine when I come to painting the figures, or the people as I like to call them; but I believe it is symptomatic of something which if I get over this difficulty, will be very good. The thing is that with certain things I can quite clearly recognise the *identity* of some imaginative notion. I can recognise what I want in certain things, objects, *places*, shapes, etc., and I can also see it in people's behaviour and in what they do, but I am lost when I come to what people *look* like.

'This is very tragic as the person in the picture is to me the most intense and most dramatic fact of all. I am keenest of all about the people in my pictures and although at present I can only very lamely express any feeling about them at all, yet my thoughts about them are moving along—to me—very exciting channels.

'It's very difficult to say in writing just what this feeling is, but certain places, especially in and about Cookham suggest to me certain very wonderful people, and vice versa people, especially great personalities suggest to me the same degree, if not the same kind of feeling as that which I get from some place. And then there seems to be a definite spiritual relationship between particular people and particular places. It does seem sad when I think of the infinite number and variety of feelings a painting of a head can express and the feeble use I make of it. I have an enlargement of a sleeping soldier's head from Piero della Francesca's Resurrection of Christ. Everything is in that head, as you look at it the Roman Empire ceases to be a real thing and falls helplessly away; the Resurrection above it is too much for it; "it o'er crows him quite".'[7]

'When I left the Slade,' he told my son Michael, 'I entered a kind of earthly paradise. Just as all my ideas seem to be unfolding in a fine order along came the war and smashes everything. When I came out the divine sequence had gone. I just opened a shutter in my side and out rushed my pictures anyhow.'

Hardy's death in 1928 closed an epoch. Gosse did not long survive Hardy. His death, too, closed an epoch. With him went rich memories of Swinburne, of Stevenson, Hardy and Henry James, of others with whom he had been intimate. Of these he was a mine of gossip and information, of anecdotes, of their habits and peculiarities, told always with a zest, a sparkling malice, a breathless enjoyment in beautifully rounded and rhythmical language. I see his face, bright-eyed behind his glasses, his white hair parted in the middle, his pale moustache, while he sat with his hands folded tight across his chest at the Savile Club, surrounded by his cronies after luncheon.

Gosse had a strong bias against Watts-Dunton, which affected his later relations with Swinburne. I, too, had nursed a grievance against Watts-Dunton and wrote unkindly of him in a previous volume.* This showed ingratitude; for it was Watts' friendship for my wife and myself which brought me to Swinburne. When, in later years, I returned to The Pines to visit Mrs Watts-Dunton, there came vivid memories of the two great friends, of Watts-Dunton, with his small rotund figure, his apple-red cheeks, his rambling talk about poetry, his enthusiasm for literature, his old-fashioned ways, and of Swin-burne's slight nervous figure, his greenish eyes, noble brow and gol-den beard, in his room above. Most of the old furniture, the Rossetti and Madox Brown pictures, two paintings by my father-in-law, Walter John Knewstub, one of them a portrait of my wife as a girl, still hung at 'The Pines'. I was a little dismayed to find a large drawing of a nude by Rossetti unframed, lying face downward on a

*After publication of *Men and Memories, 1900–1922,* Clara Watts-Dunton wrote thus (May 6, 1932. PC): 'In a letter of the 18th of February 1931 you inform me, you had naturally read with disgust your remarks on my husband in your first volume of remembrances "Men and Memories", that I might look in its sequel for much more sympathetic references to the maligned author of "Aylwin". What do I find in its sequel? I find an ill-natured insinuation by Mr Augustus John R.A. that my husband was unable to understand spoken Romany and a suggestion that he "poisoned" Swinburne's mind to the detriment of Sir Edmund Gosse. The index fails to reveal any antidote to these pages. If "sympathy" find such expression it is uncommonly like perfidy in the opinion of Yours faithfully Clara Watts-Dunton.' For the offending references, see *MM* II, 96, 168. Rothenstein must have apologised, for she replied (May 9, 1932. PC): 'One can't help being touched by your expla-nation. And yet—from the point of view of one who does not easily write books what a pity that unless one published your afterthought, the effect on your readers is merely that you follow the temporarily fashionable line of regarding my husband as an exploded reputation whereas he was in reality a poet of remarkable sincerity and technical power and a critic of uncommon sagacity.' The letter was signed 'With kind regards,' perhaps implying forgiveness. The editor takes pleasure in publishing this evidence of WR's 'afterthought.'

bed in an upstairs room, and the Madox Brown self-portrait, so dirty that I carried it off to get it cleaned at the Victoria and Albert Museum.[8]

During the autumn of 1929 Gordon Craig came over to London from his home at Genoa. He was in high spirits—C. B. Cochran had offered him at long last a theatre wherein he was again to show his genius for staging plays. There were articles in the important papers, a leader in *The Times*, enthusiasm among the younger actors. But first, Craig said, he must find a suitable theatre, then the right kind of players: not the usual professionals, but men and women who could speak verse and use gesture. Gesture! That was rare in England; I remembered how Geoffrey Scott had said, comparing English and Italian buildings, that no nation without natural gesture can produce great architecture, and Craig told us how, in testing actors, he would ask them to say 'a beautiful woman' but how dully they said it compared with the gusto, the rich impasto of the Italian actor's 'O la bella donna!' Nevertheless, he offered a part in a play to every charming woman he met at our house! He went to see two or three theatres which Cochran said were available. Then he declared he must have the old Lyceum. Unfortunately, the Lyceum was not available. We begged Teddie to be reasonable; surely he could make some other theatre suit his purpose. But no! And Craig withdrew, threw away, so it seemed to us, this unique chance. I thought of Teddie's dear mother, Ellen Terry, of how she longed for recognition for his work: 'He is a genius. Yet his hair is quite white, and no one will give him his chance.'[9]

I tried to persuade my friends at the India Office, Sir Arthur Hirtzel, Sir Malcolm Seton and Sir William Duke, to direct the attention of the Viceroy and the wealthier Princes to the desirability of providing work for Indian artists, whose work suffered much from lack of encouragement. I wrote to Lord Irwin [the Viceroy], pressing the claims of Indian artists on the Government. Not long after I heard from the Viceroy, who asked me to come out to India to advise the Government on the decoration, by Indian artists, of Sir Herbert Baker's legislative building at New Delhi. There were dissensions, it appeared, among the different Indian schools, and impartial advice was called for.[10]

*You know how glad I am to be of service where the interests of India
and of Indian art and artists are concerned. A journey to India when
my health is not very good would be for me a rather serious undertaking.
... You were good enough to show me an abstract of the conditions placed
before Indian artists, inviting scale designs for the first decorations to be
undertaken, and to ask me my views upon them. I am so warmly in sym-
pathy with this important move made by the Government of India that
I hesitate to appear over-critical. (WR to Sir Atul Chatterjee, copy dated
December 15, 1927. RP: HL.)*

Meanwhile, Sir Atul Chatterjee, the High Commissioner for India
in London, supported by Sir Herbert Baker, had in mind the decor-
ation of India House by Indian artists. This project was sanctioned
by the Government of India, who asked me to select four from
among six artists chosen by a committee in India, to work under me
at the Royal College, where there was an experimental studio where-
in they could acquaint themselves with the various methods used for
mural painting. (I found one of the six sitting outside my door at
South Kensington before the selection was made!) Three of the
artists chosen by the Committee in India turned out to be Bengalis,
the fourth came from the Tippera State. This, I was to discover later
was displeasing to the Bombay School. Before the paintings were
finished, Sir Atul retired from the office of High Commissioner. [His]
successor at India House was Sir Bhupendranath Mitra, a financial
expert, with no sense of the arts, who sent for me constantly, fearful
always that the painters were idling, and again doubtful of the reason-
ableness of their claims to payment. It was for me a trying position.
My relations, so far as their work was concerned, with the young
painters were of the happiest, but the demands made on my time
were excessive, and I resented being called on to act as a sort of
policeman. I heard that I was severely attacked in *The Times of India*
for favouring artists of the Calcutta School as against those from
Bombay. To my surprise extracts from my private letter to the
Viceroy were quoted in one of the *Times of India* articles! How a
letter to the Viceroy got into private hands, and then into the press,
was a mystery to me. I was the more glad I had not acceded to Lord
Irwin's earlier proposal!

After two years of considerable trouble supervising the artists and
their work, I got a brief note of thanks from the Government of
India and much abuse from other quarters.[11] There are so few in
England interested in Indian art and literature that these few are

much beset. The wife of an eminent scientist, for instance, was sure I could help her husband to become a Fellow of the Royal Society; another wanted a knighthood; another again an honorary degree at Cambridge; painters wanted commissions for Royal portraits, and others, whose claim was generally based on a few feeble copies of Indian paintings and enlargements of photographs, desired the Diploma of the Royal College of Art; and since I had been instrumental in getting Tagore's first book of poems printed, other aspirants sent me their verses, believing I could be equally helpful to them.[12]

During 1931 I heard from India of a volume to be offered to Tagore on his seventieth birthday. All sorts of eminent people, including Einstein, were invited to write laudatory messages to the poet. At the last moment it appeared that neither Shaw nor Yeats had replied to the Committee's repeated invitations; I was asked to whip them up. 'To the devil with these Nitwitiketan idiots!' Shaw replied. 'I spend half the year telling them to put my name to anything they like that will please Tagore, and the other half telling you to tell them so. I know by bitter experience that these people who fasten themselves on the birthdays of the eminent and beg unspontaneous and worthless messages [are] all over the place—but I haven't any room to let myself go. Tell them for the fiftieth time to put my name and *be d—d*!'[13]

I have just received via Empiradio *the following telegram:* 'English friends of Tagore practically unrepresented in golden book will you kindly arrange send messages or contributions from Shaw Wells Masefield Galsworthy Sturge Moore Barrie Yeats George Russell Max Beerbohm and others by end of Septr stop keen disappointment.'
I can do no less than send you a copy of it. I have my own ways of troubling my friends. I am busy enough to know how busy others are and don't relish tasks of this kind. There is evidently to be no boycotting of English compliments in India. I gather that the Einsteins and Keyserlings have responded and that there is some dismay that no one from England apart from my poor self has sent any messages ... In a second telegram, Ramananda Chatterjee, who is editing the book, tells me that he will keep back the book until the end of September in the hope of getting greetings or contributions from England.
I don't know whether you got the letter sent to me, pressing for some sort of greeting: but a 70th birthday is an occasion and it would cheer the old man to get a few words from his friends in England. It would even

cheer me to get a word from you! (WR to H. G. Wells, August 23, 1931. University of Illinois Library.)[14]

Yeats, too, was bored by this heavy flattery it was proposed to offer to Tagore: 'Your letter about Tagore reminds me of my sins. I did get some letter on that subject months ago, but one gets into a dream over one's work and forgets such things. Heaven knows whether I will send them anything or not or if I do whether it will be in time. Probably I shall send nothing because I hate sending mere empty compliments and have time for nothing else. I shall write to Tagore privately. I shall have plenty to say when I have not to remember that other men are looking over my shoulder.'[15]

I rather agree with you about the 'Golden Book'. I had to refuse membership of a 'Tagore Society' which is being set up in London. Vanity is Tagore's weakness—it has done his reputation harm, abroad as well as in England. I found Hauptmann very critical of him and of his work. Tagore has men like C. F. Andrews about him who flatter him and weaken his judgement. To men like you and Sturge Moore R.N.T. will always listen. And after being quiet for 6 months Tagore yearns for garlands and speeches and receptions. It is easier to sway thousands than to keep one's own feet in the narrow path. And to do anything perfectly, how much more difficult than to be a great teacher. (WR to Yeats, September 11, 1931. PC.)

The Golden Book of Tagore duly appeared, in a form which at least did credit to Indian printers. I do not know whether the poet relished the many flattering encomiums which flowed through the book. I thought of a phrase in one of Yeats's letters: 'Do you remember a saying quoted by Max Müller from an old Indian text "One thing will never go out of the world, the vanity of the Saints".'[16]

One day I found Yeats, now frequently in London, sitting before a table piled up with books; he was making an anthology of modern poetry for the Oxford Press, and reading contemporary poetry. There was one outstanding poet, he said, hitherto unknown to him, Dorothy Wellesley. Did I know anything about her?

Yes, indeed I knew her; some ten years earlier she had asked me to paint her two children, a project which, owing to illness, I had to abandon. I wrote to her of Yeats's high praise, knowing it would please her; for though J. S. Squire had long admired her work and printed her poems in *The London Mercury*, she had met with little

recognition: maybe her title stood in the way. Now Yeats was to give her work an important place in his anthology. I joined him at 'Penns in the Rocks', her home in Sussex, and sketched the two as they sat in the garden, the young and the elder poet; Dorothy fair, with deep violet eyes and auburn hair, with full arched lips somewhat drawn down, a slight Elizabethan figure next to Yeats, with his crimson shirt, flowing coloured tie, now in his later years brownskinned under his crown of blue-white hair, his dark eyes aslant, broad-shouldered and ample of form—he once so pale and lanky. He read from the books before him with his musical lilting voice, accepting this poem, rejecting that.[17] And after dinner Yeats would expand, talking as only the Irish can, of mystic experiences, deploring the loss of ancient wisdom, praising the old secret knowledge handed on by word of mouth to the uninstructed. In Ireland today Yeats found the greatest understanding among gunmen; with these he could exchange ideas. But little of the old poetry still lingered among the people; in future he would write ballads to be sung in the streets, ballads set to new tunes, if musicians would make them. For poetry should be said to music again, as it was by the Troubadours, and the old Irish poets.

In talking of poetry Yeats said the upholders of free verse claimed that its form was, without restriction, accommodated to the matter. He took the opposite view: the essence of poetry is the outpouring of the personal into a static form (this he compared with the metaphysical antimony of the individual and the infinite—the many and the one) although the form could of course be changed and adapted. 'I am a traditionalist.' He cited Byron's '*So we'll go no more a-roving*' where he relates his personal feelings, not only to traditional words, and metre, but on to an old quotation, and thus gives it 'far more melancholy'.[18] Here lay the difference between his own early and later poetry—in his later he had a philosophy. Not that he writes philosophical poetry, 'I do not write about ideas, I try to write about my emotions. But my philosophy prevents me from writing much that I might otherwise write about.'

Yeats agreed that the reaction against what is sane and traditional is tiresome. We have to accept the conditions we find at a given time in our lives; within their discipline we can still be free enough to be sincere and ourselves. Mere easy acceptance, of course, is a different matter. 'Wherever there is thought there is opposition; you cannot think in vacuo.' But an easy, conventional reactiveness is merely nega-

tive opposition. It is a danger to which clever young people are particularly exposed; I know how easy this opposition is for those who, like myself, were brought up in a provincial town, where to react against the indifference and materialism one meets with is inevitable.

On another occasion, when Ramsay MacDonald suggested our lunching together, I asked Yeats to meet him. Yeats, who had lately been seriously ill, was weak-voiced, almost inaudible, but as he talked his voice grew stronger, and he kept the conversation going throughout the luncheon, Ramsay listening and saying little. Later, in the smoking room, Yeats got on to the subject of Berkeley and Swift, spinning theories of Swift's character, of Stella's and Vanessa's, and presently George Trevelyan joined us, and as Yeats proceeded, getting more and more eloquent as he went on, Trevelyan, attracted, eager to bring his fine Whig sense of accuracy to bear on Yeats's improvisations, tried vainly to break in, while Yeats, his right hand raised, as it were forbidding interruption, grew ever more fantastic and inventive. He was trying, he said finally, to inspire the youth of Ireland with the national ideals found in Berkeley and in Swift. The poetry of the Irish movement had served its purpose and was dead. Berkeley learned his nationalism in the university, Swift in politics. He could not accept the new Realism—that the seen can exist independently of seeing. He spoke of the enigma of Berkeley's personality, the fiery entries in his commonplace book, the contrast with Berkeley's portraits and his later work, and of Berkeley's love of conversation—the dominant trait in his character. Berkeley returned from America when he had finished telling the Americans of his new philosophy.[19]

After Trevelyan left us, Ramsay wondered, he said, how he could have wished to interrupt—he himself sat spellbound; he could not have broken the thread of Yeats's wonderful talk.*

*Dorothy Wellesley, when asked to recall 'some hints of W.B.Y.'s talk', wrote as follows (September 10, 1938. RP:HL): 'I imagine that you are faced with my own difficulty in this matter. One cannot remember one of his profound, or beautifully fantastic sayings with any accuracy. I am the only person I know who does not lay claim to a thoroughly bad memory. But Yeats eludes me. . . . I may be blamed in future years for not setting down a great part of his talk. The difficulty lies in this: He has no commas; there is no time to absorb a thought of his or memorise a phrase. He is forever off again on wings of silver. . . . The plain fact is that Yeats should be stopped at intervals of 10 minutes. By this method his admirers would have time to go into another room and take down at least something. I am however, comforted by the fact that almost everything is in his prose writings; and I discard anything that is, or will be printed.'

Yeats sat usually alone at the Athenaeum and spoke to no one, but my friend John Sparrow told me how about this time he was conversing with Yeats at the Mitre at Oxford, and how Yeats's words 'the tragedy of sexual intercourse is the perpetual virginity of the soul', resounded through the lounge, and of the startled looks on the part of persons reading the *Sporting and Dramatic News* and the *Bystander*. 'Sexual intercourse,' he went on, 'is the attempt to solve the eternal antimony, doomed to failure because it takes place only on one side of the gulf, which separates the one and the many, or, if you like, God and man. But the antimony is there and can be represented only by a *myth*. The whole of life, *the world itself*, arises out of the opposition of these two. You must have a myth. No one can live without a myth. No myth can be proved, but we test it by our everyday experience.'

On December 29, 1938, he wrote to me from Cap Martin: 'You advised me two or three years ago to get some embroidery designs ... but I want something rather different now. ... My sister ... is trying to do a series of needle pictures which represents incidents or symbols of the Irish heroic age. ... In England the romantic movement is of course over and the average artist guys the dream. With us it is the opposite.'[20] Little more than three weeks later his heart gave out.

'I will tell you of Yeats's death,' wrote Dorothy Wellesley, who was staying at Mentone. 'Hilda Matheson, W. J. Turner and I went to see him on the Saturday before he died. I had never seen him in better health, wits, charm or vitality. He was wearing his light brown suit, blue shirt and handkerchief. Under the lamp his hair seemed a pale sapphire blue. I thought during the talk: "What a beautiful man." He read aloud his last poem. A fine affair as I remember it.[21] He asked Hilda to make a tune for it. She went out of the hotel, and she and I walked up and down in the darkness trying the tune. When we came back she sang the air, he seemed pleased. His last projective thought seems to me to be this wish for "words for melody". *Melody* not *music* conventionally spoken of: Folk, ballad, etc. (I from early childhood have craved for this union: "words for an air") and this is what we must now carry on—Tuesday he could not come to spend the evening here as he seemed tired. Wednesday Turner left for England. Thursday Hilda and I went to see him. I stayed only 5 minutes, he seemed very ill. In the afternoon we went again, Mrs Yeats had said: "Come back and light the flame!" I sat on the floor by his bed holding his hand; he struggled to speak; "Are you

writing—are you writing?" "Yes yes." "Good good." He kissed my hand, I his. Soon after he wandered a little in his speech. On Friday he was worse. I saw him for a few minutes; he then passed into what proved to be his last coma. He had much pain from the heart, but morphia helped him. So ended in the material sense this short and beautiful friendship.'[22]

In Paris [in the spring of 1939] I stayed in a modest hotel in the rue de l'Université, a stone's throw from the rue de Beaune, where I first lived, fifty years ago, with Herbert Fisher, Kenneth Frazier, Arthur Studd and Ludwig von Hofmann. It was delightful to find this quiet quarter of Paris much as it was fifty years earlier; I could almost imagine myself setting off again to the Académie Julian at the rue du Faubourg St Denis. I did, in fact, passing through the rue du Dragon, come upon Julian's school. But how different from the crowded, noisy, dirty airless Julian's of the past! The present studios are clean and quiet as those at the Royal College, and by no means crowded. No one shouted at me as I went in; in fact I was received with extreme politeness.

The Quai Voltaire with its old furniture and book shops I found unchanged. Unchanged, too, was the front of the Hôtel du Quai Voltaire, where in 1897 I made a drawing of the dying Beardsley.[23] Only the old Pont du Carrousel, with its iron railing, has been replaced by a new stone bridge. I crossed each morning to the Louvre. Here I found many changes, though its long gallery was familiar. I saw the *Porte [de l'Enfer]* again, at the Musée Rodin, at the Hôtel Biron, about which there had been so much hesitation and discord before the Government decided to accept Rodin's splendid gift. But Rodin was a difficult person to deal with. I was reminded of this when, loitering along the quays where the books are displayed, I happened to come upon the letters of Rilke to Rodin, which I bought for a few francs. When I took up the book to read these letters which displayed Rilke's somewhat embarrassing adulation of Rodin, I suddenly came upon a reference to myself. I was surprised to find that a letter Rilke had written to me, to which I sent a reply, was a source of grievance to Rodin, and was in part the cause of Rilke's dismissal from Rodin's establishment. From Rilke's defence of himself it appears that Rodin resented his doing anything but attend to his, Rodin's, immediate affairs; with the result, as poor Rilke says: 'Me voilà chassé comme un domestique voleur, à l'imprévu, de la

petite maison oú, jadis, votre amitié m'installait doucement.'²⁴ I can only conclude that there were previous misunderstandings and that Rodin took any opportunity that presented itself to get rid of Rilke.

I climbed up the rue Lepic to my old studio in the rue Ravignan, where Conder, and later Picasso, also lived, and found the quarter much as it was fifty years ago. Each street in Montmartre brought back memories: of Degas in the rue Victor Massé, and my excitement each time I went to be admitted to his apartment. On the Place Blanche the sails of the Moulin Rouge still turn; but Valentin and la Goulue, Rayon d'Or and Nini Pattes-en-l'air, la Môme Fromage and Jeanne Avril dance only in the memories of a few survivors— Edouard Dujardin, George Moore's friend, is one of them—of that uneasy, hectic circle of artist-noceurs. I recollected, too, how Conder, sitting with Germaine at the Café de la Rochefoucauld where Degas often came to lunch or dine, spoke of the shame he felt for the slightness of his art when he looked across at Degas, sitting austerely alone.

From the rue de l'Université, on the other side of the river, I could walk into the rue du Bac and see again, in recollection, Whistler's little Empire house, with its apple-green door, its dining room full of old silver and Long Elizas, Whistler himself delicately holding a copper plate, touching it with his needle while he talked. There Mallarmé would come, and Helleu, de Montesquiou-Fezensac and the Spaniard Gandara to pay homage to the Master. It was there I first met Walter Sickert. Nearby, in the rue des Beaux-Arts, Fantin had his studio, where his *Hommage à Delacroix*, now in the Louvre, used to hang, surrounded by unframed copies and studies made during the course of his long life; Fantin in baggy clothes and list slippers, with a shade over his eyes, half French bourgeois, half Kalmuck. And there were the nights spent at Montparnasse, at the Café François Premier, where Verlaine sat with Cazals, and at the Café d'Harcourt, with Stuart Merrill, Jean Moréas and Raymond de la Tailhède, all now departed. I retired early to my hotel, for the cosmopolitan crowds on the Boulevard St Michel had no attraction for me.

I found Blanche looking thinner than when I last saw him in London, depressed, too, at the international tension, fearing for the safety of Paris, and incidentally, of his own household and effects.²⁵ I could understand Blanche's feeling, that in case of war France would have to bear the full brunt of the first attack. But I was shocked at his

pessimism, bordering on despair. If other Frenchmen were thinking as Blanche, the prospect was not hopeful. We can only live from day to day; meanwhile the unfailing fertility of the spring brings courage. For nothing can prevent the sap from rising, or the miracle of the full-leafed, blossoming trees after the bare winter. It is poor comfort, I know. But life with its unlimited fecundity pulsating throughout the universe urges and controls more than any human agency. You and I are old, dear Blanche, but the young are full of vigour; even the old remember their desires. Yeats's last poem suggested that he would give everything for the power to bring once more fulfillment to a young woman. Our fears fill but a small proportion of each day: our small satisfactions and disappointments, above all our vanity, are with us to the very end.

And I bade farewell to my old friend; and though I believe he had enjoyed my visit, and regretted my leaving, he was impatient that I lingered while the taxi was ticking outside the gate. So, I recollected, my old father used to be, when I paid one of my brief visits to Bradford, until I was on my way to the station, in good time to catch the train back to London.

NOTES

INTRODUCTION

1. Quoted in *MW*, p. 156.
2. *Ibid.*
3. James Laver, 'Memories of Sir William Rothenstein,' *The Spectator* (London), 146 (1931), 274.
4. 'A Life Dedicated to Art' (obituary), *The Times*, February 15, 1945, p. 7.
5. Page references following in parentheses refer to the present text.
6. For complete text of Max Beerbohm's address at the Memorial Service for William Rothenstein, March 6, 1945, see *MW*, pp. 175–6.
7. See *Men and Memories, 1872–1900*, facing p. 220: 'A Recollection: Oscar Wilde, Charles Conder, Max Beerbohm, and the Writer [Rothenstein] at the Café Royal, by Max.'
8. WR to Craig, November 26 [1921]. Bibliothèque Nationale. Craig, Nash and Gill were exhibiting with the Society of Wood Engravers at the Chenil Gallery, November 1921. A tortuous three-way correspondence (Enthoven Theatre Collection) by Craig, WR, and the Victoria and Albert Museum authorities finally resulted in acquisition of a number of Craig's designs. His work was exhibited there after being first shown at Amsterdam, and Craig made the journey there with the aid of £60 obtained from Max Beerbohm.
9. WR to Shaw, January 30, 1940. Academic Center Library, University of Texas, Austin. See G. B. Shaw, 'The Royal Academy' (letter), *The Times*, January 20, 1940, p. 7. Ford Madox Brown's *Work* (1852–63), Manchester City Art Gallery. In 1876 he began to correspond with Charles Rowley, who averted a municipal plan to use Belgian mural painters to decorate the new City Hall, at £40 per yard. At a rate of pay higher than that quoted by WR but still modest, Madox Brown painted twelve large murals (1879–93); Walter Knewstub, Alice Rothenstein's father, assisted him in much of this work.
10. Max added, then crossed out: 'Every one somebody. Timid before the male,' the latter being a key phrase in a Rothenstein letter to Max after they quarrelled in 1909, and a trait about which Max often teased him; see *MW*, p. 59. WR had introduced Max to John Lane, of the Bodley Head. Max's notes: Berg Collection, New York Public Library. A much shorter passage from these appears in David Cecil, *Max: A Biography*, p. 67.
11. John Rothenstein to Robert Speaight, May 18, 1961. PC.
12. Moritz Rothenstein to WR, October 20, 1902. PC.
13. Grant Richards, *Memories of a Misspent Youth*, p. 183. J. A. Barbey D'Aurevilly's *Du Dandysme et de Georges Brummell* (1845) remains a classic about the dandy tradition.
14. John Rothenstein to Speaight, May 18, 1961. PC.
15. See Virginia Woolf, *Roger Fry*, pp. 167–9; *Letters of Roger Fry*, ed. Denys Sutton, I, 345–7, 41–2. See also *MW*, pp. 67–71.
16. Tonks to WR, January 18, February 12, 1908; Brown to WR [before May 24, 1909]. RP:HL.
17. WR to Fry, February 2, 1909. PC.
18. WR to Fry, June 12, 1910. PC. See Fry, 'The Art of Mr. Rothenstein,' *The Nation* (London), 7 (1910), 382–3.

19. Obituary, *The Times*, February 15, 1945, p. 7.
20. Quoted in *IE*, p. 32.
21. Quoted in *MW*, pp. 67–8.
22. WR then had to explain his action to Robert Ross at the Carfax Gallery, of which WR had long been an associate; he did so in a letter of April 20, 1911 (RP:HL). Ross, too, had been under the impression that Fry wanted WR's Indian drawings for the Grafton exhibition. Ross had written (April 18, 1911. RP:HL): 'I am extremely glad you are showing your work at the Grafton where it will be seen by a much greater number of persons than at Carfax or Chenil. [Arthur] Clifton [Carfax manager] would never have expected you to throw over Chenil for him; he will of course quite understand that the Grafton is a different matter, and I am sure that Chenil will see it in the same light. . . . I sympathise, however, very much with the touchy feelings of artists, and Chenil would certainly have had as much right to be annoyed, if you had thrown him over for Clifton, as Clifton would be and is by the similar action of other artists in the past. But a public gallery is quite a different thing and it would have been absurd for you to have rejected Fry's offer.'
23. Brown to WR, May 22, 1914. RP:HL. For another portion of this letter, see *WR*, p. 262.
24. Quoted in *MW*, pp. 71–2.
25. A selection of the R.A.F. portraits appears in WR's *Men of the R.A.F.*
26. Quoted in *MW*, p. 11.
27. WR to Alice Rothenstein, n.d. PC. See *IE*, p. 169.
28. Richards, *Memories of a Misspent Youth*, pp. 182–3.
29. On this episode, the only serious quarrel in the entire course of their friendship, see *MW*, pp. 57–62.
30. WR to Albert Rothenstein [early July 1911]. RP:HL.
31. Quoted in *IE*, p. 288.
32. WR to Craig, September 18 [1925]. Gordon Craig Collection: Bibliothèque Nationale.
33. Richard de la Mare to WR, May 31, 1928. RP:HL.
34. de la Mare to WR, September 21, 1928. RP:HL. Walter de la Mare wrote to WR: 'I was delighted to hear from Dick that there is some chance of your doing a book of memories. I have a sort of notion that I suggested this some time ago, or am I depriving Dick of his laurels?' (January 24, 1929. RP:HL.) His son recalls: 'I believe my father was in fact depriving me of my laurels! For my own recollection is that the suggestion to Rothenstein that he should write a full length book of Memories was my own. . . . So far as my firm was concerned, I looked after everything to do with the book, including the typography, which it gives me pleasure to remember was approved of by St John Hornby.' (Richard de la Mare to the editor, October 2, 1972.) However, Sir John Rothenstein claims prior laurels as first to suggest that his father write these memoirs.
35. In an undated memorandum, WR suggested the title, 'Figures and Shadows: A Painter's Memories.' Another hand added, 'Men and Memories.' Later Rothenstein told Richard de la Mare: 'Yes, I decided to call the book "Men and Memories" as being simple and to the point.' (July 10, 1929. Faber & Faber.)
36. Quoted in *MW*, pp. 135–6.
37. WR to H. G. Wells, March 24, 1932. Wells Archive, Library of the University of Illinois at Champagne-Urbana.
38. WR to de la Mare, February 22, 1938. Faber & Faber.
39. Quoted in *MW*, pp. 138–9.

NOTES

1. ART STUDIES: BRADFORD, LONDON, PARIS

1. Furniss' letter is not among WR's papers.
2. See Herkomer, *My School and My Gospel*. WR visited Bushey in the late 1890's, found it suffused with the Rhine-Bayreuth atmosphere, and did not regret having studied elsewhere; see *MM* I, 276. No Herkomer letters to the Rothensteins survive.
3. The Yorkshire Jubilee Exhibition opened on May 6, 1887. The letters from Leighton and Alma Tadema do not survive.
4. The Manchester Exhibition, opened on May 31, 1887, included some 1,000 pictures. Burne-Jones' *Wheel of Fortune* (1872–86), a gouache, is in the Hammersmith Public Library; his four Pygmalion paintings (1868–70) are in the Joseph Setton Collection, Paris. His more famous Pygmalion series (Birmingham City Art Gallery) was completed in 1878.
5. On Charles Furse at the Slade, see D. S. MacColl, ed., *Illustrated Memoir of Charles Wellington Furse*, p. 3. WR's 1894 group portrait (frontispiece, *Men and Memories, 1872–1900*), owned by Benjamin Sonnenberg, contains the only known portrait of Furse in the 1890's.
6. See Luke Ionides, *Memories*, pp. 12–13. According to him, Lady Ashburton asked Rossetti to recommend a copyist for her old masters. Rossetti consulted Whistler, who recommended Fantin-Latour. Legros, who had known Whistler longer than had Fantin-Latour, harboured a smouldering resentment that erupted in 1867 during an argument on another subject; Whistler struck Legros across the face, and they never again spoke to each other; see below, Chapter 7, note 1. See also *The Young George Du Maurier*, ed. Daphne Du Maurier, pp. 244, 248–9. On Whistler's bringing Legros to London, see E. R. and J. Pennell, *The Whistler Journal*, p. 79.
7. The Grosvenor Gallery opened in May 1887, the New Gallery in May 1888.
8. This drawing for Rossetti's uncompleted painting (begun 1854) was to have been in a Tate Gallery exhibition planned for some time prior to 1923 but cancelled because of suffragette disturbances. The Tate then wished to acquire it, but Brooke's daughter Evelyn told WR (May 26 [1917]. RP:HL) that she had written 'saying it is now yours.' See Virginia Surtees, *The Paintings and Drawings of Dante Gabriel Rossetti*, I, Catalogue 64C. The drawing was acquired in 1977 by the Graves Art Gallery, Sheffield.
9. The first Arts and Crafts Exhibition, September 29–December 1, 1888.
10. Whistler's first retrospective show, organised by Sickert at the College for Working Men and Women, 29 Queen Square, Bloomsbury, May 1889. It was somewhat disorganised but was a good selection that included the portrait of Carlyle (1872), Glasgow Art Gallery, and the *Arrangement in Grey and Black No. 1: The Artist's Mother* (1872), now in the Louvre.
11. Ellen and Kate Terry as *Two Sisters* (c. 1862), never completed, owned by the Hon. Mrs Hervey-Bathurst; Lillie Langtry as *The Dean's Daughter* (1880), Watts Gallery, Guildford; Lady Lytton (1862), last recorded owner (1956), Mrs A. R. Cresswell; Mrs Nassau Senior (1857–58), Wightwick Manor Collection (National Trust); Joseph Joachim (1865–66), Watts Gallery; William Morris (1870), National Portrait Gallery, London. For a drawing of Watts' Melbury Road studio in 1904, see Wilfrid Blunt, *'England's Michelangelo'*, Plate 19a.
12. Fourteen etchings, in the 1895 edition, John C. Nimmo, London.
13. 'A Loan Collection of Pictures by the Great French and Dutch Romanticists of This Century,' April–May 1889. The catalogue had an essay on Romanticism and notes on the artists by W. E. Henley.

14. *Samson,* shown at the Royal Academy in 1887, now in the Walker Art Gallery, Liverpool. WR told his father: 'I fear I have little sympathy with Solomon's work which I thought very poor indeed, when I saw it at his studio.' ([1893?]. PC.)

15. For WR's caricature of Julian, see *Men and Memories, 1872–1900,* facing p. 39.

16. Legros, *Une amende honorable* (1868), since 1938, in Tribunal de Commerce de Niort. See *Le Musée du Luxembourg en 1874,* published as *Petit Journal* (Paris), n. s. No. 13, for the Luxembourg exhibition, June 1–November 18, 1974.

17. Forain, *La Comédie Parisienne:* first series, 200 drawings (1897); second series, 188 drawings (1904).

18. Three impressionist decorative compositions on medical themes (1884). On reading excerpts from WR's memoirs, Kenneth Frazier wrote to him: 'I was also interested in your recollections of Besnard, whom we admired so much in those days. He and a host of others—famous and fortunate—acclaimed as great artists, bear the same relation to artists as the princes of the Church do to the Saints. I find this last sentence most useful when people ask me what I think of—say Zuloaga for instance—they stop and think for a minute and wonder if it is praise or criticism.' (October 11, 1929. RP:HL.)

19. Whistler's white compositions were Hamerton's *bêtes noires.* He attacked *The White Girl No. 1* (1862) and the *Symphony in White No. 3* (1867), and Whistler retaliated in *The Gentle Art of Making Enemies,* pp. 44–5, 78–80. In 1890 Hamerton planned a series of articles on the Louvre but abandoned this because of doubts about English readers' interest. WR's tepid reaction may have made him the recipient of Hamerton's frustration as well as of his knowledge of the Louvre.

20. WR confuses the chronology. Conder arrived in August 1890, when WR was at Giverny; they met at Julian's that autumn. Von Hofmann had left Paris that summer; Rothenstein visited Berlin in 1891.

21. Conder's studio was at 13 rue Ravignan. The 'irregular open space' is now the Place Emile Goudeau. The garden pavilion still stands, as do the four 'mere wooden sheds,' with what appears to be original glass in windows and skylights. This is the upper portion of the *'Bateau-lavoir,'* now owned by the City of Paris, where Picasso lived from 1905 to 1909. WR and Augustus John called there in 1906 or 1907.

22. *The Parson and the Painter,* thirty-one instalments (March–November 1890), purports to be an account by the Rev. Joseph Slapkins (*nom de plume* of Alfred Allison) of his 'Wanderings and Excursions among Men and Women,' illustrated by his 'nephew' Charlie Summers, a dandified 'rising artist' residing in Tite Street, Chelsea. Charlie is his uncle's tempter and cicerone, and the Parson is a slapstick Candide only fleetingly repentant over his liking for the fleshpots of Paris. May's delightful drawings depict the Parson as rakishly naïve and do indeed resemble WR in the 1890's. Beatrix Whistler wrote (n. d., RP:HL) to WR: 'Last night, on the Boulevard we bought an interesting work, which relates your many and dangerous experiences, in connection with your mission to Paris! It is called the "Parson and the Painter" and is by a person calling himself "Phil May". We are sure if you showed it to your many friends—it would enlighten them as to the seriousness of your work here in the Paris slums.' Whistler told M. B. Huish of The Fine Art Society: 'For I take great delight in Phil May. Certainly his work interests me far more than that of any man since Charles Keene—from whom he is quite distinct.' (May 8, 1895. Glasgow University Library.)

23. Anquetin was one, if not the principal organiser of the 1878 exhibition at Durand-Ruel. Daumier, neglected and nearly blind, was unrecognised for his work in oils.

24. *Le Bois sacré, cher aux Arts et aux Muses* (1883–84), in the Palais des Arts, Lyons.

2. PARIS INFLUENCES:
WHISTLER, WILDE, DEGAS, CONDER

1. WR moved to 23 rue Fontaine in 1891; Fry arrived early in 1892. He liked the city but disliked Julian's, which he judged 'very mild' but distasteful because of the students' crude humour. See Virginia Woolf, *Roger Fry*, p. 78; Fry, *Letters*, I, 8, 150–53.

2. Henrietta Reubell appears as Miss Barrace in James's *The Ambassadors*. Constance Wilde found her 'frightful, fair, *white*-faced and forty . . .' See *The Letters of Oscar Wilde*, ed. Rupert Hart-Davis, pp. 157–8.

3. Pamphlet unidentified. The earliest surviving Whistler note to WR was written in 1893 (RP:HL).

4. Carmen Rossi supervised his Académie Carmen, opened in 1898 at 86 rue Notre Dame des Champs. It expired in 1901, Gwen John its single distinguished alumna. Whistler had resumed lithography, working on transfer paper and experimenting with colour prints; see Thomas R. Way, *Memories of James McNeill Whistler, The Artist*, pp. 87–97. The drawing of Carmen (1890), Plate 99 in Way, *The Lithographs of Whistler*, is his first colour print.

5. See Whistler, *The Gentle Art*, p. 165.

6. On November 19, 1891, Coquelin *aîné* opened in *The Taming of the Shrew* (*La Mégère apprivoisée*, adapted by Paul Delair), his last creation at the Comédie Française. The teasing about an appointment was probably related to discussions about a translator for *Lady Windermere's Fan*; see Wilde, *Letters*, pp. 298, 306. However, if Wilde's *petit-bleu*, postmarked November 6, 1891 (*ibid.*, p. 298), refers to the theatre episode, there is some discrepancy in dates. WR introduced Wilde during a performance for which he recalled having tickets, thus after the November 19 opening.

7. WR did one portrait drawing of Coquelin *aîné* in 1892; for a second (1898), see *PD*, Plate 32. He did three drawings of Coquelin *cadet*. Richard Harding Davis bought the first, probably dated 1891, and the second, date unknown. The third was dated 1897. Present owners of these, and of a WR drawing of Davis, are unknown.

8. In March 1892, at the gallery of Le Père Thomas, 43 rue Malesherbes, to whom Lautrec recommended them; he brought Degas and Pissarro, and Degas particularly admired WR's *Parting at Morning* (Illus. 9).

9. Not now in the Gardner Museum in Boston.

10. This was the *Harmony in Blue and Silver: Trouville* (1865). It is now in the Gardner Museum, but accounts of its acquisition are extraordinarily contradictory. The Pennells, in *The Life of James McNeill Whistler* (II, 129–30), state that a bankrupt purchaser had returned it for re-sale, but there are at least four versions, in addition to WR's, of subsequent events. Morris Carter, in *Isabella Stewart Gardner and Fenway Court*, states (p. 135) that the American Ambassador to France, T. Jefferson Coolidge, was with Mrs Gardner, who asked him to carry the painting away. Louise Hall Tharp, in *Mrs. Jack*, cites this 'legend' (p. 167) and adds the Pennells' version, which puts Sir Rennell Rodd Rennell in the studio. Mrs Tharp speculates about some 'playful running up and down' with the picture. It *is* certain that if all of these persons were present, Whistler's staircase was dangerously crowded. Neither Coolidge nor Sir Rennell mentions the episode in his memoirs. Stanley Weintraub, in *Whistler: A Biography*, cites the Coolidge 'legend' (p. 377) but, in a letter to the editor, dismisses WR, if there at

all, as no more than a bystander since he forgot the price of the picture (£600, not £300). The editor believes that although WR tended to muddle dates and figures, it is entirely out of character for him to have placed himself on this scene unless he *was* there and acted as he describes. Certain other facts are apparent from letters in the Glasgow University Library. On November 30, 1892, Mr Gardner returned the picture to Whistler, apparently for signature. On December 4, Mrs Gardner wrote to ask for the address at which to deliver the cheque and collect the picture. On December 22 Mr Gardner thanked Whistler for the consular certificate and receipt. Margaret MacDonald, Whistler archivist at Glasgow, adds that the butterfly signature on the painting is a later addition—partially cleaned off by the Gardner Museum. Still unexplained is a Whistler letter to Mr Gardner cited by Mrs Tharp (*Mrs. Jack*, p. 167), dated November 10, enclosing a receipt for the Gardners' cheque and the 'consular paper.' An informal receipt may have preceded this formal one, so that the consular certificate also did some 'running up and down.'

11. By Christmas 1892 the Whistlers were settled in at 110 rue du Bac; the photographic disaster occurred in 1893. Burne-Jones partially restored the finish; the painting is in a private collection. A later oil version is at Wightwick Manor. After Whistler broke with Legros, the English painter Albert Moore replaced Legros in their Society of Three; Poynter was the third member. On Burne-Jones at the Whistler-Ruskin trial in 1878, see Whistler, *The Gentle Art*, pp. 13–17. On Whistler's views at this time, see Roy McMullen, *Victorian Outsider*, p. 184.

12. Conder to WR, June 16, 1892. RP:HL. In the summer of 1892 Conder was alone at Vétheuil, having parted—again—from Germaine. To WR, then at Montigny, he wrote: 'I am again a widower and finding the life solitary; took this house with Anquetin for the season Perhaps the life has not quite enough monotony for steady work, but one manages to do a little somehow. I hardly did a stroke when dear Germaine was with me though I cannot say it was her fault, rather the spirit of unrest that took hold of me.' ([August 1892]. RP: HL.) See *MM* I, 118–19.

13. Dujardin to WR [late 1892?]. RP:HL.

14. Whistler had as yet no real grievance. Sickert was still a faithful Follower, but his increasing independence promised trouble.

15. Davis, in France to write travel articles, reached Paris on April 16, 1893. He knew Cushing and Frazier, and after 'young Rothenstein' drew his portrait on May 12, Davis found that 'things are getting more interesting here and I shall probably have something to write about after all'. On May 14 he 'went to Whistler's and sat out in a garden with high walls about it and drank tea and laughed at Rothenstein. The last thing he said was at the Ambassadeurs when one of the students picking up a fork said, "These are the same sort of forks I have." Rothenstein said, "yes, I did not know you dined here that often." Some one asked him why he wore his hair long, "To test your manners," he answered. He is a disciple of Whistler's and Wilde's and said "yes I defend them at the risk of their lives." Did I tell you of his saying "It is much easier to love one's family than to like them." . . . It was lovely at Whistler's and such a contrast to the other American salon I went to last Sunday. It was so quiet, and green and pretty and everybody was so unobtrusively polite.' See *Adventures and Letters of Richard Harding Davis*, ed. Charles Belmont Davis, pp. 128–9. When WR left for the summer, Davis missed his 'witty but pessimistic remarks'. (Davis to WR [Summer 1893].RP: HL.) About this time Davis bought the second drawing of Coquelin *cadet*; see note 7 above. According to Davis, in 1891 Coquelin *aîné* asked WR to do two more sketches of himself at half the price for a larger portrait drawing, which

he wished to have as a gift. WR 'cut the head and shoulders out of the big one and sent him the arms and legs. It is the head he cut out that I have. When Rothenstein and I and Coquelin become famous, that will make a good story.' See Davis, *Adventures and Letters*, p. 129. WR and Coquelin remained on good terms, for Coquelin wrote cordially (RP:HL) in 1893 about his American tour.

16. WR met Pater at Oxford in late Spring 1893.
17. On Richards in Paris, see *MW*, p. 3.
18. Adrian Stephen found this 'all essentially true to life,' and pointed out that Stella Duckworth was the stepdaughter, Vanessa and Virginia the daughters, of Leslie Stephen. Also, at the time of this first visit (early Spring 1892), Vanessa would have been 'about 13 and Virginia about 10 so that I think your picture must be composite—partly coming from a later date.' He was correct: WR describes the Stephen girls as they were in 1903, when he did a portrait drawing of their father. Otherwise, 'the picture is true in all that really matters and I hope you will forgive my correcting you on such points of detail. What a household for a young man to walk into! It makes one shy to think of it.' (Adrian Stephen to WR, April 25, 1931. RP:HL.) For the drawing of Mrs Stephen, see *PD*, Plate 1.
19. Gleeson White asked WR to translate two Besnard letters on the Royal Academy exhibition for *The Studio*, 1 (1893), 75–7, 110–14. The 'work' was *Oxford Characters: Twenty-Four Lithographs*. On the contract with Lane, concluded December 20, 1893, see James G. Nelson, *The Early Nineties: A View from the Bodley Head*, pp. 99, 290–93.
20. Whistler, sceptical about WR's plans, wrote: 'They tell us, my dear Parson, that you have transplanted your earthly interests, and find much "good work to do" among "the English"—and so purpose squaring it with your Maker in London—giving up Paris as you hope to be forgiven—and walking becomingly among the money-changers of Bond Street!—Excellent!—' (N. d., unsigned. Reserved, Glasgow University Library.)
21. This first letter (RP:HL) is dated February 12, 1893.
22. See *PD*, pp. 5, 6. These were made in September 1893. The only one now traced is the undated drawing formerly owned by York Powell, now privately owned (Illus. 7).

3. OXFORD, AND A RETURN TO PARIS

1. In 1891. See above, WR to Conder, p. 75.
2. On May 16, 1893. See above, WR to Richards, p. 61.
3. Joseph Pennell, 'A New Illustrator: Aubrey Beardsley,' *The Studio*, 1 (1893), 14–19. Pennell later described this as 'an intensely hedging article, all I said being that Beardsley might do something if he went on and did something, and to my surprise he did.' See Pennell, *The Adventures of an Illustrator*, p. 216.
4. Beerbohm, 'Aubrey Beardsley,' *The Idler* (London), 3 (1898), 539–46; reprinted in his *A Variety of Things*, pp. 155–65.
5. For Mathews' letter, see Nelson, *The Early Nineties*, p. 292.
6. Acland to WR, June 18, 1893. RP:HL.
7. Ellis to York Powell, October 18 [1893]. RP:HL. Powell told WR (October 18, 1893. RP:HL): 'I have written begging Ellis to reconsider his decision and telling him it is both *pleasing and dignified*, and that we all want it. If he persists I'm afraid it must be withdrawn for the present.' For Mrs Woods' explanation of Ellis' agony, see *MW*, p. 15, note 9.
8. Ellis to WR, October 20, 1893. RP:HL.
9. Max claimed that he did go to the Oxford Union—once; see *MW*, p. 6.

10. From a card dated October 13, *1895*. RP:HL. A complaint about non-payment from Holland was written at Lunéville, September 9, 1893 (RP:HL): 'J'attends de l'argent de Hollande mais ça tarde et je vous serais obligé dès que ceci vous sera parvenu de m'envoyer si vous pouvez 100 francs que vous reprendriez sur les conférences d'Oxford et de Londres. J'écris dans le même sens à M. Lane.'

11. The order of these letters is reversed. 'Mon intention . . . de moi' is from a letter of [October] 18 [1893] (RP:HL); 'Je compte . . . à peu près,' August 14, 1893 (RP:HL).

12. Verlaine to WR, October 29, 1893. RP:HL. Sherard was assigned to escort Verlaine to Calais from Paris; see Joanna Richardson, *Verlaine*, pp. 315–16.

13. Lane to WR [November 22, 1893]. RP:HL. George Meredith hoped to see Verlaine at Box Hill, but this meeting did not take place. See Verlaine, 'My Visit to London,' trans. Arthur Symons, *The Savoy* (London), 2 (1896), 119–35. On the Oxford lecture, see Oliver Elton, *Frederick York Powell*, I, 153–4; Cecily Mackworth, *English Interludes*, pp. 100–115. For a Furse drawing of Verlaine lecturing, see Richardson, *Verlaine*, facing p. 245.

14. Verlaine spoke on 'Contemporary French Poetry,' in the Hall of Barnard's Inn, on the evening of November 21, 1893. Symons, Lane, and Herbert Horne, who had published some of Verlaine's work in *The Hobby Horse*, sold tickets at ten shillings each; Symons told WR (n. d. RP:HL) that they expected to realise about £30. Verlaine spoke in Oxford on the evening of November 23; admission, five shillings. York Powell presided. The 'room at the back of Blackwell's shop' is long since absorbed by rebuilding, but many years later an elderly employee remembered peeping through the keyhole and seeing Verlaine at a table on which two candles burned rather furtively, and an audience justly described as a 'sprinkling.' York Powell wrote to WR: 'I always remember your kindness to Verlaine. He too was very grateful for it. You ought to have a very happy old age, for you have made others happy, when you had the chance.' (January 17, 1897. RP:HL.)

15. Lawrence Evans, editor of *Letters of Walter Pater*, suggests (p. 147, note 1) that the Bussell and Pater drawings may be dated mid-January 1894. Pater's letter, quoted with errors in *MM* I (p. 156), is correct in Professor Evans' text (p. 150).

16. This is by no means all that was said, or, apparently, done. The letter (April 23, 1894. RP:HL) is from Way's son; it continues: 'However, as I suppose you intend to *lay by* these proofs and not use them now, I will contrive to let you have some. But you must keep them very dark or we shall have Lane and Pater both down on us! I shall have your proofs pulled this week, and shall have say a dozen of each so that there will be enough to make a few sets for the exhibition, and then they can take orders on them for more—What I want to avoid is taking up and putting down the stone for a few pulls each time, and when they are ready I will come and bring them to you.' 'Exhibition': by WR and Charles Shannon at the Dutch Gallery in Brook Street, May 1894. How WR was to exhibit the drawings and also 'keep them very dark' is unclear. WR's quotation of this letter in *MM* I (p. 156) reads 'stress' instead of 'threats' and contains no reference to the exhibition. Pater blew hot and cold about his portrait; see his *Letters*, pp. 147, 150, 151, 152. WR told Margaret Woods (October 29, 1894. RP:HL): 'The Pater portrait is to come out after all in the next number of the Characters.'

17. In *Edmond and Jules de Goncourt . . . Journals*, comp. and trans. M. A. Belloc and M. Shedlock, II, facing p. 234.

18. The first part of Zola's trilogy, *Les Trois Villes: Lourdes* (1894). For WR's drawing, see Zola, *Stories for Ninon* (1898), frontispiece.

19. Verlaine to WR, March 25 [1894]. RP:HL.
20. Verlaine to WR, May 27, 1894. RP:HL.
21. *Ibid.*
22. Again, chronology is skewed; this is a postcard, Verlaine to WR, January 6, 1894 (RP:HL). 'Someone else' was Esther—Philomène Boudin—who alternated with Eugénie as Verlaine's mistress. For the undated hospital drawing, see *Pall Mall Gazette*, November 23, 1893, p. 1831.
23. Verlaine to WR, April 18, 1894. RP:HL. The term 'l'harlot' appears also in a postcard, March 16, 1894 (RP:HL).

4. CHELSEA IN THE 'NINETIES

1. Lionel Johnson, also a Bodley Head poet, stated in 1891 that he had 'made great friends with the original of Dorian: one John Gray, a youth in the Temple, aged thirty, with the face of fifteen.' See Nelson, *The Early Nineties*, p. 199. However, Rupert Hart-Davis finds 'no evidence for the persistent suggestion' that John Gray was the original of Wilde's Dorian Gray; see Wilde, *Letters*, pp. 311–12, note 3.
2. Sickert at this stage concentrated on portraits, landscapes, and music-hall scenes. He certainly would have fled from Evelyn De Morgan's wispy, misty paintings. The De Morgans lived at 1 The Vale; Sickert's studio, 53 Glebe Place, became Rothenstein's; Sickert moved to 127 Cheyne Walk. 'High lights below Steers': a pun on the 1759 domestic comedy, *High Life Below Stairs*, by the Rev. James Townley, revived in February 1895 at Terry's Theatre, London.
3. There is no other record of Whistler's selling such a painting. However, he used Sickert's studio; in 1898, a year after they quarrelled, it contained a number of Whistler's 'beginnings,' one a portrait of Florence Pash Humphrey, a Sickert pupil who took his studio when he left for Dieppe in 1898. He wrote to her (probably early 1899; Islington Public Library) mentioning eight 'beginnings'; all except the portrait of her were to be destroyed. Some time after October 17, 1904, he asked whether three Whistler 'beginnings' remained. It is unclear from his 1899 letter whether all eight 'beginnings' were Whistler's, or whether some were Sickert's own: and also how eight works became three by 1904—only one of which matched descriptions in the 1899 letter. Sickert may himself have finished and sold a Whistler 'beginning.' Wendy Baron, source of this information, points out that 1896 to 1898 was particularly chaotic for Sickert, with unpredictable experimentation and paintings undated. See Baron, *Sickert*, pp. 52–4.
4. See Bruce Laughton, *Philip Wilson Steer*, pp. 49–67.
5. Furse was using Sargent's Tite Street studio. WR had 26 Tite Street. This row, with Wilde's house, now Number 23, was designed by Edward Godwin. 'Whistler was contemptuous of Oscar Wilde living in one of a row of houses,' WR wrote (*MM* I, 166). 'In Paris Whistler had described this row, drawing it to show the monotonous repetition of each house, only differentiated by its number, and putting a large 16 [now No. 23] on Oscar's house. I noticed then how childishly Whistler drew when drawing out of his head.'
6. Sturge Moore corrected WR: 'You shouldn't have put my name in for you never met me with Oscar present. . . .' (March 18, 1931. RP:HL.)
7. Longus, *Daphnis and Chloe . . . Done into English by Geo. Thornley Gent.*, published at the Bodley Head, 1893.
8. Fry wrote cordially to WR both before and after 1911; see, for example, Fry, *Letters*, I, 154; II, 409.
9. This portrait (1895), reproduced in *Men and Memories, 1872–1900*, facing p. 181, is untraced.

10. In *MM* I, 181–2, these letters are reversed. 'Very many thanks . . . Verlaine' is [c. November 20, 1893]. RP:HL. 'Thanks . . . Oxford lithos' is [September 1893]. RP:HL. For complete texts, see *The Letters of Aubrey Beardsley*, ed. Henry Maas et al., pp. 54–6.

11. *Ben Jonson His Volpone: or, The Foxe* (1898). On Sickert and Beardsley, see Baron, *Sickert*, p. 39.

12. Sargent to WR [Autumn 1893]. RP:HL. Cf. Charles Merrill Mount, *John Singer Sargent: A Biography*, pp. 205–6.

13. On WR's Synagogue paintings, see *MW*, p. 51, note 1.

14. The Boston murals are Biblical. There was much civic concern over whether the Paris-trained Sargent might prove excessively Impressionist and thus subversive to proper-Bostonianism. At the unveiling of the first murals, in 1894, proper Bostonians were shaken but appreciative of their pagan lushness. Abbey rounded off his career with decorative panels for the dome of the Pennsylvania State Capitol.

15. After Hacon's death, Amaryllis Bradshaw Hacon Robichaud kept WR's portrait of Conder, *L'Homme qui sort* (1892) until her death in 1953, when it was acquired by the Toledo (Ohio) Museum of Art. The WR-Shannon Private View was on May 7, 1894.

16. The portrait (1894) is owned by Miss Cecily Hacon.

17. Hacon invested £1,000 in the Vale Press but is not mentioned in Ricketts' *Self-Portrait: Letters and Journals* as edited by T. Sturge Moore and Cecil Lewis.

18. Watts, *A Parasite* (1903): WR was confused about having seen it in the 1890's.

19. For a WR drawing of Dolmetsch as lutenist (1897), see Margaret Campbell, *Dolmetsch*, between pp. 48 and 49.

20. Dolmetsch recalled that Runciman and Harris were 'rather drunk' when they saw the instrument; see *ibid.*, pp. 241–2.

21. Sir John Rothenstein owns the Harris portrait (1895); see *Men and Memories, 1872–1900*, facing p. 213. The pastel of Alphonse Daudet (1894) is in the Durban Art Gallery; see his *The Nabob* (1903), frontispiece. Dates and present owners of the Shaw and Verlaine drawings are unknown.

22. WR's chronology is confused. The Dolmetsch drawings were done in 1897 and 1899; the Morocco-Spain trip was in 1894–95. See *MM* I, 215–25.

23. *The Importance of Being Earnest* (1894) had opened at St James's Theatre on February 14, 1895.

24. This unidentified and untraced work had hung in Wilde's study. WR sold it through Obach's, which merged in 1911 with Colnaghi's. Records for that period have been lost, but WR received £15, which he forwarded to Wilde; see Wilde, *Letters*, p. 637.

5. CROSS-CHANNEL FRIENDSHIPS

1. Whistler wrote ([September 23, 1895]. RP:HL): 'My dear Parson— . . . I need not tell you that I am quite unprepared for this apotheosis at the hands of the great Poet—Indeed I shall feel that, even apart from all unworthiness, I am really not in it—but that a literary combination as between Editor and Bard has brought about a culmination of recognition that I might otherwise have gone from your flock without ever personally achieving! Wherefore, while highly flattered and much puffed up at the thought of Verlaine's lines, I remain soberly aware of the fact that Shannon is Director of the Pageant and that he wishes my consent to this stupendous honour to be paid to me in his first number. Say to Shannon with my compliments that he has carte blanche and shall do as he likes in the matter of

bringing out the drawing and reproduction—Also convey to Verlaine my high sense of the rare distinction proposed.' Verlaine sent his poem with a letter (July 15, 1895. RP:HL) as follows: 'Voici vers: je les crois appropriés *ad hoc*, "and the right lines of the right thing". Si vous pouvez me les faire payer tout de suite, quelle reconnaissance! Car je dois déménager vers la fin de ce mois. Quelle scie! Ne sais encore où irons. Saurez toujours—en temps utile, ne fût ce que par Vanier (19 Q[uai] St Michel). . . . Ah, tâchez donc, si possible, d'activer mes affairs p[ou]r le 3ᵉ article (Conférences) au *Fortnightly*. Travail fait, corrigé, non payé. Je finirai par me fâcher. Il est des juges à Londres! Mais préférerai "Money!" Si donc pouviez voir de ces parts? Harris, très gentil,—Courtney, naughty boy!' *The Pageant* (published 1896, 1897) paid Verlaine 100 francs, but not even WR could clarify the payment from Courtney. Verlaine wrote on Rossetti's *Monna Rosa* (1867; Surtees 198), *The Pageant* (1896), p. 17. Verlaine's verses, dated September 1895, listed in the contents as on p. 14, are on p. 19. For Conder's water-colour, *L'Oiseau Bleu* (1895), p. 113, see Ursula Hoff, *Charles Conder*, Plate 24. For WR's chalk drawing of Swinburne (1895), see *The Pageant* (1896), p. 10; *PD*, p. 8. Maeterlinck agreed, then was unable to sit.

2. *Walker, London*, by J. M. Barrie, opened at Toole's Theatre, February 25, 1892, and had 511 performances. Alice Kingsley replaced Mary Ansell as Nanny O'Brien.

3. Alice Knewstub had met Watts-Dunton and Swinburne through her father and the Rossettis; the first Watts-Dunton letter (RP:HL), dated April 15, 1890, is to her. She first took WR to The Pines on August 4, 1895.

4. Mrs Surtees, commenting on these works, knows of no studies for the Rossetti oil, *Pandora* (1871), other than her Catalogue 224D. WR may have seen *Reverie* (1868; Surtees 206) or even *Forced Music* (1877; Surtees 247), although Mrs Surtees thinks that this latter possibility *is* forced. The portrait of Jane Morris is *The Prisoner's Daughter* (1870; Surtees 218). The portrait of Watts-Dunton (1874; Surtees 529) is in the National Portrait Gallery, London. The Madox Brown 'portrait of Rossetti' may be the lamplight portrait of W. M. Rossetti (1856) now at Wightwick Manor; or, the study for the head of Chaucer for *Chaucer at the Court of Edward III* (1845–51), for which D. G. Rossetti sat, reproduced in Ford M. Hueffer, *Ford Madox Brown*, p. 74. The Madox Brown self-portrait (1875) (*ibid.*, facing p. 1), undoubtedly the one at The Pines, is in the Fogg Museum of Art. Aimée Troyen suggests that the 'water-colour by Miss Siddal' is her *Sir Patrick Spens* (1856), probably owned first by Ruskin, acquired by the Tate Gallery in 1923. Watts-Dunton may have meant these 'heads . . . by Knewstub' when he wrote to Alice Kingsley (September 25, 1895. RP:HL) about 'another water-colour drawing from your father' and suggested a model of about Alice's age who lived in Clapham. Georges Lafourcade, in *Swinburne: A Literary Biography*, pp. 275–6, adds two works by Frederic Shields, although he cites as his source manuscript notes borrowed from WR.

5. See Whistler, *Eden Versus Whistler: The Baronet and the Butterfly*; and *Wilde v. Whistler*, pp. 54–57.

6. Whistler's famous 'Ten O'Clock' lecture (*The Gentle Art*, pp. 135–59), February 20, 1885, in London; March 24 in Cambridge; April 20 at Oxford. Swinburne's review: 'Mr. Whistler's Lecture on Art,' *The Fortnightly Review*, n. s. 49 (1888), 745–51. Whistler retorted on June 3, 1888, with a letter to *The World* (*The Gentle Art*, p. 262), disowning Swinburne as a Follower.

7. See *PD*, pp. 9, 10. One unfinished drawing is in the Lilly Library, Indiana University, Bloomington.

8. Perhaps by Charles Dodgson. The Burne-Jones drawing is unidentified: not a finished work with an established provenance.

9. See Edmond and Jules de Goncourt, *Journal des Goncourt: Mémoires de la Vie Littéraire* (1896), IX, 154–5. WR's second drawing of Swinburne, a sketch in sanguine, is at the Chelsea Arts Club, London.

10. An oil portrait, *Buveur au Café (George Moore)* (1878) and a pastel (1879), both, Metropolitan Museum; and an oil (1879), Paul Mellon Collection.

11. Walter Scott, London, published Moore's *Modern Painting*; 'next book': *Esther Waters* (1894). The unused drawing is untraced.

12. The Tate Gallery has a Beardsley oil, *Caprice* (c. 1894), painted in Sickert's studio, with his help, but not a portrait of Sickert.

13. Conder to WR, August 14, 1895. RP:HL.

14. Blanche, *Le peintre Thaulow et sa famille* (1895), in the Luxembourg.

15. In 1897 WR raised a subscription of £200 for the Tate's purchase of *Femmes en Prière* (1888); see *MM* I, 255.

16. See Swinburne, 'Charles Baudelaire: Les Fleurs du Mal,' *The Spectator* (London), 35 (1862), 889–1000; reprinted in Swinburne, *Les Fleurs du Mal, and Other Studies*. Gosse's Introduction (pp. vii-xviii) refers to the Baudelaire letter, found unopened in 1912.

17. WR's drawing of Huysmans (1895), in *PD*, Plate 12; reproduced in *The Pageant* (1897), p. 217; formerly owned by 'Ryllis Hacon Robichaud; present owner unknown. Huysmans sat to WR in late November 1895; *La Cathédrale* was published in 1898. Moore was writing *Celibates* (1895), revised in 1922 as *In Single Strictness* and in 1927 as *Celibate Lives*.

18. Harris published two Verlaine poems, 'Retraite' and 'Craintes,' *The Fortnightly Review*, n. s. 61 (1894), 557, 558; and two articles, 'Notes on England' and 'Shakespeare and Racine,' *ibid.*, n. s. 62 (1894), 70–80, 440–47. Heinemann published two poems, 'A Eugénie' and 'A une Femme,' *The New Review*, 12 (1895), 259, 676. Verlaine told WR that the *Fortnightly* owed him 250 francs: 'Où d'attaquer? devant les tribunaux anglais?' The money did not arrive; he asked WR to have Horne look into the matter (July 22, October 13, 1895. RP:HL).

19. See Verlaine, 'Anniversaire: à Will Rothenstein,' *The New Review*, 10 (1894), 571. On August 1, 1895, Verlaine wrote: 'Amitiés à Symons,—et le dessin de la Salle de Barnard's Inn?'; on July 15, 'Et le croquis ou la photo de Barnard's Inn!' (Both, RP:HL.)

20. Whistler was all too recognisable as Joe Sibley, 'the King of Bohemia,' in *Trilby*, serialised in *Harper's Monthly Magazine* (London), January–August 1894. He forced Du Maurier to substitute a demonstrably fictitious character. See Leonée Ormond, *George Du Maurier*, pp. 463–79.

21. For this letter (Library of Congress), probably written in late Autumn 1867, see Léonce Bénédite, 'Whistler,' *Gazette des Beaux Arts*, s. 3, 34 (1905), 231–46.

22. Whistler to WR, November 27 [1896]. RP:HL. He told his sister-in-law, Miss Birnie Philip, that the N.E.A.C. Committee—Sickert, Frederick Brown, Steer and WR—'have *invited Sir William Eden to exhibit with them*' and had hung Eden's ' "work" ' in their gallery. On November 23, Whistler told her, he had been to the Chelsea Arts Club to observe their digestion of the ' "toad in their belly" '. (November 24, 1896. Reserved, Glasgow University Library.)

23. Whistler to WR [mid-December 1896]. RP:HL.

24. Whistler to WR [early 1897]. RP:HL.

25. 'Friendly letters' follow (RP:HL), but without reference to the 'toad in the belly'.

6. ENGLISH PORTRAITS AND LIBER JUNIORUM

1. *English Portraits* set off a vigorous contest of egos. Richards favoured public figures such as Admiral Lord Charles Beresford, Lord Rosebery, and Sir William Harcourt. WR favoured artists and also Cunninghame Graham, at whom Richards balked, since he thought that Graham had had enough publicity. Richards urged WR to pursue the Admiral, who was out of town: 'I repeat, if Cunninghame Graham is to go in, he goes in more or less at my protest. I am perfectly willing to wait until Lord Charles Beresford comes back, and failing Lord Charles Beresford there are other people. ... You will perhaps understand that I have a right to some slight annoyance that a series which was to contain all the great people of the age—the great politicians, the great musicians, the great literary people—has been strong only on its artistic side. At the same time I am perfectly willing to allow that you have done what you could to secure better people. What I now resent is your putting in Cunninghame Graham without a word, as one might say: "The whole thing has given me a lot of trouble; let's put in Cunninghame Graham, and have done with it." ' (Richards to WR, March 31, 1898. RP:HL.) WR wanted Graham simply because he admired him. Graham and Grant Allen, who was Richards' cousin, got in; the Admiral, Rosebery and Harcourt stayed out. See Richards, *Author Hunting*, pp. 68–9.

2. Bridges told Dixon about the series, and Dixon offered to sit. (Bridges to WR, October 26; Dixon to WR, December 3, 1897. RP:HL.) WR made a portrait drawing, undated, and a lithograph (1898); present owners unknown. Neither was included, thus disappointing both Dixon and a lady friend who offered £8 for the drawing. Dixon offered to write the note on Bridges, but this was apparently written by another hand. Dixon, undaunted, then proposed a 'Liber Studiorum' and a 'Liber Seniorum'; neither materialised but may have suggested WR's *Liber Juniorum*. (Dixon to WR, October 25, 1897; January 13, May 10, 1898. RP:HL.)

3. See Shaw, *Collected Letters, 1874–1897,* ed. Dan H. Laurence, p. 809. *The Silver Key,* Sydney Grundy's adaptation of Alexandre Dumas' *Mlle de Belleisle,* opened at the Haymarket Theatre on July 10, 1897. The note on Ellen Terry, presumably revised by WR, is derived from Shaw's review, 'Mr. Grundy's Improvements on Dumas,' *The Saturday Review,* 84 (1897), 59–61, reprinted in Shaw, *Our Theatres in the Nineties,* III, 189–96. Shaw wrote the note on drama critic William Archer; see Shaw, *Collected Letters, 1874–1897,* p. 809. For WR's letter to Miss Terry, see *WR,* p. 113.

4. Ellen Terry to WR, March 16 [1897]. RP:HL.

5. Pinero to WR, February 22, September 8, 1898. While Pinero was reading *Men and Memories, 1872–1900,* he wrote (March 2, 1931. RP:HL) that he regretted only the diminishing number of pages he had left to read. Then he added, 'Well, perhaps not my only regret, for I was pained to see, on the top of page 301, my extremely uncivil reference to your friend Mr Max Beerbohm. Though I have, I hope, a fairly modest estimation of my abilities, I have never been able to understand the rancour with which Mr Beerbohm has pursued me; but to-day I would not speak of him in those terms. It gives me some little satisfaction therefore, as between you and me, to withdraw the implication I allowed myself to indulge in at that time.' See *MW,* pp. 35–8.

6. Neither Lady Jeune nor Gissing appears, although Gissing sat for two drawings on June 7, 1897; see *George Gissing and H. G. Wells,* ed. Royal A. Gettman, p. 96.

7. Hardy to WR, February 24, 1898. RP:HL. For James's 'appreciation' of Gis-

sing, see his 'London Notes July 1897,' in his *Notes on Novelists with Some Other Notes*, pp. 345–52. WR made two James portraits; see *PD*, pp. 12, 100; one (*PD*, Plate 33) is in the Bradford City Art Gallery.

8. For Sargent's drawing, see John Rothenstein, *Summer's Lease*, facing p. 21. WR's prints belong to the National Portrait Gallery, London, and to Sir John Rothenstein; another is owned by the Estate of the late David Rutherston.

9. James to WR, July 13, 1897. RP:HL. For James on Sargent, see his 'John S. Sargent,' *Harper's New Monthly Magazine* (New York), 75 (1887), 683–91. The 'other day' or 'other month' had been ten years!

10. Strang, at least, disliked all art societies. In 1904 he withdrew his name after WR proposed it for the Society of Portrait Painters. In 1906 he halted at A.R.A., calling the Academy a haven for persons dissatisfied with the situation elsewhere; its strength, he thought, came largely from 'the number of societies who won't speak to one another.' (Strang to WR, June 13, 1904; January 13, 1906. RP:HL.)

11. Sir Francis Haden disapproved of Whistler's association with Jo Heffernan. Haden broke off relations when Whistler knocked him through a plate-glass window in Paris in 1867, in a dispute whose immediate cause was vague. Whistler was haled into a French court as a common brawler.

12. Haden to WR, August 6, 1897. RP:HL.

13. Haden to WR, July 27, 1897. RP:HL.

14. Haden to WR, February 16, 1897. RP:HL. Haden stated *one* condition: WR would kindly address him, when writing next, as 'Sir F. Seymour Haden, P.R.E.'

15. Whistler to WR [dated in another hand, March 3, 1897]. RP:HL. Cecil Rhodes, at one time a possibility for the series, was unavailable; see *MM* I, 296. The 'champion [uitlander?]' was Whistler.

16. See Wilde, *Letters*, pp. 604–5.

17. See *ibid.*, p. 631.

18. See *MW*, pp. 36–7.

19. See Wilde, *Letters*, pp. 635–6. W. E. Henley's 'Hospital Poems': *In Hospital, 1872–1875* (1898); reprinted in his *Poems*, pp. 3–57.

20. Bridges to WR, April 9, June 7, 1898. RP:HL. See *MM* I, 327–9.

21. On *Liber Juniorum*, see *MW*, p. 39.

7. THE END OF THE CENTURY

1. Beardsley and his mother went to Paris early in April 1897, then to Dieppe, back to Paris, and in November to Mentone, where Aubrey died on November 16, 1898. WR and Legros went to Paris on October 16, 1897.

2. Cf. Elizabeth Pennell, *Whistler the Friend*, p. 172.

3. Lithographic drawings (1897), Numbers 72 and 73, in the iconography, *PD*, p. 98.

4. Rodin to WR, July 9, 1897. RP:HL. Plainly dated in Rodin's hand, but WR did not ask until October 13 for permission to call with Legros on October 17 (Musée Rodin; transcript, RP:HL), his first meeting with Rodin. WR may have sent a drawing, perhaps of Legros, as an introductory gift. The commission to Henley is unexplained.

5. These three passages from Rodin's letters (RP:HL) appear (*MM* I, 323) to be one sequence, but the bronze medallion (Illus. 2) is mentioned on July 10, 1898, in the letter beginning 'Quel[les] excuses . . .,' while 'Le petit plâtre . . . chez vous' (no italics) is the postscript to a letter of September 1898. The passage beginning 'Vous me rendez . . .' is from a letter of April 1900 with no reference to the plaster satyr (owner unknown).

6. In the summer of 1897; see *AJ*, I, 51–3.

NOTES

7. This implies that he and Sickert saw the play *after* Albert Rothenstein came to London, but it opened at the Royal Court Theatre on January 29, 1898, and by November 22 Miss Spong was with the cast in New York. Frank Spiegelberg owns WR's oil portrait of Miss Vanbrugh; Sickert's of Miss Spong is *The Pork Pie Hat* (1898); see Baron, *Sickert*, Catalogue 77.

8. Ricketts and Shannon may have resigned because they were in the Royal Academy; Whistler disliked his Followers' being in groups other than his own. WR resigned on April 16, 1898, some time before Shannon left. Pennell and Ludovici thought that WR later repented, but Sickert, who resented Whistler's enrolling them without their permission, sent a lively indictment of the Society's members as artists and as businessmen, and congratulated WR on joining the outsiders. (Sickert to WR [late Spring 1898]. RP:HL.) On Ludovici's attitudes, see his *An Artist's Life in London and Paris*, p. 117.

9. Whistler was elected first President of the International Society in April 1898. Its first exhibition opened that June. His two paintings (both, Museum of Fine Arts, Boston) are dated 1895, thus not precisely his 'latest'.

10. This affair preceded the International Exhibition. See Sickert, 'Transfer Lithography,' *The Saturday Review*, 82 (1896), 667–8. Pennell v. Sickert and Harris came up on April 5, 1897, and turned upon Sickert's statement, 'If we are to keep our artistic diction pure—and it is, for every possible reason, artistic and commercial, well that we should do so—a lithograph by Mr. Pennell must be made to mean a drawing done on the stone by Mr. Pennell, and then printed.' Pennell sued for libel, and Harris replied that Sickert's only offence was 'looseness of statement'; see 'Messrs Lewis and Lewis in Their Favourite Role,' *The Saturday Review*, 83 (1896), 15.

11. Pennell, *The Life of James McNeill Whistler*, 5th rev. ed., p. 345. Mrs Pennell, repeating the trial story in *The Life and Letters of Joseph Pennell*, I, 309–14, lists glittering credentials for their witnesses but makes the barest possible mention of Shannon, WR and Moore for the defence.

12. In 1897 Eden had paid £15, three more than the asking price, for WR's *The Workman's Train* (1897?), present owner unknown. (Eden to WR, February 19, 1897. RP:HL.) On July 15, 1899, Eden sold at Christie's, Steer's *A Girl Reclining on a Sofa* (1892); WR's drawing; and a Sickert work listed as *Dieppe* (21 × 18 in.), which may have been *The Flower Market*, also known as *Le Marché rue de la Boucherie*, whose dimensions are 18 × 21½ in.; the discrepancy may be due to imprecise cataloguing. See Baron, *Sickert*, Catalogue 106. It is probable that at least these three works figured in the encounter with Whistler, which was made all the more tense by the fact that, in 1896, Eden had commissioned Steer to paint a portrait of Lady Eden as successor to the disputed portrait by Whistler; see Bruce Laughton, *Philip Wilson Steer*, Catalogue 182.

13. John to WR [1899]. RP:HL. 'Generals Laurence and Young': John's landlady and her lady friend at 76 Charlotte Street; see *AJ*, I, 97–8.

14. Wendy Baron warns of the difficulty of sorting out Sickert's works sent back and forth from France in the late 1890's. In an undated letter (probably early Spring 1899. RP:HL) he told WR that if Frederick Brown could sell for £40 a picture by Sickert (Sickert here mentions only one) for which Eden offered £20, Brown would be entitled to keep the extra £20. This again may have been *The Flower Market* (c. 1898), perhaps exhibited that year as *The Rag Fair*, bought by Eden for £20 and later exchanged for three small panels, unidentified. See above, note 12. Carfax sold *The Rag Fair*: hence WR's statement that Sickert 'pressed me [as a Carfax agent] to accept.'

15. Sickert to WR [c. 1906]. RP:HL. Again the sequence is reversed with radical

consequences. This was written *after* Sickert returned to England to live. WR wrote (*MM* I, 341) only 'S———'; in his annotated copy he supplied Strang's name, not Shannon's, a lapse of memory.

16. Sickert to WR [before July 1899]. RP:HL.
17. Sickert to WR [c. 1899]. RP:HL.
18. Sickert to WR [July 1899]. RP:HL.
19. Sickert to WR [July 1899]. RP:HL. WR was then writing his *Goya*, the first book in English on that painter.
20. Sickert to WR [August 1899]. RP:HL.
21. Blanche to WR, July 24, 1899. RP:HL.
22. On Lewes House and Warren's collecting, see O. Burdett and E. R. Goddard, *Edward Perry Warren: The Biography of a Connoisseur*; Kevin Herbert, *Ancient Art in Bowdoin College*.
23. A series, *Six Lithographed Drawings from Balzac*. For Number 4, see Hoff, *Charles Conder*, p. 75.
24. This account anticipates: WR left Carfax late in 1900.
25. WR's oil, *The Doll's House* (1899), in the Tate Gallery.
26. This Yorkshire expedition produced *Manchester Portraits*, not a happy project; see *MW*, p. 41. The newlyweds were at 1 Pembroke Cottages, Edwardes Square, Kensington, which WR had leased in 1898.
27. J. and E. R. Pennell, 'The Most Picturesque Place in the World,' *The Century Magazine* (New York), n. s. 24 (1893), 345–51.
28. Ross to WR, December 11, 1900. RP:HL.

8. INTO THE NEW CENTURY

1. Not 1900, as stated in *MM* I, 1. See *AJ*, I, 107.
2. Orpen to WR [January 12? 1901]. RP:HL. Grace Knewstub and Orpen married later in 1901.
3. On Estella Cerutti, see *AJ*, I, 144; the portrait (1902) is in the Manchester City Art Gallery. That of Rosa Waugh (c. 1898?), now owned by Sir Charles Forte and in the Café Royal, is based on John's red and black chalk drawing dated by Malcolm Easton about 1897, now owned by Marcus Wickham-Boynton. *Merikli* (1902), Ida's portrait, is in the Rutherston Collection, Manchester City Art Gallery.
4. John to WR [c. 1902]. RP:HL. Carfax showed John drawings in 1899 and 1900 and kept his work steadily on hand, but it did not sell in Liverpool. The Liverpool Academy rejected him as a member. WR's portrait, a subscription purchase for the Walker Art Gallery, is still catalogued simply as *Portrait of a Young Man*; see *AJ*, I, 127.
5. John to WR [August? 1901]. RP:HL.
6. John Lavery exhibited at the same time: January 5–25, 1902. WR was met upon arrival by a crowd of art students come, he learned, to honour him as a friend of Beardsley; see Margery Ross, ed., *Robert Ross, Friend of Friends*, p. 80.
7. Not in the present Berlin Museum, and presumed lost.
8. WR wrote to Albert Rothenstein (April 7, 1902. RP:HL): 'He is 87, and draws as much as ever, always draws, draws his coat when he takes it off, his foot before he gets up in the morning!—anything or anyone that comes in his way when he isn't working on his pictures.' WR did a lithograph (owner unknown) and a pencil drawing (British Museum).
9. The invitation was couched in the plural because WR, his temper failing under the strain of German family life, took steps to import his own. He begged Alice to come over into Silesia and help him. She came, with the infant John Rothen-

stein and his nurse, at the end of April 1902. With the Ludwig von Hofmanns, they set out for the Hauptmanns' home at Agnetendorf. Von Hofmann had asked Hauptmann to sit to WR, who did at least two drawings, probably in March 1902 (present owners unknown).

10. This occurred more slowly than implied here. Gerrans wrote to Hauptmann on May 8, 1905 (Hauptmann Archive, Staatsbibliothek Preussischer Kulturbesitz, Berlin); the degree was conferred in 1905.

11. Lewis, while still at the Slade, wrote a sonnet sequence in a Shakespearean mode; this, still unpublished, is with the Lewis Papers in the Cornell University Library. For Lewis on Stirling's unhappy life and death, see his *Rude Assignment: A Narrative of My Career Up-to-Date*, p. 116.

12. WR introduced John and Lewis probably in the summer of 1902, also a probable date for two early John etchings of Lewis; one absentmindedly dated 1893 was shown in 1974 at the Colnaghi exhibition of John's early drawings and etchings and is now privately owned. On the Lewis-John friendship, see *AJ*, I, 139–42.

13. Conder to WR (RP:HL), undated, but probably early April 1902. Again, the sequence is wrong: reconciliation preceded the move to Church Row.

14. Conder to WR, April 21, 1902. RP:HL.

9. PORTRAITS AND PLANS

1. In 1808, the building, erected 1743–44 for French Walloons, had, in fact, been made over for 99 years to the London Society for Promoting Christianity among the Jews. The missionaries made little progress, and in 1898 the lease went to the London Hebrew Talmud Torah Classes; in 1922 the freehold was conveyed to the Trustees of the Spitalfields Great Synagogue. It is now a mosque. See Bernard Homa, *A Fortress in Anglo-Jewry: The Story of the Machzike Hadath*. Dr Homa is the grandson of Avraham Aba Werner, Spitalfields Rabbi, 1891–1912. On WR's Synagogue paintings, see *MW*, p. 51, note 1.

2. Sargent, in the Middle East in 1905, found Jews there such disappointing models that if he could not paint at Spitalfields before the trip, he was unlikely to do so afterwards.

3. See *The Letters of A. E. Housman*, ed. Henry Maas, pp. 132, 179–80, 240, 313.

4. Conrad to WR [c. 1904]; *not* RP:HL, and present owner unknown. *Nostromo: A Tale of the Seaboard* appeared in *T. P.'s Weekly*, January 29–October 7, 1904, and in book form in the same year.

5. Whistler died on July 17, 1903. Ashbee designed and built 72 Cheyne Walk, his home until 1902, when he went to Chipping Campden, Gloucestershire. Mrs Ashbee (journal entry, March 6, 1902; King's College Library, Cambridge) found her maid talking with a stranger, whom Mrs Ashbee recognised as Whistler. The Scottish artist E. A. Walton, at Number 73, also an Ashbee house, had sent him to see Number 72. The copper door had two panels decorated with a conventionalised dianthus pattern, symbol of Ashbee's Guild of Handicraft. The house, bombed in 1941, appears in Ashbee, *Where the Great City Stands*, Plate 22. Whistler's choice *was* surprising, since Ashbee already planned to build at Number 75—information that the ageing Whistler may not have grasped. Noise and loss of sleep certainly hastened his death.

6. The date assigned to the visit in *The Flight of the Mind: The Letters of Virginia Woolf, 1888–1912*, ed. Nigel Nicolson, p. 84, is half a year earlier.

7. Swinburne, 'Charles Dickens,' *The Quarterly Review* (London), 196 (1902), 20–39.

8. Carlyle, *The History of Friedrich II of Prussia* (1858–65), Book X, Chapter 2, 'Of Voltaire and the Literary Correspondence.'

9. See *MW*, pp. 47–8.
10. Craig to WR [late April 1903]. RP:HL. A postscript (*MM* II, 54) is from a Craig letter of September 30, 1903 (RP: HL).
11. Craig to WR [Summer 1904]. RP:HL.
12. Masefield was connected with the 1902 Wolverhampton Art and Industrial Exhibition through Binyon and Strang. The Bradford gallery opened on May 4, 1904, but, as at Wolverhampton, the emphasis was more industrial than artistic. The London Committee—Strang, Steer, Shannon, Frederick Brown, Swan, and WR—assembled an outstanding loan collection that included works by Watts, Turner, Constable, and Hogarth, but news stories from Bradford ignored art. *The Times* (May 3, 1904, p. 4) boasted that Bradford 'appears to have adopted that deliciously American maxim, "Don't grumble, boost!" ' Bradford boosted local manufactures with a will, and the exhibition as a whole had a profit of £17,000. 'I would like to thank you,' Masefield wrote to WR (May 1, 1904. RP:HL) 'very much indeed for all your kindness to me during what was quite the most abominable week I have ever experienced. I think that but for you I should have gone home long before the Saturday of the opening.' His 'abominable week' was probably due to the prevailing boosterism and to his being an unknown young man, not the future Poet Laureate. WR failed to persuade Bradford to use some of the profits to buy pictures by Steer, John, Stevens and Whistler; local committeemen like Charles Rothenstein and Ernest Sichel were outvoted by local Philistines.
13. Probably 'An Anarchist' and 'The Informer,' in *Harper's Magazine*, August and December 1908.
14. Conrad himself requested the trusteeship plan. The copious correspondence describes a bewildering series of loans and accounts, transactions, and schedules for payment and repayment, which Conrad described (June 27, 1904. RP:HL) as a salvage operation for 'a rather rotten old hulk (but full of the best intentions)!'
15. See G. Jean-Aubry, *Joseph Conrad: Life and Letters*, I, 336. On November 5, 1905, Conrad told WR that his credit with Pinker was almost exhausted; on November 16 he wanted WR to ask Newbolt about sums due. (RP:HL.)
16. Bone's letters: RP:HL. WR admired Bone; see *MM* II, 69. Society rules limited the membership to artists of British nationality. Laughton suggests (*Philip Wilson Steer*, p. 52) that members may have been annoyed by Pissarro's 'scorn for the English painters'—except Steer. Although it may already have been in decline, the Society was badly shaken by this argument; see *AJ*, I, 190. Ricketts told Albert Rothenstein that he would have 'much pleasure in proposing you at the "*next*" exhibition of the Twelve. The soul, or I should say the conscience of the Society is Bone who seems, like all of us, to have got tired of the scheme. Without him it would have ceased ages ago, it is possibly already a touching memory of a romantic past, something incredible like the Grosvenor Gallery when there were live lions in Bond Street.' (N. d. PC.) When the Society finally ceased to exist, it was a real loss to its members.
17. Apparently a group show by Conder, John, Ricketts, Shannon, Steer, Strang and WR, who proposed 'each sending about six pictures, as well as a collection of drawings and prints.' Shannon and Ricketts opposed a larger show; if they were to expand, Ricketts preferred the Champs de Mars. WR pressed Conder for his views, as Durand-Ruel wanted to fix a date. Conder, then exhibiting at the Leicester Galleries, and Steer had little to contribute, and WR advised postponement: 'My own idea was that this was to be an important show of the most interesting work being done at present in England, and as this is the first time many of us are showing in France, unless we can drive the thing home, it would be better to leave it alone. I may remind you that Durand Ruel does not by any

means insist on the pictures shown being for sale. But a half hearted thing does not enlist my sympathy and what has been in my head is evidently quite a different idea from yours.' By February 1906 the group plan was dropped, but WR, knowing that Conder's strength was failing, encouraged him with the following: 'Lines written upon seeing some pictures, and missing others, at Messrs Agnew's Galleries, Feb. 6–06 / Conder, ponder: / Lequel le loup & lequel l'Agnew? / Steer & you / Qu'il beau, qu'elle est belle! / "ET TOUT LE RESTE EST DURAND RUEL!" ' (WR to Conder, December 3, December 5, 1905; February 6, 1906. Boston Public Library.) Conder's Durand-Ruel show was April 2–14, 1906.

18. Conder to WR, September 5, 1905. RP:HL.
19. Conder was at Newquay fighting the paralysis that prostrated him in June 1906. He died on April 9, 1909. See John Rothenstein, *The Life and Death of Conder*, pp. 219–29.
20. On the Chelsea Art School, see *AJ*, I, 158, 162–3, 256, 388–9.
21. Epstein came to London early in 1905, introduced to Shaw by Rodin. Shaw, advising him to forget drawing and do busts of railway directors, recommended him to Robert Ross as 'queer and Rodinesque enough' to be *au courant*. WR met Epstein through Ross; see Shaw, *Collected Letters, 1898–1910*, ed. Dan H. Laurence, p. 521. During 1906–7, WR arranged for a grant of £20, of which he gave £5, from the Education Aid Society (for Jewish Students), which appointed him 'case guardian'. The 'further small contributions' came monthly from WR's own pocket. The beneficiary mentioned him in neither his autobiography, *Epstein*, nor his other writings. Nevertheless, Epstein had not hesitated to ask WR for extra funds, to remind him that bills were due, or that the monthly 'contribution' was overdue. As few of Epstein's letters (RP:HL) are dated, it is difficult to trace the whole course of their falling-out. On December 31, 1909, Epstein offered to come and sit to WR. On June 20, 1911, he savagely rejected a WR invitation, adding that for some time he had wanted to break off relations but deferred because he found WR comical; for this letter, see *AJ*, I, 186. WR says only (*MM* II, 128–9) that Epstein 'had chosen to quarrel with me, in a way that I resented at first, but not for long,' because Epstein was a 'man of genius'. Grants from the Society were to be repaid, if possible. Epstein's Strand statues brought him £1,000, but he never repaid his £20. (Minute books in the Mocatta Library, University College, University of London.)
22. An early, undated Epstein letter (RP:HL) seems to respond to the letter of which this is a draft. He acknowledged the cheque enclosed, then said equably that what WR wrote was true, and that he knew his work was not yet satisfactory. When WR quoted briefly from Epstein's letters and paraphrased another passage (*MM* II, 87–8, 89), Epstein wrote that he had not intended these to be published; he repeated this, then asked Faber & Faber to forbid WR's using more from the letters. (Epstein to WR, March 5, 12; to Faber & Faber, July 6, 1931. RP:HL.)
23. See Epstein, *Epstein*, pp. 21–41, 238–49, which includes this article from *The Evening Standard and St James's Gazette*, June 19, 1908, but ignores WR's efforts to mobilise defence of the statues, which are still visible but sadly dilapidated, on the building that later became Rhodesia House, itself now obsolete.
24. Ida John died in Paris on March 13, 1907; see *AJ*, I, 248–52.

10. SOME COMINGS AND GOINGS

1. MacColl wrote to WR (June 20, 1906. RP:HL): 'Behold me a rond-de-cuir! It's very odd at my years to be made a clerk because of a taste for pictures. Now I

am commanding 7 porters, 7 attendants, 13 police, 7 charwomen etc. etc. and with a moment now and then for glancing at the treasures of art in the gallery.... It's all wonderfully pleasant—the good will shown me all round, not only from friends like yourself from whom I am accustomed to look for it, but even my rivals for the post write me the most generous and friendly letters. I'm terribly afraid of disappointing the hopes expressed, especially with the very small formal power I have at present, and you must all keep me up to the mark, and then pitch into me for things it is impossible at the time to get done.'

2. In January 1904 Fry went to New York for the *Burlington Magazine*, and negotiations began for appointment as Curator of the Department of Paintings; see Fry, *Letters*, I, 23–30, 227–32, 243–4, 246, 248–50, 254–5. Logan Pearsall Smith told WR that 'just as [Fry] was sailing—one of C[ampbell-] B[annerman]'s secretaries spent the night between Downing St. and Willow Road [Fry's Hampstead address], but failed to find him. They telegraphed to him at Queenstown, but he answered that he felt himself bound by his engagement in America. His father, however, has asked C. B. to keep the offer open till he can be heard from again. On the whole I hope he will stick to America—he's too good a man to become an official.' (February 11, 1906. RP:HL.) Helen Fry told Alice Rothenstein (February 6, 1906. RP:HL): 'As people now begin to say "traitor to his country" I mention what I think perhaps you know that Roger held over the long American negotiations to the last hour of the last day—this I think answers the question of whether he would have sensed the "patriotic" English public had he been asked in time. He felt really bound to America when the proposition came. I suppose the first step in patriotism is to find your [word illegible] to create your "traitors"! P.S. The proposition came the afternoon of the sailing.'

3. WR told his brother Albert (July 19, 1907. RP:HL) that he had spent several days in Paris with Fry; see Fry, *Letters*, I, 288. The Renoir was *La Famille Charpentier* (1878), acquired in 1907 for $18,480, Durand-Ruel bidding for the Metropolitan and waiving commission.

4. Rilke to WR, April 26, 1906. RP:HL. The bust of Shaw is in the Municipal Gallery of Modern Art, Dublin; see Shaw, *Collected Letters, 1898–1910*, pp. 810–11. Dan H. Laurence advises that although Rodin would have known that Shaw was a playwright, 'the sentiment is certainly Shaw's. The point he was making was that, as Rodin really knew nothing about Shaw—hadn't read or seen his plays, wasn't aware of his publicity and mountebank reputation—the bust he made reflects Shaw as Rodin actually saw him, rather than as already conceived in his mind, influenced by the *legend* of Shaw. In other words, Shaw considered Rodin's bust to be the one that best captured the *real*, actual man rather than the reputation!' (Laurence to the editor, December 14, 1975.) See Shaw, 'Rodin,' in his *Pen Portraits and Reviews*, in which Shaw says (p. 227): 'Many clever portraits of my reputation were in existence; but I have never been taken in by my reputation, having manufactured it myself.' See also *Letters of Rainer Maria Rilke, 1892–1910*, trans. Jane Bannard Greene and M. D. Herter Norton, pp. 205–7.

5. For the portrait of Berenson, now at I Tatti, see Fry, *Letters*, I, Illus. 14.

6. See Mabel La Farge, *Egisto Fabbri*.

7. Craig impressed Loeser, who provided the villa; see Edward Craig, *Gordon Craig*, pp. 228, 229. Craig's school of theatre at the Arena Goldoni was a financial casualty of World War I.

8. Tree to WR, February 22, 1908. RP:HL.

9. Craig to WR [c. late February 1908]. RP:HL.

10. The simplicity of Craig's sets alarmed scene-painters; if effects were achieved

with lighted moveable screens, what was left for painters? Illogically, the models were left in a scene-painter's dubious care; see Edward Craig, *Gordon Craig*, pp. 245, 247–8, 254, 263. In 1904 Craig, through Count Kessler (thus, indirectly, through WR) met Otto Brahm, recently made director of the Lessing Theatre, Berlin. This collaboration had expired long before Tree appeared on the horizon; see *ibid.*, pp. 181–8.

11. Craig to WR [c. October 1908]. RP:HL.
12. See Jean-Aubry, *Joseph Conrad*, II, 104. (Letter, RP:HL.)
13. Hudson to WR, n. d. RP:HL. Hudson's mother came from Maine.
14. Hudson to WR, July 13 [1909?]. RP:HL.
15. Beerbohm to WR [February 11, 1909]. RP:HL. Conder's wife Stella wrote to WR (February 19, 1909. RP:HL): 'I think he was fonder of you than of any friend he had, and being with him as I was day and night for years no one knew better than I did the few people who really got thro' into his heart.'

11. A POST-IMPRESSIONIST EXHIBITION

1. Gill later corrected WR: he never taught at the Central School.
2. For a letter on this, see *WR*, p. 171.
3. Sargent's portrait of the Duchess (1908) is at Windsor Castle.
4. Sargent to WR, August 26 [1908]. RP:HL.
5. Lethaby wrote (March 2, 1910. RP:HL) that he had heard that an architect might get the post, in which case he would accept with pleasure; otherwise, he hoped that it might be WR; see *MM* II, 211. On Fry's candidacy, see his *Letters*, I, 327–8, 329. He told WR (February 19, 1910. RP:HL) that although his chances were not brilliant there was enough possibility to make the effort worth while. For a part of WR's reply, when the attempt failed, see *MW*, p. 67.
6. Also on March 8, WR urged Fisher to put forward Lethaby or Fry (RP:HL). The post went to Selwyn Image. WR mistakenly wrote (*MM* II, 210) that H. E. Wooldridge left the Slade professorship at this time.
7. Russian painters were added to the *second* Grafton exhibition (1912), not as a planned international coup, but to help fill the walls; see Fry, *Letters*, I, 345–6. However, it was not until the second Post-Impressionist exhibition that WR 'held aloof'; 'complications with Rothenstein' (*ibid.*, p. 41) could not possibly have arisen before Spring 1911.
8. See *The Letters of Eric Gill*, ed. Walter Shewring, p. 35.

12. ROTHENSTEIN IN INDIA: TAGORE IN LONDON

1. Scott to WR, September 6, 1910. RP:HL.
2. In 1906 Mrs Herringham first visited the Ajanta Caves. She returned in 1909–10 and 1910–11 to copy the frescoes. The history of the South Kensington copies is a sad one. The first Europeans known to visit the caves were officers of the Madras Army, in 1819. Copies later made at the direction of the East India Company and exhibited at the Crystal Palace were lost in a fire. Between 1875 and 1885 a new set was made for the South Kensington Museum, but the authorities refused to allow a set of duplicates to be made. On June 12, 1885, eighty-seven of the 125 Museum copies were lost in a fire there. Until Mrs Herringham took up the cause, no new copies had been made at Ajanta.
3. Coomaraswamy, *Rajput Painting*. For his views on origins of Indian art, see *IE*, p. 31.
4. Birdwood presided, disputatiously, but it was Havell who lectured on January

13, 1910, before the Royal Society of Arts, on 'Art Administration in India.' On this meeting and its consequences, see *IE*, pp. 2–8.

5. No surviving India Office records document his warnings. However, prudent Englishmen were not conspicuously enthusiastic about things Indian; see *IE*, pp. 27–8.

6. It was as well that Sir Richmond did not see the cordial Rothenstein-Gokhale correspondence. WR wrote that 'the beauty of both the Hindu and Muhammedan architecture stirs my whole nature. It seems so absurd that I should be so near to the people I walk amongst, and that my feeling of sympathy should have to go unexpressed—I must pass like a stranger through the crowd, seemingly aloof and indifferent, on account of my ignorance of their language. This gives me a home-less and desolate feeling at times—perhaps later, when I visit some of the larger cities, I may be fortunate enough to make the acquaintance of some of your countrymen who speak English.' (November 10, 1910. National Archives of India.) The two men met in Bombay early in 1911. Gokhale's letters to Rothen-stein are in the Houghton Library.

7. This Maharaja is a recurring theme. See J. R. Ackerley, *Hindoo Holiday: An Indian Journal*; E. M. Forster, *Goldsworthy Lowes Dickinson*, pp. 138–9; *WR*, pp. 237–8; *IE*, p. 28. The Hindu state of Mau in Forster's *A Passage to India* is based in part on Chhatarpur.

8. For a self-view of WR among the tourists, see *IE*, p. 31.

9. Tagore led the opposition to Lord Curzon's 1905 Bengal Partition order, but he withdrew in protest against Bengali extremist terrorism. Thus he was mistrusted both by British and by some Bengali factions and may have been prudently noncommital before a stranger.

10. He returned in mid-March 1911. In September he went to the United States, to paint portraits and show his work in New York, Boston, and Chicago; see *MW*, pp. 88–9. He saw Frazier, Cushing, and Hale, and, through the Berensons and Logan Pearsall Smith, made new friends, some of them very influential, but he did not find America altogether congenial; see *MM* II, 256–9. See also Martin Birnbaum, *The Last Romantic*, pp. 58–61.

11. Tagore's notebook, with his first drafts of the *Gitanjali* translations, and Ajit Chakravarty's manuscripts are in the Houghton Library. The story was 'The Postmaster,' in *The Modern Review* (Calcutta), 9 (1911), 36–9; reprinted in Tagore, *Mashi and Other Stories*, pp. 157–69.

12. Bradley to WR, July 15 [1912]. RP:HL.

13. Yeats to WR, from London [late August 1912]. RP:HL.

14. For passages from Tagore's Bengali essays on his experiences in London, see Mary M. Lago, *Rabindranath Tagore*, pp. 130–36.

15. Moore to WR, July 13 [1912]. RP:HL.

16. Shaw to WR, September 18, 1912. RP:HL. See *IE*, p. 111.

17. A Fox Strangways letter proves that Curzon's objections had little to do with poetry and much to do with politics: Curzon 'did not wish a University of which he is Chancellor to take public notice of one who [as a leader of the Bengal Partition protest movement] had added politically to the labours of the Viceroy.' See *IE*, pp. 38–9. See also Sir E. Denison Ross, *Both Ends of the Candle*, pp. 142–3.

18. Yeats to WR, September 7 [1912]. RP:HL.

19. 'Mr. Tagore's Poems,' *Times Literary Supplement*, November 7, 1912, p. 492. On negotiations with Macmillan, see *IE*, pp. 43–131 *passim*.

13. THE WAR AND THE WAR ARTISTS

1. The young men had been employed on the farm.
2. Both the War Office and the Foreign Office had made difficulties over WR's German origins, thus delaying the arrival of his travel permit; he and Vandervelde finally crossed in August, 1914.
3. Northcliffe to WR, April 11, 1916. RP:HL. On April 13, 1916, Charles and Albert Rothenstein changed their surname by deed-poll to Rutherston. Northcliffe assumed that William had done the same and addressed this letter to 'W. Rutherston, Esq.' WR was still Rothenstein; he at first agreed to the change, but, when the moment came, found himself unable to do so. See *WR*, pp. 278–9; *MW*, pp. 100–101, note 3. Repington noted that Rothenstein came on April 8, 1916, 'to suggest the despatch of artists to the front to make sketches for regimental histories and the H.Q. county regiments—good idea and should be worked. I will try Lady Cunard.' See Repington, *The First World War, 1914–1918: Personal Experiences*, I, 178.
4. Northcliffe to WR, April 13, 1916. RP:HL.
5. Northcliffe to WR, March 26, 1917. RP:HL. Lady Cunard was almost too interested. On April 19 Repington found her 'full of fun, and of the scheme of painters' and poets' visit to the front. She has quite a long list of artists who want to go.' See Repington, *The First World War*, I, 188–9. The list of artists—no poets—finally sent was very short.
6. Campbell Dodgson quickly saw that more than one artist was needed and asked WR's opinion of Paul Nash (September 10, 1917. RP:HL). Nash had enlisted in the Artists' Rifles in 1914, was wounded at Ypres in 1917 and sent home; he then returned to France as a War Artist. Eric Kennington had already been at the Front. WR saw his large painting on glass, *The Kensingtons at Laventie* (1916), now owned by Viscount Cowdray, and wrote to Sir Ian Hamilton, just returned from Gallipoli, to urge a War Artist's commission for him. Sir Ian replied (July 21, 1916. RP:HL) that he had seen and admired *The Kensingtons* but doubted that many military men would approve of sending artists to paint and draw instead of to fight; see *MM* II, 308–9.
7. John to WR, April 26, 1916. RP:HL. WR, plagued by the German name to which he had been so loyal, was at first refused a French visa.
8. Dodgson's letter is untraced. WR wrote (*MM* II, 326) that he went in November, but his travel permit (RP:HL), endorsed by Vandervelde in 1914, was later validated for December 1917 to August 1919.
9. John to WR [November? 1917]. RP:HL.
10. Orpen to WR, February 23, 1918. RP:HL. See *AJ*, II, 67–74.
11. WR had arrived on the Fifth Army Front just in time to see the British forces disintegrate; see *WR*, pp. 293–7.
12. Fisher cannily prepared the way by having WR appointed to the first Chair of Civic Art, at Sheffield University; see *MW*, p. 72. When the Royal College post fell vacant, Fisher told WR that he had 'not the least doubt that if you can take it on, you will make an epoch in the teaching of art in London.' (March 14, 1920. RP:HL.) Later he wrote: 'I am not, in the least, surprised to hear your generally unfavourable view of the work done in the College. ... The difficulty is that the artist of real talent doesn't care to teach and that the vast body of the students are discouraging by reason of their indifferent talent.' (April 1, 1920. RP:HL.)

14. *SINCE FIFTY*: PIECES FROM A MOSAIC

1. The Beerbohms' came and went at Far Oakridge during World War I. The drawings in *Rossetti and His Circle* (1922) were made there in 1916–17, and shown at the Leicester Galleries in September 1921 as 'Rossetti and His Friends.'
2. A few chapters of *Far Away and Long Ago* (1918); *Dead Man's Plack* (1920); and *A Shepherd's Life* (1910). Which of these was the 'complete manuscript' is unknown, as are owners of these and of the drawings.
3. Cunninghame Graham to WR, September 21, 1922. RP:HL.
4. Fisher told WR that he was 'amused at the impotent rage of these silly Art Masters.' When he quoted WR's ideas to a gathering of the Masters at Sheffield, Fisher found them 'as meek as lambs and I hope rather ashamed of themselves.' (June 17, 1920; January 22, 1922. RP:HL.)
5. To Michael Rothenstein, the visit is 'still pretty vivid. S. had had the Resurrection canvas made to the exact size of the longest wall of the big top-floor room over the pub, facing the windows. The canvas was stretched inside the room, and would have been unstretched and lowered from the window, when it was done. The room was fairly total domestic confusion. A big low table was placed against the canvas. S. S. was, of course, tiny, and he needed it to work on the upper middle area of the canvas. This table was cluttered with brushes, rags, paint tubes, etc. as well as cereal packets, and milk bottles. I particularly remember a lot of white earthenware Keiller's marmalade jars because they seemed to materialise the white tombstones in the graveyard of the painting behind them. It seemed as if small white monuments had come forward out of the painting, and were invading the crowded room.' (Michael Rothenstein to the editor, January 12, 1976.) On the eight Burghclere murals, see Elizabeth Rothenstein, *Stanley Spencer*, Plates 25–32; the *Resurrection*, Plate 21, and details, Plates 22–4. For Gilbert Spencer on these murals and the Hampstead studio, see his *Stanley Spencer*, pp. 144–9. Lord Duveen gave the great Cookham *Resurrection* (1923–27) to the Tate Gallery in 1927.
6. Spencer to WR, n. d. RP:HL.
7. Spencer to WR, February 2, 1925. RP:HL.
8. See above, Chapter 5, note 4. Again, the identification of the Rossetti nude is uncertain.
9. Craig even refused to preside at the opening of the Phoenix Theatre scheduled for September 7, 1930 (Shaw had been the first choice) because he had not been asked to produce anything in London. Cochran, third choice, said that he would deprive Craig of that argument by offering him any available theatre for a play and company of his own choosing. Craig arrived and charmed Cochran, until it became clear that Craig actually wanted an empty theatre for six months' experimentation before starting rehearsals. See Cochran, *Cock-a-Doodle-Do*, pp. 247–50. The *Dictionary of National Biography, 1951–1960* says of Cochran: 'His enthusiasms were easily aroused, but once damped nothing could rekindle them.' Later he told WR (March 21, 1938. RP:HL): 'I offered Craig a theatre and finance for a production in September 1930. We had many meetings and some correspondence. He actually turned the proposition down after a lunch at my house at which Max Beerbohm and Norman Wilkinson were present.' On the fanfare that preceded the offer, see 'Phoenix Theatre: Mr. Cochran's Plans,' *The Times*, September 24, 1930, p. 10.
10. On Sir Herbert Baker and Sir Edwin Lutyens, co-architects, and the issue of whether the buildings should have any surface decoration at all, see *IE*, pp. 128–9; 300, note 4; R. G. Irving, *Indian Summer: Imperial Delhi* (forthcoming).

11. On the 'brief note of thanks', see *IE*, pp. 300–302. How WR's letter reached *The Times of India* remains a mystery.

12. The scientist was Sir J. C. Bose, whose work on sensitivity of plants was indeed slighted. He was knighted in 1917 and in 1920 became a Fellow of the Royal Society, but both honours were quite beyond WR's sphere of influence.

13. Shaw to WR, October 27, 1931. RP:HL.

14. Wells sent a vehement refusal; see *IE*, p. 330.

15. Yeats to WR, September 4 [1931]. RP:HL.

16. Yeats to WR, September 22 [1931]. RP:HL.

17. Yeats included eight of her poems in *The Oxford Book of Modern Verse*. Their correspondence was published as *Letters on Poetry from W. B. Yeats to Dorothy Wellesley*. WR had introduced them in the Spring of 1935; his drawing of them is now untraced, but her daughter owns one of three WR portraits of Lady Gerald.

18. For Yeats on Byron, see *The Letters of W. B. Yeats*, ed. Allan Wade, pp. 467, 473, 548, 710.

19. See Yeats, 'Bishop Berkeley,' in his *Essays and Introductions*, pp. 396–411.

20. Yeats to WR, December 29, 1938. RP:HL.

21. Yeats, 'Under Ben Bulben,' dated September 4, 1938, in his *Collected Poems*, pp. 341–4.

22. Dorothy Wellesley to WR, February 6, 1939. RP:HL. Yeats died on January 28.

23. Frontispiece to *The Gallatin Beardsley Collection in the Princeton University Library: A Catalogue*, comp. A. E. Gallatin and Alexander D. Wainwright.

24. Rilke, *Lettres à Rodin*, p. 58; the letter is dated May 12, 1906. WR's first assumption seems to have been correct: see Rilke, *Letters*, pp. 210–12.

25. Blanche had had to leave Auteuil for Offranville, which was certain to be a staging area, or beachhead, or both, in event of war: 'No, I am by no way "quiet" in this village, turned into a huge British Sanitary Base: all big houses, chateaux, Public Schools, Town Hall, Cinema requisitioned by the H.Q. staff. We, personally, happen to be just *kicked out* of the old manor house, we rented 40 years. My lease coming to an end on Dec. 31—we hoped the cottage I bought and added onto, would be ready by November. But, no use grumbling. ... Let me leave aside, in this letter, many reasons of my constant bewilderment. ... Considering humankind's universal tragedy, one has no right to feel sorry for oneself, but an artist cannot refrain keeping some attachment for his output— although the greatest masterpieces ever accomplished, seem equally threatened.' (Blanche to WR, September 27, 1939. RP:HL.)

BIOGRAPHICAL GLOSSARY

ABBEY, EDWIN A. (1852–1911), Philadelphian who came to England in 1878 as emissary for Harper Brothers. Met Sargent there, later worked with him on the Boston Public Library decorations. Worked at the Pennsylvania State Capitol, 1908.

ACHURCH, JANET (Mrs Charles Charrington) (1864–1916), actress, friend of G. B. Shaw. Acclaimed in London as Nora in *A Doll's House*, which the Charringtons produced there in 1889 by mortgaging income from a two-year tour of the Antipodes.

ACLAND, SIR HENRY WENTWORTH, 1st Baronet (1815–1900). Regius Professor of Medicine, Oxford, 1857–94.

ALEXANDER, SIR GEORGE (1858–1918), theatrical manager. Joined Henry Irving at the Lyceum in 1881; opened his own management at the Avenue Theatre in 1890, at St James's Theatre, 1891.

ALLEN, GRANT (1848–99), novelist, essayist. A cousin of Grant Richards.

ALMA TADEMA, SIR LAWRENCE (1836–1912), Dutch painter living in London. A Victorian favourite, for grandiose scenes from Greek and Roman classical life.

ANDREWS, CHARLES FREER (1871–1940), Cambridge Brotherhood missionary teacher in Delhi. Met Tagore in 1912; in 1914 joined him at Santiniketan. Active in Gandhian politics.

ANQUETIN, LOUIS (1861–1932), French painter. Influenced by Degas and Japanese design, then by Signac and Gauguin. After 1896, abandoned Impressionism for subjects and techniques in the manner of Rubens.

ARCHER, WILLIAM (1856–1924), English translator and populariser of Ibsen. Dramatic critic of *The World*, 1884–1905.

ARNOLD, SIR THOMAS WALKER (1864–1930), Assistant Librarian, India Office, 1904–09; lecturer at Punjab University and Muhammadan College, Aligarh, then Professor of Arabic, University College, London, from 1904; India Office Educational Adviser to Indian Students, 1909–16; Adviser to the Secretary of State for India, 1917–20.

ASHBEE, CHARLES ROBERT (1863–1942), architect, designer, writer on relations of industry and the crafts. Founded Guild of Handicraft, Essex House Press, and London Survey Committee, precursor of Royal Commission on Historical Monuments. Lived at 72 Cheyne Walk until 1902, when he moved to Chipping Campden.

ASHBURTON, LADY LOUISA (d. 1903), second wife of 2nd Baron Ashburton, large landowner and owner of numerous large residences.

BAKER, SIR HERBERT (1862–1946), architect for India House, London, and for South African Government buildings. Co-designer, with Lutyens, of Government buildings for New Delhi.

BATE, FRANCIS J. P. (1858–1950), painter, lithographer. Trained at South Kensington Art School and Antwerper Akademie.

BAWDEN, EDWARD, English painter, designer, muralist. Tutor in Graphic Design, Royal College of Art.

BEARDSLEY, AUBREY VINCENT (1872–98), illustrator whose stylised black-and-white drawings became a hallmark of Art Nouveau. Attended Brighton Grammar School and began architectural training but turned to illustration for *Pall Mall Magazine* and *Pall Mall Budget*.

BEAUCHAMP, WILLIAM LYGON, 7th Earl (1872–1938). Commander-in-Chief, Colony of New South Wales, 1899–1901. First Commissioner of Works, 1910–14. Lord Lieutenant, County of Gloucester, 1911–31.

BEERBOHM, SIR HENRY MAXIMILIAN (1872–1956), caricaturist, essayist, dramatic critic. Succeeded Shaw in 1898 as dramatic critic of *The Saturday Review*. Resigned in 1910, married American actress FLORENCE KAHN (1877–1951), lived thereafter at Rapallo, Italy.

BELLOC, HILAIRE (1870–1953), Anglo-French journalist, man of letters. Attended Balliol College, Oxford, 1893–95.

BERENSON, BERNHARD (1865–1959), art historian and source of received opinions on attributions of Renaissance paintings. Born in Boston, educated at Harvard; lived at I Tatti, Settignano.

BERESFORD, ADMIRAL LORD CHARLES WILLIAM DE LA POER, 1st Baron, of Metemeh and of Curraghmore (1846–1919). Cadet in 1859, and Rear-Admiral by 1897. Commanded Mediterranean Fleet, 1905–07, and the Channel Fleet, 1907–09.

BESNARD, PAUL ALBERT (1849–1934), French painter and muralist. Studied with Ingres and balanced uneasily between classicism and modernism.

BING, SAMUEL (1838–1905), art dealer and connoisseur with trans-Atlantic influence on Art Nouveau. By 1871 was living in Paris, visited Japan in 1875, showed Oriental decorative arts at Paris Exposition of 1878, then opened two Paris shops and a New York showroom. Published *Le Japon Artistique*, in three languages, thirty-six issues (1888–91).

BINYON, LAURENCE (1869–1943), poet, art historian. Appointed Assistant Keeper of Prints and Drawings, British Museum, 1909; Deputy Keeper, then Keeper, of Department of Oriental Prints and Drawings, 1913–33.

BIRDWOOD, SIR GEORGE C. M. (1832–1917), Indian Medical Service officer and Professor of Materia Medica and Botany, Grant Medical College, Bombay. In Revenue and Statistics Department, India Office, London, 1871–1902. Royal Commissioner for assorted Indian, colonial, and trade expositions.

BLACKWOOD, LORD BASIL (1870–1917), barrister and colonial administrator.

BLANCHE, JACQUES-EMILE (1862–1942), French Impressionist painter. Visited London in 1882 with Whistler and Sickert and maintained close ties with New English Art Club.

BLUNT, WILFRID SCAWEN (1840–1922), diplomat, traveller, author. In Diplomatic Service, 1858–70. Staunch advocate of Irish Home Rule.

BODENHAUSEN-DEGENER, HANS EBERHARD VON (1868–1918), German industrialist.

BOLDINI, GIOVANNI (1845–1931), Italian painter living in Paris, from 1872.

BONE, SIR MUIRHEAD (1876–1953), Scottish etcher, draughtsman, painter. Official War Artist, 1916–18; Official Artist to the Admiralty, 1941–48.

BOSE, SIR JAGADISH CHANDRA (1858–1937), Bengali plant physiologist. Close friend and associate of Tagore, with whom he shared disciples.

BOUDIN, ESTHER. Mistress of Verlaine, alternating with Eugénie Krantz.

BRACQUEMOND, FELIX-HENRI (1833–1914), French painter, engraver. Artistic director for the Haviland firm, 1872–80.

BRADLEY, ANDREW CECIL (1851–1935), Shakespearean scholar. Professor of Modern Literature, University College, Liverpool, 1881–89; of English Language and Literature, Glasgow University, 1889–1900; Professor of Poetry, Oxford, 1901–06.

BRAHM, OTTO (né ABRAHAMSON) (1856–1912). Appointed Director of the Lessing

Theatre, Berlin, in 1904 and engaged Gordon Craig to design a production of Otway's *Venice Preserved*.

BRANGWYN, SIR FRANK (1867–1956), Welsh mural painter, influenced by Pre-Raphaelite medievalism and by Impressionism. For eighteen panels commissioned in 1924 as a war memorial for the Royal Gallery of the House of Lords, he combined figures, flora and fauna of the Empire at peace. In 1930 the Lords rejected the designs; murals, studies, and cartoons are in the Guildhall, Swansea.

BRIDGES, ROBERT SEYMOUR (1844–1930), physician and poet, with particular interest in the lyric and in metrical problems. Retired in 1882 as Assistant Physician at Children's Hospital, London. Appointed Poet Laureate, 1913.

BROOKE, MARGARET ALICE LILI DE WINDT, Ranee (d. 1936), wife of Charles Brooke, second White Rajah of Sarawak.

BROOKE, STOPFORD AUGUSTUS (1832–1916), liberal Irish clergyman until 1880, when he continued in liberal ways but seceded from Church of England. Continued preaching, and lectured on English literature, at Bedford Chapel, Bloomsbury. Author of books on English literary history and on Shelley, Tennyson, Browning, among others.

BROWN, FORD MADOX (1821–93), painter. Born and studied on the Continent, came to England in 1845. Entered Pre-Raphaelite circle when Rossetti asked him for painting lessons.

BROWN, FREDERICK (1851–1941), painter. Trained at South Kensington and Paris. Head, Westminster School of Art, 1877–93; Slade Professor of Fine Art, University of London, 1892–1917. A founder of the New English Art Club.

BRUANT, ARISTIDE (1851–1925), Montmartre café ballad composer, singer.

BURDON-SANDERSON, SIR JOHN SCOTT (1828–1905), Waynflete Professor of Physiology, 1882–95, and Regius Professor of Medicine, Oxford, 1892–1904.

BURNE-JONES, SIR EDWARD COLEY, Baronet (1833–98), painter. Native of Birmingham; educated at Exeter College, Oxford, where he met the Pre-Raphaelites and joined in the Oxford Union murals project.

BURRELL, ARTHUR (1859–1946), teacher, Bradford Grammar School. Became Principal, 1900, of the Borough Road College, Isleworth, Middlesex. Retired, 1912, to study Twickenham history and is honoured there with an annual Burrell Memorial Lecture.

BUSSELL, FREDERICK WILLIAM (1862–1944), Fellow of Brasenose College, Oxford, 1886; ordained, appointed Chaplain, 1892; Vice-Principal, 1896–1913.

BUTLER, SIR MONTAGU (1873–1952), Indian Civil Service. Chancellor, Nagpur University, and Governor, Central Provinces, 1925–33.

CAMERON, SIR DAVID YOUNG (1865–1945), Scottish painter and etcher.

CARLISLE, GEORGE JAMES HOWARD, 9th Earl of (1843–1911). Painter, art collector, faithful patron of Burne-Jones.

CAZALS, FRÉDÉRIC-AUGUSTE (1865–1941), painter, designer, poet, song-writer. Met Verlaine about April 1886.

CERUTTI, ESTELLA. Italian girl living in London, subject of a number of Augustus John drawings and oil portraits.

CHAKRAVARTY, AJIT KUMAR. One of Tagore's first students, then a teacher at Tagore's school at Santiniketan.

CHARLES, JAMES (1851–1906), Yorkshire artist, trained at Royal Academy Schools and Académie Julian.

CHATTERJEE, SIR ATUL (1874–1955), High Commissioner for India in London, 1925–31.

CHATTERJEE, RAMANANDA (1865–1943), Bengali journalist. Editor, *The Modern Review*, Calcutta English-language cultural review, from 1906.

CHHATARPUR, VISHRANATH SINGH (SHAHU CHHATRAPATI), Maharaja (1866–1932). Chief Ruler, Chhatarpur State, founded 1707; now in Madhya Pradesh.

CLARKE, SIR EDWARD (1841–1931), barrister. Writer in India Office, 1859–60, while studying law in evening classes. Solicitor-General, 1886–92. Defended Wilde at his trials.

CLAUSEN, SIR GEORGE (1852–1944), English figure and landscape painter. Sometime Professor of Painting, Royal Academy Schools.

CLIFTON, ARTHUR BELLAMY (1863–1932), solicitor, then manager of Carfax Gallery. Poet, as 'Arthur Marvell'. Wilde's bankruptcy trustee.

COCHRAN, CHARLES BLAKE (1872–1951), theatrical producer. Attended Brighton Grammar School with Beardsley.

CONDER, CHARLES (1868–1909), painter. Born in England, grew up in Australia, lived in Paris 1890–95, and divided his time thereafter between France and England. In 1901 married STELLA BELFORD.

COOLIDGE, THOMAS JEFFERSON (1831–1920), diplomat. Boston banker.

COOMARASWAMY, ANANDA KENTISH (1877–1947), Ceylonese authority on Ceylonese and Indian art. Director, Art Section, United Provinces Exhibition, Allahabad, 1910–11; Fellow for Research in Indian, Persian, and Muhammedan Art, Museum of Fine Arts, Boston, 1917–47.

COQUELIN, BENOÎT-CONSTANT (1841–1909), French actor (Coquelin *aîné*), for whom Rostand created the character of Cyrano.

COQUELIN, ERNEST ALEXANDRE HONORÉ (1848–1909) (Coquelin *cadet*), brother of Constant Coquelin. *Vice-doyen*, Comédie Française.

CORELLI, MARIE, pseudonym of MARY MACKAY (1855–1924), popular novelist.

CORNFORD, FRANCES (1886–1960), poet. Daughter of Sir Francis Darwin; wife of Francis Cornford, Cambridge classicist.

COSTA, GIOVANNI (1833–1903), Italian landscape painter. Stopford Brooke and Lord Carlisle were among friends and patrons in England, where he was more popular than in Italy.

COURTNEY, WILLIAM LEONARD (1850–1928), author and journalist. Edited *Murray's Magazine*, 1891; *The Fortnightly Review*, from 1894.

CRACKANTHORPE, HUBERT (1870–96), writer of short fiction much influenced by French naturalist writers. Drowned in the Seine at Paris; whether a suicide or a victim of a murder is still unknown.

CRAIG, EDWARD GORDON (1872–1966), stage and woodcut designer, theatrical producer and theorist. Son of Ellen Terry and Edward Godwin.

CRAIGIE, PEARL MARY-TERESA (1867–1906), as John Oliver Hobbes, a popular novelist.

CRANE, WALTER (1845–1915), painter, decorator, illustrator, socialist associate of William Morris. Organiser and first President of Art Worker's Guild, 1884. President, Arts and Crafts Exhibition Society, 1888–90, 1895–1915.

CRESSWELL, WALTER D'ARCY (1896–1960), poet. Born in Canterbury, N.Z. Made four trips to England, during second of which he peddled his poems from door to door in London. During third trip, WR gave him work as editorial assistant. Fourth and last trip ended with death in his home in St John's Wood.

CUNARD, LADY MAUD ALICE (d. 1948), American wife of Sir Bache Edward Cunard, 3rd Baronet.

CUNNINGHAME GRAHAM, ROBERT BONTINE (1852–1936), of Ardoch, Dumbartonshire. A founder of Scottish Labour Party and a Socialist M.P. Writer, sometime rancher and gaucho in South America, hence known as 'Don Roberto'.

CURZON OF KEDLESTON, GEORGE NATHANIEL CURZON, 1st Marquis (1859–1925),

Under-Secretary of State for India, 1891–92, and for Foreign Affairs, 1895–98. Viceroy and Governor-General of India, 1899–1905. Became Oxford University Chancellor, 1907.

CUSHING, HOWARD GARDINER (1869–1915), Boston painter. Studied at Académie Julian, 1891–96.

DAVIS, RICHARD HARDING (1864–1916), American novelist, journalist, foreign correspondent. Collaborated with Charles Dana Gibson, originator of the 'Gibson girl,' on *About Paris* (1895), an American view of Paris in the 1890's.

DE LA MARE, RICHARD, publisher. Joined the Faber firm in 1925; Director, 1928–45; Vice-Chairman, 1945–60; President since 1971.

DE LA MARE, WALTER (1873–1956), poet and writer of fiction blending fairy tales, fantasy and reality.

DE MORGAN, WILLIAM FREND (1839–1917), worker in stained glass and ceramics, and later a popular novelist. In 1888 he married MARY EVELYN PICKERING, painter. They lived at 1 The Vale, Chelsea.

DICKINSON, GOLDSWORTHY LOWES (1862–1932), Cambridge historian.

DIXON, RICHARD WATSON (1833–1900), poet. A Canon of Carlisle Cathedral. Author of a massive history of the Church of England (1877–1900).

DODGSON, CAMPBELL (1867–1948), authority on etching and woodcut processes. Keeper of Prints and Drawings, British Museum, 1912–32.

DODGSON, THE REV. CHARLES L. (1832–98), mathematician, better known as the writer 'Lewis Carroll'.

DOLMETSCH, ARNOLD (1858–1940), French musician and instrument builder, largely responsible for English revival of interest in authentic sounds and texts of Renaissance and Baroque music.

DOUCET, HENRI-LUCIEN (1856–95), French history and genre painter.

DOWSON, ERNEST (1867–1900), poet. Attended Oxford, 1886–88, without completing a degree. Worked at dry-dock owned by his father but spent spare time with Rhymers' Club poets, whom he met in 1891. Lived in France but returned to England shortly before his death.

DRINKWATER, JOHN (1882–1937), poet and playwright. He and his first wife lived in Winstons Cottage, Iles Farm, 1918–21. His play *Abraham Lincoln* (1919) was his greatest success.

DUCKWORTH, SIR GEORGE HERBERT (1868–1934), stepson of Leslie Stephen. Served as Secretary to a number of Government officials and agencies.

DUCKWORTH, STELLA (1869–97), stepdaughter of Leslie Stephen.

DUJARDIN, EDOUARD (1861–1949), Symbolist writer. His novel, *Les Lauriers sont coupées* (1888) was first to use *monologue intérieure*.

DU MAURIER, GEORGE (1834–96), illustrator and novelist, author of *Trilby*. Born in Paris and studied art there and in Antwerp. Joined *Punch* staff in 1864.

DURHAM, C. J. (d. 1888), Art Master, Bradford Grammar School.

DYER, GEORGE (1755–1841), poet and essayist, incurably absentminded.

EDEN, SIR WILLIAM, 7th Baronet (1849–1915), soldier and amateur painter.

ELLIS, ROBINSON (1834–1913), University Reader of Latin Literature, 1883–93; Corpus Professor of Latin Literature, 1893–1913, Oxford.

ELTON, OLIVER (1861–1945), Lecturer in English Literature, Owens College, Manchester, 1890–1900; King Alfred Professor of English Literature, Liverpool University, 1900–25.

EPSTEIN, SIR JACOB (1880–1959), American-born sculptor. Lived in England after 1907.

FABBRI, EGISTO (1866–1933), wealthy Italian-American connoisseur. Educated in the United States, lived near Florence after 1884. By 1889, owned sixteen Cézanne works. Active in revival of Gregorian Chant and early church music.

FAED, JOHN (1820–1902), and his brother THOMAS FAED (1826–1900), painters, from a Kirkcudbrightshire family of genre and miniature painters.

FANTIN-LATOUR, HENRI (1836–1904), French Romantic painter of figures, portraits, still-lifes, pictures on Wagnerian musical themes.

FISHER, HERBERT ALBERT LAURENS (1865–1940), historian. Fellow and Tutor, New College, Oxford; Warden, from 1925. Member, Royal Commission on Public Services in India, 1912–15. Vice-Chancellor, Sheffield University, 1912–16. President, Board of Education, with Cabinet rank, 1916–22.

FORAIN, JEAN-LOUIS (1852–1931), French painter and lithographer.

FORSTER, WILLIAM EDWARD (1818–86), M.P. for Bradford. Liberal reformer noted for his part in writing the Education Act of 1870, making elementary education a national system. Bradford Grammar School was the first to be reconstituted under the new law.

FOTHERGILL, JOHN ROWLAND (1876–1957), author, archaeologist, artist, and artistic innkeeper celebrated as proprietor of the Spreadeagle at Thame, Oxfordshire.

FOX STRANGWAYS, ARTHUR HENRY (1859–1948), musicologist and music journalist. Critic for *The Times* and *The Observer*. Founder-editor, *Music and Letters*. Author of *The Music of Hindostan* (1914), still the standard text on Indian music by a Western writer. First secretary of the India Society and Tagore's unpaid agent in London, 1912–14.

FRAMPTON, GEORGE JAMES (1860–1928), sculptor. Works include Peter Pan statue, Kensington Gardens (1912); lions at North Entrance, British Museum (1914); Edith Cavell Memorial, St Martin's Place (1920).

FRAZIER, KENNETH (1867–1949), American painter. Born in Paris, settled later at Garrison, New York.

FRITH, WILLIAM POWELL (1819–1909), Victorian painter. Began as illustrator; about 1851, turned to contemporary subjects.

FRY, CHARLES BURGESS (1872–1956), in 1893, Oxford football and cricket captain, and President of the University Athletic Club; Honorary Director, Training Ship 'Mercury,' 1908–50.

FRY, ROGER ELIOT (1866–1934), painter, critic, art historian. Took science degree at King's College, Cambridge, then turned to art. Organised exhibition, 'Manet and the Post-Impressionists,' known thereafter as London's First Post-Impressionist Exhibition, at the Grafton Galleries, November 1910. Curator, Department of Paintings, Metropolitan Museum, 1906–10. From 1933, Slade Professor of Fine Art, Cambridge. In 1896, married HELEN COOMBE (d. 1913), painter.

FURNISS, HARRY (1854–1925), English caricaturist, illustrator, author, lecturer, film producer and actor in England and America.

FURSE, CHARLES WELLINGTON (1868–1904), painter. Son of an Archdeacon of Westminster and son-in-law of J. A. Symonds. Died of tuberculosis.

GANDARA, ANTONIO DE LA (1862–1917), Spanish-English painter and pastellist born in Paris. Pupil of Gérôme.

GARDNER, ISABELLA STEWART (1840–1924), the redoubtable 'Mrs Jack' of Fenway Court, Boston, her home and art gallery, now a museum. In 1860, she married JOHN LOWELL GARDNER (d. 1890), Boston manufacturer and financier.

GARNETT, EDWARD (1868–1937), author and publisher's reader, son of Richard Garnett, Director, British Museum. Had limited success with his own fiction

and dramas but performed inestimable services to literature by encouraging emerging writers.

GAVARNI, PAUL, pseudonym of Sulpice-Guillaume Chevalier (1804–66), designer, water-colourist, lithographer; noted for variety of his subjects.

GERRANS, HENRY TRESAWNA (1858–1921), Fellow, Bursar and Tutor, Vice-President and Lecturer, Worcester College, Oxford. Proctor in 1895.

GILBERT, SIR ALFRED (1854–1934), sculptor. Professor at Royal Academy, 1900–09. Created Shaftesbury Fountain, Piccadilly.

GILL, ERIC (1882–1940), sculptor, stone-carver, engraver, designer. Created Stations of the Cross, Westminster Cathedral.

GISSING, GEORGE (1857–1903), novelist, journalist. Education at Owens College, Manchester, interrupted by unfortunate marriage in 1875, by travels abroad, and by unremitting financial difficulties, the subject of many of his novels, and only temporarily eased by work as tutor to sons of Positivist philosopher, Frederic Harrison.

GODWIN, EDWARD WILLIAM (1833–86), architect and theatrical designer. In 1868 set up house with Ellen Terry. Father of Gordon Craig and his sister Edith.

GOKHALE, G. K. (1866–1915), Maharashtrian Moderate nationalist. Founder, Servants of India Society.

GOLOUBEW, VICTOR (1879–1945), Russian, living in Paris. Photographer, archaeologist, collector of Indian and Indochinese art.

GOSSE, SIR EDMUND (1849–1928), man of letters. Assistant Librarian, British Museum, 1867–75. Librarian, House of Lords, 1904–14.

GOULDING, FREDERICK (1842–1909), London lithographic printer.

GOURMONT, RÉMY DE (1858–1915), French novelist, playwright, philosopher, commentator on Symbolism.

GRAY, JOHN (1866–1934), English Symbolist poet and London dandy. Member of the Rhymers' Club. Taught himself French and joined Arthur Symons' Francophile circle before visiting France himself. Wilde financed his poems, *Silverpoints* (1893), published by Lane.

GREEN, ALICE STOPFORD (1848–1929), author of books on Irish history. Her Kensington Square home a gathering place for Irish Home Rulers.

GRØNVOLD, BERNT (1859–1923), Norwegian landscape and genre painter. Lived in Germany, France and England (Cornwall); settled in Norway in 1890.

GUTHRIE, JAMES (1859–1930), Scottish painter.

HACON, WILLIAM LLEWELLYN (1860–1910), London barrister. Remembered chiefly for association with the Vale Press. Married AMARYLLIS BRADSHAW (d. 1953).

HADEN, SIR FRANCIS SEYMOUR (1818–1910), surgeon and etcher. Founder and President, Royal Society of Painter-Etchers. Married DEBORAH WHISTLER (d. 1908) in 1847.

HALE, PHILIP LESLIE (1865–1931), Boston painter. Trained at Art Students' League, New York; Académie Julian; Ecole des Beaux Arts.

HAMERTON, PHILIP GILBERT (1834–94), writer on painting and etching; novelist; editor, 1870–93, *The Portfolio*. Contributed to various London journals on literature and the arts.

HAMILTON, GENERAL SIR IAN (1853–1947). Entered Army in 1873, served in Afghanistan, South Africa, Egypt, Burma. Chief of Staff to Lord Kitchener, 1901–02. In World War I, commanded Mediterranean Expeditionary Force.

HAMMERSLEY, HUGH (1858–1930), a partner in Cox's Bank, and his first wife, MARY FRANCES (d. 1911) lived at The Grove, Hampstead, which they made a center for the New English Art Club group.

HAMMOND, JOHN LAWRENCE LE BRETON (1872–1949), journalist. Author, with his wife, BARBARA HAMMOND, of a landmark series of studies on history of British labouring classes.

HANNAY, ARNOLD. Scottish collector of Whistler works, about whom little is known beyond the Whistler portrait (1896) in the National Gallery of Art, Washington.

HARCOURT, RT. HON. SIR WILLIAM (1827–1904), barrister, specialist in international law. From 1861 onwards, wrote as 'Historicus' in *The Times*.

HARRIS, JAMES THOMAS (FRANK) (1856?–1931), novelist, biographer, editor.

HARRISON, LAWRENCE A. (d. 1937), amateur painter. Son of the Positivist philosopher Frederic Harrison. A regular attendant at George Moore's evenings in Ebury Street, where he was known as Peter.

HAUPTMANN, GERHARDT (1862–1946), distinguished German playwright, novelist, poet.

HAVELL, ERNEST B. (1861–1934), Superintendent of the Government School of Art at Madras, 1884–92, and at Calcutta, where he was also Keeper of the Government Art Gallery, 1896–1906.

HEINEMANN, WILLIAM (1863–1920), publisher of *The New Review*; founder of the publishing house that still bears his name.

HELLEU, PAUL CÉSAR FRANÇOIS (1859–1927), painter of fashionable portraits, who worked in France, Germany, England, and the United States.

HENLEY, WILLIAM ERNEST (1849–1903), poet, critic, dramatist, editor of *The Magazine of Art*, 1882–86; *The Scots* (afterwards *National*) *Observer*, where he gathered the group of writers known as the 'Henley Regatta,' 1888–93; and *The New Review*, 1893–98.

HERKOMER, SIR HUBERT VON (1849–1914), painter and art teacher, born in Waal, Bavaria. He collected an imposing array of foreign honours and orders and was Slade Professor of Fine Arts at Oxford, 1885–94. He founded the Herkomer School at Bushey in 1883.

HERRINGHAM, LADY CHRISTIANA JANE POWELL (1853–1929), wife of Dr Wilmot Herringham, Consulting Physician to St Bartholomew's Hospital. She was a talented and energetic copyist, especially interested in the history and techniques of tempera painting and wall decoration.

HOBBES, JOHN OLIVER. See CRAIGIE, PEARL MARY-TERESA.

HOFMANN, LUDWIG VON (1861–1945), German painter. Came to Paris in 1889, later taught at the Weimar Kunstschule and the Dresden Akademie.

HOLDEN, CHARLES (1875–1960), C. R. Ashbee's assistant, later Senior Partner and principal designer for the firm of Adams, Holden and Pearson.

HOLMES, SIR CHARLES JOHN (1868–1936), English landscape painter, art critic. Manager, Vale Press, 1896–1903. Editor, *Burlington Magazine*, 1903–09. Slade Professor at Oxford, 1904–10. Director, National Portrait Gallery, 1909–16. Director, National Gallery, 1916–28.

HOLROYD, SIR CHARLES (1861–1917), painter, etcher. Assisted Legros at Slade School. Keeper, National Gallery, Millbank (Tate Gallery), 1897–1906. Director, National Gallery, 1906–16.

HORNBY, C. H. ST JOHN (1867–1946), barrister, bibliophile; senior partner in W. H. Smith Company. Founded and maintained Ashendene Press, 1894–1916.

HORNE, HERBERT (1864–1916), connoisseur and art historian. In 1886, founded Century Guild of Artists; edited *The Century Guild Hobby Horse*, 1887–91, and *The Hobby Horse*, 1893–94. In 1896 he bought a Florentine palazzo, settled there in 1912, wrote a major study of Botticelli (1908), and finally bequeathed palazzo and collection to the city of Florence.

HOWARD, FRANCIS (1874–1954), Honorary Managing Director of Grafton and Grosvenor Galleries; journalist and art critic.

HUDSON, WILLIAM HENRY (1841–1922), naturalist and nature writer, novelist. Born near Buenos Aires and came to England in 1869.

HUEFFER, FORD MADOX (later FORD) (1873–1939), grandson of Ford Madox Brown. Founder of *The English Review*, in 1908. Prolific novelist.

HUNT, WILLIAM HOLMAN (1827–1910), painter. Founding member of Pre-Raphaelite Brotherhood. Best known for paintings on Biblical themes.

HUYSMANS, JORIS-KARL (1848–1907), French novelist, whose *A Rebours* (1884) had a great vogue among the London dandies of the 1890's.

IMAGE, SELWYN (1849–1930), artist, clergyman, music scholar. Studied at Slade School under Ruskin. Held London curacies, 1875–80; Slade Professor of Fine Art, Oxford, 1910–16.

IONIDES, LUKE. Member of the London Anglo-Greek family of collectors and patrons of Whistler and his circle.

IRVING, SIR HENRY (1838–1905), actor-manager of the Lyceum Theatre, London. Knighted in 1895, the first actor thus honoured.

IRWIN, EDWARD FREDERICK LINDLEY WOOD, 1st Baron, later 3rd Viscount and 1st Earl of Halifax (1881–1959). Viceroy of India, 1925–31. Foreign Secretary, 1938–40. Ambassador to the United States, 1941–46.

JACKSON, MARIA PATTLE (1818–92), mother of Mrs Leslie Stephen.

JACOMB-HOOD, GEORGE PERCY (1857–1929), painter, illustrator. Official artist for *The Graphic* in India, for 1902 and 1911 Durbars and for 1905–06 tour of Prince of Wales.

JEUNE, LADY SUSAN. Wife of Francis Henry Stowe, Baron St Helier.

JEWSON, NORMAN (1884–1975). Apprentice-architect to Herbert Ibberson, in London; went to Cirencester in 1907 and lived thereafter in the Cotswolds.

JOHN, AUGUSTUS (1878–1961), Welsh painter, mainly of portraits. Professor of Painting, Liverpool University, 1901–02. Elected to the Royal Academy, 1928; resigned, 1938; re-elected, 1940. Received Order of Merit, 1942. In 1901 married IDA NETTLESHIP (d. 1906).

JOHN, GWENDOLYN MARY (1876–1939), sister of Augustus John. Slade School student, painter of small-scale portraits, interiors. After 1898, lived principally in Paris; from about 1906, closely associated with Rodin. Died at Dieppe.

JOHNSON, LIONEL (1867–1902), London journalist, poet, critic. Associated with Yeats and Irish Literary Society; member, Rhymers' Club.

JULIAN, RODOLPHE (1839–1907), sometime painter; art school entrepreneur, founder of Institut Julian in 1860. In 1881, made a member of the Legion of Honour.

KEENE, CHARLES (1823–91), *Punch* illustrator, 1851–90.

KEKULÉ VON STRADONITZ, REINHARD (1839–1911), Professor of Archaeology, Berlin University. Uncle and father-in-law of Ludwig von Hofmann.

KENNINGTON, ERIC HENRI (d. 1960), painter and sculptor. Official War Artist, 1916–19, 1940–43.

KER, WILLIAM PATON (1855–1923), Professor of English Literature, University College of South Wales, 1883–89, and University College, London, 1889–1922. Professor of Poetry, Oxford, from 1920.

KESSLER, COUNT HARRY (1868–1937), German banker, diplomat, patron of the arts. Educated in England; lived at Weimar, where he founded the Cranach Press and was an editor of the art journal, *Pan*.

KEYSERLING, COUNT HERMANN (1880–1946), German philosophical writer.

KNEWSTUB, WALTER (1831–1906), painter, father of Alice Rothenstein. In 1862 became D. G. Rossetti's pupil, then his assistant.

KNIGHT, JOHN BUXTON (1843–1908), English landscape painter.

KRANTZ, EUGÉNIE. Verlaine's mistress. Formerly a Second Empire cocotte known in the music halls as Ninie Mouton.

LANE, JOHN (1854–1925), publisher. With Elkin Mathews, founded the Bodley Head, Vigo Street, London, in 1887.

LANG, ANDREW (1844–1912), Scottish journalist, man of letters. His folklore studies inspired considerable anthropological research.

LANKESTER, SIR EDWIN RAY (1847–1929). Professor of Zoology and Comparative Anatomy, University College, London, 1874–90; Regius Professor of Natural History, Edinburgh, 1882; Linacre Professor of Comparative Anatomy, Oxford, 1891–98; Director, Natural History Department, British Museum, 1898–1907.

LAVER, JAMES (1899–1975), author, museum official, authority on the history of costume. Keeper, 1938–59, Department of Engraving, Illustration and Design, and of Painting. Victoria and Albert Museum.

LAVERY, SIR JOHN (1856–1941), Irish painter. President, 1932–41, Royal Society of Portrait Painters.

LECOQ DE BOISBOUDRAN, HORACE (1802–97), undistinguished as painter, but a notable teacher at Ecole de dessin des Arts décor, Paris.

LEGROS, ALPHONSE (1837–1911), French painter, sculptor, etcher. At Whistler's urging, came to England in 1863. Succeeded Poynter as Slade Professor, University College, London, in 1876.

LEIGHTON OF STRETTON, FREDERIC LEIGHTON, Baron (1830–96), painter. Born in Yorkshire; settled in London, 1860. Made a Peer in 1896, first English painter thus honoured.

LETHABY, WILLIAM RICHARD (1857–1931), author, architect. First Principal of the London County Council School of Arts and Crafts, 1894. Surveyor to Dean and Chapter of Westminster Abbey, 1906–28, and a formidable member of the Society for the Protection of Ancient Buildings.

LEWIS, PERCY WYNDHAM (1884–1957), English painter, novelist. Attended Slade School, 1898–1901; joined Camden Town Group, 1911. Founded Vorticism, and edited its paper, *Blast*.

LIEBERMANN, MAX (1847–1935), German genre, landscape, portrait painter.

LIPPMANN, FRIEDRICH (1839–1903), German writer on etching and engraving.

LOESER, CHARLES (1864–1928), American connoisseur and collector of Cézanne's paintings. Lived near Florence. Collection of drawings is in the Fogg Museum, Harvard University.

LOMONT, EUGÈNE (b. 1864), French painter.

LUDOVICI, ALBERT (1820–94), English painter. Met Whistler in 1884 and became a faithful Follower.

LUTYENS, SIR EDWIN (1869–1944), architect. Recommended by Royal Institute of British Architects as designer for New Delhi; accepted on condition that central buildings be in European classical style.

LYTTON, NEVILLE STEPHEN LYTTON, 3rd Earl of (1879–1951), painter. Wounded in 1916 on Western Front, then assigned to General Staff as Controller of Press Censorship and Guidance.

MacColl, Dugald Sutherland (1859–1948), painter, art critic, elder statesman of the New English Art Club; writer for *The Spectator, The Saturday Review, Art-Work* (editor). Keeper, Tate Gallery, 1906–11; and Wallace Collection, 1911–24.

McEvoy, Ambrose (1878–1927), painter. Slade School crony and travelling companion of Augustus John.

Macmillan, George (1855–1936), publisher. Member of the Macmillan family firm.

Mahoney, Charles (1903–68), painter. Trained at Royal College of Art; an instructor there, 1928–53.

Masefield, John (1878–1967), poet and playwright. Appointed Poet Laureate, 1930.

Matheson, Hilda (1888–1940), BBC's first director of talks, then Director of Joint Broadcasting Committee for recorded foreign broadcasts.

Mathews, Elkin (1851–1921), publisher. Until 1894, at the Bodley Head.

May, Phil (1864–1903), illustrator and caricaturist. Born and educated in England; lived in Australia and worked for *The Sydney Bulletin* before coming to Paris in the 1890's.

Menpes, Mortimer (1860–1938), Australian etcher, raconteur, nurseryman, and devoted Whistler Follower.

Menzel, Adolf von (1815–1905), German genre painter and engraver.

Merrill, Stuart (1863–1915), American poet living in Paris. Tried but failed to persuade French writers to petition for Wilde's release in 1895.

Meryon, Charles (1821–1868), Anglo-French etcher and draughtsman. Entered French Navy in 1837 but turned to art when his health collapsed.

Mitra, Sir Bhupendranath (1875–1937), High Commissioner for India, 1931–36. Government service, from 1896, principally in civil and military accounting.

Montesquiou-Fezensac, Comte Robert de (1855–1921). Parisian dandy. Huysmans' model for Des Esseintes, hero of his *A Rebours*.

Monticelli, Adolphe (1824–96), Italian Impressionist painter living in France. Strongly influenced by Corot and Delacroix.

Moore, Albert (1841–1892), English figure painter and illustrator.

Moore, George (1852–1933), Anglo-Irish novelist, dramatist, short-story writer. Studied painting in Paris, 1872–82, and tried to apply what he had learned from writers of French naturalistic fiction, to fiction-writing in England.

Moore, Thomas Sturge (1870–1944), poet, playwright, wood-engraver. Brother of Cambridge philosopher, G. E. Moore.

Moréas, Jean (né Papadiamantopoulos) (1856–1910), Greek poet. Born in Athens, came to Paris in 1872. Published a Symbolist manifesto in 1886, later led the Ecole Romane, neo-classical departure from Symbolism.

Morison, Sir Theodore (1863–1936), educator. Tutor to Maharaja of Chhatarpur, 1885. Taught at Muhammedan College, Aligarh, 1889–99; appointed Principal, 1899–1905.

Morrell, Lady Ottoline (1873–1938), wife of Philip Morrell, Liberal politician. A founder of the Contemporary Art Society and a patron of new movements in the arts and in literature.

Müller, Friedrich Max (1823–1900), German Orientalist and Sanskrit scholar. Corpus Professor of Comparative Philology, Oxford.

Munnings, Sir Alfred (1878–1959), painter of horses and horsemanship scenes. President, Royal Academy, 1944–59.

Murray, Sir Gilbert (1866–1957), Hellenic scholar and translator. Regius Professor of Greek, Oxford, 1908–36.

NASH, JOHN (1893–1977), painter, illustrator noted for meticulous botanical drawings. Commissioned by Imperial War Museum as War Artist, 1916–18; Official War Artist to the Admiralty, 1940. Assistant Teacher of Design, Royal College of Art, 1934–57.

NASH, PAUL (1889–1946), painter and designer, brother of John Nash. Official War Artist, Autumn 1917, 1940–41.

NEVINSON, CHRISTOPHER (1889–1946), painter, etcher, lithographer. Son of H. W. Nevinson.

NEVINSON, HENRY WOODD (1856–1941), foreign correspondent, reporting from Near East and Mediterranean, beginning in 1897 with Greek and Turkish War; Central Africa, where he exposed Portuguese slave trade in Angola; Russia; India; the Continent. Staff member, *The Nation*, 1907–23.

NEWBOLT, SIR HENRY (1862–1938), barrister and poet. Professor of Poetry, Oxford, 1911–21.

NICHOL, JOHN (1833–94), Professor of English, Glasgow University, 1862–89. Shared Swinburne's admiration for Italian republican patriots.

NICHOLSON, SIR WILLIAM NEWZAM PRIOR (1872–1949), painter. Studied at Herkomer's school at Bushey but gained little except acquaintance with MABEL PRYDE, whom he married in 1893, and her brother, Scottish painter, James Pryde (1869–1941), with whom he formed the poster-designing partnership known as the Beggarstaff Brothers.

NORTHCLIFFE, ALFRED CHARLES HARMSWORTH, 1st Viscount (1865–1922). Chief Proprietor, *The Times*, from 1908. During World War I, was Director of Propaganda in Enemy Countries.

ORPEN, SIR WILLIAM (1878–1931), Irish painter, principally of portraits. Official War Artist in both World Wars. In 1901, married GRACE KNEWSTUB (1877–1948), Alice Rothenstein's sister.

PARTRIDGE, SIR BERNARD (1861–1945), *Punch* illustrator, cartoonist, 1891–1945.

PENNELL, JOSEPH (1860–1926), Philadelphia etcher and art critic, and his wife, ELIZABETH ROBINS PENNELL (1855–1936), Whistler's biographers and his most idolatrous Followers.

PICARD, LOUIS (b. 1861), French painter, pupil of Gérôme.

PINERO, SIR ARTHUR WING (1855–1934), playwright. *The Second Mrs Tanqueray* (1893), with Mrs Patrick Campbell, was his first great success.

PINKER, JAMES BRAND (1863–1922), London literary agent.

PISSARRO, LUCIEN (1863–1944), Impressionist painter, son of the Creole-Portuguese-Jewish painter Camille Pissarro. Moved to England in 1890, was naturalised a British citizen in 1916.

POWELL, FREDERICK YORK (1850–1904), barrister, linguist, Icelandic scholar. Lecturer in Law at Christ Church, Oxford, 1884–94; Regius Professor of Modern History, 1894–1904. A founder of the *English Historical Review*, 1886, and of Ruskin College, Oxford, 1899.

POYNTER, SIR EDWARD JOHN, 1st Baronet (1836–1919), English painter. First Slade Professor of Fine Art, University College, London University, 1871–75; Principal, National Art Training School (later, Royal College of Art); Director, National Gallery, 1894–1905; President, Royal Academy, 1896–1918.

PUVIS DE CHAVANNES, PIERRE (1824–1898), French mural painter who aimed at re-creation of Italian fresco style.

236 BIOGRAPHICAL GLOSSARY

QUEENSBERRY, JOHN SHOLTO DOUGLAS, 9th Marquess of (1844–1900), father of Wilde's friend, Lord Alfred Douglas, and inciter of the 1895 legal action that culminated in Wilde's imprisonment.

RALEIGH, SIR WALTER (1861–1922), a native of Scotland; Professor of English Literature, Oxford, from 1904.

RAVILIOUS, ERIC (1903–42), English painter, trained at Royal College of Art.

REDMOND, JOHN EDWARD (1851–1918), Irish political leader and Member of Parliament. In 1892, a staunch supporter of Parnell.

RENNELL, JAMES RENNELL RODD, 1st Baron (1858–1941), diplomat. In 1892, British Attaché at Paris.

REPINGTON, COLONEL CHARLES À COURT (1858–1925), soldier and military correspondent, 1904–18, variously for *The Morning Post, The Times, Daily Telegraph*.

RHYS, ERNEST (1859–1946), poet, essayist, critic. Originator and editor of J. M. Dent's Everyman's Library.

RICHARDS, GRANT (1872–1948), author and publisher; established his own firm in 1897.

RICHMOND, GEORGE (1809–96), painter, draughtsman. Trained in Royal Academy Schools.

RICKETTS, CHARLES (1866–1931), painter, stage designer, connoisseur. Lived in The Vale, Chelsea, with Charles Shannon.

RILKE, RAINER MARIA (1875–1926), German poet, fiction writer.

RITCHIE, SIR RICHMOND THACKERAY (1854–1912), Permanent Under-Secretary of State for India, from 1910.

ROCHEGROSSE, GEORGES ANTOINE (1859–1938), French painter, lithographer for *La Vie Parisienne*.

ROSEBERY, ARCHIBALD PHILIP PRIMROSE, 5th Earl of (1847–1929). Under-Secretary for the Home Office, 1881–83; Lord Privy Seal, 1885; Secretary for Foreign Affairs, 1886, 1892–94; Prime Minister and Lord President of Council, 1894–95.

ROSS, ROBERT BALDWIN (1869–1918), Canadian-born literary critic, art dealer. Succeeded WR as a Carfax Gallery Director. Wilde's literary executor.

ROSSI, CARMEN. Whistler's model from childhood. Caretaker of his so-called school of painting at 6 Passage Stanislas, Paris.

ROTHENSTEIN, ALBERT DANIEL (later RUTHERSTON) (1881–1953), WR's younger brother. Painter, stage designer; Master, Ruskin School, Oxford, 1929–49.

ROTHENSTEIN, ALICE KNEWSTUB (1870–1958), WR's wife; daughter of Walter Knewstub. Actress, before marriage, with stage name Alice Kingsley.

ROTHENSTEIN, BETTY, WR's younger daughter; Mrs Ensor Holiday.

ROTHENSTEIN, BLANCHE (1867–1970), WR's eldest sister; Mrs Max Schwabe.

ROTHENSTEIN, CHARLES LAMBERT (later RUTHERSTON) (1886–1928), WR's elder brother. Continued the family firm while contributing to support of many artists, his brothers among them. His modern art collection, purchased with WR's advice, was presented to the Manchester City Art Gallery, as the Rutherston Collection, intended as a travelling loan collection for schools and other public institutions.

ROTHENSTEIN, EMILY (1868–1961), WR's second sister, married New York textile manufacturer Edgar Hesslein (1862–1938), who, with WR's advice, assembled another notable modern collection, now dispersed.

ROTHENSTEIN, SIR JOHN, WR's elder son. Director, Leeds City Art Gallery, 1932–34; City Art Galleries and Ruskin Museum, Sheffield, 1933–38; Tate Gallery, 1938–64.

ROTHENSTEIN, LOUISA (1869–1918), WR's third sister, married Louis Simon, Manchester shipper. Their sons founded the Curwen Press.

ROTHENSTEIN, MICHAEL, WR's younger son. Painter, printmaker, writer and lecturer on graphics.

ROTHENSTEIN, MORITZ (1836–1914), WR's father. Senior partner in the Bradford firm, Rothenstein and Kafka. Married BERTHA DUX (Doczy) (1844–1913), daughter of a Hildesheim banker.

ROTHENSTEIN, RACHEL, WR's elder daughter; Mrs Alan Ward.

ROWLEY, CHARLES (1839–1933), Manchester picture-framer, art entrepreneur, social reformer; founder of the Ancoats Brotherhood.

ROYER, HENRI-PAUL (1869–1938), French genre and portrait painter.

RUNCIMAN, JOHN F. (1866–1916), music critic for *The Saturday Review*. Fabian associate of Shaw.

RUSSELL, GEORGE WILLIAM (AE) (1867–1935), Irish poet, artist, mystic, editor, agricultural reformer. Edited *The Irish Statesman*, 1923–30.

ST CYRES, STAFFORD HENRY NORTHCOTE, Viscount (1869–1926), student at Merton College, 1888–92; Don at Christ Church, Oxford, 1893.

SALAMAN, MICHEL, English painter, Slade School student.

SARGENT, JOHN SINGER (1856–1925), American painter. Born in Italy, studied in Florence and Paris, settled in London in 1884. Travel in Spain in 1880 introduced Spanish influences into his work.

SASSOON, RT. HON. SIR PHILIP, 3rd Baronet (1888–1939), Private Secretary to General Haig, 1915–18, then Under-Secretary of State for Air, 1924–29.

SCHWOB, MARCEL (1867–1905), Paris journalist and fiction writer.

SCOTT, GEOFFREY (1883–1929), architect, secretary and librarian to Berenson at I Tatti. First editor of the Malahide Castle Boswell Papers. Died of pneumonia in New York while engaged on this project.

SCOTT, SIR GEORGE GILBERT (1811–1878), architect and restorer in the Victorian Gothic style, St Pancras Station his best-known building. He and his family left 26 Church Row, Hampstead, in 1864.

SHANNON, CHARLES HASLEWOOD (1863–1937), painter, lithographer. Lived with Charles Ricketts in The Vale, Chelsea.

SHARMA, NRUSINGH. Through WR, Sharma met Lowes Dickinson, Robert Trevelyan, and E. M. Forster when they went to India in 1912.

SHERARD, ROBERT (1861–1943), Paris correspondent for papers in England, America, and Australia.

SHIELDS, FREDERIC (1833–1911), illustrator who turned to painting, under influence of Pre-Raphaelite associations.

SICHEL, ERNEST (1862–1941), painter. Except for study in London, lived and worked in his native town, Bradford.

SICKERT, ROBERT (?1861–1923), brother of Walter Sickert. Secretarial assistant in early years of the Carfax Gallery.

SICKERT, WALTER RICHARD (1860–1942), with Steer, the leading British Impressionist painter, influenced by Whistler, Degas, and intermittent sojourns in France. Founded Camden Town Group, 1911, later absorbed by the London Group, to which Sickert also belonged.

SIDDAL, ELIZABETH (1834–62), wife of Dante Gabriel Rossetti. Her art works were principally on Biblical and Shakespearean themes.

SMITH, LOGAN PEARSALL (1865–1949), critic and essayist. A Philadelphian educated at Haverford College, Harvard, and Balliol. Naturalised as a British subject in

1913. His sister Mary married Bernhard Berenson; his sister Alys, Bertrand Russell.

SMITHERS, LEONARD (1861–1907), London publisher. Principally remembered as a purveyor of pornography, but to be credited also with publishing and encouraging avant-garde writers and artists.

SOLOMON, SIMEON (1840–1905), historical painter, illustrator, friend of the Pre-Raphaelite circle. Showed promise but died in St Giles's workhouse in an advanced state of alcoholism.

SOLOMON, SOLOMON J. (1860–1927), historical painter trained at Royal Academy Schools, Munich Academy, and Ecole des Beaux Arts.

SOMERVELL, THEODORE HOWARD (1890–1975), physician, artist, mountaineer with Everest expeditions, 1922, 1924. Medical missionary in South India, 1923–48.

SPENCER, SIR STANLEY (1891–1959), English painter, mural painter. Took scenes and subjects from his home, Cookham, treated iconographically. Studied at Slade School, then served in Macedonia in 1915–18. Postwar work marked by death-and-resurrection allegory.

SPONG, HILDA, minor actress. Had role of Imogen Parrott in Pinero's *Trelawney of the 'Wells'* (1898).

SQUIRE, SIR JOHN COLLINGS (1884–1958). Became literary editor of *The New Statesman* in 1913; edited *London Mercury*, 1919–34. Editor, English Men of Letters Series.

STANLEY, SIR HENRY MORTON (1841–1904), African explorer, retriever of Livingstone.

STCHOUKINE (SHCHUKIN), SERGEI (1851–1936), Russian collector of Impressionist paintings.

STEAD, WILLIAM THOMAS (1849–1912), London journalist, foreign correspondent, crusader-at-large. Staff member, then editor, *Pall Mall Gazette*, 1880–89. Founded *The Review of Reviews*, 1890.

STEELE, ROBERT (1860–1944), science teacher and medievalist.

STEER, PHILIP WILSON (1860–1942), English Impressionist painter. Taught at the Slade School, London, 1893–1930.

STEPHEN, SIR HARRY LUSHINGTON, 3rd Baron (1860–1945), third son of Sir James Fitzjames Stephen. Judge of the High Court, Calcutta, 1901–14.

STEPHEN, SIR LESLIE (1832–1904), critic and man of letters. Son of Sir James Stephen. Edited *The Cornhill Magazine*, 1871–82. In 1882, began work on *Dictionary of National Biography*. In 1878 he married JULIA JACKSON (1846–95), widow of Herbert Duckworth.

STEVENS, ALFRED (1828–1906), Belgian painter, popular in Paris during Second Empire. Whistler brought him into the Society of British Artists in 1886; he left when Whistler resigned in 1888.

STIRLING, WILLIAM (d. 1902), unemployed Scottish architect, poet, writer on aesthetic theory and the occult. His book, *The Canon: An Exposition of the Pagan Mystery Perpetuated in the Cabala as the Rule of All the Arts* (1897), proposes symbolism of the ground plans of early churches. He died of starvation in his Adelphi flat.

STRANG, WILLIAM (1859–1921), Scottish painter and etcher. From 1875, lived in London.

STUDD, ARTHUR (1863–1919), English painter, pupil of Legros.

STURGES, JONATHAN (1864–1911), American journalist living in Paris. Translated Maupassant. Perhaps a model for Little Bilham in Henry James's *The Ambassadors*.

SWAN, JOHN (1847–1910), English genre, landscape, and animal painter.

SYMONS, ARTHUR (1865–1945), Welsh poet and critic. His book, *Symbolist Movement*

in Literature (1899), made him the leading interpreter in England of French Symbolism. Edited *The Savoy*, 1896. His abilities were later impaired by nervous breakdown suffered in 1908.

TAGORE, ABANINDRANATH (1871–1951), Bengali artist and art teacher, cousin of Rabindranath Tagore. Was Ernest Havell's Vice-Principal in the Government School of Art, Calcutta; then Acting Principal, 1906–09, thus the first Indian to occupy a Principal's chair in any of the four art schools in India. In 1910, at his own expense, he sent three students to assist Lady Herringham at Ajanta.

TAGORE, GAGANENDRANATH (1867–1938), artist; brother of Abanindranath.

TAGORE, RABINDRANATH (1861–1941), foremost modern Bengali man of letters. Educational theorist and founder of a school at Santiniketan, West Bengal, now Visva-Bharati University. Nobel Prize for Literature, 1913.

TAILHÈDE, RAYMOND DE LA (1867–1938), poet; follower of Jean Moréas and the Ecole Romane group.

TAYLOR, SIR HENRY (1800–86), Colonial Office official, c. 1822–72. Author of an enormous poetic drama, *Philip Van Artevelde* (1834).

TERRY, ELLEN (1847–1928), actress who made her stage début at the age of nine. Joined Irving's company at the Lyceum in 1878, remained there until 1902. In 1864 she became the girl-bride of the middle-aged G. F. Watts; in 1865 they separated. Later, she lived with Edward Godwin, father of her son Gordon Craig.

THAULOW, FRITS (1847–1906), Danish genre painter, decisively influenced by French Impressionism.

THOMAS, EDWARD (1878–1917), nature writer and poet. Died at the Battle of Arras, after enlisting in 1915.

TILAK, B. G. (1856–1920), Maharashtrian Extremist leader.

TISSOT, JAMES (1836–1902), French painter and etcher. Came to London, 1871–72, as refugee from the Commune. Noted for scenes of Victorian London life and, later, for Biblical illustrations.

TONKS, HENRY (1862–1937), surgeon and anatomist, then painter. Slade Professor of Fine Art, University College, London University, 1917–30. Academic artist, in the best sense, and a clever caricaturist.

TOOLE, JOHN LAWRENCE (1832–1906), comedian and stage producer. From 1852, toured United Kingdom, United States, Australia, New Zealand. Toole's Theatre, remodelled from the Charing Cross Theatre, opened in King William IV Street in 1882.

TOOROP, JAN (1858–1928), Dutch-Javanese painter. Combined Symbolism and stylised designs of Javanese batik and puppets.

TREE, SIR HERBERT BEERBOHM (1853–1917), actor-manager; Max Beerbohm's elder half-brother. Proprietor, Haymarket Theatre, 1887–97; Her Majesty's Theatre, 1897–1917.

TREE, VIOLA (1884–1938), eldest daughter of Sir Herbert Tree. Actress and singer.

TREVELYAN, GEORGE MACAULAY (1876–1962), third son of Sir G. O. Trevelyan; Regius Professor of Modern History at Cambridge, 1927–40.

TREVELYAN, ROBERT C. (1872–1951), poet; second son of Sir G. O. Trevelyan. In 1893–94, lived with Roger Fry at 29 Beaufort Street, Chelsea.

TURNER, REGINALD (1869–1938), journalist, novelist. Student at Merton College, 1888–92; after 1900, lived on the Continent.

TURNER, WALTER JAMES (1889–1946), literary editor, *The Spectator*, and musical critic, *The New Statesman*, 1916–40.

TWEED, JOHN (d. 1933), sculptor, creator of numerous memorial works.

VANBRUGH, DAME IRENE (d. 1949), joined Toole's company in 1889, Tree's in 1892, and George Alexander's in 1893.

VANDERVELDE, EMILE (1866–1938), Belgian Minister of State from 1914; Minister of Justice, 1918–21; and of Foreign Affairs, 1925–27.

VANIER, LÉON. Paris printer and principal publisher of the Symbolists.

VERNET, HORACE (1789–1863), French painter and lithographer, especially dedicated to glorification of the Bonaparte régime.

WALKER, SIR EMERY (1851–1933), designer and typographer. Helped to organise Arts and Crafts Exhibition Society. Assisted William Morris with starting the Kelmscott Press in 1890.

WALKER, FREDERICK (1840–75), painter, illustrator, wood-engraver.

WALTON, EDWARD ARTHUR (1860–1922), Glasgow artist. President, Royal Scottish Society of Painters in Water Colours.

WARREN, EDWARD P. (1860–1928), archaeologist and art collector. Son of S. D. Warren, wealthy New England paper manufacturer. Settled in England and devoted his life to Hellenic studies. In 1890, acquired Lewes House, School Hill Street, Lewes.

WATTS-DUNTON, WALTER THEODORE (1832–1914), solicitor, poet, novelist, play-wright, critic. Gipsies and Romany lore were predominant themes. From 1879, companion to Swinburne at The Pines, Putney Hill. In 1905 Watts-Dunton married CLARA JANE REICH, of Putney.

WAY, THOMAS ROBERT (1861–1913), lithographic printer, with assistance from his son, TOM WAY.

WELLESLEY, LADY DOROTHY (d. 1956), poet. Wife of Lord Gerald Wellesley.

WELLS, JOSEPH (1855–1929), authority on Herodotus. Warden, Wadham College, Oxford, 1913–27.

WHELEN, FREDERICK (1867–1955), political writer, lecturer, Fabian associate of Shaw. Helped to found the Stage Society in 1898.

WHISTLER, REX (1905–44), painter, etcher on glass. Studied at the Slade School and in Rome. Died in active service in World War II.

WHITE, GLEESON (1851–1898), author, editor. Born Christchurch, N.Z. Edited various art journals and annuals: *Art Amateur* (New York), 1891–92; *The Studio*, 1893–94; *The Pageant*, 1896, 1897.

WILKINSON, NORMAN (1882–1934), artist and theatrical designer; later, Governor of Shakespeare Memorial Theatre, Stratford-on-Avon.

WINTER, JOHN STRANGE, pseudonym of HENRIETTA E. V. STANNARD (1856–1911), popular novelist.

WOODROFFE, SIR JOHN (1865–1936), Puisne Judge of the Calcutta High Court, 1904–22. As Arthur Avalon, writer on Tantric rites and philosophy.

WOODS, MARGARET BRADLEY (1856–1945), poet and novelist; wife of Henry G. Woods, President, Trinity College, Oxford, 1887–97.

WYNDHAM, RT. HON. GEORGE (1863–1913), Private Secretary to A. J. Balfour, 1887–92; Parliamentary Under-Secretary of State for War, 1898–1900; Chief Secretary for Ireland, 1900–05.

ZULOAGA Y ZABALETA, IGNACIO (1870–1945), Spanish painter who settled in Paris and associated with Symbolist groups, as well as with disciples of Degas and Rodin.

BIBLIOGRAPHY

Manuscript Collections Cited:

Academic Center Library, Humanities Research Center, University of Texas, Austin.

Beinecke Rare Book and Manuscript Library, Yale University: John Drinkwater Papers.

Bibliothèque Nationale, Paris: Gordon Craig Collection.

Bodleian Library, Oxford: H. A. L. Fisher Papers.

Boston Public Library: Department of Rare Books and Manuscripts.

The British Library, London: Northcliffe Papers; Cornford Papers.

Brotherton Collection: University of Leeds.

William Andrews Clark Memorial Library, University of California at Los Angeles

Cornell University Library: Wyndham Lewis Collection.

Faber & Faber Ltd, London.

Isabella Stewart Gardner Museum, Boston.

Glasgow University Library: Special Collections.

The Houghton Library, Harvard University: Rothenstein Papers.

Library of the University of Illinois at Champaign-Urbana: Grant Richards Papers; Wells Archive.

Institut Néerlandais, Paris: Fondation Custodia (Collection F. Lügt).

Islington Public Library.

King's College Library, Cambridge: C. R. Ashbee Papers.

Library of Congress.

National Archives of India, New Delhi.

The New York Public Library, Astor, Lenox and Tilden Foundations: Berg Collection.

Staatsbibliothek Preussischer Kulturbesitz: Gerhart Hauptmann Archive.

University College Library, University of London: Anglo-Jewish Archive, Mocatta Library.

Victoria and Albert Museum, London: Enthoven Theatre Collection.

Books by William Rothenstein:

English Portraits. London: Grant Richards, 1898.

The French Set: Portraits of Rodin, Fantin-Latour and Alphonse Legros. London: The Unicorn Press, 1898.

Goya. The Artist's Library. London: The Unicorn Press, 1900.

Liber Juniorum: Six Lithographed Drawings. London: The Unicorn Press, 1899.

Manchester Portraits. Manchester: W. E. Cornish, 1900.

Men and Memories: Recollections of William Rothenstein, 1872–1900. London: Faber & Faber, 1931. Rose and Crown Edition, 1934.

Men and Memories: Recollections of William Rothenstein, 1900–1922. London: Faber & Faber, 1932. Rose and Crown Edition, 1934.

Men and Memories: A History of the Arts, 1872–1932: Being the Recollections of William Rothenstein. New York: Tudor Publishing Company, 1937.

Men of the R.A.F. London: Oxford University Press, 1942.

BIBLIOGRAPHY

Oxford Characters: Twenty-Four Lithographs. London: John Lane; New York: R. H. Russell and Son, 1896.
Paul Verlaine: Three Drawings. London: Hacon and Ricketts [1898].
The Portrait Drawings of William Rothenstein, 1889–1925. John Rothenstein, comp. London: Chapman and Hall, 1925.
Since Fifty: Men and Memories, 1922–1938: Recollections of William Rothenstein. London: Faber & Faber, 1939.

Other Books:

Ackerley, J. R. *Hindoo Holiday: An Indian Journal.* London: Chatto and Windus; New York: Viking, 1932.
Allison, Alfred. *The Parson and the Painter: Their Wanderings and Excursions among Men and Women.* London: Central Publishing and Advertising Co. [1892].
Ashbee, C. R. *Where the Great City Stands: A Study in the New Civics.* London: Essex House Press and B. T. Batsford, 1917.

Baron, Wendy. *Sickert.* London: Phaidon Press; New York: Praeger Publishers, 1973.
Beardsley, Aubrey. *The Letters of Aubrey Beardsley.* Henry Maas, J. L. Duncan and W. G. Good, eds. Rutherford, N. J.: Fairleigh Dickinson University Press [1970]. London: Cassell, 1971.
Beerbohm, Max. *Rossetti and His Circle.* London: William Heinemann, 1922.
—— *Seven Men.* London: William Heinemann, 1919. New York: Alfred A. Knopf, 1920.
—— *A Variety of Things.* London: William Heinemann; New York: Alfred A. Knopf, 1928.
Birnbaum, Martin. *The Last Romantic: The Story of More than a Half-Century in the World of Art.* New York: Twayne Publishers, 1960.
Blunt, Wilfrid. *'England's Michelangelo'.* London: Hamish Hamilton, 1975.
Burdett, Osbert, and E. H. Goddard. *Edward Perry Warren: The Biography of a Connoisseur.* London: Christophers [1941].

Campbell, Margaret. *Dolmetsch: The Man and His Work.* London: Hamish Hamilton; Seattle: University of Washington Press, 1975.
Carter, Morris. *Isabella Stewart Gardner and Fenway Court.* Boston and New York: Houghton Mifflin, 1925.
Cecil, David. *Max: A Biography.* London: Constable [1964]. Boston: Houghton Mifflin, 1965.
Chatterjee, Ramananda, ed. *The Golden Book of Tagore: A Homage to Rabindranath Tagore from India and the World in Celebration of His Seventieth Birthday.* Calcutta: Golden Book Committee, 1931.
Cochran, C. B. *Cock-a-Doodle-Do.* London: J. M. Dent [1941].
Conder, Charles. *Six Lithographed Drawings from Balzac.* London: Carfax, 1898.
Coomaraswamy, A. K. *Rajput Painting: Being an Account of the Hindu Paintings of Rajasthan and the Punjab Himalayas from the Sixteenth to the Nineteenth Century, Described in Their Relation to Contemporary Thought, with Texts and Translations.* 2 vols. London and New York: H. Milford for Oxford University Press, 1916.
Craig, Edward. *Gordon Craig: The Story of His Life.* London: Victor Gollancz Ltd, 1968.

Davis, Richard Harding. *Adventures and Letters of Richard Harding Davis.* Charles Belmont Davis, ed. New York: Charles Scribner's Sons, 1917.

Du Maurier, George. *The Young George Du Maurier: A Selection of His Letters.* Daphne Du Maurier, ed. London: P. Davies, 1951. Garden City, N.Y.: Doubleday, 1952.

Elton, Oliver. *Frederick York Powell: A Life and a Selection from His Letters and Occasional Writings.* 2 vols. Oxford: The Clarendon Press, 1906.
Epstein, Jacob. *Epstein: An Autobiography.* New York: E. P. Dutton, 1955. London: Vista Books, 1963.

Forster, E. M. *Goldsworthy Lowes Dickinson.* London: E. Arnold; New York: Harcourt, Brace, 1934.
Frith, W. P. *My Autobiography and Reminiscences.* 2 vols. London: Richard Bentley, 1887. New York: Harper, 1888.
Fry, Roger. *Letters of Roger Fry.* Denys Sutton, ed. 2 vols. London: Chatto and Windus; New York: Random House, 1972.

Gallatin, A. E. and Alexander D. Wainwright. *The Gallatin Beardsley Collection in the Princeton University Library: A Catalogue.* Princeton: Princeton University Library, 1952.
Gettmann, Royal A., ed. *George Gissing and H. G. Wells.* London: Hart-Davis; Urbana: University of Ilinois Press, 1961.
Gill, Eric. *Letters of Eric Gill.* Walter Shewring, ed. London: J. Cape, 1947. New York: The Devin-Adair Company, 1948.
de Goncourt, Edmond and Jules. *Edmond and Jules de Goncourt, with Letters and Leaves from Their Journals.* M. A. Belloc and M. Shedlock, comps. and trans. 2 vols. London: William Heinemann, 1895.
—— *Journal des Goncourt: Mémoires de la Vie Littéraire.* 9 vols. Paris: Ernest Flammarion, Fasquelle [1872–96].

Henley, W. E. *Poems.* London: D. Nutt; New York: Scribner, 1898.
Herbert, Kevin. *Ancient Art in Bowdoin College: A Descriptive Catalogue of the Warren and Other Collections.* Cambridge, Mass.: Harvard University Press, 1964.
Herkomer, Hubert von. *My School and My Gospel.* London: Archibald Constable; New York: Doubleday, Page, 1908.
Hoff, Ursula. *Charles Conder.* Melbourne: Lansdowne Australian Art Gallery, 1972.
Holroyd, Michael. *Augustus John.* 2 vols., London: William Heinemann, 1974. 1 vol., New York: Holt, Rinehart and Winston, 1975.
Homa, Bernard. *A Fortress in Anglo-Jewry: The Story of the Machzike Hadath* London: Shapiro, Vallentine, 1953.
Housman, A. E. *The Letters of A. E. Housman.* Henry Maas, ed. London: Hart-Davis; Cambridge, Mass.: Harvard University Press, 1971.
Hueffer, Ford Madox. *Ford Madox Brown: A Record of His Life and Work.* London and New York: Longmans, Green, 1890.

Ionides, Luke. *Memories.* Paris: Herbert Clarke, 1925.

James, Henry. *Notes on Novelists, with Some Other Notes.* London: J. M. Dent, 1914. New York: Scribner, 1916.
Jean-Aubry, G. *Joseph Conrad: Life and Letters.* 2 vols. Garden City, N.Y.: Doubleday, Page; London: William Heinemann, 1927.
Jonson, Ben. *Ben Jonson His Volpone; or, The Foxe; a New Edition, with a Critical Essay on the Author by Vincent O'Sullivan, and a frontispiece, five initial letters, and a cover design illustrative and decorative by Aubrey Beardsley; together with*

244 BIBLIOGRAPHY

an eulogy of the artist by Robert Ross. London: L. Smithers; New York: John Lane, 1898.

La Farge, Mabel. *Egisto Fabbri (1866–1933)*. New Haven: privately printed [Yale University Press], 1937.
Lafourcade, Georges. *Swinburne: A Literary Biography*. London: G. Bell and Sons; New York: Russell and Russell, 1932.
Lago, Mary M., ed. *Imperfect Encounter: Letters of William Rothenstein and Rabindranath Tagore, 1911–1941*. Cambridge, Mass.: Harvard University Press, 1972.
—— *Rabindranath Tagore*. Boston: Twayne Publishers, 1976.
—— and Karl Beckson, eds. *Max and Will: Max Beerbohm and William Rothenstein, Their Friendship and Letters, 1893–1945*. London: John Murray; Cambridge, Mass.: Harvard University Press, 1975.
Laughton, Bruce. *Philip Wilson Steer*. Oxford Studies in the History of Art and Architecture. Oxford: The Clarendon Press, 1971.
Lewis, Wyndham. *Rude Assignment: A Narrative of My Career Up-to-Date*. London and New York: Hutchinson [1950].
Ludovici, Albert. *An Artist's Life in London and Paris, 1870–1925*. London: T. F. Unwin [1926]. New York: Minton, Balch and Co., 1926.

MacColl, D. S., ed. *Illustrated Memoir of Charles Wellington Furse, A.R.A., with Critical Papers and Fragments, A Catalogue of the Pictures Exhibited at the Club in 1906, and a Chronological List of Works*. London: Burlington Fine Arts Club, 1908.
McMullen, Roy. *Victorian Outsider: A Biography of J. A. M. Whistler*. New York: E. P. Dutton, 1973. London: Macmillan, 1974.
Mackworth, Cecily. *English Interludes: Mallarmé, Verlaine, Paul Valéry, Valéry Larbaud in England, 1860–1912*. London: Routledge and Kegan Paul, 1974.
Moore, George. *Modern Painting*. London: W. Scott; New York: Scribner, 1893.
Mount, Charles Merrill. *John Singer Sargent: A Biography*. New York: W. W. Norton, 1955.

Nelson, James G. *The Early Nineties: A View from the Bodley Head*. Cambridge, Mass.: Harvard University Press, 1971.

Ormond, Leonée. *George Du Maurier*. London: Routledge and Kegan Paul, 1969.

Pater, Walter. *Letters of Walter Pater*. Lawrence Evans, ed. Oxford: The Clarendon Press, 1970.
Pennell, Elizabeth. *The Life and Letters of Joseph Pennell*. 2 vols. Boston: Little, Brown, 1929. London: Ernest Benn, 1930.
—— *Whistler the Friend*. Philadelphia and London: J. B. Lippincott, 1930.
Pennell, E[lizabeth] R. and J[oseph]. *The Life of James McNeill Whistler*. 2 vols. London: William Heinemann; Philadelphia: J. B. Lippincott, 1908. Fifth rev. ed. (1 vol.), 1921.
—— *The Whistler Journal*. Philadelphia: J. B. Lippincott, 1921.
Pennell, Joseph. *The Adventures of an Illustrator, Mostly in Following his Authors in America and Europe*. Boston: Little, Brown, 1925.

Repington, Charles à Court. *The First World War, 1914–1918: Personal Experiences*. 2 vols. London: Constable; Boston and New York: Houghton Mifflin, 1920.

BIBLIOGRAPHY

Richards, Grant. *Author Hunting, by an Old Literary Sportsman: Memories of Years Spent Mainly in Publishing*. London: Hamish Hamilton; New York: Coward-McCann, 1934.

—— *Memories of a Misspent Youth, 1872–1896*. London: William Heinemann; New York: Harper, 1933.

Richardson, Joanna. *Verlaine*. London: Weidenfeld and Nicolson; New York: Viking Press, 1971.

Ricketts, Charles. *Self-Portrait: Taken from the Letters and Journals of Charles Ricketts*. T. Sturge Moore, coll. and comp.; Cecil Lewis, ed. London: Peter Davies [1939].

Rilke, Rainer Maria. *Lettres à Rodin*. Paris: Les Images du Temps, No. 7, 1928.

—— *Letters of Rainer Maria Rilke, 1892–1910*. Jane Bannard Greene and M. D. Herter Norton, trans. 2 vols. New York: W. W. Norton [1945].

Ross, Sir Denison. *Both Ends of the Candle: The Autobiography of Sir E. Denison Ross*. London: Faber & Faber, 1943.

Ross, Margery, ed. *Robert Ross, Friend of Friends. Letters to Robert Ross, Art Critic and Writer, together with Extracts from his Published Articles*. London: Jonathan Cape, 1952.

Rothenstein, Elizabeth. *Stanley Spencer*. Oxford and London: Phaidon Press, 1945.

Rothenstein, John. *Brave Day, Hideous Night*. London: Hamish Hamilton; New York: Holt, Rinehart and Winston, 1966.

—— *The Life and Death of Conder*. London: J. M. Dent; New York: E. P. Dutton, 1938.

—— *Summer's Lease*. London: Hamish Hamilton, New York: Holt, Rinehart and Winston, 1965.

Shaw, G. B. *Collected Letters, 1874–1897*. Dan H. Laurence, ed. London: Max Reinhardt; New York: Dodd, Mead, 1965.

—— *Collected Letters, 1898–1910*. Dan H. Laurence, ed. London: Max Reinhardt; New York: Dodd, Mead, 1972.

—— *Our Theatres in the Nineties*. 3 vols. Standard ed. London: Constable, 1932.

—— *Pen Portraits and Reviews*. London: Constable, 1931. Rev. standard ed., 1932.

Slapkins, Joseph (pseud.). See Allison, Alfred.

Speaight, Robert. *William Rothenstein: The Portrait of an Artist in His Time*. London: Eyre and Spottiswoode, 1962.

Spencer, Gilbert. *Stanley Spencer*. London: Victor Gollancz, 1961.

Surtees, Virginia. *The Paintings and Drawings of Dante Gabriel Rossetti (1828–1882): A Catalogue Raisonné*. 2 vols. Oxford: The Clarendon Press, 1971.

Swinburne, Algernon C. *Les Fleurs du Mal and Other Studies*. London: [privately printed for T. J. Wise] 1913.

Tagore, Rabindranath. *Gitanjali (Song-Offerings)*. London: The India Society, 1912; London and New York: Macmillan, 1913.

—— *Mashi and Other Stories*. London and New York: Macmillan, 1918.

Tharp, Louise Hall. *Mrs. Jack: A Biography of Isabella Stewart Gardner*. Boston: Little, Brown [1965].

Way, Thomas R. *Lithographs of Whistler*. 2 vols. New York: Kennedy and Co., 1914.

—— *Memories of James McNeill Whistler, The Artist*. London: John Lane, The Bodley Head; New York: John Lane Co., 1912.

Weintraub, Stanley. *Whistler: A Biography*. New York: Weybright and Talley, 1974.

Whistler, J. A. M. *Eden versus Whistler: The Baronet and the Butterfly: A Valentine with a Verdict.* New York: R. H. Russell [1898]. Paris: 'Valentine', privately printed, 10 February 1899; Paris: Louis-Henry May [1899].

—— *The Gentle Art of Making Enemies.* Sheridan Ford, ed. Unauthorised ed., New York: F. Stokes and Brothers, 1890. Authorised ed., London: William Heinemann, 1890.

—— *Wilde v. Whistler: Being an Acrimonious Correspondence on Art Between Oscar Wilde and James A. McNeill Whistler.* London: privately printed, 1906.

Wilde, Oscar. *The Letters of Oscar Wilde.* Rupert Hart-Davis, ed. London: Rupert Hart-Davis, 1961; New York: Harcourt, Brace and World [1962].

—— *Salome: A Tragedy in One Act.* London: Elkin Mathews and John Lane; Boston: Copeland and Day, 1894.

Woolf, Virginia. *The Flight of the Mind. The Letters of Virginia Woolf, 1888–1911.* Nigel Nicolson, ed. London: Chatto and Windus; New York: Harcourt, Brace Jovanovich, 1975.

—— *Roger Fry: A Biography.* London: The Hogarth Press; New York: Harcourt, Brace, 1940.

Yeats, W. B. *Collected Poems.* London and New York: Macmillan, 1933.

—— *Essays and Introductions.* New York: Collier Books [1968].

—— *The Letters of W. B. Yeats.* Allan Wade, ed. London: Rupert Hart-Davis, 1954. New York: Macmillan, 1955.

—— *Letters on Poetry from W. B. Yeats to Dorothy Wellesley.* London and New York: Oxford University Press, 1940.

INDEX